Photographic Science

Photographic Science

Earl N. Mitchell

The University of North Carolina at Chapel Hill

JOHN WILEY & SONS
New York Chichester Brisbane Toronto Singapore

Cover photograph by Earl N. Mitchell

Library of Congress Cataloging in Publication Data:

Mitchell, Earl N. (Earl Nelson), 1926–
Photographic science.

Includes index.
1. Photgraphy. I. Title.

TR145.M57 1984 770 83-19808
ISBN 0-471-09046-8

Printed in the United States of America

10 9 8 7 6 5 4 3 2 1

*This book is dedicated to
Ross Scroggs
who taught me much of the
photography I know.*

Preface

This book is an outgrowth of the author's experience in teaching a photography course in the physics and astronomy department at the University of North Carolina at Chapel Hill (UNC) for at least ten years. The book is designed to be the principal text in a one-semester photography course taught to undergraduate college students with no previous experience in science or photography. The emphasis is on black-and-white (monochrome) photography. The course at UNC is accompanied by a laboratory in which the students learn to take black-and-white pictures, process, and make enlargements of them. A manual[1] is available for use in a laboratory, which might accompany the lecture part of the course. Although the major emphasis is on black-and-white photography, sufficient material on color photography is presented so that students should have little difficulty applying what has been learned to color photography.

It is my belief that a student who knows why a system works can use it more effectively than if he/she only knows how the the system works and what to do to make it work. This is especially true if the student is confronted with a situation requiring that the system be used in a new or unfamiliar manner. With that in mind, this book does more than explain the how and what of photography. It tries, also, to explain the why of photography within the limits of the capability of the student and the author.

On occasion, material is presented that may be beyond the capability of the beginning student, but this supplementary material is designated by screening the background light gray and can be omitted without loss of continuity. Chapter 1 emphasizes the history of the technical aspects of photography. A discussion of the development of the camera lens is deferred to Chapter 4 and the evolution of color photography is discussed in Chapter 12. For a more comprehensive history

[1] Timothy Haywood and Earl Mitchell, *Laboratory Manual for Photographic Science,* New York: John Wiley & Sons, 1984.

of photography, see for example a history by Beaumont Newhall.[2] A discussion of photography and its impact on America can be found in Robert Taft's history.[3] Chapter 3 presents some rudimentary aspects of composition. Chapters 1 and 3 can be omitted completely if time is not available to present all the material in the book. However, I have found that students consider this material very interesting.

Although designed to be a text, this book is sufficiently complete that it will be useful to teachers of photographic courses emphasizing less science and to practicing photographers who want to learn more photographic science.

The text is divided into four parts. The first is called "getting started" and is designed to introduce the student to photography. The goal here is to as rapidly as possible get the student to a point where satisfactory pictures can be taken. The second part of the book emphasizes the optics of photography and is designed to help the student understand the camera and use it more effectively. The third part of the book emphasizes the silver halides and the way they work. The goal here is to enable the student to obtain proper exposures, good quality negatives, and good prints from these negatives. The fourth and final part of the book discusses light sources, color and color photography, and filters. Here, the goal is to fill in some gaps in the student's knowledge of black-and-white photography and to introduce him/her to color photography. A Glossary is included that is designed to help the uninitiated student recall troublesome photographic terms. The definitions are not global but are designed to illuminate the terms as they are used in this book. The first appearance in the text of an item that is in the glossary, is indicated by italicizing the item in the text.

Many people helped in the preparation of this book. Ross Scroggs shared his considerable knowledge and commented on much of the manuscript. The comments of other teachers in our photography course or ones similar to it were most beneficial — James Crawford, Timothy Haywood, Louis Roberts, Dietrich Schroeer. Lawrence Slifkin read Chapters 7 and 11 critically; John Dixon reviewed the text as a writer, teacher, and amateur photographer. Van Neie read the entire manuscript and made suggestions that have improved its style. Rege Anders was most helpful in sharing with me his extensive knowledge of modern photographic materials and equipment. Lee Howe, Jane Hamborsky, and their assistants provided some excellent darkroom work. The first-rate line drawings and graphs are the work of Jeanne G. (Didi) Dunphey (Media and Instructional Support Center, University of North Carolina at Chapel Hill), who successfully interpreted my primitive efforts. For the past 28 years, my wife, Marlys Mitchell, has served patiently as secretary, photographer's assistant, and model during photographic expeditions which allowed me to improve my skill and knowledge and to generate some of the photographs contained in this book. Finally, Cynthia Howard has competently and patiently typed and retyped this manuscript numerous times. My thanks to all of them. The words are mine, however, as is the responsibility for any errors found among them.

1 July, 1983 Earl N. Mitchell

[2]Beaumont Newhall, *The History of Photography*, New York: The Museum of Modern Art, 1964.

[3]Robert Taft, *Photography and the American Scene*, New York: Dover Publications, 1938.

Contents

PART 4 Light, Color, and Filters

part

· 1 ·

GETTING STARTED

chapter
·1·

History of photography

■ **PRECURSORS OF PHOTOGRAPHY**

The earliest device used for projecting and copying images was the *camera obscura*. In its earliest form, this was a darkened room with a hole in one wall. The image of objects outside the room was projected through the hole onto the opposite wall, and persons in the room could study these images (see Fig. 1.1) and trace them on paper. Although it is not known when the camera obscura was invented,

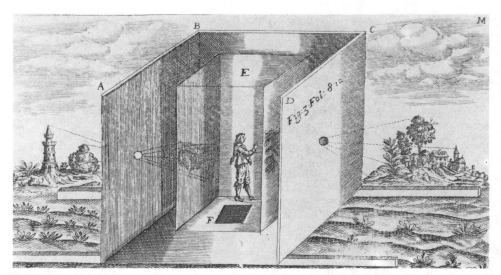

FIGURE 1.1 A room used as a camera obscura. (International Museum of Photography at George Eastman House)

it was used in the eleventh century to view a solar eclipse, and it was known to Leonardo da Vinci (1452–1519). In about the sixteenth century, the device had evolved into a box. Girolamo Cardano, an Italian mathematician and physician (1501–1576), had fitted a *lens* to it, and the image could be projected by a mirror onto a ground-glass plate where the illustrator could copy it on paper (see Fig. 1.2).

Civilization has used the glass lens for centuries. One was discovered in the ruins of Nineveh, destroyed by the Babylonians in 612 B.C. Glass lenses probably were first used as an aid to vision before the beginning of the fourteenth century. Giordano Pisa praised their use in a sermon in 1306 and alluded to their discovery less than 20 years earlier.

Although images could be traced, and in a sense recorded, using the camera obscura, a less laborious way to record images was desired. By 1826, a French inventor, Nicéphore Niepce, had used an asphaltum called bitumen of Judea to record high contrast images. This asphaltum, which normally is soluble in lavender oil, becomes insoluble when exposed to sunlight. In one of his experiments Niepce varnished a polished pewter plate with asphaltum and exposed the plate to sunlight through a lithograph. On the part of the plate under the lines of the lithograph that received less sunlight, the asphaltum was dissolved by a solvent such as lavender oil. After further etching and engraving, this plate was inked and used to make copies of the original lithograph. The varnished plates were also used with a *camera* to form permanent images. All of these images were called *heliographs* (see Fig. 1.3).

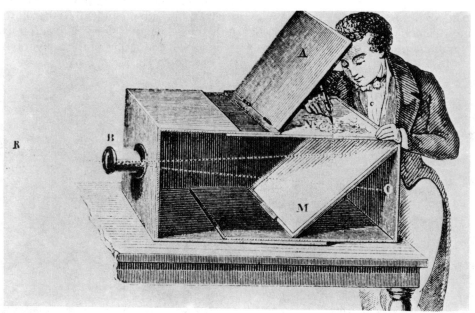

FIGURE 1.2 Using a camera obscura to trace the image of a scene. (International Museum of Photography at George Eastman House)

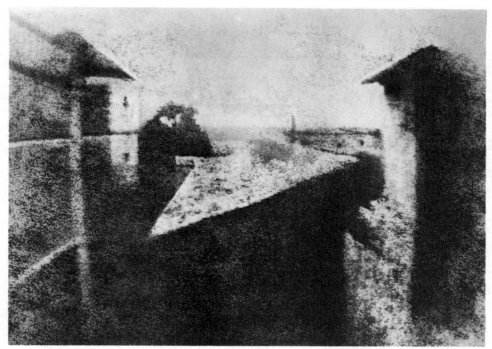

FIGURE 1.3 View from his Window at Gras, an early heliograph, N. de Niepce, 1826.
(Gernsheim Collection, Humanities Research Center, The University of Texas at Austin)

■ THE DAGUERREOTYPE

By 1727, John Schulze, a German physicist, discovered that certain silver salts darkened when exposed to sunlight. Thomas Wedgwood, son of the English potter Josiah Wedgwood, used silver nitrate on leather to form copies of paintings on glass by exposure to sunlight. He did not know how to make these images permanent however. Sir Humphrey Davy reported these experiments in the *Journal of the Royal Institution* in 1802.[1] Niepce also had attempted to use silver salts to make pictures. He and Louis Mandé Daguerre, a French painter, entered into an agreement in 1829 to improve and market the heliograph. By that time, Niepce had improved his heliograph using metal plates coated with silver and exposing the bare metal areas to iodine vapor to change their color.

By 1837, after Niepce died, Daguerre had modified Niepce's methods so that images of much greater brilliance could be produced. He felt the new process sufficiently different from heliography, that he called the new images *daguerreotypes.* In this process, a copper plate coated with silver and properly buffed is exposed

[1]H. Davy, *Journal of the Royal Institution, 1,* 170 (1802).

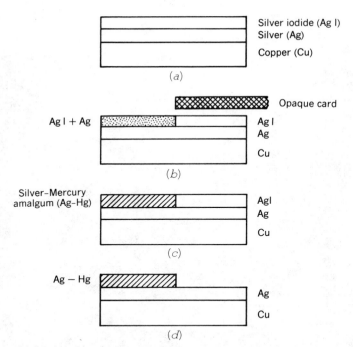

FIGURE 1.4 Making a daguerreotype: (a) the unexposed plate, (b) the exposure of the plate, (c) the developed plate, and (d) the fixed plate.

to iodine vapor, forming a thin layer of silver iodide on the surface of the plate (see Fig. 1.4a). The plate is then exposed to *light*. In the example in Figure 1.4b, the left half is exposed totally to light, whereas the right half is covered by an opaque sheet.

Normally, the plate would be exposed in a camera to a subject consisting of various shades of light and dark areas. In those areas where light reaches the plate, some of the silver iodide is converted to small particles of silver that are not visible to the eye. The plate is then developed by exposing it to mercury vapor. The particles of silver combine with the mercury to form an amalgam of silver and mercury that is visible (Fig. 1.4c). The plate is then washed in a solution of sodium thiosulfate to remove the unexposed silver iodide (Fig. 1.4d). Originally, common salt (sodium chloride) was used for this purpose.

The first daguerreotypes were made of inanimate objects (Fig. 1.5), because exposures of several minutes were required to form the images, even in bright sunlight. Daguerre was awarded a pension from the French government, and the process was first described and demonstrated to the public in 1839.

By 1840, three improvements made the process commercially feasible. That year, Joseph Petzval developed a portrait lens for the camera (see Fig. 4.40) which compared with the earlier *meniscus lens* made the image on the plate as much as 16 times brighter. The plates were made more sensitive by exposing them to bromine vapor or a combination of bromine and chlorine vapor. These two improve-

ments made possible exposures of less than one minute in bright light, so that the process could be used for portraiture. Finally, the finished plate was toned a purple brown by bathing the plate in gold chloride. In addition to changing its color, this process made the plate much more durable.

Figure 1.4 shows that the highlight areas of the plate are a rather dull gray silver-mercury amalgam like the material used to fill teeth. The shadow areas are polished silver. Viewed in direct light, a daguerreotype frequently looks as though the tones are reversed from those of the actual scene. If the plate is viewed at a glancing angle against a dark cloth such as velvet (see Fig. 1.6), however, the reflection of the dark cloth by the silver makes the shadow areas appear dark compared with the matte surface of the amalgam. Just as with a mirror, an image formed on a daguerreotype surface is reversed.

Mirrors were sometimes placed in front of the camera so that this second reversal would yield a daguerreotype in which left and right are not reversed. Daguerreotypes were sometimes colored either by applying pigment with a brush or through a mask.

Daguerreotype pictures could show considerable detail and yield excellent images, but the exposure times were very long, which was a distinct disadvantage. Another disadvantage was that to produce more than one copy of a subject, it was necessary to make a daguerreotype of the original, which was not a very satisfactory procedure. Nonetheless, daguerreotypes were commercially successful.

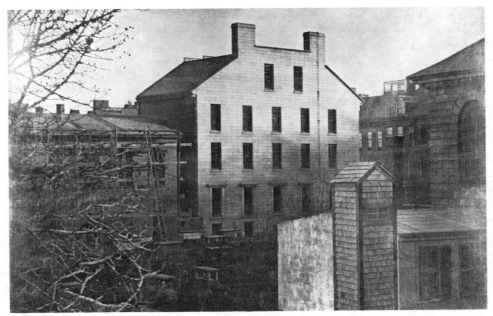

FIGURE 1.5 King's Chapel Burying Ground, a daguerreotype, S. Bemis, 1840. (International Museum of Photography at George Eastman House)

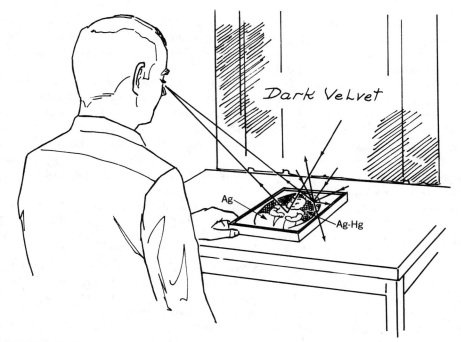

FIGURE 1.6 Viewing a daguerreotype against dark velvet.

Although the process was used to record scenery, architecture, and still life, the majority of daguerreotypes was portraits. Prior to its development, the only way to make a permanent image of a person was by painting or drawing, which was time consuming and expensive. The daguerreotype provided an inexpensive way to make a permanent image of the human face and became especially popular for portraiture in America.

■ THE NEGATIVE-POSITIVE PROCESS

Out of frustration at his lack of artistic skill, William Henry Fox Talbot, English country gentleman and amateur scientist among other things, experimented with and ultimately invented a photographic process that could be used to make multiple copies. He made light-sensitive paper by bathing paper first in a solution of common table salt (sodium chloride) and after it had dried, one of silver nitrate to form silver chloride on the paper. This sensitized paper was exposed in a small camera until an image visible to the eye was formed.

This process, called *printing-out,* requires much longer exposure than is required when a developing step is included. The paper was then washed in a solution of sodium chloride or potassium iodide, making the unaltered silver chloride less sensitive to light. The highlight areas, composed of small silver particles, were dark. In the shadow areas, the white paper was visible and thus, light in color. Talbot presented these early results to the Royal Society in January 1839.

In 1819, Sir John Herschel a German-born English astronomer, discovered that sodium thiosulfate dissolved various silver salts. On hearing of Daguerre's and Fox Talbot's work in January 1839, he sensitized paper with silver salts, exposed part of the sensitized paper, and fixed the image with sodium thiosulfate. Sodium thiosulfate originally was called sodium hyposulfite from which comes the abbreviation *hypo*. This is one of the modern photographer's words for a *fixing* solution.

Although the tones in Talbot's original images were reversed, he observed that they could be reversed again by copying the original picture photographically on a second sensitized paper. Herschel called the picture in which the tones were reversed a *negative* (Fig. 1.7), and the one in which the tones matched those of the original subject was called a *positive* (Fig. 1.8).

In 1840, Talbot improved his process significantly and named the pictures *calotypes*. Later, at the suggestion of friends he called them *talbotypes*. In the improved process, he prepared the paper by bathing it first in silver nitrate and then in potassium iodide to form the light-sensitive salt, silver iodide. He then bathed the paper in a mixture of gallic acid and silver nitrate. After a short exposure in the camera, the negative was *developed* by again bathing the paper in the gallic acid-silver nitrate mixture.

Joseph B. Reade, an English amateur scientist, discovered in 1837 that gallic acid altered the light response of the light-sensitive silver salts. He did not realize, however, that gallic acid acted as a developer. In Talbot's earliest experiments, the negatives were fixed in potassium bromide, but later they were fixed in hot hypo. Positive copies were made using his original silver chloride paper and the original printing-out process. Because the fibers of the paper negative reduced the detail in the positive, the negatives were waxed to reduce the loss of detail.

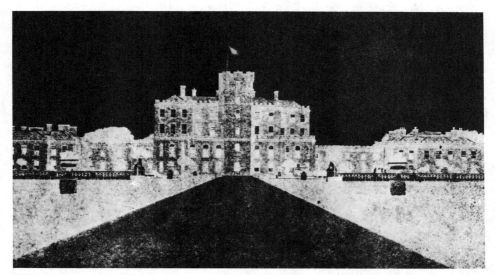

FIGURE 1.7 Gordon Castle, a calotype negative, Dickens, 1854. (International Museum of Photography at George Eastman House)

FIGURE 1.8 The Open Door, a calotype positive, W. Talbot, 1844. (International Museum of Photography at George Eastman House)

The calotype was never as popular as the daguerreotype, partly because Talbot's patents restricted its use. The calotype's inability to record fine detail made it less popular for portraiture than the daguerreotype. The calotype was used most often to record architecture and landscapes, where the soft image frequently heightened rather than reduced the visual impact of the image.

In 1850, Louis Blanquart-Evrard, who had been using Talbot's process, invented a new kind of paper called *albumen paper* which became the norm for printing paper for most of the remainder of the century. The paper was coated with egg white in which potassium bromide and potassium iodide were dissolved. The paper was sensitized by floating it on a solution of silver nitrate. An image was formed (printed out) by a long exposure to the sun through a negative, toned with gold chloride, fixed, washed, and dried.

Blanquart-Evrard did not like the print-out process, because exposures took so long. He modified Talbot's calotype negative process and used it to make *developing-out* printing paper. After exposures of only a few seconds, a *latent image* was developed to a visible olive-green image, and changed to gray slate tone using acid fixer. By 1852, Blanquart-Evrard had established a large commercial firm near Lille, France, to produce *prints* using this process, and by 1857 this firm had made at least 100,000 of these prints. Although the prints were of excellent quality, the process did not become universally popular and developing-out paper did not reappear until the late 1800s.

■ GLASS NEGATIVES

The calotype negative, even when oiled, yielded an image that was not very sharp, because the paper base diffused light during the printing process. Some method was needed to attach the light-sensitive silver salts to a transparent backing. In 1847, Claude Niepce de St. Victor, a cousin of Nicéphore Niepce, invented the albumen plate. Glass plates were coated with egg white containing potassium iodide. As with the albumen print, the plate was sensitized with a solution of silver nitrate. After exposure in the camera, the plate was developed in gallic acid, then fixed and washed. These negatives could be used to make prints of very fine detail. However, an exposure of 5 to 15 minutes was necessary to form the latent image on the plate. A much more light-sensitive plate was needed, especially for portraiture.

Frederick Archer, an Englishman, in 1851 invented the *collodion wet plate,* which immediately became the negative material of choice. Collodion in its viscous state is a solution of nitrocellulose in ether and alcohol. Archer's plates were made by dissolving appropriate salts of iodine and bromine in viscous collodion, then coating glass plates with this mixture. While still wet, the plate was sensitized in a bath of silver nitrate, exposed in the camera, developed, fixed, washed, and dried. These wet plates were quite sensitive to light and gave good detail. Their principal limitation was the necessity to keep them wet until processing was complete, because once dried, they were virtually impervious to water. As with all glass plate negatives, they also were heavy and fragile.

Although the collodion wet plates were designed to be used as negatives from which positive prints could be made, Archer observed that if the negative was viewed against a black surface, the resulting image would appear as a low contrast positive. The light areas were gray and the dark ones black.

Ambrose Cutting patented this process in America in 1854, and Marcus Root named such direct positives *ambrotypes* (see Fig. 1.9). Hamilton Smith, in 1856,

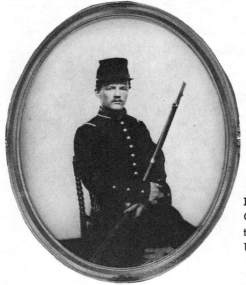

FIGURE 1.9 Meshack F. Hunt of Rowan County, 5 N.C. Regiment, CSA, an ambrotype, c. 1860. (North Carolina Collection, UNC Library, Chapel Hill)

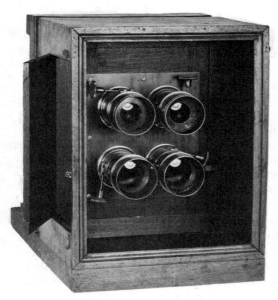

FIGURE 1.10 A four tube camera used to make carte-de-visite photographs. (International Museum of Photography at George Eastman House)

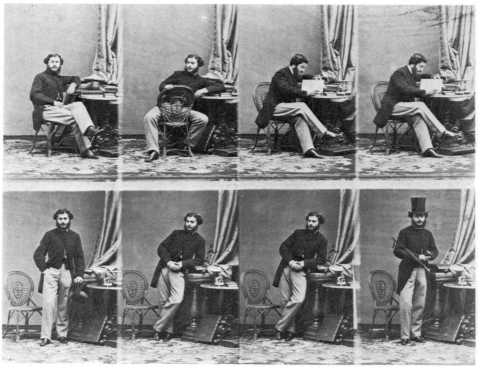

FIGURE 1.11 Uncut print from a carte-de-visite negative. (International Museum of Photography at George Eastman House)

patented what was to become known as a *tintype*. In this variation of Archer's direct positive, the emulsion was coated on a black or brown enameled metal surface. Adolphe Martin, a French scientist, first reported the process in 1853. These metal-backed photographs were also known as *melianotypes* and *ferrotypes*.

In 1854, Adolphe-Eugene Disdéri, a Frenchman, patented the *carte-de-visite*. In this process, a multiple lens camera (see Fig. 1.10) exposed a collodion wet plate to form several images of the same subject. Frequently, the plate could be moved in the camera so that several exposures of one plate were possible. These carte-de-visite negatives were used to make albumen prints (see Fig. 1.11) which were cut apart and could be used as pictorial calling cards.

The tintype, the ambrotype, and the carte-de-visite replaced the daguerreotype as the medium for inexpensive portraiture. The collodion wet plate replaced the calotype and the daguerreotype for serious photography. The collodion wet plate made the photographic process available to the wealthy amateur and the artistic photographer. It was used to record pictorially everything from history (e.g., the American Civil War) to geography (e.g., the American West).

■ DRY PLATE NEGATIVES

Although the collodion wet plate was a distinct improvement, the photographer had to prepare the plates and use them wet. B. J. Sayce and W. B. Bolton invented the collodion dry plate in 1864, and the product was marketed in 1867. These plates were coated with collodion containing ammonium bromide, cadmium bromide, and silver nitrate. They did not need the additional sensitizing step required by the collodion wet plate, and could be made up in advance, used dry in the camera, and later processed. However, they required about three times the exposure required for a collodion wet plate.

Richard L. Maddox, an English physician, in 1871 announced in the *British Journal of Photography* a plate similar to that of Sayce and Bolton. It differed in that gelatin rather than collodion was used as the dispersing medium. Gelatin dissolved in water was mixed with potassium bromide and then silver nitrate. Glass plates were coated with the gelatin mixture; when dry, they were used as photographic plates. After further improvement by Charles H. Bennett in 1878, these plates, called *gelatin dry plates*, could be used successfully with exposures of a fraction of a second. Photographers no longer needed a tripod and were freed from making their own plates.

■ FLEXIBLE FILM AND THE PORTABLE CAMERA

Although the gelatin dry plate made it possible to use shorter exposures, the bulk of glass plates and their fragile nature limited the portability of the camera. In 1888, John Carbutt of Philadelphia manufactured a film with a transparent flexible backing. A gelatin based emulsion was coated on thin celluloid sheets provided by John Hyatt of the Celluloid Manufacturing Company. This support was lighter and less

fragile than glass plates but was too thick to be very flexible. A truly flexible backing and some form of roll film holder was needed. Such a holder had been proposed as early as 1854 by the Englishman, A. J. Melhuish.

In 1884, George Eastman was issued a patent on a new system of photography that utilized roll film with a paper base and a roll film holder, which was developed by Eastman and his associate William H. Walker. This film holder was loaded in the darkroom and attached as an accessory to a plate film camera. In 1888, Eastman patented a small format box camera which incorporated a roll film holder. Initially, this camera was used with the paperbacked *stripping film* of the 1884 patent. The camera was loaded in the dark with a 100-exposure roll of film by the manufacturer or his dealer. After the customer exposed the film, the camera was returned to the dealer or manufacturer, who unloaded the camera and placed a new roll of film in the camera. After processing, the emulsion was tediously stripped from the paper support, reinforced, and used to make positive paper prints. A transparent flexible backing was still needed.

In 1887, Hannibal Goodwin of Newark, New Jersey, applied for a patent that described a transparent flexible film. The base was made by flowing cellulose nitrate in solution on a smooth surface such as glass. After the cellulose nitrate hardened, it was to be used as a flexible transparent base for a photographic emulsion. The patent was not granted until 1898. In 1889, Eastman Kodak Company made available to the public a transparent flexible film that also used cellulose nitrate as a base. This film was developed by George Eastman and Henry M. Reichenback and was made in much the same way as was described in the Goodwin patent application. In 1914, Eastman settled with Goodwin's heirs and successors for patent infringement. Samuel W. Turner, in 1895, developed a method for rolling the film so that it could be loaded in daylight. By this time photography was sufficiently simple and inexpensive for it to be made available to the public.

■ IMPROVEMENT OF GELATIN EMULSION

The light-sensitive silver salts are, by themselves, sensitive only to blue and violet light in the visible part of the spectrum. Herman W. Vogel, in 1873, discovered that by bathing the emulsion in appropriate dyes called *optical sensitizers,* photographic plates could be made sensitive to all colors of visible light except the deepest reds. Although not entirely satisfactory, the first commercial plates incorporating optical sensitizers were produced in France in 1875.

By 1883, Joseph Eder, an Austrian chemist, had discovered a green optical sensitizer called erythrosine which was far superior to earlier dyes for this purpose. Plates incorporating optical sensitizers, manufactured in 1884 by the firm of Lowry and Plener in Vienna, were called *orthochromatic* plates. The same term is used today to designate film and plates that are sensitive to all parts of the spectrum except red. By 1905, Benno Homolka, an Austrian chemist working in Germany, had discovered a red sensitizing dye called pinacyanol. In 1906, Wratten and Wainwright in England incorporated this dye, together with an improved green sensitizer, in commercial photographic plates called *panchromatic* plates. This term is

used today to describe film and plates that are sensitive to all of the visible colors.

One of the earliest systematic scientific studies of the photographic process was started about 1876 by Vero C. Driffield and Ferdinand Hurter in England. In particular, they studied the relationship between the amount of silver in developed film and its initial exposure. They reported the results of their findings in 1890. Their field of study is called *sensitometry* (see Chapter 8), and the curve that shows the relation between blackness *(density)* of a film and exposure is called an *H & D curve* (see Chapter 8) in recognition of these two early investigators.

It was not until 1923 that the role of organic sulfur compounds in gelatin based emulsions was discovered. Samuel E. Sheppard, an Englishman, noted that small quantities of these compounds existing as impurities in gelatin, supplied sulfur to the gelatin, significantly increasing the light sensitivity of the film.

■ THE EVOLUTION OF PRINTING PAPERS

Although Blanquart-Evrard had invented and used a developing-out printing paper as early as 1850, his albumen printing-out paper was the standard of the industry until the latter part of the nineteenth century. A cumbersome *enlarger* called a solar camera had been invented in 1857 by an American, David A. Woodward. With the advent of arc lamps, enlargements could be made in the darkroom, but a faster printing paper was needed. In 1874, Peter Mawdsley, in England, announced the manufacture of a gelatin silver bromide paper, and in 1879 Sir Joseph W. Swan undertook the manufacture of such a paper on a large scale. The gelatin based developing papers replaced the albumen printing-out papers and are still the standard of the industry.

A family of processes called *control processes*[2] was invented and used for making opaque positive prints. They were so named because the printmaker could control the range and in some cases the color of the tones. All of these processes in some way depend on the action of a bichromate solution on gelatin or *gum arabic*. *Bichromated gelatin* or gum arabic hardens on exposure to light. Typically, after exposure through a negative, the bichromated gelatin or gum was developed by dissolving the unhardened gelatin (or gum) in water. The relief image could then be inked and used as a master to make prints. In 1855, Alphonse L. Poitevin invented oil printing, which is based on these principles.

Joseph W. Swan perfected the *carbon process* in 1864. If dyes other than carbon are used in this process, it is called the *gum bichromate process.* Thomas Manly in 1905, laid the basis for the *carbro process,* and Ernest H. Farmer in 1919, perfected it. Edward J. Wall invented the *bromoil process* in 1907, which depends on the hardening of bichromated gelatin by contact with the silver in a bromide print. Many other variations of these bichromate processes were in use at one time or another. The gum bichromate (including carbon), carbro, and bromoil processes are still in use today.

[2]A. Kraszna-Krausz, Chairman, Ed. Board, *The Focal Encyclopedia of Photography, Desk Edition,* London: Focal Press, 1969, p. 348.

Although a discussion of the development of photomechanical methods for making copies of photographs is beyond the scope of this book, at least one process, the *woodburytype,* invented by Walter B. Woodbury in 1864, utilizing bichromated gelatin, will be mentioned. In this process, a bichromated gelatin positive, made by exposure of the gelatin to light through a negative, was pressed into a lead plate forming a relief image in the lead. The relief image was then filled with pigmented gelatin which, after transfer to paper, was hardened. In this way continuous toned copies could be made. Although the process was cumbersome, compared with modern halftone techniques in which screening is used to obtain a gray scale, the quality of the woodburytype was unsurpassed.

William Willis invented the platinum printing process which he patented as the *platinotype* in 1873. This process utilized the light sensitivity of certain iron salts mixed with platinum salts to make a paper based print. The dark areas of the print were composed of platinum metal instead of silver and hence were more stable than silver. During World War I, because of a shortage of platinum, a similar printing process utilizing palladium was developed. The *palladiotype* and the platinotype have become obsolete, primarily because of the high cost of the basic materials used in the process.

■ **PORTABLE PHOTOGRAPHY**

Although Eastman's portable (sometimes called detective) camera has been mentioned, miniature cameras were in use much earlier. Fox Talbot's earliest photographs were made using plates that were 1 inch square. However, his camera could not be used portably, because long exposure times were required. Thomas Skaife, in 1858, devised a miniature camera having sufficient light gathering capability to be considered portable. It too used 1 inch square plates.

Jules Carpentier, in 1892, designed a precision camera that he called a Photo-Jumelle, because it resembled a pair of binoculars. Jumelle is the French word for binoculars. One lens was used for viewing the scene and the other for recording the image. This camera used 2¼ by 1½ in. dry plates and had a spring shutter that exposed the plate for 1/60 sec. One of the first shutters to be used on a camera was built by Eadweard Muybridge in 1869. Using this shutter in some of his earliest studies of running horses, he claimed that the shutter exposed the plate for less than 1/1000 sec. The Photo-Jumelle became very popular and was widely imitated and improved. Guido Sigriste, in 1899, built a single lens jumelle with an attached view finder and a focal plane shutter that exposed the plate for 1/2500 sec.

In 1914 in Germany, Oskar Barnack developed a small camera that was to revolutionize candid photography. First marketed in 1924 by the Leitz Company under the name Leica, the camera was improved shortly thereafter, so that interchangeable lenses of different focal lengths could be used. In 1932, Ikon Zeiss AG marketed a similar camera called the Contax. It had a built-in range finder coupled to the focusing mechanism. This type of camera has come to be known as a *range finder camera* (see Chapter 2). These cameras formed 24 by 36 mm images on 35 mm wide motion picture roll film.

Although the 35 mm camera was the ultimate in portability for the serious photographer, it was limited by its small format, because it could not compete with the large format camera in recording detail. Cameras using 2⁷/₁₆ in. wide film are also portable and are more capable of recording detail than the 35 mm cameras. Franke and Heidecke, in 1929, marketed a *twin-lens reflex camera* called the Rolleiflex, which used such film. This camera, its successors, and its competitors (see Chapter 2) form 2¼ in. square images. One of the two identical lenses in the camera was used to view the scene, and the other was used to take the picture. Today, many other cameras use this size film, forming images that are square or rectangular.

The most popular camera used by the serious photographer today is the 35 mm *single-lens reflex camera* (SLR) (see Chapter 2). The SLR camera has been available in larger format for some time. For example, the revolving back Graflex dates back to about 1900. The first 35 mm SLR camera to be available commercially was the Kine Exakta Model One, introduced by Ihagee in Germany in 1936. This camera is used at waist level, much like the twin-lens reflex camera, because the image of the subject is reflected by a mirror onto a horizontal ground-glass screen viewed by the photographer from above. In 1949, the German firm Zeiss introduced the Contax S 35 mm SLR camera, which had a pentaprism mounted above the ground glass so that the camera could be used at eye level.

All of these cameras were designed to be used with available light, and although their lenses had considerable light gathering capability, they could not be used hand held at low levels of illumination. In 1859, Robert W. Bunsen of Germany and Henry Roscoe of England reported the considerable illumination resulting from burning magnesium and suggested its potential as a light source for photography. By 1864, Edward Sonstadt was marketing magnesium in wire form which, when burned, could be used as illumination for photography. Although the exposures were of the order of a minute, this could be considered the first portable light source for photography. However, the burning magnesium generated a dense cloud of white smoke, which complicated its use.

G. A. Kenyon, in 1883, suggested mixing powdered magnesium and potassium chlorate to form a combustible powder which, on burning, would yield a very bright light of short duration. An improved mixture containing these materials was used as a portable source of illumination; this is known as flash powder. Smoke was still a problem, however.

In 1925, Paul Vierkotter patented the first *flash bulb.* In his invention, the powder was placed in a glass envelope containing air or oxygen at low pressure. The magnesium was ignited by passing an electric current through a magnesium-coated wire in contact with the magnesium powder. In 1929, Johannes Ostermeier improved the flash bulb by filling it with aluminum foil instead of magnesium powder. This flash bulb was marketed as the Vacu-Blitz in Germany in 1929, as the Sashalite in England, and as the Photoflash Lamp in America in 1930. Being truly portable light sources, they were immediately adopted. The first *electronic flash* was developed by Harold Edgerton in 1931, and today has replaced the flash bulb in many photographic applications.

EXERCISES

1.1. Describe how bitumen of Judea can be used to make a copy of a pencil sketch. Show how this can be used to make a positive print.

1.2. What were the major advantages and disadvantages of the daguerreotype as compared with the heliograph?

1.3. In what ways was the calotype superior to the daguerreotype? In what ways was it inferior?

1.4. Why and in what ways did the collodion wet plate and its various derivative processes displace the daguerreotype and calotype?

1.5. Discuss the evolution of printing paper. Speculate on why the ''printing-out'' process was used long after developing papers had been available.

1.6. Why did the gelatin dry plate replace the collodion wet plate? Why was the collodion dry plate unsuccessful?

1.7. Trace the evolution of flexible film.

1.8. What are the roles of sulfur and the organic dyes in modern monochrome (black and white) emulsions?

1.9. What are the main formats (image sizes) for modern portable cameras? Which are used by the serious photographer? Why?

1.10. Trace the development of flash illumination.

chapter ·2·

Taking a picture

This chapter is concerned with the parts of a camera, and the various kinds of cameras, and discusses methods for getting an acceptable exposure of a film.

■ THE CAMERA

Because the *silver halides* (silver bromide, silver chloride, and silver iodide), which are used to record the image on film, are sensitive to light, the film must be enclosed in a light-tight box which can be opened to expose the film to the scene at an appropriate time. This device is called a camera (see Fig. 2.1). A device is needed to hold the film in an appropriate position. In smaller cameras, film is most often in roll form, but in larger cameras sheet film is used. Roll film cameras need a film advance mechanism to transport the film from one spool to the other as the film is exposed to successive scenes. This film advance mechanism may be coupled to a mechanism that cocks the *shutter* as the film advances.

In all but the most primitive pinhole cameras, a lens is incorporated in the camera to increase the light gathering capability of the instrument (see Fig. 2.1). In very simple cameras, this lens is placed in a fixed position relative to the plane of the film. However, a camera lens cannot focus a sharp image of objects that are at different distances from the lens unless the distance between lens and film can be altered. In all but the most rudimentary cameras, the position of the lens can be moved relative to the film plane to focus the camera on a chosen subject (see Fig. 2.1). A scale marked in meters or feet is attached to the adjustment mechanism which indicates where the camera is *focused* for any position of the lens. The camera has a *view finder* so that the photographer can select the subject to be photographed. This view finder may be a peep sight or a simple telescope which shows the field of view but not where the camera is focused (see Fig. 2.2). In more sophisticated cameras, the view finder may be part of the *range finder* and thus indicate where the camera is focused.

In the very earliest cameras, the film was exposed by removing a cap from the lens to start the exposure and replacing the cap to end the exposure. In modern

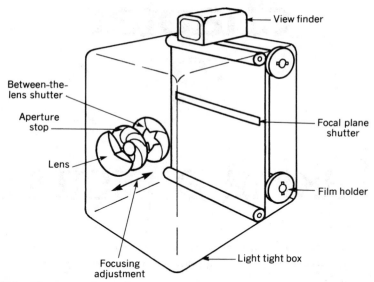

FIGURE 2.1 The parts of a rudimentary camera.

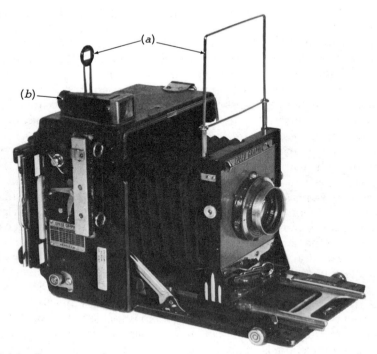

FIGURE 2.2 Two kinds of view-finders: (*a*) peep sight or sports finder, and (*b*) small telescope. (Earl N. Mitchell (ENM), 1983)

cameras, a shutter is used to control the exposure. This shutter is usually adjustable so that the length of time of the exposure can be adjusted to accommodate different lighting conditions and different kinds of film. The shutter is usually placed in the lens mechanism or directly in front of the film (see Fig. 2.1). The first type is called a *leaf* or *between-the-lens shutter* (Fig. 2.3) and the second a *focal plane shutter* (see Fig. 2.4). In addition, most cameras have some means of controlling the brightness of the light reaching the film. This device is called an *aperture stop* or *iris* (see Fig. 2.1) and usually is in the form of an adjustable opening somewhat like the iris of the eye (see Fig. 2.5). In some older cameras and in some lenses of very short focal length, a piece of metal with several holes of various sizes is placed between the lens and the film. The lens opening (aperture) is selected by placing the appropriate sized hole behind the lens. Such an aperture stop is called a *waterhouse stop*.

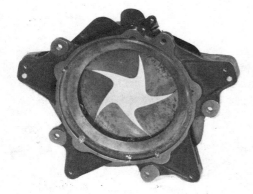

FIGURE 2.3 Between-the-lens shutter from an aerial camera. (ENM, 1983)

FIGURE 2.4 Focal plane shutter at left in a Revolving Back Graflex camera. (ENM, 1983)

FIGURE 2.5 Iris aperture stop.

Many of the modern small and medium format cameras have *light meters* incorporated in them which are used to determine the proper exposure of the film. This meter may be used for manual determination of the exposure or it may automatically control the exposure by adjusting the aperture and/or the *exposure time.* Electrical connections for use with flash bulb or electronic flash illumination are common in modern cameras. *Self-timers,* which make it possible to start the exposure after a predetermined time delay, are also common, especially on small format cameras. Many other refinements such as *winders* or *motor drives* for rapid film advance, automatic flash control, interchangeable lenses, and movable film backs and lens boards are available for various modern cameras. These refinements will be discussed in appropriate sections of the text.

■ KINDS OF CAMERAS

The discussion of specific kinds of cameras will be limited to those that have adjustable focus, aperture, and exposure time. Cameras will be grouped by the size film they use. Small format cameras use film that is 35 mm or less in width. Medium format cameras include those that use film larger than 35 mm but no wider than 70 mm. Large format cameras use film wider than 70 mm.

The most popular camera using 35 mm film which meets the criteria in the paragraph above is the single-lens reflex (SLR) camera. This camera, of which the Asahi Pentax MX is an example (see Fig. 2.6), is designed so that focusing and framing the scene are done by looking through the lens used to expose the film (see Fig. 2.7). Light from the scene passes through the lens and is reflected by a mirror up to a ground-glass screen where an image is formed which is similar to the one that would appear on the film if the mirror was not in place. A *pentaprism* located above the ground-glass screen reflects this image through a small lens to the eye of the photographer. The combination of the mirror and the lens forms an image

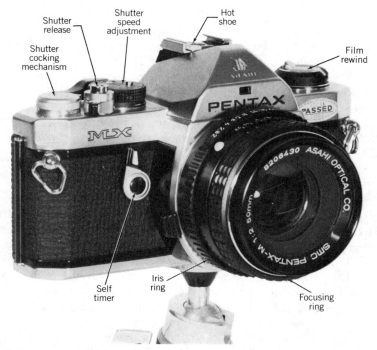

FIGURE 2.6 The Asahi Pentax MX single-lens reflex camera. (ENM, 1983)

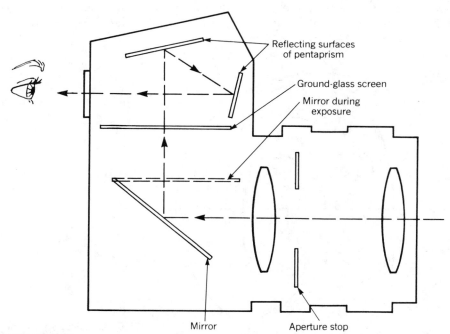

FIGURE 2.7 Focusing arrangement in a single-lens reflex camera.

at the ground-glass screen which is erect but which has left and right reversed if viewed from above. The pentaprism and the viewing lens provide an image to the eye that is erect with left and right not reversed. That is, the image seen by looking through the view finder is similar to that seen by looking directly at the scene. Typically, the optics of the view finder form this image about 6 feet in front of the photographer.

Farsighted (hyperopic) persons usually can focus the camera without using eyeglasses; unfortunately, however, they cannot see the dials on the camera. On the other hand, *nearsighted (myopic)* persons will usually need to use eyeglasses when focusing the camera. With a standard lens on the camera, the image will appear to be very nearly the same size as the scene itself.

The central portion of the ground glass is usually modified in some way to provide a focusing aid. Frequently a *biprism* (or many small biprisms) (see Chapter 5) is used which distorts the image if it is not in focus. The single biprism shifts part of the image with respect to the rest of the image if the scene is out of focus (see Fig. 2.8). If many biprisms are used, the out-of-focus image is broken into many offset segments and appears to shimmer when viewed by the photographer. Focusing of the camera is accomplished by moving the lens in its mount by means of a ring on the lens mount (see Fig. 2.6). The distance to the object in focus can be determined from a scale on the barrel of the lens. In many SLR cameras, the field of view in the view finder is slightly less than the image size that is recorded on the film.

An iris aperture stop is built into the body of the lens assembly (see Fig. 2.7). The opening of the iris is adjusted by means of a ring on the lens assembly marked in *f-numbers* to indicate what the lens opening will be when the picture is taken (see Fig. 2.6). Many 35 mm SLR cameras are designed so that the iris is at its maximum

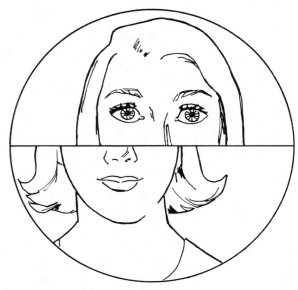

FIGURE 2.8 Distortion of an out-of-focus image by a biprism.

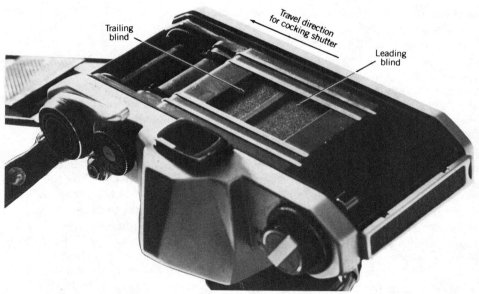

FIGURE 2.9 Cloth blinds of a single-lens reflex camera. The shutter is partially cocked to show both blinds. (ENM, 1983)

opening before the picture is taken and closes down to the chosen aperture when the shutter is activated. The added light at maximum opening makes focusing the camera easier. On many cameras of this kind, it is possible to close the aperture to the selected setting before the picture is taken so that the scene can be seen as it will appear on the film when the picture is taken. This can be important because more of the scene is in focus when the aperture is reduced. Absence of this feature is a disadvantage for the serious photographer.

Most small format SLR cameras use a focal plane shutter placed directly in front of the film. The more common shutter uses two cloth blinds that travel horizontally (see Fig. 2.9). When the shutter is cocked (see Fig. 2.6), the leading blind is pulled in front of the film and the trailing blind is stored on a spool to one side of the gate. In addition, the cocking mechanism advances the film, placing unexposed film behind the gate and advances an exposure counter. When the shutter is released (see Fig. 2.6), the leading blind is pulled to the left by a spring (see Fig. 2.9) and stored on a spool. After a period of time determined by the shutter speed adjustment (see Fig. 2.6), the trailing blind is released, which covers the film. It takes about 1/60 sec for either blind to travel the width of the gate. For exposure times shorter than 1/60 sec, the trailing blind is released before the leading blind has cleared the gate. Hence, no matter how short the exposure of any part of the film, at least 1/60 sec is needed to expose the entire frame completely. As a result, image distortions of rapidly moving objects may occur, and limitations are placed

on the way flash illumination can be used with this type shutter. The length of time of the exposure is determined mechanically using springs, or electronically.

In most cameras of this type, the shutter release mechanism initiates the closing of the aperture stop to its predetermined setting and causes the mirror to swing up out of the light path from the lens so that the image can be formed on the film. In normal operation of most SLR cameras, the mirror returns to its original position and the iris reopens automatically after the exposure is completed. Some SLR cameras are designed so that the mirror can be locked up in the picture taking position before the shutter is opened to reduce vibration during exposure.

Some focal plane shutters on SLR cameras travel vertically. These are usually made of two sets of overlapping metal plates that look and work much like a folding fan. One set is stored below the gate and the other above it. One set acts as the leading blind and the other the trailing blind. They do not travel exactly vertically but swing in a more or less vertical segment of an arc. Because the vertical travel distance is shorter (about 24 mm compared with 36 mm) and because of its design, this kind of shutter typically requires about half as long to open and close. Hence, it takes about 1/125 sec to take a picture with this kind of shutter.

One of the advantages of the SLR camera is the ease with which different kinds of lenses can be used with the camera. The lenses are usually attached to the body by a bayonet or threaded mount and can be removed without additional tools. Because the lens is used both as the view finder and range finder, no other adjustment is necessary in the viewing and focusing mechanism when lenses are interchanged. The focal plane shutter blinds prevent exposure of the film so that the lens may be removed even when the camera is loaded. If a between-the-lens shutter is incorporated in an SLR camera, the mechanisms that make it possible to interchange lenses and to view the scene through the lens are quite complex. In addition, each lens will contain a shutter, making the lens more expensive. Hence, small format SLR cameras with between-the-lens shutters are no longer manufactured.

Most small format SLR cameras have some method for connecting a flash unit to the camera to synchronize the activation of a flash bulb or electronic flash and the shutter. This connection may be in the form of a *hot shoe* on the top of the camera or a jack on the body of the camera. For more discussion of flash illumination, see Chapter 10.

Most small format SLR cameras have a built-in reflected light meter that is used to determine proper exposure. The sensing element of the meter receives part of the light that passes through the lens. An electrical signal is generated, causing the needle of a meter or electronic readout devices *(light-emitting diodes* or *liquid crystal displays)* to indicate the exposure. The method has limitations which will be discussed later in the chapter. In some fully automatic SLR cameras, the light meter can be coupled to the shutter and/or aperture stop so that exposure can be made automatically. If the photographer sets the aperture and if the meter controls the exposure time, this procedure is called *aperture priority automatic exposure.* If the reverse is true, the procedure is called *shutter priority automatic exposure.* Some cameras are designed to operate in either mode. Many of the fully automatic SLR cameras have an override feature so that the photographer can set the exposure manually. This is a very desirable feature. Its convenience and utility depend on how the *manual override* feature is designed.

Range finder
apertures

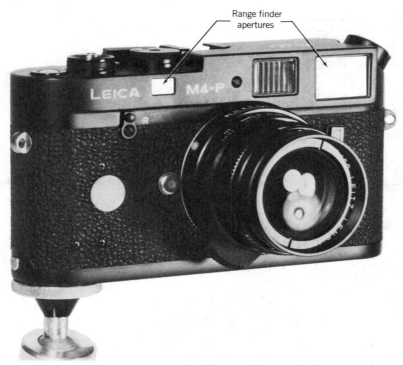

FIGURE 2.10 The Leica M4P camera fitted with a 50 mm focal length lens.(ENM, 1983)

Many other features may be a part of, or added to some small format SLR cameras. These include a motor drive for rapid shutter cocking and film advance, a self-timer for delayed initiation of exposure after the shutter release button has been activated, and *automatic flash* control using a built-in light meter to control the amount of light emitted by the flash unit.

The range finder camera in *35 mm format* is an alternative to the small format SLR camera (see Fig. 2.10). The photographer does not look through the main lens of this camera to compose and focus the picture but rather through two range finder apertures mounted near the top of the camera (see Fig. 2.10). Typically, light from the scene (see Fig. 2.11) passes through one aperture (*A*) and through a partially silvered mirror to reach the eye. Light from the same part of the scene passes through the other aperture (*B*) and is reflected by a rotatable silvered mirror. This second beam of light is reflected by the partially silvered mirror into the eye. In the example, the rotating mirror is set so that the images of the object at *X* formed by the beams through *A* and *B* appear coincident. The images from *O* will appear displaced with respect to each other (see Fig. 2.12). The focusing ring on the lens is linked to the mechanism which rotates the mirror behind aperture *B* so that the lens and mirror move together. The linkage is so adjusted that when the lens is focused on an object at any point (e.g., *X*), the images seen by the eye are coincident. The ranging image (that through *B*) ordinarily consists of a small central part of the overall scene to be recorded on the film when the picture is taken. The

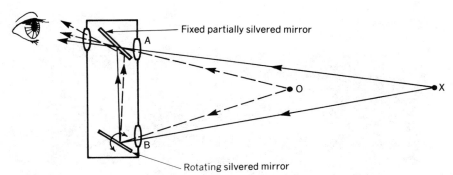

FIGURE 2.11 Schematic diagram of the focusing of a range finder camera. The point X is in focus; that at 0 is not.

FIGURE 2.12 Displaced images in the range finder of a range finder camera. The small rectangular area delineates the image through aperture B of Figure 2.11.

beam forming this image is frequently filtered (typically yellow or pink) to aid in distinguishing it from the view finder image from A. Because the image seen through A represents the entire scene to be photographed, this image can be used for composing the scene.

Because this kind of viewing mechanism requires no large moving mirror, the operation of the camera is often less noisy, which is an advantage in some applications. In addition, this focusing system may provide a brighter viewing image so that the camera can be focused in dimmer light. The simple range finder camera (because it does not use the main camera lens as part of the view finder) presents a slightly different point of view to the eye than that which will be imaged on the film (see Fig. 2.13). The center of the field of view as seen through the view finder

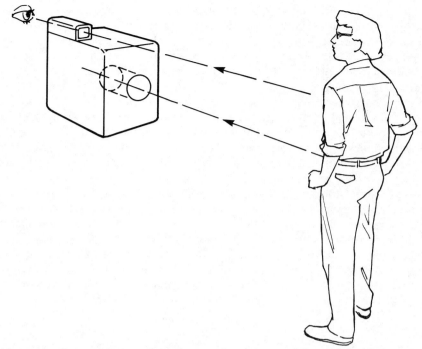

FIGURE 2.13 Comparison of the center of the field of view and the center of the image in a range finder camera.

will be slightly above the center of the picture. This offset called *parallax error* is inconsequential when viewing distant objects but is a nuisance and can be a source of error when photographing nearby objects. The view finders of less expensive range finder cameras are marked so that this error can be corrected somewhat by aiming the camera in a slightly different direction when composing the picture. The Leica shown in Figure 2.10 has a mechanism in the view finder to overcome this problem, causing it to tilt downward as it is focused on nearby objects.

Most 35 mm range finder cameras use between-the-lens shutters because most of these cameras do not have interchangeable lenses. Such shutters make possible more flexible flash photography especially when an electronic flash is used with supplementary illumination. This is discussed more extensively in Chapter 10.

The Leica shown in Figure 2.10 is an exception having both interchangeable lenses and a focal plane shutter. Because the field of view is different for different lenses, the view finder is automatically adjusted to make the field of view correct for each of the more standard lenses. In addition, the range finder is corrected so that it will function properly with each lens.

Many of the other features that are found on various 35 mm SLR cameras are also found on the 35 mm range finder camera. Historically, the range finder camera was simpler and smaller than comparable SLR cameras, but that is not so today. The Leica camera clearly is very sophisticated and not significantly smaller than the

more compact 35 mm SLR cameras. Most other 35 mm range finder cameras are relatively inexpensive and quite compact. Although they are easy to use they are not simple. Many have automatic exposure control with no alternative for setting the exposure manually. Some also have automatic focusing capability. These cameras are designed for the person who wants to make casual pictures, often referred to as *snapshots.*

Sometimes a larger image is needed than that provided by a 35 mm camera. Most medium format cameras use 61 mm wide roll film, which is designated either by the numbers 120 or 220 (read one-twenty or two-twenty). One-twenty film is rolled with a black paper spacer, whereas 220 film has an opaque layer on the film that is removed during processing. The image width for this film is typically 56 mm (2³⁄₁₆ in.). The format may be square or rectangular.

Several different format SLR cameras use this kind of film. The square format is referred to as a 2¼ × 2¼ or a 6 × 6 format because these are, respectively, the nominal size of the image in inches and centimeters. The actual image size is 5.6 cm × 5.6 cm. The Hasselblad SLR camera has this format and is unusual in that it employs a between-the-lens shutter on some models. The Pentax 6 × 7 has a nominal format that is 6 cm × 7 cm (2¼ × 2¾ in.). The nominal format of the Mamiya M 645 is 6 cm × 4 cm. Most of these cameras look like larger versions of 35 mm SLR cameras and work in much the same way (see Fig. 2.14).

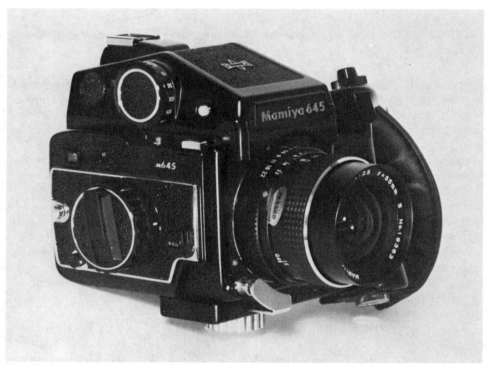

FIGURE 2.14 The Mamiya M645 medium format SLR camera. (ENM, 1983)

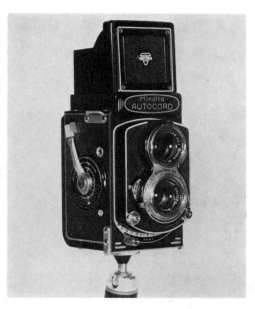

FIGURE 2.15 The Minolta Autocord twin-lens reflex camera. (ENM, 1983)

The twin-lens reflex camera is a medium format alternative to the single lens reflex camera (see Fig. 2.15). Although not as flexible as the SLR camera, the twin-lens reflex camera, in its least expensive form, offers one of the most economical routes to medium format photography. This camera typically uses 120 film and has a 2¼ × 2¼ in. format. Two identical lenses are mounted one above the other (see Fig. 2.16). The upper lens serves as a view finder and range finder. A fixed mirror reflects the image of the scene formed by the lens up to a hooded ground-glass screen that can be viewed directly or through a lens which serves as an aid in focusing the camera. When the between-the-lens shutter in the lower lens is opened, the image of the scene is recorded on the film. Except for the offset of the two lenses, the image in the view finder is the same as that on the film. Because a mirror is used for viewing, left and right are reversed in the view finder. The more sophisticated of these cameras have interchangeable lenses, prism view finders, together with many other accessories, and are comparable in price to some medium format SLR cameras.

Although range finder cameras are available in medium format, they are not very common. The Koni-Omega Rapid is an example of such a camera. It has a 2¼ × 2¾ in. format, interchangeable lenses, and features a rapid film advance mechanism, making it possible to advance the film manually more rapidly than in most medium format cameras.

The most common large format cameras use sheet film whose dimensions are 4 × 5 in. or 8 × 10 in. The cameras are used primarily in commercial work. The 4 × 5 (read four by five) *folding camera* (see Fig. 2.17), although unwieldy, is the most portable of the large format cameras. These cameras are seen open more often than closed because closing them may be difficult. The camera has a corru-

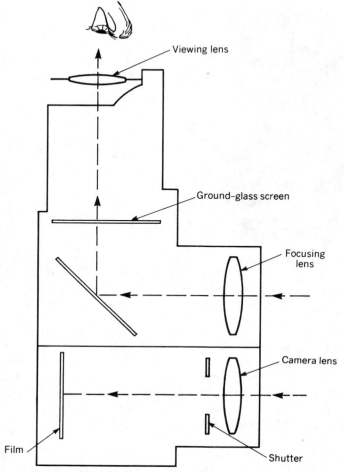

FIGURE 2.16 Schematic of a twin-lens reflex camera.

gated cloth *bellows* surrounding the light path between the lens and the camera body. A range finder and view finder may be incorporated in the camera, but for critical work the image formed by the lens is viewed on a ground-glass viewing screen at the film plane. To focus the camera, the lens shutter is opened and the lens position relative to the camera body is changed until the image of the subject appears sharp on the ground glass. To take the picture the shutter is closed, a sheet of film in a *film holder* is substituted for the viewing screen, and the shutter is activated to make the exposure.

Although this folding camera is designed primarily for use with a tripod, with a *sports finder* and/or a range finder it can be hand held. For many years it was used as a press camera. Many of these cameras are designed so that the lens can be raised relative to the body of the camera and tilted about a horizontal axis. These motions, called *shift* and *tilt* are sometimes necessary in order to reduce geometric distortion of the image and to improve the sharpness of the image across the field.

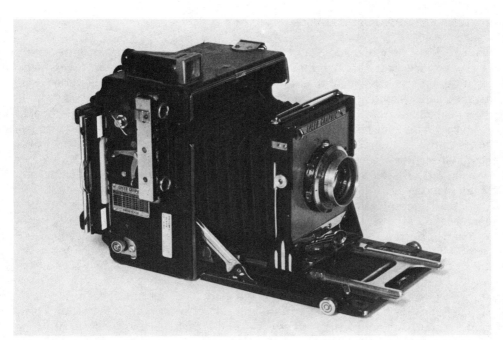

FIGURE 2.17 Speed Graphic 4 × 5 folding camera shown in the open position. (ENM, 1983)

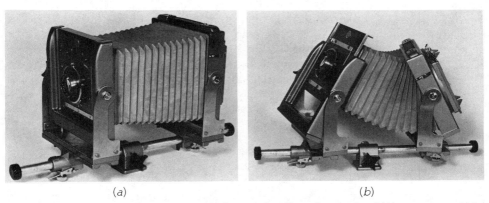

(a) (b)

FIGURE 2.18 View camera showing (a) no shift, tilt, and swing and (b) maximum shift, tilt, and swing. (ENM, 1983)

The *view camera* (see Fig. 2.18) provides the most flexibility in altering the relative position of the lens and film holder. As with the folding camera, the lens of the view camera is connected by a bellows to the back, but both lens and back are mounted on a rail so that maximum motion of each is possible. View cameras are commonly available in both the 4 × 5 and 8 × 10 format. Some aspects of the use of the view camera are discussed in Chapter 5.

■ THE RECIPROCITY LAW

A great deal of mathematics is not used in this book, except for some necessary elementary algebra. Although they are household words, a few words with mathematical implications are frequently misunderstood. To state that *A* varies as *B*, means that as *A* increases in value *B* increases in value. If *A* varies inversely with *B*, then as *A* increases in value *B* decreases in value. Writing that *A* is proportional to *B* means that if *A* increases in value, then *B* increases proportionally. For instance, if *A* is doubled, then *B* is doubled. Mathematically, *A* and *B* are related so that *A* = *KB* where *K* is a constant. If *A* is inversely proportional to *B*, then as *A* increases in value *B* decreases proportionally. For example, if *A* is doubled, then *B* is halved. Mathematically, *A* and *B* are related so that *A* = *K/B*, where *K* is a constant.

All of the above statements could be repeated using examples in which *A* decreases and the sense of the relations will be preserved. For instance, if *A* varies as *B* and *A* decreases, then *B* decreases. The use of the word directly when used to modify varies or proportional as in "varies directly" or in "directly proportional" does not change the sense of the phrases. Finally, the ratio of *A* to *B* means that *A* is to be divided by *B* (*A/B*).

The exposure (*E*) of the film refers to the amount of light that reaches the film. This depends on how much light passes through the lens at any instant and how long the shutter is open. The former is called the *illuminance* (*I*) and the latter the exposure time (*t*) or the time. The exposure, the illuminance, and the time are related mathematically so that

$$E = I \times t \qquad\qquad (2.1)$$

This law, called the *reciprocity law,* implies that a large amount of light can be let through the lens for short periods of time, or, alternatively, a smaller amount of light can be let through the lens for a longer time to get the same exposure. Some particular exposure of a film yields the best negative when the film is developed. This law implies that it makes no difference how the correct exposure (*E*) is obtained if the above equation is satisfied. In general this is true, but there are exceptions to this statement, and these will be discussed in Chapter 7.

▶ **Example 2.1**

I know that in a given photographic situation an exposure time of ½ sec gives me a correct exposure. If I choose to increase the exposure time to 1 sec, what must I do to the illuminance?

In some fashion I must reduce the illuminance to one half its former value because the product of *I* and *t* must remain the same according to Equation 2.1. I can do this by decreasing the size of the aperture.

The illuminance of the film depends on the amount of light reflected from the subject to the camera and on the setting of the aperture stop, which is calibrated in terms of the f-number. To define the f-number, the *focal length* of a lens must first be defined; this will be done operationally. Suppose that in a room in which daylight passes through a window, a simple magnifying glass is used to project an image of an outside scene onto the wall opposite the window (see Fig. 2.19). The

FIGURE 2.19 Formation of an image of a distant object by a simple magnifying lens.

image will be inverted. Careful inspection shows that the lens must be positioned at two different distances from the wall to get the sharpest image of the window frame and the scene beyond the window. The distance of the lens from the wall will be greater when the window frame is sharpest (in focus). In fact, the greater the distance to the scene outdoors, the closer the lens must be placed to the wall to form a sharp image of the scene, although in this simple experiment the difference probably cannot be detected.

The distance from the wall to the lens, when a remote scene is in focus, is called the focal length (f) of the lens. In principle, the distance to the remote scene must be greater than any finite distance that can be measured or described. Physically, the distance to the scene increases without limit and becomes *infinite,* and the scene is said to be at *infinity.* Practically speaking, the distance used in this experiment is satisfactory for finding the focal length of the lens. The same experiment could be performed with a camera lens. However, another concept is needed before the focal length of a lens as complex as the modern camera lens can be defined. In particular the position in the lens from which f is to be measured must be known. In most camera lenses the reference position is not the physical center of the lens. Nonetheless, the operational definition is consistent with that obtained in this experiment. The subject is treated in more detail in Chapter 4.

The f-number (f/) for a simple lens is defined as

$$f/ = f/d \qquad (2.2)$$

where f is the focal length and d is the diameter of the lens. The f-number is a measure of the light gathering capability of the lens. To understand this, the dependence of the light gathering capability of a lens on f and d must be understood.

Imagine a point light source such as a small electric lamp bulb (see Fig. 2.20) emitting beams of light in all directions. These beams are represented by the lines with arrows in the figure and are called *rays.* Some of these rays strike a lens, forming an image of the lamp. The brightness of the image is proportional to the number of rays intercepted by the lens which in turn is proportional to the area of

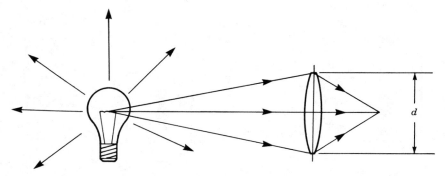

FIGURE 2.20 Using a simple lens to form an image of a point light source.

FIGURE 2.21 Imaging a square with a pinhole camera.

the lens. Because the area of the lens (A) is $\pi d^2/4$, the brightness of the image and the illuminance (I) are proportional to the square of the diameter.

To understand the dependence of the illuminance on focal length, the dependence of the brightness of the image on its distance from the lens needs to be understood. This is understood most easily by studying the same problem in a *pinhole camera*. Imagine that an image of a square is being formed using such a camera (see Fig. 2.21). Note that the size of the square image increases as the distance to the image plane increases. The lengths of the sides of the square (h) are proportional to the distance from the aperture to the image plane (v). Hence, the area of the square image is proportional to the square of the distance from the aperture to the image plane. The total amount of light gathered by the aperture is indepen-

dent of the position of the image plane. As the image plane is placed further from the aperture, the same total amount of light must illuminate an area that increases as the square of v. Therefore, the illuminance at any point on the image is inversely proportional to the square of v.

► **Example 2.2**

If the distance from aperture to image plane is doubled, how will the image brightness change?

The brightness is proportional to the illuminance of the image plane. If the image is a distance v from the aperture, the area of the image will be h^2 (see Fig. 2.21). If v is doubled, h will be doubled and the new area will be $(2h)^2$ which is $4h^2$, and the area has increased four times. The illuminance at any point on the new image will be equal to the illuminance on the first image (I) divided by 4 ($I/4$). Hence, the brightness is reduced to one fourth its former value.

The image formed by a modern camera using a lens has the same characteristics as those attributed to the pinhole camera. Because an object at infinity is imaged at a distance from the lens equal to the focal length, the amount of light reaching the image plane is inversely proportional to the square of the focal length ($I \sim 1/f^2$). If the dependence on lens diameter and focal length are combined, then

$$I \sim \frac{d^2}{f^2} = K\frac{d^2}{f^2} \tag{2.3}$$

where K is a constant of proportionality that depends on the units in which the illuminance is measured. From Equation 2.2, $d/f = 1/f/$. Hence

$$I = K\left(\frac{1}{f/}\right)^2 \tag{2.4}$$

Strictly speaking, the above equation is valid only for images of objects that are infinitely far away. If a camera is focused on nearer objects, the lens must be moved further from the image plane. However, unless the objects are very close, the amount of movement is small compared with the focal length of the lens, and Equation 2.4 is sufficiently accurate for the current discussion. The correction cannot be ignored in *macrophotography* (see Chapter 5).

Reflecting on Figure 2.21, one may wonder if image brightness depends on the distance between the camera and the subject. It is true that if the subject is placed further from the aperture, the image size is reduced. For example, if the distance to the subject is doubled, the image height and width will be halved (see Fig. 2.22), and the area of the image will be reduced by a factor of four. This seems to indicate that image brightness would increase by a factor of four using an argument similar to that used with Figure 2.21. However, what happens to the amount of light gathered by the aperture must also be considered.

Imagine, as in Figure 2.20, that a point light source is emitting rays of light in all directions (see Fig. 2.23). All of the rays originate at the light source, because they represent the light emitted by the source. Moreover, it is known that a lamp becomes dimmer when placed further away. Imagine that two transparent spheres enclose the light source. The same number of rays pass through each sphere. The

FIGURE 2.22 Change in image size with change in distance between subject and aperture.

FIGURE 2.23 Illustration of the inverse square law.

intensity of light per unit area at the larger sphere is less than that at the smaller sphere because the same amount of light (same number of rays or *flux*) has to illuminate a larger area. Technically, illumination per unit area is called the illuminance (I) and at any sphere is equal to the total flux (F) divided by the area of the sphere (A); that is, $I = F/A$. But the area of a sphere is $4\pi R^2$, where R is the radius of the sphere, hence

$$I = \frac{F}{4\pi R^2} \tag{2.5}$$

This is called Gauss's law or the inverse square law. If R is doubled, the area increases by a factor of four and the illuminance decreases by a factor of four. If a photographer uses a camera with a fixed size aperture to take a picture of this light source, one fourth as much light is gathered by the aperture if the camera is

twice as far away. Referring again to Figure 2.22 and noting the above, recognize that one fourth as much light illuminates an image having one fourth the area. Hence, the image brightness is unchanged, and does not depend on the distance between the camera and the subject.

If the aperture stop of the lens is not fully open, the light gathering capability is limited by the aperture stop and not the lens diameter. If the iris could be placed in the lens, the diameter of the iris would replace the diameter of the lens in the definition of the f-number. This cannot be done in a real lens. However, something that is equivalent can be done. For the purposes of this discussion, imagine that the iris is placed in the lens (see Fig. 2.24). (Those interested in a more exact treatment should refer to Morgan.[1]) Equation 2.2 applies as before, except that d is now the diameter of the aperture stop.

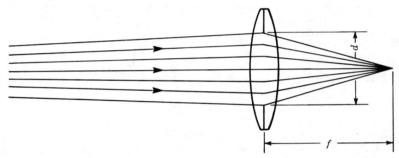

FIGURE 2.24 Light gathering capability of a lens limited by an aperture stop.

From the earlier discussion, it can be seen why the iris control ring is marked in f-numbers rather than the diameter of the aperture (see Fig. 2.6). All lenses when set at the same f-number have the same light gathering capability independent of focal length. A lens of longer focal length requires a larger diameter aperture than a lens of shorter focal length in order to have the same f-number (see Eq. 2.2 and Fig. 2.25). If lenses were marked in terms of aperture diameter, the focal length of the lens would have to be known to determine the light gathering capability of the lens. In this era of interchangeable lenses, this would be a burden. The system may appear cumbersome, but many alternatives would be worse.

From Equations 2.1 and 2.4 it follows that

$$E = K \left(\frac{1}{f/} \right)^2 \times t \tag{2.6}$$

The amount of light reaching the film can be controlled by adjusting the aperture or the time. A system for the camera is desired that makes it possible to vary the amount of light reaching the film by a factor of two between adjacent settings of

[1] J. Morgan, *Introduction to Geometrical and Physical Optics*, New York: McGraw-Hill, 1953, p. 81ff.

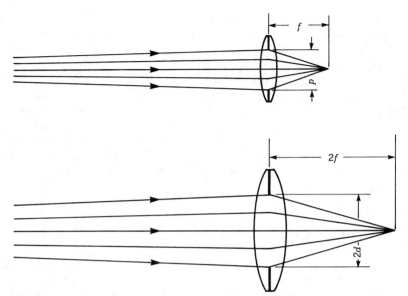

FIGURE 2.25 Two lenses of different focal lengths and diameters having the same f-number.

the aperture or shutter speed. This system will be consistent with the way the eye and brain discern different levels of illumination, because the eye is logarithmic (see Chapter 8). Most modern shutter speed controls are marked as shown in Table 2.1. The exposure times are the reciprocals of the numbers in seconds. Note that adjacent exposure times differ nominally by a factor of two. These exposure times are sometimes called *shutter speeds.*

TABLE 2.1 Shutter Markings and Exposure Times on Modern Camera Shutters

Shutter Marking	Exposure Time (sec)
1	1
2	1/2
4	1/4
8	1/8
15	1/15
30	1/30
60	1/60
125	1/125
250	1/250
500	1/500
1000	1/1000

TABLE 2.2 Determination of the f-Number System

I	1	1/2	1/4	1/8	1/16	1/32	1/64	1/128	1/256	1/512	1/1024
$1/I$	1	2	4	8	16	32	64	128	256	512	1024
$1/\sqrt{I}$	1	1.4	2	2.8	4	5.6	8	11.2	16	22.4	32
f/	1	1.4	2	2.8	4	5.6	8	11	16	22	32

Most shutter controls are marked with the letter B and/or the letter T. The former is called the *bulb* position and the latter the *time* position. In the bulb position, the shutter remains open as long as the shutter release is depressed. In the time position, the shutter opens when the shutter is depressed a second time.

To generate a set of f-numbers that will do the same thing, note from Eq. 2.4 that the f-number is inversely proportional to the square root of the illuminance ($f/ \sim 1/\sqrt{I}$). Assume a set of illuminances such that each one is one half the one preceding it (see Table 2.2). If reciprocals (see line 2, Table 2.2) and then the square roots are taken, the resulting numbers will be those in line 3. If these are rounded to two significant figures, they become the standard f-number system marked on modern cameras. Recall that the system has been generated so that the illuminance between the adjacent f-numbers changes by a factor of two. These settings are sometimes called *f-stops* or stops. Note that as the f-number setting is increased, the amount of light reaching the film decreases. As a memory aid note that alternate f-numbers increase by a factor of two. Larger lenses may be marked with even larger f-numbers, but they follow the same sequence. When photographers speak of *opening up* the lens, they mean that they are decreasing the f-number setting. When they speak of *closing down* or *stopping down* the lens, they mean the opposite.

Increasing the f-number setting causes more of the scene in front of and behind the chosen subject to appear sharper. In other words, the *depth of field* increases as the lens is stopped down. This is discussed in more detail in Chapter 5. To keep moving objects from appearing blurred, it may be necessary to use shorter exposure times. If the impression of motion is desired, a longer exposure time should be chosen. This is discussed in more detail in Chapter 5. When a film of different sensitivity is used, different combinations of shutter speed and f-number may be needed. This also will be true if the lighting is changed.

▶ **Example 2.3**

I have determined, using my light meter, that a proper exposure of a scene is f/2 at 1/500 sec. When I preveiw with my SLR camera, I see that I can get a more pleasing image, because of increased depth of field, if the camera is stopped down to f/4. What exposure time should be chosen to get the correct exposure?

If the camera is stopped down from f/2 to f/4, the illumination reaching the film decreases by a factor of four. From the reciprocity law we see that we will have to increase the exposure time by a factor of four from 1/500 sec to 1/125 sec, or a shutter adjustment setting of 125. Other equivalent exposures for this photographic situation are listed in Table 2.3.

TABLE 2.3 Equivalent Exposures for Example 2.3

	Equivalent Exposure Settings							"Correct" Exposure Setting	Equivalent Exposure Setting
f/	f/22	f/16	f/11	f/8	f/5.6	f/4	f/2.8	f/2	f/1.4
Time	1/4	1/8	1/15	1/30	1/60	1/125	1/250	1/500	1/1000
Shutter marking	4	8	15	30	60	125	250	500	1000

Most modern lenses have detents, sometimes called *click stops,* in the iris ring assembly so that the aperture can be set more accurately at the prescribed f-numbers. Most of these lenses have, in addition, detents for setting the lens at an intermediate position between some or all f-stops. This is called a *half stop* or a half stop setting and offers more choice of light gathering capability for better exposure control. Closing down the aperture one half stop reduces the amount of light reaching the film to about 70 percent of its former value if no other conditions are changed.

It might be wondered why the intermediate stop is not designed so that 75 percent of the light is admitted, because closing down one stop reduces the light to 50 percent of its former value. Recall, however, that the calibration system for the illuminance is logarithmic. That is, as the iris is opened the illuminance increases from f-number to f-number as 2^n where n is any integer. To be consistent the half stops should correspond on the same scale to illuminances of $2^{n+1/2}$. For instance, if the illuminance at f/4 is called one (2^0), then the illuminance at f/2.8 will be two (2^1), and the illuminance at the half stop between f/4 and f/2.8 will be $2^{0+1/2} = 2^{1/2} = 1.4$. Hence, the illuminance increases 40 percent. In stopping down, the illuminance decreases to $1/1.4 = 0.71$ or about 70 percent of its former value. Incidentally, the f-number for this aperture setting is $2^{7/4} = 3.4$.

In addition to the f-stops listed in Table 2.2, the iris control ring is marked with the maximum lens opening. Frequently, this maximum opening does not correspond to one of the f-stops but to numbers such as f/1.8 and f/3.5. For historical reasons these numbers usually are not half stops but are *one-third stops.* If the illuminances for the f-stops are designated as 2^n, then those at the one-third stop settings are $2^{n\pm1/3}$ (see the discussion above). The illuminance at f/1.8, which is 1/3 stop open from f/2, is 125 percent of that at f/2. An aperture setting of f/3.5 is 1/3 stop open from f/4 and gives the same increase in illuminance.

■ DETERMINING AN ACCEPTABLE EXPOSURE

Although the relationship between equivalent f-numbers and exposure times has been explained in Example 2.3, the correct exposure still must be determined. To pick a particular f-number and exposure time as a starting point, the sensitivity of the film and the illumination of the subject must be known.

The sensitivity of the film is determined primarily by the way a particular film is made. The amount of silver in the developed negative can be altered slightly during processing, but for optimum performance the film should be exposed and processed as prescribed by the manufacturer. The manufacturer of the film designates the sensitivity of a film in terms of the ASA and/or the *DIN* number. This sensitivity is called the film speed. When both numbers are stated, this combination is called the *ISO speed*. Film speed will be discussed here in terms of the ASA numbers, and other systems will be discussed in more detail in Chapter 8. The more sensitive the film, the larger will be the ASA film speed. The *ASA film speed* is so defined that the proper exposure of a film is inversely proportional to the ASA film speed. For example, Kodak Plus-X Pan film has an ASA film speed of 125 and Kodak Ektachrome 64 has an ASA film speed of 64. Proper exposure of the latter film will be twice that of the former for the same lighting conditions.

▶ **Example 2.4**

I am photographing an outdoor scene using Kodak Plus-X Pan film which is a *monochrome* (black-and-white) *film* and have determined that the proper exposure of the film will be f/11 at 1/250 sec. I wish to photograph the scene in color using Kodak Ektachrome 64 film. What will be the proper exposure of this film assuming that all other conditions are the same?

Because the color film is half as fast as the black-and-white film, the exposure will have to be doubled. This could be done by opening up one stop for an exposure of f/8 at 1/250 sec or increasing the exposure time by a factor of two for an exposure of f/11 at 1/125 sec. Either exposure can be chosen depending on whether f-number or time should remain unaltered.

Finally, to get a proper exposure the illumination of the subject must be determined. This can be done visually, based on experience or using a light meter of some kind. When photographing in daylight outdoors, the proper exposure can be determined rather well by observing the sky condition. Except in early morning or late afternoon, the exposure can be based on the degree of cloud cover if the subject is illuminated by the sun and/or the sky.

This information can be summarized for all films in a system called the Rule of Thumb, which is stated in Table 2.4. In the first three cases, it is assumed that the subject is facing the sun. If the subject is backlighted (illuminated from behind by the sun), the exposure may have to be increased as much as two stops depending

TABLE 2.4 Rule of Thumb for Determining Daylight Exposures

Lighting Condition	f-Number	Time (sec)
Bright or hazy sun on sand or snow (distinct shadows)	f/22	1/ASA
Bright or hazy sun (distinct shadows)	f/16	1/ASA
Hazy sun (indistinct shadows)	f/11	1/ASA
Cloudy bright (no shadows)	f/8	1/ASA
Heavy overcast	f/5.6	1/ASA
Open shade	f/5.6	1/ASA

FIGURE 2.26 Photographing a subject in open shade.

on the proximity of the subject and the lighting configuration. The last situation in the Table refers to a lighting configuration in which the subject is illuminated by considerable sky as well as by light reflected from nearby objects but not directly illuminated by the sun (see Fig. 2.26). This table lists one correct exposure for each lighting condition for a given film, but all equivalent exposures can also be used (e.g., see Table 2.3).

▶ **Example 2.5**

I am photographing a sprint at a track meet on a bright, sunny day. I am using a black-and-white film that has an ASA film speed of 125. I would like to use an exposure time of 1/500 sec to reduce the blurring of the runners. What will be the proper exposure of this scene if it is directly lighted by the sun (not backlighted)?

From Table 2.4 we see that if the sun is bright, the exposure should be f/16 at 1/ASA sec. Because the ASA film speed is 125, a proper exposure would be f/16 at 1/125 sec. Because I must use a shutter speed of 1/500 sec to stop the motion in the picture, I need to open up two stops and use the equivalent exposure of f/8 at 1/500 sec.

A very common ASA film speed is 400. Most cameras do not provide a shutter speed of 1/400 sec. For these films use 1/500 sec instead of 1/ASA sec for the initial exposure time. This will cause the film to be underexposed 20 percent but should cause no difficulty.

Note that the exposure has been determined on the basis of the illumination of the scene. For example, f/22 at 1/ASA sec is selected when photographing a subject on sand or snow, because extra light from the sun reflected off the sand or snow increases the illumination of the subject.

In circumstances where illumination cannot be judged visually, using a light meter to measure it will be more successful. An *incident light meter* can take the place of the eye in judging the level of illumination (see Chapter 9). Alternatively, a *reflected light meter* (Chapter 9) can be used, but it must be used carefully. The most common reflected light meter is one that is built into the camera. Only the most rudimentary use of this kind of meter is discussed here.

A reflected light meter measures the light reflected from the subject to the camera. The reading of the meter and the exposure determined from this reading depend on the amount of light illuminating the subject and the amount of light reflected to the meter by the subject. Dark subjects such as black cloth reflect very little light, whereas light subjects reflect a great deal of light. Imagine a subject composed of a white cloth and a black cloth. If the meter reading is made off the black cloth, a certain exposure will be indicated. A different exposure will be indicated if the meter reading is made off the white cloth. Yet it is possible to make an acceptable picture of a black cloth and a white cloth taken together. What exposure should be used? The answer is that neither should be used, because the camera light meter is calibrated to indicate proper exposure when used to measure light reflected from a neutral gray test card that reflects 18 percent of the incident light. The black cloth typically reflects about 5 percent of the incident light, whereas the white cloth reflects about 80 percent of the incident light. An 18 percent reflecting gray card reflects about the same amount of light as that reflected from an average outdoor scene.

If the reflectance of the subject is not average and the light meter is used without any correction to determine the exposure, the subject will be rendered as 18 percent gray in the final photograph, if standard processing is used. If the reflectance of the subject is not average, a gray test card can be placed in the scene and the light reflected from it measured using the meter to determine the proper exposure. Alternatively, some correction of the indicated exposure must be made. The use of the gray card and correction methods are discussed in Chapter 9.

One way to use the camera meter to get a more nearly correct exposure if the subject does not reflect an average amount of light is to proceed as follows. Instead of monitoring the light from the subject, move close and monitor the light reflected off the palm of a hand (yours or that of a subject) when the hand is illuminated by the same light that illuminates the subject. After the meter reading has been determined in the standard way, double the exposure. It is assumed that the hand is at least moderately clean. Some variation from hand to hand will occur depending on the complexion of the individual, but the variation will usually be much less than the variation in general skin tone. The rationale for this procedure is also discussed in Chapter 9.

EXERCISES

2.1. Explain the difference between a focal plane shutter and a between-the-lens shutter.

2.2. In what ways is a focal plane shutter inferior to a between-the-lens shutter for taking pictures of rapidly moving objects?

2.3. Discuss the limitations of an in-camera reflected light meter.

2.4. Why has the SLR camera become the favorite small format camera for the serious photographer?

2.5. Discuss the relative merits of the small format range finder and SLR cameras.

2.6. Discuss the relative merits of the small and medium format SLR cameras.

2.7. State the reciprocity law. If the time of exposure is doubled, what must be done if the exposure is to be unaltered?

2.8. Compare the diameters of two lenses with 50 and 100 mm focal lengths that have the same f-numbers.

2.9. If the f-number is doubled and no other changes in exposure are made, how does the exposure change?

2.10. If a lens is opened up one stop, how does the exposure change?

2.11. A correct exposure for a scene is f/4 at 1/125 sec. Find two other equivalent correct exposures.

2.12. Kodachrome 25 film has an ASA film speed of 25. Kodak Ektachrome 400 film has an ASA film speed of 400. How many stops faster is the latter film compared with the former film?

2.13. I have taken a picture of an outdoor scene using black-and-white film with an ASA film speed of 125. The exposure was f/11 at 1/250 sec. If I retake the picture using a black-and-white film with an ASA film speed of 32, what will be the proper aperture setting if the exposure time is left unchanged? What will be the proper exposure time if the aperture is left unchanged?

2.14. If the day is cloudy bright (no shadows) and I am photographing a subject under this illumination using Kodak Plus-X film (ASA film speed equal to 125), what exposure time should I use if the aperture is set at f/16?

chapter
·3·

Pictorial aspects of photography

In this chapter, the aesthetic nature of photography will be described and some simple rules presented that might make it easier to produce an acceptable picture. A comprehensive discussion of composition is not intended. Some discussion of composition seems in order, however, because the goal of beginning serious photographers is to make decent pictures.

■ WHAT IS PHOTOGRAPHY?

The answer to this question is very much a function of who is asked and when. In Chapter 1 the technical development of photography was traced, and it was noted that the daguerreotype process was the first commercially successful photographic process. In that period, photography was looked upon primarily as portraiture and certainly limited to subjects that did not move. Prior to the daguerreotype, portraiture (done by a painter) was accessible only to the wealthy. The daguerreotype made portraiture less expensive and more accessible because the time and skill required to make an acceptable portrait was greatly reduced. Landscapes, buildings, and still life were photographed, but the bulk of commercial activity was limited to making pictures of people.

If the question ''What is photography?'' is asked of a practicing photographer today, the answer will be that it is many things, and the emphasis of each answer will probably depend on the area of emphasis of the photographer. If the answer is couched in terms of what is photographed, it will be found that the finished products may be portraits, landscapes, commercial photographs for advertising everything from ball bearings to fashion to real estate, documentary photographs, photojournalistic pictures, scientific and technical photographs, and artistic photographs. These practicing photographers will be amateurs making record snap-

shots, serious nonprofessional photographers making pictures to satisfy their pleasure or need, and professional photographers plying their trade for hire.

Frequently it is asked whether photography is craft or art. Certainly a great deal of craft is required to make good pictures, just as a great deal of craft is required to weave a wall hanging or paint a picture. A friend of mine, to whom this book is dedicated, has said that a work of art is a formalized expression of experience as seen through a personality. Put another way, it might be said that the artisan must be "visible in the work" for it to qualify as art. If my friend's words are taken as a definition of a work of art, then the photograph, the wall hanging, and the painted picture can each be a work of art. However, if there is no "expression of experience" by the artisan, the work does not meet the criterion and is not art. Unfortunately, these "expressions of experience" are often difficult to discern by the viewer of the work, and what for one person is art, is for another mechanical reproduction. The medium in which the artist works places boundary conditions on what is technically possible. Although the painter, the weaver, and the photographer all work in two dimensions, their media impose different limits on what they can do. These craft limitations necessarily impose different criteria on what is aesthetically acceptable in each medium. Probably the painter has the most freedom and the photographer the least. If a photograph is to be meaningful, whether craft or art, it should at least transmit information and/or have some impact on the observer.

FIGURE 3.1 The Flatiron Building, New York, Platinum and ferroprussiate print, Edward Steichen, 1905. (The Metropolitan Museum of Art, The Alfred Stieglitz Collection, 1933)

FIGURE 3.2 Laughing Boxes, West 86th Street, New York, Edward Steichen, c. 1922. (Collection, The Museum of Modern Art. Gift of Samuel Kootz. By exchange)

FIGURE 3.3 The City of Ambition, Alfred Stieglitz, 1910. (Courtesy The Art Institute of Chicago)

FIGURE 3.4 Georgia Engelhard, Alfred Stieglitz, 1921. (Collection, The Museum of Modern Art, New York. Alfred Stieglitz Collection. Gift of Georgia O'Keeffe)

Photography can be categorized in many ways. For example, it can be asked whether a photograph is romantic or realistic, abstract or concrete, or straight or manipulated. These groupings are not hard and fast, but they help give feeling to what is meant by photography. Much of the early work of Edward Steichen could be considered romantic (see Fig. 3.1), although much of his later work could be considered realistic (see Fig. 3.2). This change in style may have been partially motivated by a change in the technology of photography. Similar changes can be seen in the work of other photographers of that period (see Figs. 3.3 and 3.4). It has been argued that all of photography is abstract, because in most instances three-dimensional objects are recorded in two dimensions. But, if this is so, then most of painting must also be considered abstract. In any case, there are degrees of abstractness. It is likely that the untitled photograph in Figure 3.5 would be classified as abstract and that the photograph in Figure 3.6 of two calla lilies is less so.

When photographers speak of *straight photography,* they mean photography in which the process has not been manipulated. In the limiting case (the most "straight"), the film is exposed by standard procedures, processed in a standard way, and used to make a print with no manipulation. In practice, a certain amount of *cropping* is usually done in the printing process as is minor *burning in* and *dodging,* but these kinds of procedures usually yield straight photographs. *Manipulation,* for this discussion, is defined as any process in which the exposure or processing of the film or printing paper is not standard. It does not include manipulation of the subject matter or the lighting of the scene. Sometimes it is difficult to tell

FIGURE 3.5 Untitled, Paul Caponigro, 1957. (Collection, The Museum of Modern Art, New York. Purchase)

FIGURE 3.6 Two Callas, Imogen Cunningham, c. 1929. (The Imogen Cunningham Trust)

FIGURE 3.7 Untitled, Jerry N. Uelsmann, 1966. (Copyright © 1966, Jerry N. Uelsmann)

whether manipulation has occurred, and the definition is admittedly somewhat artificial. By this definition, Figure 3.7 would not be considered manipulated. However, some would consider this picture to be very much a manipulated photograph.

Manipulation may involve multiple exposure of either film or paper, and other manipulations of the processing[1] (see Fig. 3.8). The *Sabattier* and *Albert effects* discussed in Chapter 8 can be used as manipulative devices. *Toning,* in which the color of a photograph is altered by a chemical process, and the use of high contrast film to increase the contrast of a print compared with that of a normal print, are other manipulative devices. Paper negatives, in which the tones are reversed compared with the original scene, would be considered manipulated.

Although some consider Figure 3.7 a manipulated photograph, few would argue if Figure 3.9 is called straight.

John Szarkowski organized an exhibit of photographs for the Museum of Modern Art called *Mirrors and Windows,* subtitled *American Photography since 1960.* In an essay in the book with the same title[2] containing reproductions of the photographs of this show, he discussed his perception of yet another way to divide modern photography. The thesis elucidated there and the theme for the show was that contemporary photographers could be divided roughly into two groups. At the risk of oversimplification these two groups are described as follows.

[1] J. Szarkowski, *Mirrors and Windows,* New York: The Museum of Modern Art, 1978, p. 21ff.

[2] Szankowski, p. 11ff.

FIGURE 3.8 Spring on Madison Square, Barbara Morgan, 1938. (Copyright © Barbara Morgan, 1938)

FIGURE 3.9 Heading West, Tulare Lake, California, Dorothea Lange, 1939. (Library of Congress)

FIGURE 3.10 Danville, Virginia, Emmet Gowin, 1973. (Copyright © Emmet Gowin, 1973)

FIGURE 3.11 Man at a Parade on Fifth Avenue, New York City, Diane Arbus, 1969. (Collection, The Museum of Modern Art, New York. Mrs. Armand P. Bartos Fund)

One group includes photographers whose main purpose is self-expression. That is, their goal is to express photographically their reaction to some subject or situation. Their photographs are mirrors reflecting their feelings about a subject or circumstance. The second group includes photographers whose purpose is to visualize, for the viewer, the world about them regardless of how mundane, bizarre, or base the subject might be. Their photographs are, so to speak, windows through which to see the world. An example from the former group is Emmet Gowin's, *Danville, Virginia* (Fig. 3.10). An example from the latter is Diane Arbus's *Man at a Parade on Fifth Avenue, New York City* (Fig. 3.11).

Szarkowski readily acknowledged that each category is very broad and that the boundary between the two is indistinct. The show and the thesis were controversial, but the division is certainly another valid way to look at photographs today. In his essay, he advances the tenet that the magazine *Aperture,* (founded in 1952) and the photography of its long time editor Minor White, is characteristic of and significant to the growth of the mirror concept. Certainly Minor White's *Capital Reef, Utah* (see Fig. 3.12) would not be out of place in the mirrors part of *Mirrors and Windows.* Szarkowski contends that the counterpart to *Aperture* and White for the window concept is Robert Frank's *The Americans,* published in 1958. For example, his *Political Rally, Chicago* (see Fig. 3.13) could be included in the window category of *Mirrors and Windows.* Even if one disagrees with Szarkowski, the essay is quite stimulating and well worth reading.

FIGURE 3.12 Capitol Reef, Utah, Minor White, 1962. (Reproduction courtesy The Minor White Archive, Princeton University. Copyright © 1982 The Trustees of Princeton University)

FIGURE 3.13 Political Rally, Chicago, Robert Frank, 1956. (Collection, The Museum of Modern Art, New York. Purchase)

Each of the ways in which photography has been divided has its utility. This discussion of composition will do little more than scratch the surface, and the discussion will be most applicable to straight photography.

■ SOME QUALITIES OF A GOOD PHOTOGRAPH

Because a photograph is usually a two-dimensional representation of a three-dimensional subject, some way must be found to capture in the photograph the impression of depth that is perceived when looking at three-dimensional objects. Frequently this is done by taking advantage of shadows cast by natural or manipulated light. Note that Figure 3.14a gives more impression of depth than Figure 3.14b, because of the shadow cast by the strong single oblique light source used to illuminate the linen in Figure 3.14a. In Figure 3.14b, the linen is illuminated from above by a more diffuse light source.

A well-made photograph should contain all the essentials needed to transmit information and make an impact on the viewer. In Figure 3.15a, both the man and the boy are looking at their hands. The viewer is left to wonder why and the pic-

(a) (b)

FIGURE 3.14 The use of shadow to generate the impression of depth. (ENM, 1983)

(a) (b)

FIGURE 3.15 Inclusion of the essential in a photograph. (ENM, 1983)

ture leaves him/her perplexed. In Figure 3.15b, the soccer ball gives a reason for the subjects to look at the hands and ball. The ball is essential in making the picture meaningful. Sometimes it is desirable to leave something to the imagination of the viewer. However, Figure 3.15a leaves the viewer wondering why these two individuals are staring at nothing. In Figure 3.15b, the viewer knows why they are looking as they are, but the significance of the soccer ball is left to the imagination.

If it is important that all the essentials of a good picture be in the picture, it is at least as important that the extraneous be omitted. Figure 3.16a is a portrait of a man dressed for outdoor activity. The straw hat and the hoe seem to imply gardening. The picture hangs together. On the other hand, posing him with a tree apparently growing out of his head as in Figure 3.16b adds an extraneous element to the picture.

In general, simple photographs carry more impact than complicated ones, although there are exceptions. Most would agree that the portrait made with a plain background in Figure 3.17a is more effective than the portrait made against a floral background in Figure 3.17b.

(a) *(b)*

FIGURE 3.16 Inclusion of the extraneous detracts from a picture. (ENM, 1983)

(a) *(b)*

FIGURE 3.17 In general, simple photographs are better. (ENM, 1983)

■ PURPOSE OF THE PICTURE

At the outset, the photographer presumably has a goal in mind. If the photographer works for hire, that goal is defined by the contract drawn up before the work is started. If an individual is working to satisfy personal needs, the thoughts that catalyze the photographer to pick up the camera define the goals. If meaningful pictures are to be made, the photographer must think about what is being done. It is true that some significant work is done by accident. Some snapshots do indeed have merit, but without thought the chances of doing meaningful photography are slim. This thought process should precede the venturing forth and should continue throughout the entire picture making process.

For example, if a portrait is being made and the goal is to flatter the subject, a soft-focus portrait lens may be used to take the picture (see Fig. 3.18a). If, on the other hand, the goal is to capture his weatherbeaten features for a salon print, a very sharp lens and lighting that highlights the facial lines may be used (see Fig. 3.18b). Above all, the photographer should look and think before taking the picture. Trees growing out of people's heads (see Fig. 3.16b) usually occur because the photographer is careless before activating the shutter. A slight change in vantage point and/or defocusing the background frequently can eliminate such errors.

The photographer should observe the scene carefully and try to recognize that which is more or less universal. This is especially important when photographing the familiar. Relatives and close friends are especially treacherous subjects, because the photographer may read into their expressions more than the average viewer will see. The photographer should critically examine the subject to see

(a) (b)

FIGURE 3.18 A soft lens and diffuse lighting (a) deemphasize the lines in this face, whereas direct lighting and a sharp lens (b) emphasize the lines in this face. (ENM, 1982)

everything that others will see. Close friends and loved ones are usually not seen as others see them. The marks that time and nature put in a face are overlooked. A scar from an accident that has been familiar for years is not seen. Cherished possessions cause similar difficulties. An old automobile that has served well over many years may seem like a timeworn friend to the owner but probably looks like a piece of junk to most other observers.

The viewer of the finished picture should be kept in mind. This is yet another viewpoint for the discussion of pictures such as those in Figure 3.18. Wedding pictures taken for hire should please the bride and groom and perhaps their parents. Pictures taken for personal gratification need only please the photographer. If the goal is to become a recognized artist, the photographer must cater to professional critics and a not very well-defined audience.

■ COMPOSITION

In this section some rules will be illustrated that should be helpful in composing pictures. Rules are not enough, however. Circumstances will arise in which any of these rules should be broken. Doing everything by the book often results in work that is static and perhaps hackneyed.

Because there is relatively little abstraction in photography, proper arrangement of the identifiable is important. For example, when looking down a railroad track, an observer expects to see the apparent spacing of the rails decrease for the simple reason that objects viewed from afar appear smaller than when viewed nearby. However, if a very long focal length lens is used to photograph a distant object and a modest enlargement is made, more distant objects will appear larger than nearby objects when the enlargement is seen at a comfortable viewing distance, despite the fact that the objects are the same size. Figure 5.16 demonstrates this for the case of railroad boxcars. The general problem of how depth is visualized is discussed in Chapter 5. This example shows that although unusual, the photograph does not show proper arrangement of the identifiable. An observer is not used to looking at boxcars that appear larger on the far end compared with the near end. Incidentally, if Figure 5.16 is viewed at a distance of several feet, the picture appears normal. The problem is one of viewing distance and not something characteristic of a telephoto lens.

It is not meant to imply that no abstraction can occur in photography nor that abstraction is always bad, but that it should be used with caution. High contrast prints, negative prints, and Sabattiered prints (see Chapter 8) all have their place. The negative print of the rainy street scene in Figure 3.19b certainly has merit and to many will appear superior to the positive print of the same scene in Figure 3.19a. The high contrast picture in Figure 3.20b is an interesting, different, and effective way to portray a scene, although the normal contrast picture in Figure 3.20a has merit also.

Mention has been made of the use of shadow to achieve an impression of depth in a picture of a solid object. When an overall impression of depth is desired in a picture, frequently *linear perspective, aerial perspective,* and differences in image

FIGURE 3.19 Rainy street scene; (*a*) positive print, (*b*) negative print. (ENM, 1983)

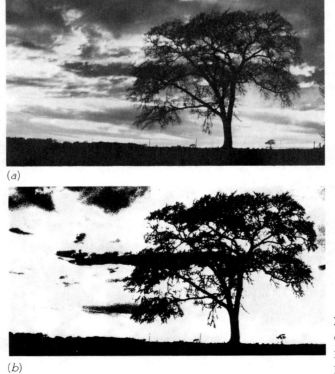

FIGURE 3.20 Minnesota elm: (*a*) normal contrast print, (*b*) high contrast print. (ENM, 1967)

sharpness are used to achieve this goal. Linear perspective is alluded to in the discussion of the distorted boxcars of Figure 5.16. The apparent decrease in the spacing of railroad tracks with distance is an example of linear perspective. For example, the apparent narrowing of a path with distance gives the impression of depth in Figure 3.21.

Aerial perspective refers to a change in tone with distance. Lighter tones generally are associated with distant objects and darker tones with those that are nearby. This may be due in part to the light color of the sky and the darker earth tones that are associated with a landscape. The haze that tends to obscure distant scenes also makes them appear lighter in tone, which may be another factor causing aerial perspective. Figure 3.22 shows how aerial perspective is used to contribute to a feeling of depth in this picture of an Appalachian mountain scene.

The eyes scan a scene and focus first on one part of the scene and then another. At any instant, some part of the scene will be *sharp,* and other parts will be out of focus. For example, if an observer is intently studying something at some intermediate distance, both nearby and distant objects will be ignored. The ignored objects may or may not be in focus on the retina of the eye. Nonetheless, they will give an impression similar to that of out-of-focus objects in a picture. This difference in apparent sharpness reinforces the realization that different parts of a scene are located at different distances. A variation in sharpness can be used to heighten the impression of depth in a picture. The family picture in Figure 3.23*b* with its defocused background gives a greater impression of depth than that of 3.23*a,* in which the background is more in focus. For a summary of the factors contributing to sharpness see Chapter 8.

FIGURE 3.21 Swiss school children at recess. (ENM, 1970)

FIGURE 3.22 An Appalachian mountain scene. (ENM, 1971)

(a) (b)

FIGURE 3.23 The use of a defocused background to increase the impression of depth.
(ENM, 1983)

FIGURE 3.24 On the path to Kleine Scheidegg, Switzerland. (ENM, 1970)

The impression of space and scale can be reinforced by familiar objects placed throughout the scene. The houses that appear small, and the hikers that appear much larger in Figure 3.24, help to remind the viewer that the distance to the village from where the photographer stands, is great. Space and scale can be manipulated further by the positioning of the horizon line. If the horizon line is placed high in the picture as in Figure 3.24, the land and terrain will be emphasized. If the horizon line is placed low in the picture as in Figure 3.25, the sky will be emphasized. If the horizon line is omitted from the picture as in Figure 3.26, the picture frequently will give the impression of being confined even if the distances are obviously great, as is indicated by the apparent differences in the sizes of the houses in this picture.

Choice of focal length of lens and how it is used can be a factor in controlling space and scale. If the viewing distance of the print and the print size are kept the same, pictures taken with long focal length lenses tend to appear compressed in depth and narrow in view, whereas pictures taken with short focal length lenses appear the opposite (see Chapter 5 for a more complete discussion of *perspective*). The picture of Mt. Washington and Lake Winnipesaukee (see Fig. 3.27a), taken with a 135 mm *telephoto lens* using a 35 mm SLR camera, appears to show considerable depth and *field of view* until it is compared with a picture taken from the same vantage point with the same camera using a 28 mm *wide-angle lens* (see Fig. 3.27b). The part of Figure 3.27b shown in Figure 3.27a is framed by the rectangle in Figure 3.27b. The added impression of space and scale is achieved more

FIGURE 3.25 Teton Mountains after thunderstorm. (ENM, 1971)

FIGURE 3.26 On the cable car to the Schilthorn near Berg, Switzerland. (ENM, 1970)

(a)

(b)

FIGURE 3.27 Mt. Washington and Lake Winipesaukee, New Hampshire from Gun-stock Mountain; photographed with (a) a telephoto lens and (b) a wide-angle lens. (ENM, 1967)

FIGURE 3.28 Peaks of Otter Lodge near Buchanon, Virginia, photogaphed with (*a*) 55 mm, (*b*) 135 mm, and (*c*) 28 mm focal length lenses. (ENM, 1977)

from the increased depth of field of the wide-angle lens than its increased field of view although the latter characteristic helps. Although the *angle of view* (see Chapter 5) of the 28 mm lens is about four times that of the 135 mm lens, the angle of view as seen by a person using both eyes is 180°, which is about 2½ times that of the 28 mm lens. Only a fish-eye lens can capture for the camera the wide expanse seen visually.

Note that the picture taken with the wide-angle lens shows very little of the details of Mt. Washington and Lake Winnipesaukee. In many instances a standard lens of about 50 mm focal length is an appropriate compromise between a telephoto and a wide-angle lens. The pictures of the Peaks of Ottor Lodge on the Blue Ridge Parkway (Fig. 3.28) taken from the same vantage point using a 35 mm SLR camera and lenses of focal lengths of 28 mm, 55 mm, and 135 mm, demonstrate this.

Still photography records what is happening at any instant in time, yet it is possible to capture with a still photograph a sense of motion and activity. If the subject is moving, a sense of its motion may be achieved by using a relatively long exposure so that the image of the subject is blurred (Fig. 3.29a). If the subject is to be relatively sharp, the camera can be *panned* as the subject moves and with a relatively long exposure, blur the background (Fig. 3.29b). It is not necessary, however, to have a blurred image to achieve an impression of motion. The dog's paws and the automobiles are blurred for different reasons, but the sense of motion in Figure 3.30 comes more from the position of the woman's foot and furs. Lartigue captured the feeling of motion by taking this picture at the right instant. Although it may seem like a minor factor, the direction in which moving subjects are looking can alter the impression of motion in a picture. In Figure 3.31, the runner is seen first looking toward an unspecified goal and then looking back where he has been. The first picture gives a greater feeling of motion or at least more intensity of purpose than the second.

(a) (b)

FIGURE 3.29 Using a long exposure to give the impression of motion. (ENM, 1983)

FIGURE 3.30 Avenue du Bois de Bologne, Paris, Jacque Henri Lartigue, 1911. (Collection, The Museum of Modern Art, New York. Gift of the artist. Photo Researchers, Inc.)

(a) (b)

FIGURE 3.31 Runner (a) looking toward a goal and (b) where he has been. (ENM, 1983)

FIGURE 3.32 Use of the rule of thirds to determine placement of the center of interest in a picture.

Most pictures are better if they have one center of interest, and care should be taken in emphasizing it. The center of interest is usually not placed at the center of the picture or at one edge. The rule of thirds can be helpful in determining this placement. This rule states that the center of interest should be at one of the intersections of imaginary lines dividing the picture horizontally and vertically into three equal parts (Fig. 3.32). Although the rule is honored almost as much in its breaking as in its keeping, it reminds the photographer not to make pictures either too symmetric or asymmetric. In Figure 3.33, the placement of the Matterhorn illustrates the keeping of the rule. In addition, the path to the village of Findeln and the stratified clouds lead the eye toward that center of interest. The nearby mountains tend to frame the picture. The houses seem to be part of the unit and secondary to the center of interest.

Placing a human figure in the edge of a landscape photograph is a simple trick that can provide both emphasis and a feeling of scale. The person should look into the picture if the landscape is to be emphasized (see Fig. 3.34a). If the person looks toward the camera (see Fig. 3.34b), the landscape may be reduced to the status of a portrait background which is, of course, legitimate.

If lines in a picture are vertical or horizontal, the picture frequently gives the impression of stability. On the other hand, diagonal lines tend to give a feeling of instability. The diagonal line formed by the rocky outcropping enhances the feeling of precariousness of the position of the woman in Figure 3.35.

FIGURE 3.33 The Matterhorn from near Findeln, Switzerland. (ENM, 1970)

(a)

FIGURE 3.34 Marly and The Blue Ridge near Blowing Rock, North Carolina. (ENM, 1973)

(b)

FIGURE 3.35 The Blue Ridge from Looking Glass Rock, North Carolina. (ENM, 1971)

FIGURE 3.36 The wreck of the *Laura Barnes,* Cape Hatteras, North Carolina. (ENM, 1968)

Sometimes a photographer gets so involved in taking a picture of a particular subject that the orientation of the camera relative to the surrounding landscape is ignored. For instance, the remains of the old victim of Cape Hatteras storms was so interesting that the tilted horizon line implying that the ocean was emptying out of the right side of the picture was ignored (Fig. 3.36). Horizon lines in ocean scenes and flat midwestern plains scenes that are not horizontal are, in most instances, disquieting. Similar problems can arise with floors and ceilings that are not horizontal, unless the purpose of the picture is to create a feeling of instability.

A repeat pattern can give a picture a sense of rhythm, as in Figure 3.37. The montage of a poet's face seems particularly apt for illustrating rhythm.

Most observers see subjects in color, but in black-and-white photography the print will be rendered in white, various shades of gray, and black. Figure 3.20 showed how contrast could be manipulated to alter the mood of a picture. In Chapter 9 several techniques will be discussed that can be used to vary the rendition of the *tones* of a particular subject. The photographer should think of how a scene, which is seen in color, will appear in black and white. This can affect the composition considerably. For example, the relative placement of light and dark tones can alter the feeling of stability in a picture.

FIGURE 3.37 Carl Sandburg, Edward Steichen, montage, 1936. (Collection, The Museum of Modern Art, New York. Gift of the photographer)

If a picture is dark at the bottom and light at the top, usually a sense of stability is felt in the picture. If the tones are reversed, the picture gives the impression of instability. For example, the picture of the Matterhorn in Figure 3.33 probably gives a feeling of relative stability, whereas the picture of the mountain valley in Figure 3.26 probably gives a feeling of instability. Many factors contribute to these feelings, and the relative placement of light and dark tones in the two pictures is undoubtedly one of these factors.

In the section discussing purpose, it was mentioned that the photographer should look at the scene as the camera will record it. Some things will finally become almost automatic, but many will not, and the photographer must think before taking the picture. The mind and eye should be trained to check out the background, the framing of the scene, the lighting, the vantage point, the timing of the picture taking, and so on.

Once a subject has been recorded on film, several darkroom manipulations may be used to alter the nature of the final print. These include manipulation of film development, printing procedure, and cropping. It is tempting to depend on these manipulations to compensate for lazy picture taking. The best pictures usually result when the film is exposed for normal processing and printing. This reserves the manipulative techniques for improving the product of a good negative rather than salvaging the product of a bad one. Sometimes no decent picture can be made of a given subject under the prevailing circumstances. If this is the case, it is best not to take the picture. The photographer should know the limitations and possibilities of the medium. One of the best ways to do this is to study the work of successful photographers.

■ PORTRAITURE

The faces of human beings are probably the most universally interesting and diverse subjects for photography. Individuals are usually somewhat curious about how they look, and most of us find interest in the faces of other persons. The interest may be limited to family, friends, and the famous, or it may include most of humanity.

Making pictures of people is not easy because the photographer must either interact with them or proceed so surreptitiously that his/her presence is undetected. Often the subject must be manipulated and at the same time, relieved of the anxiety caused by the presence of a camera. Good communication skill on the part of the photographer is a great asset in portrait work. Good command of the equipment and an appearance of technical competence are necessary if the subject is to be at ease; tense subjects usually photograph poorly.

A good portrait should tell the viewer something about the subject. It may reveal the subject's apparent character, feelings at the moment, status, life-style, and/or occupation. The whole face can transmit this kind of information, but in the usual portrait the eyes reveal more than any other part of the face. Hence, unless there is a very good reason to do otherwise, the eyes of the subject should be made visible in the picture.

FIGURE 3.38 Marian Anderson, Yousuf Karsh, 1945. (Copyright © Yousuf Karsh, Ottawa/Woodfin Camp)

FIGURE 3.39 Joyce Goldstein in Her Kitchen, Judy Dater, 1969. (Copyright © Judy Dater, 1969)

Portrait photography can be divided conveniently into three categories; *formal, informal,* and *candid.* The division between each group is not hard and fast but is helpful in categorizing portraits. A formal portrait relies almost exclusively on the features of the face to tell us about the individual. Rather conventional lighting (to be discussed later) is used; props and the surroundings are usually not used. For example, clothing is simple, little jewelry is evident, and surroundings are deemphasized. Frequently, such a picture is taken in a studio using a plain backdrop. Often the picture is confined to no more than the head and shoulders of the individual (see Fig. 3.38). However, as with all compositional rules, there are exceptions. The full-length studio picture of a bride taken against a plain background is clearly a formal picture.

The informal picture, on the other hand, uses props, takes advantage of unusual lighting, and/or uses the surroundings to tell about the subject or dramatize his/her features. In Figure 3.39 the kitchen setting, the hands, the dress, and even the pose tell something of the circumstances of Joyce Goldstein. It is worth noting that Stieglitz used background, pose, hands, and dress to achieve a similar effect with Georgia Engelhard in 1921 (see Fig. 3.4). The techniques of portraiture haven't changed much in 50 years.

The candid portrait, as opposed to either the formal or informal portrait, is not posed. The subject usually is photographed doing something. The picture of a doctor treating an injured child in Figure 3.40 is an example of such a picture. The strain in the eyes of the doctor is heightened by the sight of the injured child. It can be said that the hand and skill of the photographer should be evident in a portrait.

FIGURE 3.40 Dr. Ceriani, W. Eugene Smith, 1948. (Copyright © W. Eugene Smith, 1949)

This is usually clearly apparent in a good posed portrait. It might be argued that a good candid portrait is an example of a lucky snapshot, and such may be the case on occasion. Good candid photography is not just a matter of luck, however. Considerable planning and anticipation are necessary as is the instinct for the right moment to take the picture. Candid portraits include those in which the subject is totally unaware of the photographer's presence.

■ POSING THE SUBJECT

All the ways in which a subject can be posed will not be discussed here, but rather some general rules will be considered that should be helpful. Normally, the subject is not posed looking directly into the camera with shoulders perpendicular to the line of sight of the camera. Such a pose may be correct for an identification picture and is required for passport photographs but usually yields a picture that portrays the subject as catatonic (see Fig. 3.41). Occasionally, this kind of pose can be used to help transmit a sense of static intensity and sternness as in the picture of J. P. Morgan in Figure 3.42. The usual portrait will be one in which the figure is not perpendicular to the line of sight of the camera. The subject may look into the camera (see Fig. 3.43) or off camera (see Fig. 3.44). A greater feeling of intimacy between subject and viewer will occur in the former case. The degree to which the subject seems oblivious of the view depends on other facial features and how far off camera the subject appears to be looking.

FIGURE 3.41 A "passport" photograph. (ENM, 1983)

FIGURE 3.42 J. Pierpont Morgan, Edward Steichen, 1903. (The Metropolitan Museum of Art, The Alfred Stieglitz Collection, 1949)

FIGURE 3.43 Using direction of view to create a feeling of intimacy. (ENM, 1983)

FIGURE 3.44 Using direction of view to distance the subject from the viewer. (ENM 1983)

FIGURE 3.45 Using camera position to generate a feeling of dominance on the part of the subject. (ENM, 1983)

The features of the face and how they are emphasized are also factors in determining where the subject looks. To lessen the impact of prominent ears, the subject should turn his/her head and look off camera. One ear can be hidden behind the head and the other will usually appear less prominent. Lighting also can be altered to reduce the visibility of the prominent ear. When using a 35 mm camera and a standard lens, it is tempting to photograph the subject with too little distance between subject and camera, especially if the picture is to include only head and shoulders. This is desirable because it reduces the amount of enlargement necessary to get a proper sized print.

If the camera is too close, the nearer features like the nose will appear too large compared with the size of more remote features such as the ears (see Fig. 5.17). If it is necessary to work at less than ideal distance (about 6 feet for a head and shoulders portrait), the shoulders should be approximately perpendicular to the camera line of sight. If they are not, the nearer shoulder will, for the above reason, appear too large in the picture. A longer focal length lens is very useful for head and shoulders portrait work. For instance, a lens of 100 mm focal length is an excellent choice for this kind of 35 mm format photography.

The vertical placement of the camera with respect to the subject can be used to alter the mood of the picture. Placing the camera at or near eye level usually enhances a feeling of intimacy between subject and viewer. If the camera is placed well below eye level, the viewer will more likely see the subject as an authority figure or a dominant person (see Fig. 3.45). Conversely, if the picture is taken from above the person, he/she will more likely seem dominated by the viewer. Camera elevation also can be used to alter the perspective of facial features. For a discussion of this and other useful portrait techniques see Kodak's publication 0-4.[3]

[3]*Professional Portrait Techniques,* Rochester, N. Y.: Eastman Kodak Company, 1980.

■ PORTRAIT LIGHTING

Human subjects can be lighted by available light sources or by light sources provided by the photographer. Good available light sources include direct light from the sun, light from the open sky, light from windows, and illumination from incandescent and fluorescent room lights.

The illumination tools of the professional photographer include *floodlights, spotlights,* electronic flash units, and flash bulbs. White cards, white cloth umbrellas, and other surfaces can be used to enhance all light sources. In many ways, floodlamps are the most flexible to use. The direct sun can be used as a satisfactory light source, but it is frequently high in the sky, and without an auxiliary reflector it usually causes unsatisfactory shadows in the eyes, under the chin, and under the nose. Even with reflectors, the sun is used best as a source placed so that the subject does not look directly into it.

The open sky (see Chapter 2) can be a very satisfactory light source, but without additional reflectors, shadows that help give depth to the face are virtually nonexistent, and the picture will be soft or somewhat flat. Even so, many good portraits are made using the open sky and light reflected from the surrounding surfaces as light sources. Flash illumination has the advantage of portability and, being instant illumination, eliminates squinting by the subject. However, without modeling lights it is difficult for the uninitiated to visualize the final picture. Flash illumination placed directly on the camera yields pictures in which the features of the subject appear flat especially if he/she is looking directly into the camera. In color photography this combination of pose and illumination will cause the pupil of the eye to appear red because the retina of the eye is illuminated by the flash unit, and its image is projected back to the camera through the pupil.

If improvisation is necessary, floor and table lamps without shades are very satisfactory light sources. The amount of light they provide is limited, however, and relatively long exposures and/or large apertures are required. For example, two 150 W bare household incandescent lamps positioned 6 feet from the subject require an exposure of f/2.8 at 1/60 sec for ASA 400 film. Such an exposure severely limits the depth of field of the camera (see Chapter 4). Larger f-numbers with greater depth of field require longer exposures, increasing the risk of subject movement during the exposure. These longer exposures make necessary some kind of support for the camera. Posed portraiture is, in general, more satisfactory if the camera is supported by a *tripod.*

In this discussion of light positioning for portraiture, only the placement of the light sources is designated, not their nature. If unlimited lighting is available, it may be desirable to use as many as five or six light sources. In conventional portrait lighting, the first light position to be determined is that of the *main* or *key light.* This is followed by positioning the *fill light,* which softens the shadows formed by the main light. In addition, a *background light* may be used to illuminate the background and a *hair light* to highlight the hair. Finally, *kicker lights* may be added to accent parts of the face.

The main light usually is positioned in one of three positions. If the light is placed so that the side of the face nearest the camera is illuminated by this source, the

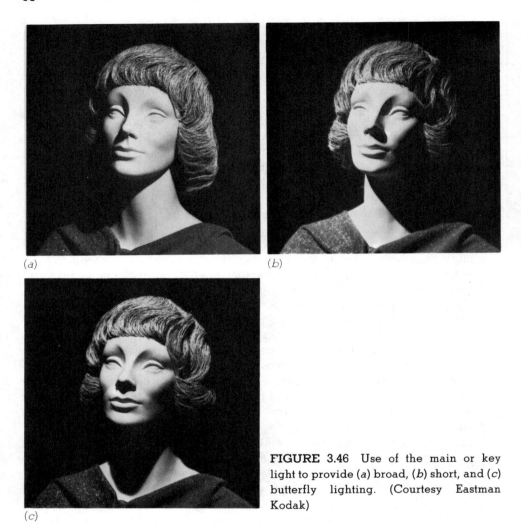

(a)

(b)

(c)

FIGURE 3.46 Use of the main or key light to provide (a) broad, (b) short, and (c) butterfly lighting. (Courtesy Eastman Kodak)

lighting is called *broad lighting* (Fig. 3.46a). Main light illumination in which the side of the face away from the camera is lighted by the main light is called *short lighting* (Fig. 3.46b). If the person is looking directly into the camera, these two lighting configurations are the same. If the main source of illumination is placed to illuminate equally both sides of the face, the lighting arrangement is called *butterfly lighting* (Fig. 3.46c). Short lighting makes the face look narrower, whereas broad lighting makes it look wider.

In broad and short lighting, the main light usually is placed at an angle of about 45° with respect to the line of sight of the camera. The position of the main light in butterfly lighting is determined by the position of the face. Normally, the main light is placed higher than the person's head, but the exact height is dictated by the person's features. Deep-set eyes and craggy features are deemphasized if the

main light is placed lower. If only one light source is available, butterfly lighting or some variation thereof is uaually the configuration of choice.

The second light source is the fill light that fills the shadows created by the main light. This light usually is placed near the camera on the side of the camera opposite the main light. It usually is placed lower than the main light to fill the shadows created by the main light. Typically, the fill light is about half as bright as the main light at the subject's face. This can be achieved by using a light source half as intense as the main light or by placing the fill light farther from the subject. The proper balance between main and fill light can be determined visually. *Lighting ratio* is discussed in more detail in Chapter 10. The effect of a fill light in a short lighting

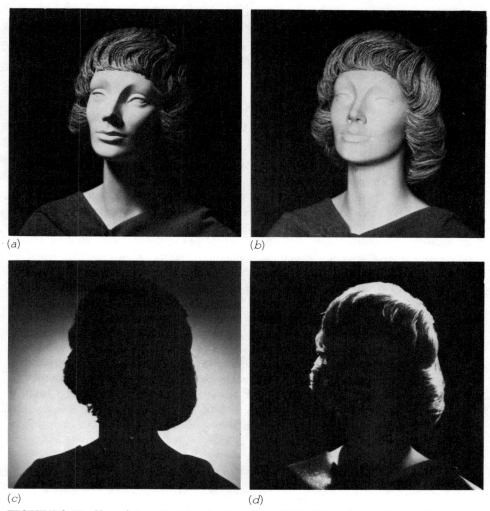

(a) (b)

(c) (d)

FIGURE 3.47 Use of short lighting to show the effect of the (a) main light, (b) fill light, (c) background light, and (d) hair light. (Courtesy Eastman Kodak)

situation is shown in Figure 3.47b. If a light meter is used to determine exposure, readings should be made with both the main and fill lights in place.

The background light is used to illuminate the background. This is especially desirable when photographing a dark-haired subject against a dark background, because otherwise it is difficult to differentiate between hair outline and backdrop. The effect is demonstrated in Figure 3.47c. The background light sometimes can be used to fill shadows on a light-colored background caused by the main and fill lights. If no such light is used, undesirable background shadows can sometimes be minimized by placing the main light higher and moving the subject away from the background.

The hair light is used to highlight the hair and usually is placed above and behind the subject. The main, fill, and background lights are most often diffused light sources such as floodlights, whereas the hair light is a more concentrated light source such as a spotlight. Figure 3.47d shows the effect of the hair light. Sometimes accent lights called kickers are added to accent other parts of the face. These and other illumination techniques are discussed in Kodak's "Professional Portrait Techniques," mentioned earlier.

EXERCISES

3.1. Look at the pictures in this chapter. Which would you consider "mirror" photographs and which "window" photographs?

3.2. Discuss the various ways to give an impression of depth in a photograph.

3.3. Select five photographs in this chapter and discuss extraneous elements that may appear in each.

3.4. Speculate on the purpose of the five photographs in this chapter that interest you most. For what audience is each designed?

3.5. Compare the ways in which the eye and the camera "see" a picture.

3.6. What devices have been chosen to give the impression of space and scale in five photographs in this chapter?

3.7. Which pictures in this chapter give a feeling of motion? Which give a static feeling?

3.8. Discuss the difference between formal, informal, and candid portraits. Classify the portraits in this chapter according to these categories.

3.9. Discuss the relative postion of subject and camera in a posed portrait. Include in your discussion the implications of camera height, direction of gaze, and body position.

3.10. Make a drawing showing the position of two lights, camera, and subject used to provide "broad" lighting for a portrait.

part ·2·

OPTICS OF PHOTOGRAPHY

chapter ·4·

Light and lenses

Although some of the most basic aspects of optics were considered in Chapter 2, a great deal more knowledge of light and optics is necessary if the photographic experience is to be satisfactory. In this chapter, the basics of light and optics will be discussed. In the next chapter, these basics will be applied to several specific photographic problems.

■ LIGHT

Models are frequently used in describing physical phenomena. For example, light can be thought of as a ray. This can be visualized by imagining that a ray is like a beam of sunlight streaming through a small hole in an opaque screen into an otherwise totally darkened room. The beam of light illuminates the dust particles in the air, making the light path visible. This was the earliest model for light, and with it, much of the optical phenomena relevant to photography can be described. This simple model has not stood the test of time, however, and more complex models have superseded it. Later, light was pictured as a *wave* something like those that move across the surface when a stone is thrown into a still pool of water. Finally, to explain how light behaves on a microscopic scale, it is necessary to picture light as massless bundles of energy. This latter model can be used to explain most optical phenomena, including those explained by the ray and wave models, although the explanations are often complicated.

Many scientists would say that this last model, sometimes called the *quantum* model, describes what light really is like. Such conviction, however, is a matter of faith because no model can be proven to be the ultimate one nor can uniqueness be proven. In describing light and optical phenomena relevant to photography, all three models will be used, and although it will be written that ''light is,'' this means ''light behaves as though.'' An effort will be made to use the simplest model to explain a given phenomenon. Perhaps this brief explanation will help to clarify the meaning of the question, ''What is light really like?''

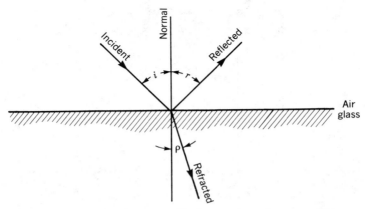

FIGURE 4.1 Reflection and refraction of light at an air glass boundary.

The ray concept relies on two laws that describe how a light ray changes direction when it intersects the boundary between two different optical materials (e.g., the boundary between air and glass). Suppose that light is incident on an air-glass boundary at angle i with respect to the *normal* to the *surface* (see Fig. 4.1). Some light will be *reflected* at the surface at an angle r with respect to the normal, whereas some light will pass through the surface and be bent *(refracted)* so that the angle between the normal and the refracted ray is ρ. The law of reflection states that

$$i = r \tag{4.1}$$

This law, stated in words, says that the *angle of incidence* is equal to the *angle of reflection*. Some light will always be reflected. The refracted beam follows the law of refraction, which states that

$$n_A \sin i = n_G \sin \rho \tag{4.2}$$

where n_A and n_G are the *indices of refraction* of the air and glass, respectively. The value of n_A is very close to one and n_G is typically about 1.5. The meaning of these numbers will become evident when light is studied from a wave point of view.

The sine (sin) function is a trigonometric function that increases monotonically with angle between 0 and 90° and its values are between 0 ($i = 0°$) and 1 ($i = 90°$). Air is said to be optically less dense than glass. This law can be generalized and stated qualitatively in words as follows: When light passes from a material of less optical density (air in this case) to one of greater optical density (glass in this case) at an angle greater than zero with respect to the normal to the surface, the ray representing the light is bent toward the normal to the surface. If light is passing from an optically more dense to an optically less dense material, the ray is bent away from the normal to the surface. If $i = 0$, the ray is not bent. The law as given in Equation 4.2 can be generalized by substituting for the indices of refraction of glass and air those of the appropriate materials.

Under certain circumstances, light traveling from an optically more dense mate-

rial to an optically less dense material is totally reflected at the boundary and no light enters the less dense material. Note that as the angle of incidence (i) increases (see Fig. 4.2) the *angle of refraction* (ρ) also increases and ρ always is greater than i. As i is increased ρ eventually becomes 90° and no light passes through the boundary. The incident angle (i_c) for which $\rho = 90°$ is called the critical angle. Because sin 90° = 1 the critical angle can be computed using a generalized form of Equation 4.2.

$$n_1 \sin i_c = n_2 \sin 90° = n_2 \tag{4.3}$$

For all angles greater than the *critical angle* (e.g., i' in Fig. 4.2) all of the light is reflected back into medium one. This is called *total internal reflection*. The phenomenon is sometimes used to make special high quality mirrors, because no reflective coating of the surfaces is necessary if the angle of incidence of the light is always greater than the critical angle.

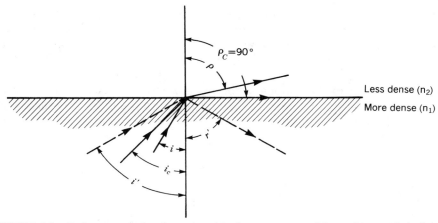

FIGURE 4.2 Reflection and refraction of light at an optical boundary with light incident on the surface from the optically more dense medium.

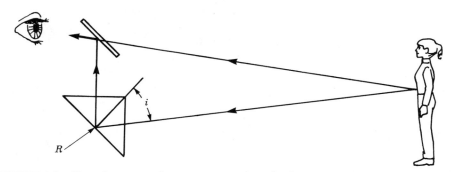

FIGURE 4.3 Use of a triangular prism in a range finder.

▶ **Example 4.1.**
I want to build a high quality range finder of the kind sometimes used in a range finder camera (see Chapter 2). I would like to use a triangular prism to reflect the light of the lower beam (see Fig. 4.3) up to the upper mirror. If the angle of incidence *(i)* is 45°, will all of the light be reflected at *R* if I use a crown glass prism having an index of refraction of 1.5?

If the critical angle is less than 45°, all of the light at *R* is reflected. From Equation 4.3

$$\sin i_c = \frac{1}{1.5} = 0.667 \tag{4.4}$$

$$i_c = \text{arc sin } 0.667 = 41.8° \tag{4.5}$$

and we see that all of the light is internally reflected for incident angles greater than about 42°.

The behavior of optical instruments such as mirrors and lenses can be described using mathematical formulations derived from the laws of reflection and refraction. However, because most reflecting and refracting lens surfaces are spherical sections, these laws must be used carefully. To determine how light is refracted at a spherical surface, the law of refraction must be used as shown in Figure 4.4. Imagine a plane *tangent* to the surface at the point where the ray is incident on the glass surface and erect the normal perpendicular to this surface. The angles are measured with respect to this normal, and the law will be as stated in Equation 4.2.

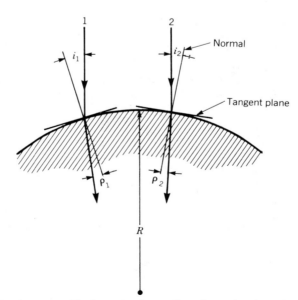

FIGURE 4.4 The refraction of light at a spherical surface of radius *R*.

Parallel rays 1 and 2 are refracted differently because the incident angles i_1 and i_2 are different and because the tangent planes are not parallel. This makes it possible for the lens to form an image.

Although the ray idea can and will be used to describe the simple behavior of a lens, the descriptions soon would be very complex. For example, the colors of a rainbow and the spreading of white light into many colors when it is transmitted through a prism indicate that white light is comprised of many different kinds of light. It would be cumbersome to describe the behavior of these different colors using the ray model. Moreover, phenomena such as *interference, diffraction,* and *polarization* are not explained by the ray model.

To overcome some of these difficulties, Huygens, Maxwell, and others developed a wave model for light. Waves can be classified as *longitudinal* or *transverse*.

Suppose that a weak coiled spring (e.g., a toy Slinky) is stretched out on a table between two hands (see Fig. 4.5). If one hand is moved sharply to the left along the direction of the spring, the spring will be compressed momentarily near that hand, and the compression will travel along the spring until it strikes the other hand, causing it to move. This compression is a kind of longitudinal wave because the displacement in the wave and the force exerted on the hand are along the direction of propogation of the wave (the axis of the spring). Sound waves in air used to communicate through speech and hearing are longitudinal waves.

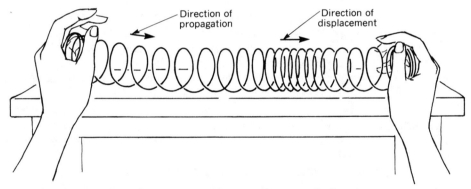

FIGURE 4.5　Example of a longitudinal wave along a coiled spring.

Suppose that a rope is stretched between two persons and that each person holds one end of the rope (see Fig. 4.6). The person on the left jerks the rope up and down sharply so that a wavelike vertical oscillation is propagated along the rope. When the wave reaches the person on the right, his/her hand will be moved vertically. The direction of propagation is horizontal, whereas the direction of oscillation is vertical and perpendicular to the direction of propagation. Such a wave is a transverse wave. If the person on the left had jerked the rope horizontally (in and out of the page on which the figure is drawn), the oscillation would have been horizontal, and this also would be a transverse wave. If the person on the left had

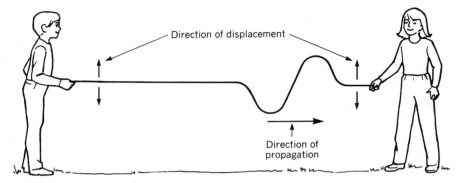

FIGURE 4.6 Example of a transverse wave along a stretched rope.

moved his/her hand in a circular motion in a plane perpendicular to the axis of the rope, a spiraling wave would have been generated, which also would be considered a transverse wave moving along the rope. If a light wave is confined to oscillate in a plane as in the first two examples, it is called a *plane-polarized wave*. Any other light wave can be reduced to two plane-polarized waves which are oscillating in planes perpendicular to each other.

Light emitted from an incandescent lamp can be thought of as emitting waves in all directions, somewhat like waves propagated across the surface of a still pond when a stone is dropped into the water. The surface waves spread out in a circular pattern because they are propagated on a two-dimensional surface, whereas light waves are spherical because they are propagated in free space from a point source. If the rope pictured in Figure 4.6 had been oscillated continuously, a continuous procession of waves might have been propagated and would appear as in Figure 4.7. Light waves can be considered in the same way. The repeat distance in space of the light wave is called the *wavelength* (λ), and the number of complete oscillations at a given point in space in a unit time is called the *frequency* (f). Frequency is usually measured in cycles per second, a unit that has been given the designation Hertz (Hz).

Light waves are but a small part of the collection of *electromagnetic waves* that make up the electromagnetic spectrum. These waves have many similar electromagnetic characteristics and include many kinds of radiation that have become household words. All of these waves are transmitted through a vacuum (free

FIGURE 4.7 A continuous sinusoidal wave.

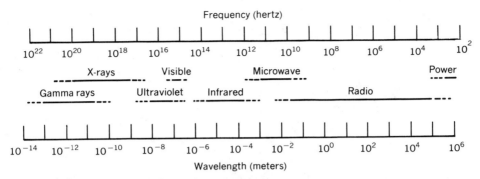

FIGURE 4.8 The electromagnetic spectrum.

space) at the same velocity called the *velocity of light* ($c = 3 \times 10^8$ m/sec). The velocity of light, the frequency, and the wavelength are related so that

$$c = f\lambda \tag{4.6}$$

where f and λ are as defined above. The different parts of the electromagnetic spectrum are shown in Figure 4.8. The boundaries between the different parts of the spectrum are not sharp, but they overlap. The span of the overall spectrum is at least 20 orders of magnitude, and yet the visible part of the spectrum is confined to the wavelength interval from 400 to 700 nanometers (400 to 700 \times 10^{-9} meters). This is the part of the spectrum of most interest in photography. The short and long wavelengths correspond to the violet and to the red parts of the spectrum, respectively.

When light passes through a transparent medium other than a vacuum, its velocity (c_m) is reduced compared with its velocity in a vacuum (c) and

$$n_m = \frac{c}{c_m} \tag{4.7}$$

where n_m is the *index of refraction* of the medium. The frequency of a given light wave is the same in all media. It follows from Equation 4.6 that the wavelength must be reduced when the wave passes from an optically less dense to a more dense medium, and this reduction in wavelength helps to explain why light is refracted when it passes from one transparent medium to another (see Fig. 4.9).

The velocity of light in any transparent medium except a vacuum depends on the frequency of the light. In general, the higher the frequency the more the velocity of propagation is reduced. The resulting variation of index of refraction with frequency (Eq. 4.7) is called *dispersion*. Because violet light is slowed more than red light in passing through an interface, it will be refracted more. If white light passes through two surfaces of a prism, the light will be spread out in a spectrum (see Fig. 4.10) when it emerges.

The wave model can be used to explain most optics that are pertinent for photography. However, this model fails to describe the interaction of light with matter. In particular, the model cannot be used to explain how light interacts with a silver

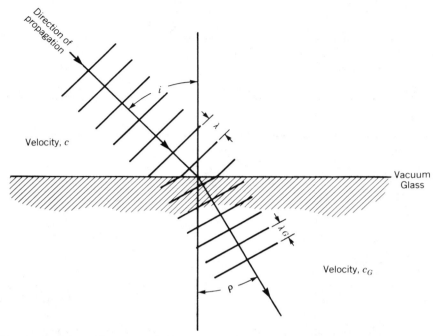

FIGURE 4.9 The refraction of light and change in wavelength at a vacuum-glass boundary. The bars at right angles to the ray represent the spacing of the waves.

halide to form a photographic image. For this task light will be considered as a stream of massless bundles of energy called *photons*. To use this model rigorously a knowledge of quantum mechanics is necessary. Fortunately, only the barest essentials of the model are needed and the quantum mechanics can be avoided. Each photon is considered to have an amount of energy

$$E = hf \tag{4.8}$$

where f is the frequency of the light and h is Planck's constant (6.6×10^{-34} joule-sec). Equation 4.8 implies that blue photons have more energy than red photons. This is important in the explanation of the response of the light-sensitive silver salts to different colors of light. Because the photons are very small, they can interact with individual atoms, and this will help in the explanation of the interaction of light with light-sensitive materials.

■ THIN LENSES

In the last section it was shown that light rays are refracted when they pass through an air-glass interface. Camera lenses usually are constructed of elements of glass with spherical surfaces. A lens that is thicker in the center than at the edge is called

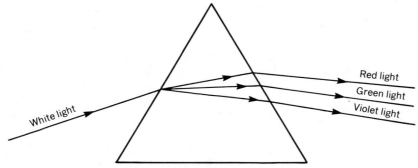

FIGURE 4.10 The separation of white light into its component colors as a result of dispersion.

a *converging* or *positive lens,* whereas one that is thicker at the edges is called a *diverging* or *negative lens* (see Fig. 4.11). How a lens bends a bundle of light rays could be determined by applying the law of refraction to every ray incident on the surface of the lens (see Fig. 4.4). However, if the lens is very thin its behavior (for many applications) can be characterized by its focal length.

(a) (b)

FIGURE 4.11 Examples of (*a*) a converging and (*b*) a diverging lens.

The focal length was defined operationally in Chapter 2 in terms of the image position of objects that were a great distance from the lens. However, it can be shown that the focal length is a function of the shape of the lens and the material from which it is made. To a first approximation the focal length (*f*) of a lens is given by

$$\frac{1}{f} = (n - 1)\left(\frac{1}{R_1} + \frac{1}{R_2}\right) \tag{4.9}$$

where *n* is the index of refraction of the glass and R_1 and R_2 are the *radii of curvature* of the spherical glass surfaces (see Fig. 4.12). R_1 and R_2 are positive if the surfaces are convex and negative if the surfaces are concave. In Figure 4.12*a* both surfaces are convex. In Figure 4.12*b* both surfaces are concave.

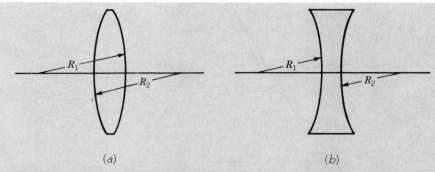

FIGURE 4.12 Radii of the spherical surfaces of a lens.

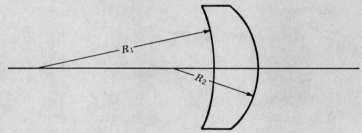

FIGURE 4.13 Simple meniscus lens.

▶ **Example 4.2**

The earliest camera lens was a simple meniscus lens, shown in Figure 4.13.

I wish to use such a lens in a model of a simple camera I am building. The lens is made of crown glass ($n = 1.5$) with radii $R_1 = 20$ mm and $R_2 = 15$ mm. Because R_1 is greater than R_2, even though the left surface is concave, the lens will be thicker in the center than at the edges and will be a positive lens. What is its focal length?

In Equation 4.9, R_1 will be negative and R_2 positive so that

$$\frac{1}{f} = (1.5 - 1)\left(-\frac{1}{20} + \frac{1}{15}\right) = 0.0083$$

and $f = 120$ mm.

If the focal length of a lens is known, the position of the image of any object can be determined, provided the position of the object relative to the lens is known. This can be found geometrically or mathematically. Because the geometrical construction is easier to visualize, this will be used first. Imagine a bundle of rays coming from a point object (O) as shown in Figure 4.14. Those rays striking the positive lens will be refracted and form a point image at the point (I) where the rays cross. If the point object is moved away from the lens, the rays from the object become more nearly parallel to the line through the center of the lens called the *optical axis*. If the object is moved to infinity, the rays will become parallel to

the optical axis and the image formed at the *focal point* (see Fig. 4.15). Note that all of the rays parallel to the optical axis (the axis of symmetry) pass through the focal point. In these two drawings, the ray has been shown as bent at both surfaces of the lens. However, if the lens is thin, the drawing can be simplified by extending the rays to a plane through the center of the lens (see Fig. 4.16). If the point is off the optical axis, the image will be formed as in Figure 4.17. Note that the ray through the center of the *thin lens* is undeviated.

Any object can be considered a collection of points and its image a similar collection of points. The facts that all rays parallel to the optical axis pass through the focal point and that all rays through the center of the lens are undeviated will be utilized to locate the image of a finite object. The construction for a point object is shown in Figure 4.18*a* and that for two points on an extended object in Figure 4.18*b*. This construction is representative of all objects beyond the focal point of a positive thin lens. Note that rays from every point on the object pass through every point on the lens. This means that two or more light rays, unlike matter, can occupy the same place at the same time. Often it is thought that different parts of the lens are used to form different parts of the image; this is not true for a well-designed lens.

If all the object points are in a plane, the image points to a first approximation will be in a plane. This plane is called the *image plane*. The image plane that is perpendicular to the optical axis and intersects it at the focal point (*F*) is called the *focal plane*. It is the image plane for an object at infinity. Unfortunately, in photography the image plane of the in-focus image is usually called the focal plane regard-

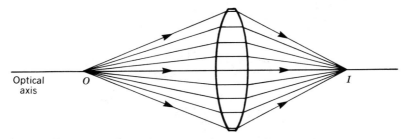

FIGURE 4.14 Formation of a point image of a point object.

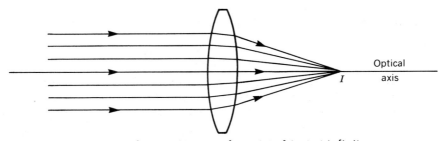

FIGURE 4.15 Formation of a point image of a point object at infinity.

FIGURE 4.16 Thin lens construction for a ray parallel to the optical axis.

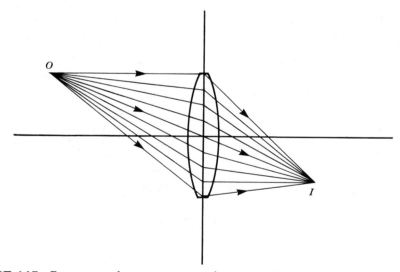

FIGURE 4.17 Formation of a point image of a point object that is not on the optical axis.

less of the location of the object plane. For example, the shutter of Figure 2.4 is called a ``focal plane'' shutter regardless of where the camera is focused.

If the object is between the positive lens and its focal point, the construction is as shown in Figure 4.19. Note that the rays diverge and never actually cross. To form an image that can be photographed, the rays must converge. Light reflected

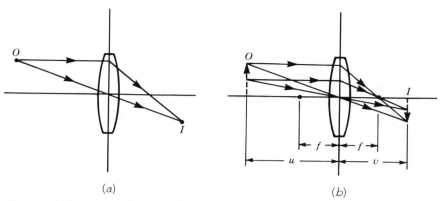

FIGURE 4.18 Ray construction for images of points and extended objects.

from an object is a form of energy and must be concentrated at a point on the film to alter the film and form a permanent image. It is possible to start a fire by focusing the rays of the sun with a magnifying glass on paper or leaves. The focused rays concentrate enough energy in one place to ignite the leaves. Similarly, the film must be altered; set on fire, so to speak, if a permanent image is to be formed. Images in which the rays actually cross are called *real images.*

Images must be real if they are to be recorded on film. The dashed arrow in Figure 4.19 is called a *virtual image.* The position of this image is determined by projecting the rays backward until they cross. Such an image cannot be recorded on film. However, if the object (*O*) is observed through the lens from the right, the image (*I*) appears located as shown. The lens of the eye is forming a real image of the image (*I*) on the retina of the eye.

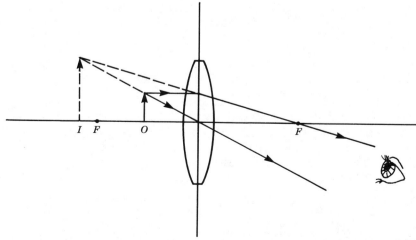

FIGURE 4.19 Ray construction for the image of an object placed between the focal point and the lens.

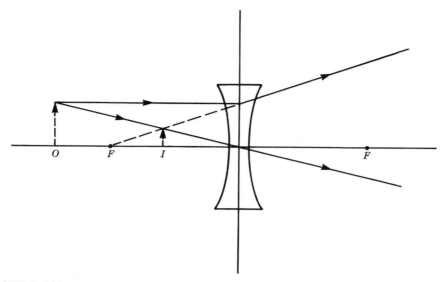

FIGURE 4.20 Formation of the image of an object by a negative lens.

The graphical representation of image formation by a negative lens is shown in Figure 4.20. The ray parallel to the optical axis will diverge at the lens and appear to come from the focal point (*F*) on the left side of the lens. The real rays diverge and the image *I* is always virtual. It follows from these facts that a camera lens must be positive, that it can be used only to form real images of objects placed at distances greater than the focal length of the lens from the lens, and that the images will always be inverted. However, a camera lens is made up of several elements and some of the elements of the lens may be negative.

Although this graphic presentation is illuminating, it is also cumbersome. Once the focal length (*f*) of a thin lens is known, the position of the image of any object can be determined using the relationship

$$\frac{1}{u} + \frac{1}{v} = \frac{1}{f} \qquad (4.10)$$

where *u* is the distance from the object to the lens and *v* is the distance from the image to the lens (see Fig. 4.18*b*). This relationship is applicable to both converging and diverging lenses, but *f* is negative for a diverging lens and positive for a converging lens. Other sign conventions that must be considered in certain cases will be introduced as needed in the discussion.

▶ **Example 4.3**
A lens of 100 mm (= 10 cm) focal length is to be used in a model of a bellows camera which has adjustable focus. Where must the film be placed to form images on the film of objects at the following distances from the lens? Infinity, 10 m, 5 m, 1 m, 20 cm, and 5 cm.

TABLE 4.1 Position of Images (v) for Objects at Selected Distances (u) from a Lens of 10 cm Focal Length

u(cm)	v(cm)
∞	10
1000	10.1
500	10.2
100	11.1
20	20
10	∞
5	−10

From Equation 4.10, we see that if $u = \infty$, $1/v = 1/f$ and the image is formed a focal length from the lens. The film must be placed 10 cm behind the lens. When $u = 10$ m $= 1000$ cm, $1/1000 + 1/v = 1/10$, $1/v = (1/10 - 1/100) = 0.099$, and $v = 10.1$ cm. The rest of the calculations are similar and the results are shown in Table 4.1. The image distance increases as the object distance is reduced and increases more rapidly as the object distance approaches f. Although a real image could be formed of an object 20 cm (about 8 in.) from this lens, the film would have to be moved back 8 in. from the lens, which might not be practical. When the object is at the focal point, the image would be at infinity (i.e., the rays would not converge in any finite distance). The negative result for an object 5 cm from the lens implies that the image is virtual and on the same side of the lens as the object shown in Figure 4.19. As the object distance approaches the focal length, the image distance becomes very large, and focused images of such objects cannot be formed on the film because of mechanical limitations of the camera.

Although the majority of camera lenses are refractive, certain long focal length lenses use concave mirrors for image formation. It can be shown that the focal length of a spherical concave mirror is equal to half its radius of curvature and that object and image distances satisfy Equation 4.10 provided the mirror is not too large.

■ THICK LENSES

The treatment of the thin lens may sound convincing, but a quick look at modern camera lenses reveals that they are not very thin and in most instances are made of several pieces of glass. How can a lens of two or more elements be made to fit into the thin lens formulation? It is possible to treat the image formed by one lens as the object for a second lens and use Equation 4.10 repeatedly to locate the position of the image, but this is cumbersome. It is also possible to use the law of refraction (Eq. 4.3) repeatedly to locate the image of an object, but this is even

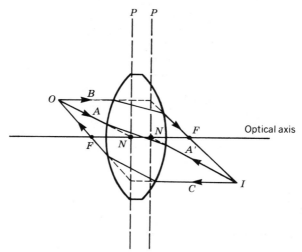

FIGURE 4.21 Thick lens representation for a single thick lens.

more cumbersome. If the focal length of each of two lenses is known, the focal length of the combination can be determined mathematically using the relationship

$$f = \frac{f_1 f_2}{f_1 + f_2 - s} \qquad (4.11)$$

where f is the focal length of the combination, f_1 and f_2 are the focal lengths of the two lenses, and s is the spacing between the two. This is no longer a thin lens, however, and the location of the simplifying plane of Figure 4.16 must be determined.

The thin lens concept is a simplification of a more complex and inclusive concept called the *thick lens* formulation. Consider a spherical lens of nonnegligible thickness (see Fig. 4.21). Its image forming characteristics can be described in terms of two focal points, two *principal planes,* an optical axis, and two *nodal points.* Strictly speaking, these points should be called *principal points,* but the principal points and the nodal points coincide if the lens is immersed in a single substance. The optical center, although not necessary for describing the behavior of the lens, is a helpful concept for understanding the formulation. The discussion here is limited to a situation in which the lens is immersed in a single substance (air). For a more complete treatment see Morgan.[1]

The two principal planes (P) that are perpendicular to the optical axis intersect it at the nodal points (N). It is a property of the nodal points that any ray directed toward one nodal point from outside the lens will emerge from the other side of the lens parallel to the incident ray and directed from the other nodal point (see Fig. 4.21—rays A and reversed A'). The actual path of the ray is such that it is refracted at the first surface, passes through the optical center on the optical axis,

[1] *J. Morgan, Introduction to Geometric and Physical Optics,* New York: McGraw-Hill, 1953, p. 57ff.

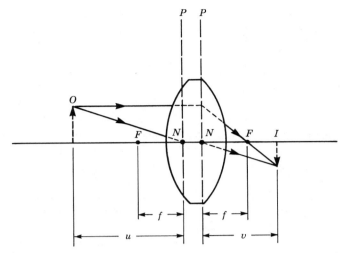

FIGURE 4.22 Image formation of an object at a finite distance for a thick lens.

and is refracted again at the second surface. All rays directed toward a nodal point pass through this optical center. Any incident ray parallel to the optical axis (ray *B*) will be refracted at surfaces one and two and pass through the focal point (*F*). However, its path will be such that it can be described as passing undeviated to the second principal plane and bent sharply at that plane to pass through the focal point. A property of the nodal points, principal plans, and focal points is that the results will be the same if the rays pass from right to left (see ray *C* and a ray *A'*). Hence, the image forming characteristics of the lens are symmetrical with respect to the principal planes and focal points.

A single focal length, *f* (the distance between the appropriate focal point and nodal point) can be assigned to the lens. Its image forming characteristics can be determined graphically (see Fig. 4.22) and mathematically using Equation. 4.10, where *u* and *v* are object and image distances measured from appropriate principal planes (see Fig. 4.22). If the thick lens is symmetrical, the principal planes will be located symmetrically. In general, this will not be the case, and in some cases the principal planes will be outside the lens. In certain instances the principal planes can be reversed but this is not very common.[2] The principal planes of a lens can be located experimentally by observing visually the path of incident rays parallel to the optical axis or by rotating the lens about one of the nodal points.[3]

In general, any number of discrete lenses (e.g., elements of a photographic lens) can be represented by an equivalent thick lens having the characteristics ascribed to it in the thick lens formulation (i.e., two principal planes intersecting the optical axis at the nodal points and two focal points located a focal length from the appro-

[2]Morgan, p. 62.
[3]Morgan, p. 69.

priate principal planes). It is this feature that makes the thick lens formulation so important in describing the behavior of photographic lenses. This is why a collection of relatively thin lenses can be assigned a single focal length.

■ COMPOUND LENSES

Sometimes more than one element is used in a camera lens to solve a mechanical problem. A classic example is the telephoto lens. In its simplest form a converging lens is located in front of a diverging lens (see Fig. 4.23). If the lenses have the proper focal lengths and are properly spaced, it is possible to make a lens system in which the back principal plane is in front of the lens. Because the focal length is measured from the principal plane, the physical length of the lens can be made less than its focal length, and the lens will be more compact. The lens also will be lighter and more maneuverable. Unfortunately, the term telephoto lens has come to mean any relatively long focal length lens for a given format. For example, any lens of more than 100 mm focal length used with a 35 mm camera is often referred to as a telephoto lens. This may or may not be a true telephoto lens depending on its basic design. A more appropriate term would be *long focus lens*. The term *retrofocus lens* is used to describe a lens in which a negative lens is placed in front of a positive lens (see Fig. 4.24). If the lenses are of the proper focal lengths and are properly spaced, the back principal plane can be behind the lens system. Such a design is especially useful for wide-angle lenses intended for small format single-lens reflex cameras. A typical 35 mm SLR wide-angle lens has a focal length of about 30 mm. If the back principal plane is located inside the lens system, the space behind the lens and in front of the focal point of the lens is less than 30 mm. If the lens is designed as a retrofocus lens, the focal length is measured from the nodal point behind the lens, and more working space is available in which to place a mirror, a shutter, and other necessary mechanical parts of the camera.

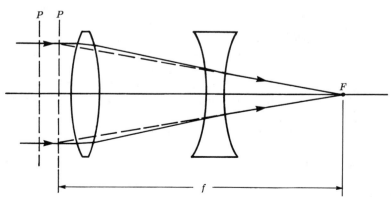

FIGURE 4.23 Basic design of a telephoto lens.

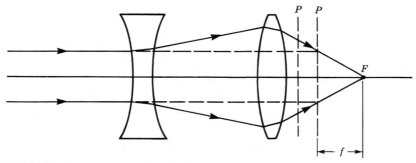

FIGURE 4.24 Basic design of a retrofocus lens.

▶ **Example 4.4**

I have a 500 mm focal length telephoto lens that I use with my 35 mm SLR camera. The front element has a focal length of 450 mm, the back element has a focal length of −700 mm, and the two elements are placed 380 mm apart. Determine the position of the principal planes of this lens.

If we can find the position of the image of an infinitely distant object, we will have located the focal plane and focal point. By measuring 500 mm back from that point, we will have located one principal plane. From Figure 4.25, we see that the front element would form an image of an object at infinity at O, 450 mm behind the lens. However, the rays are intercepted by the negative lens and diverge so that the image is formed at I. The image at O can be considered a virtual object for the negative lens. The object distance u becomes $380 − 450 = −70$ mm. Substituting in Equation 4.10 we find $−1/70 + 1/v = −1/700$ and $v = 78$ mm. Hence, the principal plane is located $500 − 78 − 380 = 42$ mm in front of the front element.

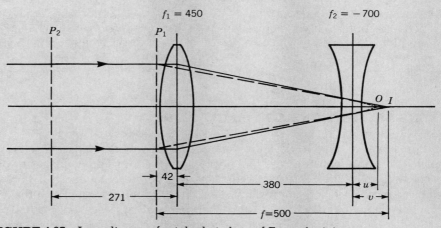

FIGURE 4.25 Lens diagram for telephoto lens of Example 4.4.

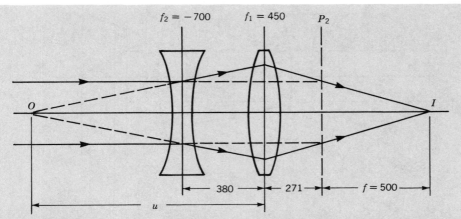

FIGURE 4.26 Lens diagram for lens of Example 4.4 when viewed as a retrofocus lens.

To find the other principal plane, turn the lens around, find the position of the image of an infinitely distant object, and locate the second principal plane (see Fig. 4.26). Considered in this way the lens becomes a retrofocus lens. In this case, the negative lens forms a virtual image 700 mm to the left of the lens. This image becomes a real object for the convex lens located u = 700 + 380 = 1080 mm to the left of the positive lens. Using Equation 4.10 we find $1/1080 + 1/v = 1/450$ and $v = 771$ mm. The principal plane, in this case, must be located 500 mm in front of the image plane or 771 − 500 = 271 mm to the right of the positive lens. Hence, both principal planes lie outside the lens system on the positive lens side of the system. Their relative position is shown in Figure 4.25. The dashed lines show the ray paths for the thick lens formulation in which the rays are visualized as being refracted at the principal planes. Practically speaking, this is a lens of long focal length for a 35 mm format camera. Turning it around makes it a retrofocus lens but not a wide-angle lens for this format. To make a wide-angle lens the simple lenses have to be of different focal lengths and spaced differently.

■ LENS ABERRATIONS AND LIMITATIONS

The representation used to describe the behavior of spherical lenses is somewhat simplified. It is not rigorously true that a spherical lens forms point images of point objects, especially if the lens is of large diameter. The presentation is valid only for rays that are paraxial (i.e., nearly parallel and close to the optical axis of the lens). In practice, camera lenses accept other than *paraxial rays* and hence are subject to a number of aberrations which, if not corrected, will yield images unsuitable for photography. In simple lenses these aberrations all will be present at the same time

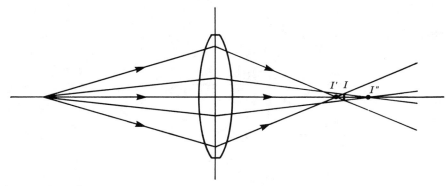

FIGURE 4.27 Spherical aberration in a simple positive lens.

in varying degrees. However, in discussing them, each aberration will be considered as if all others were absent. In each case the behavior of a simple double convex positive lens will be used to demonstrate and describe the aberration. For a more complete discussion, see Morgan.[4]

Careful observation of the image formed by a simple positive lens of a point object on the optical axis discloses that the image is not a point but a blur. If the rays are carefully traced through the lens using the law of refraction, the peripheral rays are found to be bent more than the paraxial rays (see Fig. 4.27). If the image *I'* is observed, the peripheral rays are in focus, but the paraxial rays blur the image. If *I"* is observed, the reverse is true. The best image (smallest diameter) occurs at *I,* and the resulting image is a circle called the *circle of least confusion,* shown as a vertical line in this cross-sectional drawing. This is called *spherical aberration.*

A related aberration called *coma* occurs in the imaging of a point object not on the optical axis. If the rays that lie in the plane of the optical axis and the object *O* (see Fig. 4.28*a*), are traced accurately, the best image of the object is found to be a line and not a point. All the rays incident on the periphery of the lens (numbered 3 in the figure) form a circular image in a plane perpendicular to the optical axis (labeled 3 in Fig. 4.28*b*). The rays incident on the lens in a circle of smaller diameter form a smaller circular image centered about a different point in the plane (see 2 in Fig. 4.28*a* and *b*). The overall effect of these rays is to form an image as shown in the figure. The image looks like the head of a comet, which is called the coma by astronomers. As the point object *O* is moved toward the optical axis, the coma becomes shorter and degenerates into a circle when *O* is on the optical axis.

Astigmatism is another aberration of the image of a point object which is off the optical axis. Comparison of the focusing of the rays lying in the plane determined by the object and the optical axis with the focusing of the rays in the perpendicular plane containing the optical axis (see Fig. 4.29) shows that they do not form a point image at the same distance from the lens. The rays in the plane containing the object point *O* focus at *A* and those in the perpendicular plane focus at *B*. The image formed at *A* is a horizontal line because the rays in the perpendicular plane

[4]Morgan, p. 85ff.

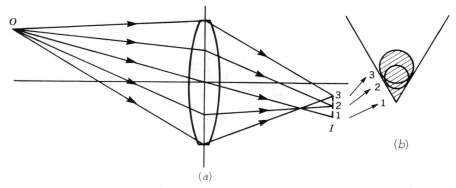

FIGURE 4.28 Coma in a simple spherical lens: (*a*) image formed in the plane of the point object and optical axis and (*b*) the image formed by the entire lens.

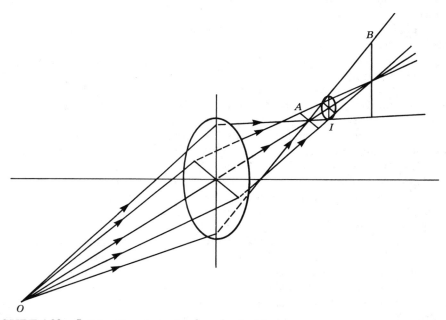

FIGURE 4.29 Astigmatism in a simple spherical lens.

have not converged. The image at *B* is a vertical line because the rays in the plane containing the object have converged at *A* and are diverging at *B*. If the entire bundle of rays is considered, the emerging bundle is elliptical in cross section and degenerates into lines at *A* and *B*. The lines are shown as straight, but this is only approximately true. Somewhere between *A* and *B* (*I*) the bundle is reduced to the circle of least confusion, which represents the best image of the object.

This aberration should not be confused with the eye defect called astigmatism. In the case of the astigmatic eye, the cornea is not a spherical surface but has

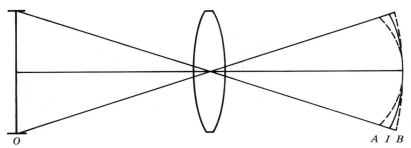

FIGURE 4.30 Cross section of the image of a plane object showing curvature of field.

different radii of curvature in different planes containing the optical axis of the eye. Any lens having such a characteristic is called an astigmatic lens and hence the term "astigmatism of the eye." Such a lens can be approximated as a combination of a spherical lens and a cylindrical lens. The two astigmatisms do not result in the same image distortion. For instance, if a person with an astigmatic eye looks at a spoked wheel along the axis of the wheel, one pair of radially opposite spokes will appear in sharper focus than all the others. If the simple spherical lens of Figure 4.29 is used to form an image of this same spoked wheel, all of the spokes will be in focus at *B* and the rim will be in focus at *A*.

The image of a plane surface that is perpendicular to the optical axis of a simple spherical lens is not a plane but a curved surface. This aberration is called *curvature of field* (see Fig. 4.30). The surface may be curved toward the lens or away from it depending on the design of the lens. If the plane is observed point by point as is done for one point in Figure 4.29, it is discovered that the astigmatic line images fall on curved surfaces on either side of the best image of the plane (shown as dotted lines in cross section in Fig. 4.30). The circles of least confusion lie on the image plane which is shown as a solid line in Figure 4.30.

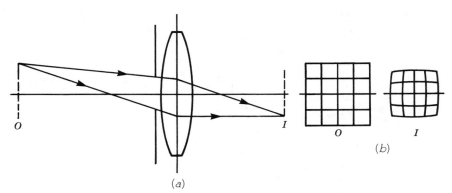

FIGURE 4.31 Barrel distortion in cross section (*a*) and showing the object and image planes (*b*).

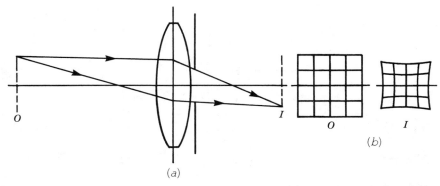

FIGURE 4.32 Pincushion distortion in cross section (*a*) and showing the object and image plane (*b*).

If an iris is placed in front of a simple spherical lens, and a square lattice is used as an object, the image will not be square but barrel shaped (see Fig. 4.31). As the iris is moved closer to the lens, the distortion (*barrel distortion*) is reduced. If the iris is placed behind the lens, *pincushion distortion* will occur (see Fig. 4.32). The image resembles the projection of a square array on a spherical surface such as a pincushion and hence the name. In each case, various parts of the object are being enlarged differently. The enlargement is greatest at the center for barrel distortion and greatest at the perimeter for pincushion distortion. The two cases are different, because various parts of the lens surfaces are used in different order in forming the images (see Figs. 4.31*a* and 4.32*a*).

Thus far, it has been assumed that the light is *monochromatic* (light on one frequency). Because the index of refraction of light depends on the frequency of the light, and because the focal length of a lens depends on the index of refraction, Equation 4.10 indicates that image position depends on frequency. In general, because violet light is bent more than red light in passing through a positive lens, the image of a violet point object is formed closer to the lens (see Fig. 4.33) than that of a red point object. This is an example of *longitudinal chromatic aberration.*

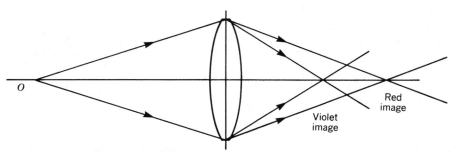

FIGURE 4.33 Longitudinal chromatic aberration in a positive lens.

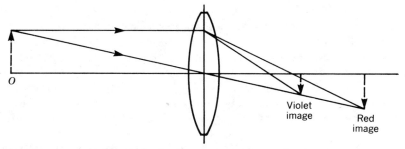

FIGURE 4.34 Lateral chromatic aberration in a positive lens.

Construction of the images of an extended object using the ray construction of Figure 4.18 shows that the violet image will be smaller than the red image (see Fig. 4.34). This difference in image size is an example of *lateral chromatic aberration*. In the construction the red and violet undeviated rays through the center of the lens are coincident, and the rays parallel to the optical axis reflect the fact that the focal length of the lens is shorter for violet light than for red light.

Although not strictly an aberration, reflection at the surfaces of lens elements can cause a great deal of difficulty in camera lenses. This is illustrated in Figure 4.35 for a simple positive lens. A ray incident on the lens is partially reflected and refracted at 1 and at each of the other numbered points on the lens. The light reflected at 1 and refracted at 3 and 5 reduces the brightness of the image. The light refracted at 4 and 6 may become part of the image, degrading it, because these rays will not be coincident at the image plane with the ray from 2. In a camera, some of this stray light also may be reflected from the internal surfaces of the camera, further degrading the image. In photography, the entire phenomenon is called *flare*.

If a parallel beam of light passes through a small aperture, an image of the aperture is expected to be seen on a screen that intercepts the transmitted beam. However, if the hole is small enough, in addition to the illuminated spot, a set of concentric illuminated rings is seen (see Fig. 4.36). This phenomenon is called

FIGURE 4.35 Internal and external reflection of light at the surfaces of a lens.

diffraction and becomes objectionable in photography if the aperture of the camera is too small. The net effect is to degrade the quality of the image at the film plane, because the rings do not contribute to the main part of the image but interfere with other parts of the image. The cause of the phenomenon can be explained using the wave model. Consider water waves that move past a post in otherwise still water (see Fig. 4.37). It appears that the action of the incident wave on the post is to generate new circular waves whose origin is at the post. These waves interfere with incident waves and give rise to a quasi-herringbone pattern with regularly spaced valleys and peaks. In some places the waves add, and in other places they cancel. In the case of light passing through a small aperture, the perimeter of the aperture acts much like the post, and the resulting interference pattern appears at the image plane as in Figure 4.36b. A mathematical treatment of the problem shows that the diameters of the rings are approximately proportional to the distance between the hole and the viewing screen and inversely proportional to the diameter of the hole. Hence, the diameter of the rings will be proportional to the f-number setting of the iris of the camera.

■ CORRECTION OF LENS ABERRATIONS AND DISTORTIONS

In successful modern photography, the lens limitations discussed in the last section cannot be ignored. In particular, the small format camera will not perform satisfactorily because considerable enlargement of the negative is necessary for satisfactory viewing of the final print. If these limitations are not reduced or eliminated, acceptable photographs of many subjects cannot be made. The angle of view (see Chapter 5) and the resolution of detail will be limited and the tonal range degraded. In addition, the size of lens opening will be limited and hence, many minimally illuminated subjects cannot be recorded.

Aberrations were described as they would look if a double convex lens was used to form the images. If the shapes of the lens surfaces are changed, however, the details of the aberrations can be changed. Altering the position and/or size of apertures can modify the aberrations and reduce diffraction. Some aberrations can be reduced by using glasses of different indices of refraction and dispersion

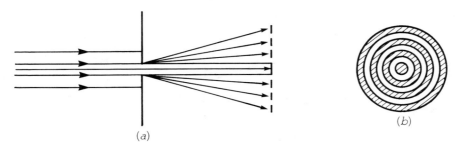

(a)

(b)

FIGURE 4.36 Diffraction of light by a pinhole (a) in cross section and (b) in the plane of the image.

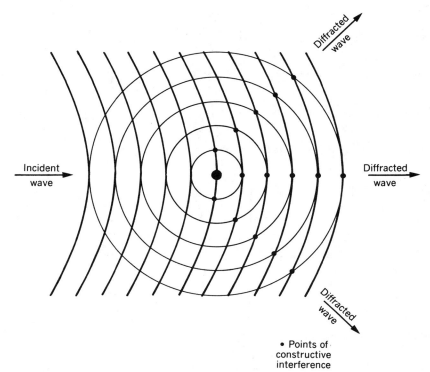

FIGURE 4.37 Interference of incident and diffracted water waves.

and/or by altering the positions of the lens elements. The thickness of a lens can affect some aberrations. Thin coatings of transparent material deposited on the surface of a lens can in some measure control reflection at the lens surfaces. In general, none of these lens limitations can be corrected totally, but they can be reduced to permit more flexibility in photography.

For example, coma and spherical aberration can be reduced by altering the shape and the indices of refraction of the lens elements. Astigmatism and curvature of field can be reduced by proper choice of the shape of the lens elements and proper positioning of the aperture stops. Chromatic aberration can be reduced by using two elements made of glasses of different dispersion and/or properly spacing the lens elements. Distortion can be reduced by using lenses of symmetric design. Most of the improvement in lens quality is a result of the mathematical study of lens behavior. Lenses are also modeled and general conditions for reducing aberrations studied. Ray tracing may be used with model lenses to study lens performance.

This discussion of the development of lenses will not be encyclopedic but mentions only some of the more important lenses. Systematic lens development probably started about 1812 when Wollaston developed the meniscus lens (see Fig. 4.38) for use with the camera obscura. The arrow indicates the direction that light travels from object to image. In 1840, Chevalier adapted the *achromat* to early

FIGURE 4.38 Simple meniscus lens of Wallaston.

FIGURE 4.39 Achromat of Chevalier.

FIGURE 4.40 Petzval portrait lens.

cameras. This lens consisted of two elements of differing dispersions cemented together (see Fig. 4.39) and was corrected for chromatic aberration at specified frequencies. It could be used at an aperture of about f/16. Today, the term achromat is used to describe a lens that has been corrected for chromatic aberration at two frequencies. An *apochromat* is a lens that has been corrected for chromatic aberration at three frequencies.

In 1840, Petzval developed a multiple element lens (see Fig. 4.40) that was sufficiently corrected for spherical aberration, coma, and chromatic aberration to be used at f/3.5, provided the angle of view was not too large. This Petzval portrait

lens was not suitable for landscape photography because it was subject to considerable astigmatism and curvature of field.

In 1866, Dallmeyer in England and Steinheil in Germany combined two achromatic meniscus lenses (see Fig. 4.41) to form a symmetric lens that corrected all the aberrations and distortion sufficiently so that it could be used a f/8 with an angle of view as large as 50°. The English lens was called a *rapid rectilinear* and the German lens an *aplanat*. The term aplanat as used technically today means a lens that is corrected for spherical aberration and coma. Some of these lenses were constructed with a removable front element and were called convertible lenses. With one element removed, the lens had approximately twice the focal length and f-number of the entire lens.

Note that as the development of lenses progresses, more surfaces and different kinds of glass are used to improve the optical performance. Until 1886, the choice of glass was limited to crown and flint glass. In that year in Jena, Germany, at the Schott glass works, several new glasses of different indices of refraction and dispersion were developed, opening new vistas for lens design.

In 1893, using some of these new glasses, Taylor developed an asymmetrical lens of three elements which was named a *Cooke triplet* (see Fig. 4.42). Corrected for astigmatism and curvature of field, this lens is one of a number called *anastigmats*. The Cooke triplet was deisgned to operate at apertures as large as f/4. Technically, an anastigmat is a lens that is totally free of astigmatism for one object dis-

FIGURE 4.41 Rapid rectilinear or aplanatic lens.

FIGURE 4.42 Cooke triplett lens.

tance and subject to minimal curvature of field. However, the lens usually performs quite well at other object distances.

In 1902, the firm of Carl Zeiss developed the *Tessar* lens (see Fig. 4.43) which had a cemented rear element. Variations of this lens are used today at apertures as large as f/2.8.

Another historically significant standard lens was the *Zeiss Planar* lens designed by Rudolph in 1896 (see Fig. 4.44). This symmetrical lens was designed to be used at f-numbers as small as f/3.5 and is the ancestor of many modern standard lenses used on small format cameras. These modern lenses operate at f-numbers as small as f/1.4.

The details of these developments are too complex to trace here, but four innovations are worth noting. In 1934, the first *rare earth glasses* were developed. These had higher indices of refraction than any before them and offered more freedom in lens design. The development of digital computers during World War II made it possible to consider more complex lens designs starting about 1950. The space missions of the 1960s required better lenses and provided funds for the design of new, more sophisticated optical systems which then spun off into the

FIGURE 4.43 Zeiss Tessar lens.

FIGURE 4.44 Zeiss Planar lens.

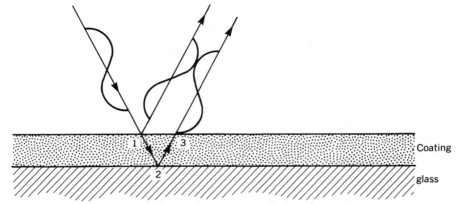

FIGURE 4.45 Interference of light from two parallel surfaces.

consumer field. Recently, improved technology and increased computing capabil-
ity have made it possible to consider other than spherical lens surfaces. These new
lenses, called *aspheric lenses,* usually are made by laminating an organic plastic and
glass to make a lens. They are used to reduce the number of elements and to
improve the optical speed of lenses without reducing optical performance.

 As elements are added to a lens system, flare becomes a more severe problem.
If a lens surface is *coated* with a material of appropriate thickness and smaller index
of refraction than the glass, the surface reflection can be reduced. This happens
because the light reflected from the two interfaces destructively interferes, causing
no light to be reflected. If the reflected light from the two surfaces is considered
from a wave point of view (see Fig. 4.45), it is seen that the phase of the two
reflected waves is shifted relative to each other. If the optical path in the coating
(1-2-3) is exactly equal to one-half the wavelength of the light in the medium, the
two reflected rays are shifted in phase by 180°, canceling each other, and no light
is reflected. The above condition can be satisfied only for one wavelength, but
considerable reduction in the amount of reflected light occurs at adjacent wave-
lengths. If several coatings of different indices of refraction are used, surface reflec-
tion can be reduced considerably over most of the visible part of the optical spec-
trum. Lenses so coated are designated as *multicoated.* Commercial camera lenses
have been coated since about 1950, and multicoating has been practiced com-
mercially since about 1970.

 The development of the long focus and wide-angle lens has not been discussed.
For the small format camera, these lenses are usually telephoto in the former case
and retrofocus in the latter instance. Some long focus lenses incorporate spherical
mirrors to reduce the overall length of the lens (see Fig. 4.46). The light enters the
lens in an annular fashion and is reflected by at least two mirrors before coming to
focus on the film plane. Because the light enters at the perimeter, an iris cannot be
used to reduce the aperture, and *filters* must be used to control the image illumi-
nance. Because spherical mirrors are subject to considerable spherical aberration,
a special aspheric lens called a Schmidt corrector plate is usually incorporated in

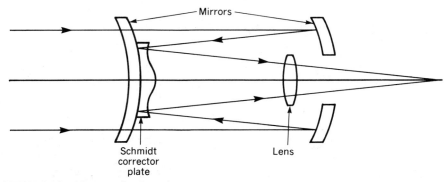

FIGURE 4.46 Mirror telephoto lens.

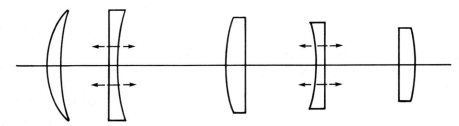

FIGURE 4.47 Schematic of a variable focal length lens.

the lens to correct this aberration. Spherical lenses may also be included to aid in focusing the light.

Lenses of variable focal length are becoming increasingly common as lens technology improves. In such lenses, different elements are moved relative to each other to change the focal length (see Fig. 4.47). The lens is focused by moving the entire lens assemby with respect to the camera body. Focal length is changed by moving the elements with respect to each other as indicated by the dashed arrows in the figure. In a *zoom lens,* more than one element is moved as the focal length is changed so that the chosen object remains in focus as the focal length is varied. The optical quality and speed of zoom lenses have improved considerably in the past few years. Although not as fast as the standard lens (for comparable optical quality), good zoom lenses capable of operating at f/3.5 are available. They are, however, more complicated, more expensive, and heavier than standard lenses of comparable focal length.

In choosing lenses, it is very important to know how they will be used. With so much emphasis on optical speed, there is a tendency to consider lenses with large aperture as better. Unless an f-number of 1.4 is needed, a lens of comparable cost designed to operate with a minimum f-number of 2 probably will perform better. If a fixed focal length lens will suffice, there is no point in using a zoom lens if both are available. The wise buyer of lenses tries to anticipate the kind of photography he/she is going to do and chooses lenses accordingly.

Most lenses do not form their sharpest images either totally open or totally stopped down but at some intermediate aperture. Diffraction usually limits performance when the lens is stopped down, and the various spherically related aberrations limit performance when the lens is totally open. Consequently, the lens should be used at an intermediate aperture if some other parameter does not require use of the lens in either extreme condition. However, a lens may have to be stopped down for increased depth of field or opened up to get a brighter image.

Much could be written about lens testing. The criteria for quality are similar to those used to evaluate film performance. Because most well-corrected lenses perform better than film, most lens testing is done using photodetectors or by visually examining lens performance. The criteria for good image formation are discussed in Chapter 8, where film performance is discussed. This latter factor usually is more critical, especially for the small format camera user. The best measure of lens performance for the working photographer is the quality of work that the instrument delivers when used for what it is intended — making pictures.

EXERCISES

4.1. Draw a diagram showing how light is refracted when it passes through an air-glass interface going from air to glass. If the glass has an index of refraction of 1.5 and if the angle of incidence is 45°, find the angle of refraction.

4.2. If the wavelength of violet light in a vacuum is 400 nanometers, what is its frequency? What are the wavelength and frequency of this light if it is transmitted through glass?

4.3. Organize the following kinds of electromagnetic waves in order of increased wavelength: x-rays, light, gamma rays, infrared, ultraviolet, radio, microwave.

4.4. Which of the following images can be photographed?
 (a) The image of an object placed twice the focal length from a convex lens.
 (b) The image of an object placed half the focal length from a convex lens.
 (c) The image of an object placed twice the focal length from a concave lens.

4.5. If a 50 mm convex lens is used to photograph an object placed 100 mm from the lens, where is the image formed?

4.6. Using graph paper, construct a ray diagram locating the image of an object placed 200 mm in front of a positive lens of 50 mm focal length.

4.7. Draw a diagram showing how image position is determined using the thick lens formulation for a positive lens.

4.8. Discuss the limitations of optical image quality imposed by a simple spherical lens.

4.9. Design a lens that totally corrects for barrel and pincushion distortion.

4.10. Show graphically how the useful optical speed of lenses increased with the evolution in time of the lens. Discuss the implications of your graph.

chapter ·5·

Photographic applications of optics

■ MAGNIFICATION

Now that something of the "how" and "why" of lenses has been explained, this knowledge will be applied to some problems that occur in photography. In certain photographic situations it is helpful to know in advance the size of the image formed by a particular camera lens. A convenient number to use in discussing image size is the *linear magnification* (*m*), defined as

$$m = \frac{i}{o} \tag{5.1}$$

where *i* is the height of the image and *o* is the height of the object. The *area magnification* is the square of the linear magnification. In this text the term *magnification* means linear magnification.

It is convenient to express the magnification in terms of focal length and object distance, because these numbers are readily available to the photographer working in the field. From Figure 5.1

$$m = \frac{i}{o} = \frac{v}{u} \tag{5.2}$$

(note the similar triangles). Because

$$\frac{1}{u} + \frac{1}{v} = \frac{1}{f}$$

v can be expressed as a function of *u* and *f*. If this is done, then

$$m = \frac{f}{u - f} \tag{5.3}$$

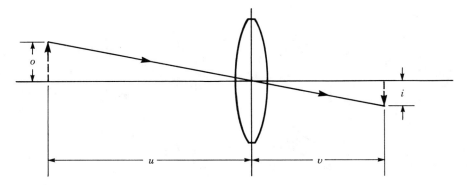

FIGURE 5.1 Object and image relationship for a simple lens.

If the object distance is large compared with f, then

$$m \simeq \frac{f}{u} \tag{5.4}$$

This last relation is satisfactory for estimating image sizes in all cases except *macro-photography* (the photography of small objects), where m is approximately one.

▶ **Example 5.1**

Assume that you are planning a trip to a nearby museum to photograph some sculpture using a 35 mm camera. It would be helpful to know in advance which lens would provide a full frame image and a convenient working distance, because this has to be done on Sunday when museums are crowded. Among the works is a copy of Rodin's *Balzac* which is about 3 m tall. Because a 35 mm camera has a 24 mm × 36 mm (1 in. by 1½ in.) format, the maximum magnification that can be used is

$$m = \frac{36 \text{ mm}}{3 \text{ m}} = \frac{3.6 \text{ cm}}{300 \text{ cm}} = 0.012$$

Hence, the ratio of object distance to focal length must be

$$\frac{f}{u} < 0.012$$

For a 50 mm lens, we find

$$u = \frac{50 \text{ mm}}{0.012} = 4.2 \text{ m}$$

This is almost 14 ft and although not prohibitive, care and tact must be used or some unpleasantness may develop. Note that in this example neglecting f in the denominator introduces an error of about 1 percent.

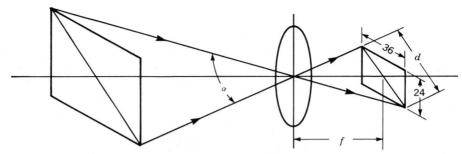

FIGURE 5.2 Relation between angle of view and frame size.

■ ANGLE OF VIEW

That part of a scene that can be recorded on film by a camera is called the field of view. It is sometimes convenient to express the field of view in terms of the angle of view (α). This is particularly useful when working with distant objects, such as landscapes.

The angle of view in photography is defined as the angle subtended at the lens by the diagonal of a distant scene that fills the frame of the camera. This is illustrated in Figure 5.2 for the 35 mm format camera. Practically speaking, a photographer often is more interested in the vertical or horizontal angle of view, because these are usually the relevant dimensions in a photograph. Nonetheless, much like television manufacturers, lens manufacturers persist in quoting this diagonal measurement as if big is always better. Typical values for some standard 35 mm format lenses are shown in Table 5.1.

The angle of view of a lens can be computed from the focal length (f) of the lens and the diagonal measurement of the film (d) using trigonometry (i.e., tan $\alpha/2 = d/2f$ — see Fig. 5.2). The vertical (α_V) and horizontal (α_H) angles of view can be calculated in a similar way using the height or width of the frame instead of the diagonal length. The diagonal for the 24 x 36 mm format is about 43 mm. For a 55 mm lens this yields

$$\alpha_V = 24° \quad \text{and} \quad \alpha_H = 36°$$

The angle of view is approximately inversely proportional to the focal length of a lens. If it is remembered that the standard 35 mm camera lens has an angle of

TABLE 5.1 Angle of View for Selected
35 mm Camera Lenses

Focal Length	Angle of View
28 mm	75°
55 mm	43°
105 mm	23°
200 mm	12°

view of about 45°, then the angle of view of any other lens can be found using this proportionality. Table 5.1 shows that this relation is confirmed, more or less, with better agreement occurring for lenses of long focal length. The angle of view is reduced as the camera is focused on nearer objects, because the film must be placed farther from the lens to obtain a sharp image. The reduction is not very great, except when focusing on nearby objects, as in macrophotography.

The so-called standard lens is one for which the focal length is approximately equal to the diagonal of the frame. Such a lens has a 53° angle of view. The typical 35 mm SLR camera uses a standard lens having a slightly longer focal length and hence, a somewhat reduced angle of view. This is a consequence of a compromise between optical speed and mechanical design.

■ ANGLE OF ILLUMINATION

Thus far it has been assumed that angle of view is determined by frame size and focal length, but this is not always the case. If an idealized thin lens is considered (something like the old meniscus lens that was used in early cameras), the field of view seems to be limited by the size of the film put behind it. Its angle of view conceivably could approach 180°. As soon as a lens of several elements of finite size separated in space (a thick lens) is considered, the maximum allowable angle of view is reduced because some obliquely incident rays on the front element do not strike the second lens (note ray 3 in Fig. 5.3). This maximum allowable angle of view (the angle between rays 1 and 2 in Fig. 5.3) is called the *angle of illumination* and labeled β in Figure 5.3.

If the angle of view of a lens is larger than the angle of illumination, the corners of the frame will not be illuminated, and the picture is said to be *vignetted*. Properly designed lens should not vignette to any significant extent.

In Figure 5.4 the angle of view (α) is determined by the frame size, but the angle of illumination (β) must be greater than α if the frame is to be operated off axis as sometimes happens with a view camera (see Chapter 2).

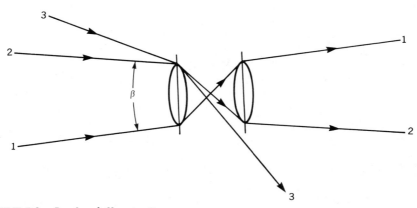

FIGURE 5.3 Angle of illumination.

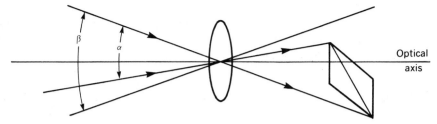

FIGURE 5.4 Relation between angle of view and angle of illumination.

▶ **Example 5.2**

Assume that you have access to a 5 x 5 in. view camera equipped with a standard lens (f = 6.5 in. = 165 mm). This lens has an angle of illumination of 100°. How far can the center of the frame be moved off the optical axis and the lens still be totally illuminated?

Because the standard lens has an angle of view of 53°, 100° − 53° = 47° may be used for offset. This must be divided equally between left and right diagonal offset. Hence, the diagonal offset must be limited to 47°/2 = 23.5°. The allowable diagonal offset when photographing distant objects will be 165 (tan 100°/2 − tan 53°/2) = 144 mm. With just a little geometry you can show that the offset along the 5 in. side of the frame is 5 in. and that along the 4 in. side is about 5.3 in.

■ UNIFORMITY OF ILLUMINATION

It has been implied that the illuminance of an image is the same for the entire field of view. In general, this is not true. In the simplest case of a thin lens, three effects enter to reduce the illumination at the corners of the field compared with the center.

First, the illumination of the film off the optical axis is reduced because the lens is further from the object. This is another instance of the application of the inverse square law (see Chapter 2). As the subject is moved to the periphery of the field of view of a lens, it is in effect, being moved away from the lens. In Figure 5.5, D_1 is clearly greater than D. This part of the effect is proportional to $\cos^2 \theta$.

The second effect is a result of the plane of the aperture of the lens not being perpendicular to the axial ray from L. The effective diameter is reduced to d_1 from d in the plane of the paper. As θ increases, the amount of light passing through the lens decreases in proportion to $\cos \theta$. It may help understand this qualitatively by realizing that the amount of light passing through the lens is zero when $\theta = 90°$. The third effect arises because the film plane is not perpendicular

to the axial ray from L_1. The image of the rays formed by a point light source (like a miniature Christmas tree light) before they come to focus (in the plane F' of Fig. 5.5) form a circle for the rays from the light L on the optical axis of the lens. The image (I'_1) for L_1 will be an ellipse with the dimension of the ellipse (S_1) in the plane of the figure being longer than the diameter (S) of the beam of light at I'_1. The dimension perpendicular to the plane of the figure will be equal to the diameter of the beam of light. The energy of the Christmas tree light is being spread over a larger area. The same thing happens at the film plane F (images I and I_1), resulting in an effect that is proportional to $\cos \theta$.

The overall effect is to reduce the off-axis image illumination in proportion to $\cos^4 \theta$. Modern camera lenses, however, do not show significant darkening at the perimeter of the image, because special precautions are taken to eliminate this problem. It might be expected that wide-angle lenses, in particular, would show considerable darkening at the edges. Such is not often the case. These lenses are usually of retrofocus design and constructed to minimize this problem. For instance, if a 28 mm lens is used on a 35 mm SLR camera to photograph a uniformly illuminated surface, the illuminance at the corners should be less than half that at the center. This implies one stop less exposure at the corners compared to the center. The print of a negative so exposed should show considerable darkening at the corners; that such is not the case can be seen from Figure 5.6. The subject

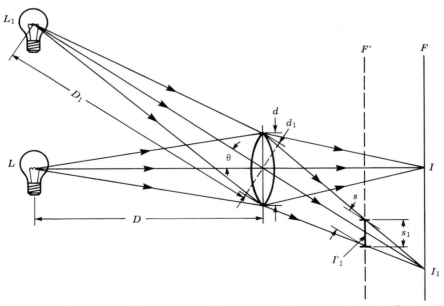

FIGURE 5.5 Reduction of illumination of the image of objects positioned off the optical axis.

FIGURE 5.6 Photograph of a uniformly illuminated subject using a modern wide-angle lens (ENM, 1983)

(open sky) was of uniform luminance within plus or minus one-sixth stop. No darkening at the corners is evident.

When a photographer uses a view camera in which the optical axis of the lens does not necessarily pass through the center of the frame but may be offset, the lens must be so designed that its angle of illumination can accommodate this offset.

■ THE TELEXTENDER

To increase the versatility of a lens with a minimum increase in cost, a *telextender* can be added to the existing lens, thereby increasing the focal length of the system (at the expense of optical speed, of course). For example, a 2X telextender increases the focal length to twice that of the existing lens and increases all f-numbers by a factor of two. Unfortunately, optical quality is sometimes reduced markedly, especially if the telextender has not been designed to mate with a specific lens.

▶ **Example 5.3**
 I have a 2X telextender that I use with a 135 mm f/3.5 telephoto lens. The new
 system has an effective focal length of 270 mm with a minimum f-number of

f/7, and it works rather well. The same telextender used with a 55 mm, f/1.8 lens is not very satisfactory because image sharpness is noticeabley reduced. This telextender is not entirely satisfactory when used with a 550 mm f/6.3 lens, because it vignettes noticeably, although the center of the field is quite satisfactory. When used in this fashion, the lens becomes a lens of 1000 mm focal length with a minimum f-number of f/12.6. Note that although the focal length is doubled, the maximum illumination of the film is reduced by a factor of four.

■ **MACROPHOTOGRAPHY**

Photographing objects whose size is approximately that of the frame size of the camera (magnification is the order of unity) is called *macrophotography*. Such work can be very absorbing and requires very little extra equipment. Pitfalls abound, however, and they need to be recognized.

Suppose that an object is to be photographed so that it will be life-size on the negative. In this case, the magnification (*m*) is one and image distance and object distance must be equal ($v = u$). Using

$$\frac{1}{u} + \frac{1}{v} = \frac{1}{f}$$

it is found that

$$\frac{2}{v} = \frac{1}{f}$$

and $v = u = 2f$. If a lens of 55 mm (2 in.) focal length is used on a 35 mm camera, this means that the object distance will be about 4 in., and the film must be placed an equal distance behind the back principal plane of the lens. The average camera does not provide enough adjustment to allow this placement. Devices are available which can be put between the lens and the body of cameras with removable lenses, so that close focusing can be accomplished. These may be *extension tubes, bellows,* or *reversing rings.* Examples of these items for use with 35 mm SLR cameras are shown in Figure 5.7. A continuous range of magnification up to about two is possible using a standard lens on a 35 mm camera and a nest of four extension tubes (Fig. 7a) of differing lengths. The overall length of the set is about 100 mm.

This continuous range of magnification from the maximum for the camera without tubes (about 0.15) to two can be achieved by using the tubes in suitable combinations. Extension tubes are often constructed so that the automatic stop down feature of the camera is preserved. This is a convenience well worth looking for, especially because the photographer is accustomed to this feature when using the camera in its normal configuration. In situations where greater magnification is needed, a bellows (Fig. 5.7b) can be used, but with a standard lens these usually cannot be used at magnifications of much less than one, because the minimum length of the bellows is about 50 mm (2 in.).

A magnification of about one-half can be achieved using a reversing ring (Fig.

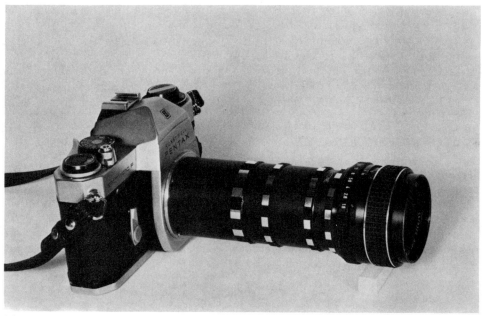

(a)

(b)

FIGURE 5.7 Devices for macrophotography with 35 mm SLR cameras: (a) extension tubes, (b) bellows and reversing ring, (c) reversing ring, (d) 100 mm macro lens. (ENM, 1983)

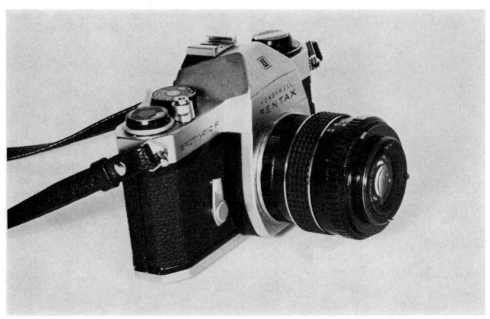

(c)

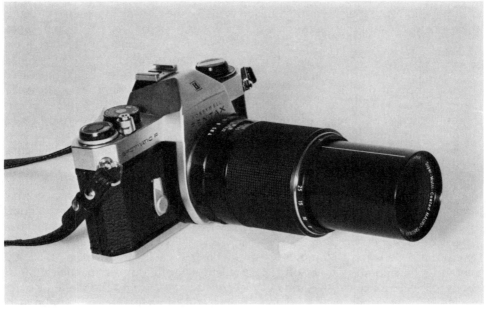

(d)

5.7c) with a standard lens. This ring has male threads on both ends and is so constructed that the lens may be attached to the camera with the front of the lens facing the camera body. Only one magnification is possible, however, and any automatic stop down features will be lost. A reversing ring is able to achieve this magnification (instead of the usual maximum of about 0.15) primarily because of the mechanical and optical asymmetry of the lens. The finite width of the ring also contributes to some of the extension. The normal lens is not designed for close focusing. Reversing the lens for macrophotography frequently will improve the optical performance of the lens (Fig. 5.7b).

It might be expected that other focal length lenses can be used with extension tubes and to an extent this is true. For instance, a 135 mm focal length telephoto lens, when combined with the set of extension tubes mentioned above, yields a maximum magnification of about one. One advantage of this configuration is an increase in working distance, which can be particularly helpful in difficult lighting situations. It might seem from Equation 5.4 that what is gained in working distance is lost in magnification. However, this is precisely the case in which the approximation does not apply and Equation 5.3 must be used in computing magnification. For example, when a 100 mm focal length lens is used at $m = 0.5$, the distance from object to film plane is about 44 cm. This distance is about 27 cm when a 55 mm focal length lens is used at the same magnification.

It might be expected that large magnifications would be achieved with a short focal length (wide-angle) lens. This is possible, but a reversing ring should be used in conjunction with the extension tubes because of the optical asymmetry of wide-angle lenses. Most of these lenses are of retrofocus design with the principal planes located toward the rear of or behind the lens. The combination of short focal length and lens asymmetry makes the working distance from the front of the lens very small. The reversing ring allows more working distance and in some cases improves optical performance. Using the extension tubes mentioned above, a reversing ring, and a 28 mm focal length lens, a maximum magnification of about six can be achieved. The reversing ring combined with the set of extension tubes and a 55 mm focal length lens yields a maximum magnification of about 2.5. A reversing ring is of little use with a true telephoto lens, because the principal planes are toward or in front of the lens.

Special lenses called *macro lenses* (see Fig. 5.7d) can be purchased for doing macrophotography. The most obvious difference between macro and normal lenses is the extended range over which each can be focused. However, a good macro lens is more than a standard lens mounted in a lengthened barrel, because it must be designed optically to work satisfactorily over this extended range. A typical macro lens for a 35 mm SLR camera has a focal length of from 50 to 100 mm and a minimum f-number of 4. Such a lens is useful up to a magnification of about 0.5. Bellows or extension tubes can be added to extend the range of magnification. Recently, lenses that combine macro and zoom features have been marketed. Some perform very well, but they tend to be rather bulky.

In the discussion of macrophotography, reference is sometimes made to the *reduction* of a lens, which is the reciprocal of the magnification ($r = 1/m$). The barrels of macro and macro-zoom lenses are often marked with a series of num-

bers typically ranging from 2 to 25. These numbers indicate the reduction when the lens is focused at the indicated distance.

▶ **Example 5.4**

I have a 100 mm f/4 macro lens which, when focused on an object at a distance of 0.45 m (1.48 ft) from the film plane, indicates a reduction of 2. The same lens when focused on an object which is about 0.63 m (2.05 ft) from the film plane, indicates a reduction of 4. What is the size of the image relative to the size of the object in each of these cases?

In the first case, the magnification is 1/2 so the image is half the size of the object. In the second case, the magnification is 1/4 so the image is one-fourth the size of the object.

The f-number, in the earlier discussion, was considered an accurate measure of the light gathering capability of a lens, provided that the image plane was placed at a distance from the lens comparable to the focal length of the lens. Because this is not the case in macrophotography, some modification is necessary if one is to describe accurately the light gathering capability of the lens. The correction that must be introduced is called the *bellows factor* and the corrected f-number is designated f/*eff* defined as

$$f/eff = \frac{v}{D} \tag{5.5}$$

where D is the diameter of the aperture and v is the image distance. Note that this is a measure of the light gathering capability of the lens for all cases. The f-number is rigorously accurate only for infinite object distances.

Because the magnification (Eqs. 5.2 and 5.3)

$$m = \frac{v}{u} = \frac{f}{u - f}$$

and

$$f/ = \frac{f}{D},$$

these equations together with Equation 5.5 can be solved simultaneously to derive a more useful expression for f/*eff*.[1] The result is

$$f/eff = (m + 1)f/ \tag{5.6}$$

[1]

$$f/eff = \frac{v}{D} = \frac{vf/}{f} = \frac{muf/}{f}$$

but

$$m(u - f) = f$$
$$mu = mf + f$$
$$f/eff = \frac{f(m + 1)f/}{f} = (m + 1)f/$$

The bellows factor is $(m + 1)$ and the net result of forming the image further behind the lens is to increase the f-number by this factor and to reduce the light gathering capability of the lens by a factor of $1/(m + 1)^2$. When using a hand held meter to monitor the incident light on the scene or the light reflected from the scene, a correction in exposure must be made to compensate for this loss in light gathering capability.

▶ **Example 5.5**

Consider the following assignment. You are to make a series of color pictures of flowers. Among these pictures are to be some of small zinnias showing the details of the individual flower. The pictures are to be made in bright sun using extension tubes and a standard lens on a 35 mm SLR camera. What is the proper exposure if the image size is equal to the object size?

To assure that the magnification will be one, compare the image size with the frame size, and adjust the camera position so that the image size equals the object size when the image is in focus. Because the day is bright and the film has an ASA film speed of 64, the needed exposure of the film is 1/60 sec at f/16. Because of bellows extension, however, an f/16 setting on the camera will yield less light than necessary. The effective f-number (f/*eff*) must be 16. Because $m = 1$, using Equation 5.6 you find that the correct camera setting will be f/ = 16/2 = 8. In other words, the camera must be set at f/8 when used at unity magnification to get the same exposure of the film obtained at f/16 when taking a picture of a distant object similarly illuminated.

It should occur to the thoughtful reader that the mathematical complications might be avoided if a through-the-lens (TTL) metering system is used. In some instances this will work, but at least two words of caution are in order. In most cameras utilizing TTL metering, the light sensors are placed to measure the image luminance at the film or some equivalent position. The most common configuration places the sensors so that they detect the luminance of the image at the ground-glass screen under the pentaprism. On such cameras, accuracy will not be altered by using extension tubes. In some cameras, however, the sensors are placed to read the light at the *exit pupil*,[2] and because the exit pupil is moved with the addition of extension tubes, the meter will not necessarily be correct. An 18 percent gray card, the bellows factor equation, and a properly calibrated reflected light meter can be used to verify whether or not a TTL meter can be used reliably in macro work.

A more general problem in macrophotography, however, is that the subject matter tends to be unusual. In many instances, the subject matter is not of average reflectance (18 percent gray). When using reflected light meters in macrophotography, it is good practice to use an 18 percent gray card to determine exposure. Frequently, subjects for macrophotography are uniformly illuminated; therefore, an incident light meter and the bellows factor equation can be used to find the proper exposure with the least trouble.

[2]See Glossary for definition.

As built-in metering systems in SLR cameras have become more sophisticated, especially regarding their capability to meter at full aperture, it has become necessary to provide more coupling levers between the lens and the camera. Unless extension tubes have all of these couplings, the built-in meter may not function properly. In such situations, it is advisable to rely on hand held meters.

To form larger than normal images, *close-up lenses* can be used as an alternative to the macro devices discussed above. Such lenses are placed in front of the regular lens and have positive focal lengths. The focal length of the combination is less than that of the original lens. The back principal plane of the combination is moved forward relative to the back principal plane of the camera lens alone, effectively increasing the image distance (v). Because the position of the film relative to the lens is unchanged, the camera can now focus closer to the lens (u is reduced) and the magnification ($m = v/u$) is increased. The main disadvantage of this approach is a reduction in optical quality, because these lenses usually are relatively simple. They are not well corrected for various aberrations and even if coated, represent two more interfaces in the optical path.

Close-up lenses usually are marked in *diopters* rather than focal lengths. The *dioptic power* of a lens is equal to the reciprocal of the focal length in meters. A convex (positive) lens will be marked in plus diopters, and a concave (negative) lens will be marked in negative diopters. If a lens of +2 diopters is placed in contact with one of +1 diopters, the combination will behave like a single lens of +3 diopters.[3] This additive feature explains the usefulness of this notation. In this illustration a lens of 0.5 meters focal length has been combined with one of 1 meter focal length to make a combination whose focal length is 0.33 meters.

Is the light gathering capability of the lens reduced as a consequence of this modification? Recall that the f-number is equal to the ratio of the focal length of the lens (f) to the diameter of the aperture stop[4] (D). For objects close to the camera the effective f-number is $f/eff = v/D$. In practice, one finds that f/eff is increased when a close-up lens is added because v is increased slightly and D is decreased slightly. For example, the addition of a one diopter (one meter focal length) close-up lens to a typical camera lens of 55 mm focal length increases the f-number about 5 percent when focused on an object about 12 in. from the camera. Such a change results in a decrease in light gathering capability of approximately 10 percent. This is relatively small compared with a half stop reduction in aperture which causes a 30 percent reduction in light gathering capability. When

[3]This rule applies for thin lenses in contact. More generally, the focal length f of two simple lenses of focal lengths f_1 and f_2 spaced a distance s apart is

$$f = \frac{f_1 f_2}{f_1 + f_2 - s}$$

If s is zero, the above can be reduced to: $\frac{1}{f} = \frac{1}{f_1} + \frac{1}{f_2}$ and if d is the dioptric power, $d = d_1 + d_2$.

[4]Generally, the diameter of the *entrance pupil* rather than the diameter of the stop itself defines the f-number. See the Glossary for a definition.

this was tested experimentally using a built-in light meter on a SLR camera, the observed reduction was something less than 15 percent. Because the close-up lens in that test was not coated, some of the loss must have been due to light lost by reflections at the added surfaces.

The addition of a close-up lens does not affect a built-in light meter; hence, it may be used to meter the subject, keeping in mind the limitations previously cited.

A lens in which the front element is moved relative to the rear element is called a front element focusing lens and is often used on less expensive cameras. Focusing is achieved by changing the focal length of the lens. As the separation of the lenses is increased (see footnote 3), the focal length and the object distance are increased because the image distance is virtually fixed. The f-number of such a lens will not change much as the object distance is changed, for reasons similar to those mentioned in the discussion of close-up lenses.

■ THE FRESNEL BIPRISM

As mentioned in Chapter 2, one or more Fresnel biprisms are used as focusing aids in many SLR cameras. The basic biprism consists of two prisms oriented with their bases in contact (see Fig. 5.8a).

To understand how the biprism works in a focusing screen as demonstrated in Figure 2.8, imagine that the two prisms are placed side by side as shown in Figure 5.8b. These prisms are incorporated in the center of a ground-glass screen as in Figure 5.9. If the images are out of focus on the ground-glass screen, the image at the center of the biprism will be split (see Fig. 5.9a), because the back prism refracts the image to the right, and the front prism refracts the image to the left. The image formed by the front prism corresponds to the bottom of the subject in Figure 2.8. If the images are in focus on the ground-glass screen, the image in the center of the biprism will coincide at the surface of the biprism and no offset will be caused by the prism. Some focusing screens have many small biprisms in the center of the screen. Each functions like the single biprism shown here, and the overall effect gives an out-of-focus image that is dappled and seems to shimmer.

(a) (b)

FIGURE 5.8 The Fresnel biprism (a) and the biprism as modifed for use in a focusing screen (b).

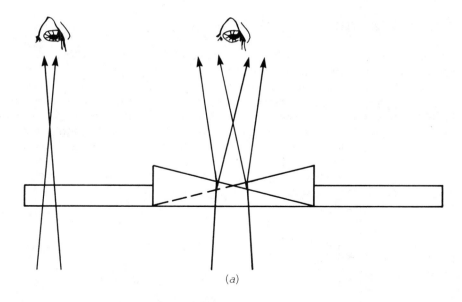

(a)

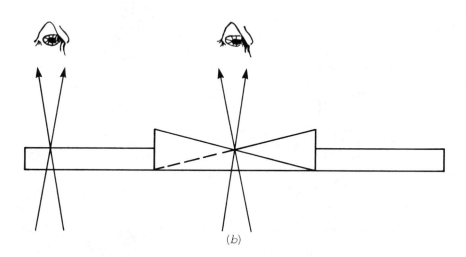

(b)

FIGURE 5.9 Modified Fresnel biprism in a ground glass screen showing (a) out-of-focus and (b) in-focus images.

■ PRESERVING ARCHITECTURAL LINES

Most photographers have noticed that when taking a picture of a tall building while standing at its base, the parallel sides of the building seem to come to a point in the picture. This is actually what is seen when looking up the side of the building. On the other hand, architectural pictures are made in which the sides appear parallel. How is this done? To achieve this result it is necessary to have the plane of the film parallel to the plane of the face of the building being photographed. This can be verified by using a little geometry and the relation for magnification. To

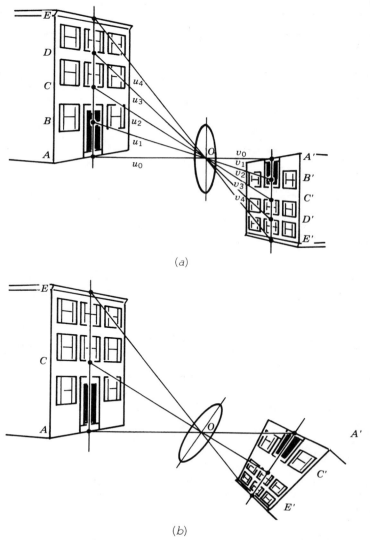

(a)

(b)

FIGURE 5.10 Relation between object and image when photographing tall buildings.

have the sides parallel it is necessary that the magnification in the horizontal direction remain the same at all heights. Figure 5.10a shows the face of the building being photographed. Recall $m = v/u$ so that

$$m_1 = \frac{v_1}{u_1} \ldots m_4 = \frac{v_4}{u_4}$$

Because triangle BOA is similar to $B'OA'$ and COA is similar to $C'OA'$, and so on,

$$\frac{v_1}{u_1} = \frac{v_0}{u_0}; \qquad \frac{v_2}{u_2} = \frac{v_0}{u_0} \ldots$$

hence $m_1 = m_2 = m_3 = m_4$.

Because the magnification is the same, the width of the image will be the same at all heights and the sides of the building will be parallel. If the film is tilted (i.e., the camera is pointed up the side of the building), the cross-sectional view is as shown in Figure 5.10b. AOE is not similar to $A'OE'$ and $m_0 \neq m_4$.

If a standard 35 mm camera is used with the film parallel to the face of the building, much of the field of view is occupied by foreground (see Fig. 5.11a) and some of the building is not photographed. Figure 5.11b shows that lowering the film

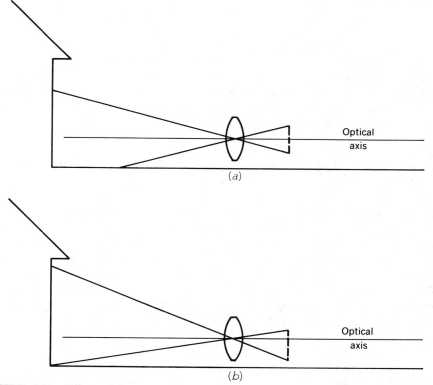

FIGURE 5.11 Effect of lowering film back relative to optical axis in architectural photography.

FIGURE 5.12 Relation between object and image planes for objects not perpendicular to the optical axis.

relative to the optical axis would make it possible to photograph the entire building while preserving architectural lines on the front of the building. View cameras that provide for vertical movement of the lens relative to the film holder can be used for this. Lenses called shift or perspective control lenses can also be used to solve this problem and are available for SLR cameras. Such lenses allow vertical movement of the lens relative to the body of the camera.

■ PHOTOGRAPHING OBJECTS NOT PERPENDICULAR TO THE OPTICAL AXIS

View cameras (but not shift lenses) are also designed so that the planes of the lens and the film can be swiveled about axes perpendicular to the axis of the camera. Such movement makes it possible to focus objects in planes that are not perpendicular to the optical axis of the lens. Rotation about a horizontal axis is called a tilt; that about a vertical axis is called a swing. It can be shown that if a plane object is inclined at an angle ϕ with respect to the optical axis (see Fig. 5.12), the image will be formed in a plane at an angle ϕ' with respect to the optical axis and the projections of the planes will intersect in a line in the plane of the lens.[5]

[5]This relationship is known as the Scheimpflug principle. T. Scheimpflug, *Photographische Korrespondenz Vienna, 43,* 516, 1906.

Furthermore, if the object distance on the optical axis is u, then

$$\tan \phi' = \frac{u - f}{f} \tan \phi$$

where f is the focal length of the lens.

This information can be used in determining the tilt of the lens board and film holder of a view camera to get the sharpest image of an object that is not in a plane perpendicular to the optical axis of the lens.

▶ **Example 5.6**

Consider the problem of photographing a group of small figurines (Lalique glassware, for example) placed on a table (see Fig. 5.13). The distance (u) to the center of the table is 36 in. and the focal length of the lens is 6 in. If the angle of the film holder relative to the optical axis of the lens (ϕ') is 70° (limited by the "swings" of the camera and the angle of illumination of the lens), what will be the angle between the optical axis and the plane of the table (ϕ)?

$$\tan \phi = \frac{f}{u - f} = \frac{6}{36 - 6} \tan 70° = 0.549$$

The arc tan of 0.549 is about 29°.

Note that the pieces will be viewed more from the side than the top and that dimensions in the vertical plane will be preserved fairly well because the angle between the film holder and the table (θ) is 80°. In practice the angle would not need to be calculated. The fact that the object, image, and lens planes meet in a line can be a great aid in composing this kind of picture.

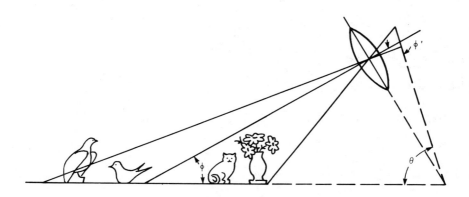

FIGURE 5.13 Photographing figurines on a table using a view camera.

■ PERCEPTION OF DEPTH

The camera records as a plane image, objects that usually are three dimensional. When the picture is viewed the mind reconstructs a three-dimensional impression of the object. Sometimes the three-dimensional construct agrees with reality and sometimes it does not. Why is this so?

When a photograph is viewed, an effort is made to construct a mental picture that is consistent with experience. As an example, consider what happens when a picture is taken of a square arbor supported on four posts of the same size. A plan view of the photographic situation, seen from above, is shown in Figure 5.14a. Two different lenses of focal lengths f_1 and f_2 are used to form the images. Assume that $f_2 = 2f_1$. After an enlarged picture has been made of image II, it is viewed by an observer, who notes four pillars in a plane. The outer ones seem larger and the inner ones smaller. This person perceives that they all must be the same size and that the spacing of the outer and inner posts should be the same. The observer concludes that the inner pair must be farther away and constructs the mental

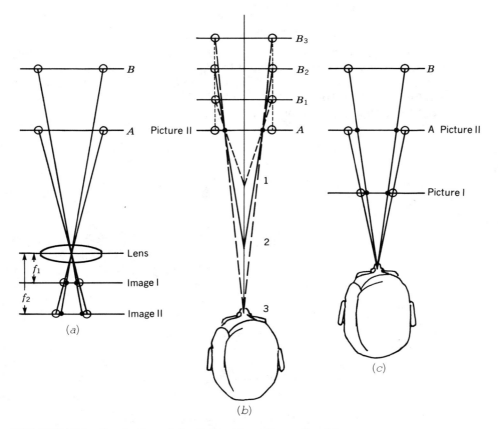

FIGURE 5.14 Perception of depth from two-dimensional images.

image of Figure 5.14*b*. If the observer's eye is at (1), the mental construct is of an arbor that is wide and shallow (posts in planes *A* and B_1). If the eye is at (3), the arbor is relatively deep and narrow (posts in planes *A* and B_3). If the eye is at (2), the arbor is square (posts in planes *A* and B_2). Hence, the viewing distance plays a role in the perception of the arbor. Only one viewing distance produces a mental image consistent with reality.

If image I had been used with the same enlargement in the darkroom, the spacing of the pillars would have been half as large. Observing picture I at half the distance of that used for viewing picture II results in the same mental image of the arbor (see Fig. 5.14*c*). If the enlargement of image I is twice that of image II, the two pictures will be the same size, and proper perspective is preserved if these pictures are viewed from the same correct distance. Hence, preservation of proper perspective of a picture depends on the focal length of the lens, the enlargement, and the observer's viewing distance.

In regard to perspective, increased enlargement in the darkroom is equivalent to using a longer focal length lens. This is demonstrated in Figure 5.15. On the right are three pictures of a scene taken from the same position using three different lenses. The images are all enlarged the same. Note the difference in the perspective of each. On the left, the central part of each has been enlarged until the image sizes are the same. Note that the perspectives are identical.

Occasionally a picture distorts depth so much that the mind cannot cope with preserving width. Photographs taken with telephoto lenses and enlarged many times are good examples of this problem. In Figure 5.16, for example, the far end of each railroad car seems larger than the near end. Everyone knows that railroad cars are rectangular solids and long and narrow. If width is preserved in the mental image, the car appears shorter than in reality. The mind resolves the dilemma by moving the far end further away, and the car appears a more realistic length even if it looks as if it was made by an incompetent craftsman. If the viewing distance of Figure 5.16 is increased, the picture will appear normal.

Pictures are sometimes taken of people sitting with their feet near the camera, so that the feet seem much larger than the head. Usually the picture has been taken from a low angle at a relatively short distance. When looking at such a picture, the viewer is tempted to say that something is "wrong" with the perspective. Actually nothing is wrong with the perspective because it agrees with reality. However, the viewer is not accustomed to looking at people from this unusual point and that is what is "wrong."

A similar problem occurs in making portraits of people. It is tempting to photograph from a close vantage point with a 35 mm camera fitted with a standard lens, so that the entire frame is filled by the head and shoulders. This reduces the amount of enlargement necessary for a specified print size (e.g., 8 × 10 in.). However, the face seems distorted; the nose appears too broad for the spacing of the ears, as demonstrated in Figure 5.17. The left picture (Fig. 5.17*a*) was taken from a distance of 1 foot, the center (Fig. 5.17*b*) from 2 feet, and the right (Fig. 5.17*c*) from 5 feet. Nothing is wrong with the perspective in any of the pictures. The difficulty with the top picture is that the viewer is unaccustomed to examining the human face from such a close position.

Relative
Enlargement

Focal Length
of Lens (mm)

1

135

2.5

55

4.8

28

FIGURE 5.15 Pictorial demonstration of interchanging the use of a long focal length lens in the field and enlargement in darkroom. (ENM, 1983)

FIGURE 5.16 Distortion caused by using a long focal length lens and excessive enlargement to photograph a distant object. (ENM, 1983)

(a) (b) (c)

FIGURE 5.17 Three portraits of an individual taken from three different distances. (ENM, 1983)

The only way to produce a picture with the proper perspective relative to how the scene would appear from a given vantage point is to take the picture from that position. That is, if a picture of a person is to look as he/she would when seen from 10 ft, the picture must be taken from a distance of 10 ft. The proof of this is shown in Figure 5.18. Consider a spaceman whose head (admittedly transparent) is trapezoidally shaped so that when he is observed from a comfortable distance (say 10 ft), his eyes obscure his ears. If a picture of him is made from a distance less than this comfortable distance, his ears will be recorded between his eyes (Fig. 5.18a).

No enlargement procedure exists that will make the ears coincide with the eyes. If the picture is taken from a distance greater than the comfortable viewing distance, the ears will be recorded outside the eyes (Fig. 5.18b), and no enlargement can make them coincide. If the picture is taken from a comfortable viewing distance, the eyes and ears will coincide (Fig. 5.18c), and it is possible to make an enlargement that squares with the usual impression of the man with a trapezoidal head. However, if enlargement and/or viewing distance is incorrect, perspective will not be preserved.

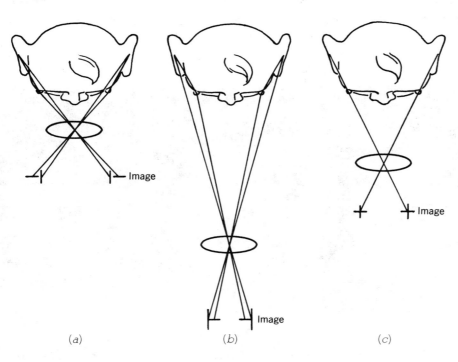

(a) (b) (c)

FIGURE 5.18 Schematic, from above, of a spaceman with a trapezoidal head.

■ GEOMETRICAL TREATMENT OF DEPTH OF FIELD

It has been implied that if a given lens is used to form images of objects at varying distances from the lens, the sharp images will also be at varying distances from the lens. This seems to imply that sharp images can only be formed of objects that are the same distance from the camera. Yet, it is evident that the images formed in pictures frequently seem to be in focus over a considerable range of distance. In fact, many cameras have calculators on the lenses that give the depth of field as a function of range and aperture setting (see Fig. 5.19).

The resolution of this dilemma lies in the limitation in the ability of the eye to tell when images are sharp. Imagine a set of dots on a printed page. It is verified using a hand lens that no two are the same diameter. If the set of dots is observed with the unaided eye from a minimum comfortable viewing distance (say 10 in. or 25 cm), it is concluded that many of the smaller dots appear to be the same size. This minimum size that the eye can resolve is called the *limit of resolution* of the eye and is, ultimately, a consequence of diffraction limitations of the eye. The limit of resolution of a normal eye is about 0.003 in. (0.08 mm). For all but the most discriminate viewing, however, a more reasonable and practical limit is about 0.01 in.

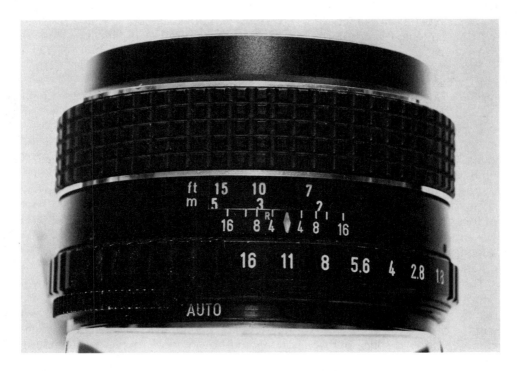

FIGURE 5.19 Typical depth of field calculator. (ENM, 1983)

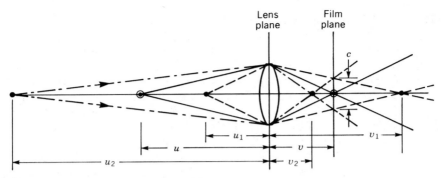

FIGURE 5.20 Illustration of depth of field.

(0.25 mm). This number is used for most practical depth of field calculations in photography. A picture may be thought of as a collection of dots, and if each dot appears sharp, the picture will appear sharp.

Figure 5.20 illustrates the manner in which images of points at different object distances are formed on a single plane (film plane). Imagine a camera focused on a point object at a distance u from the lens with the image in focus at a distance v from the lens. Point objects at u_1 and u_2 are focused at distances v_1 and v_2, respectively. The images formed at the film plane of these objects are circles.

The distances u_1 and u_2 have been so selected that the circles are the same diameter c. This circle is sometimes called the *circle of confusion*. Note that an object placed closer than u_1 to or further than u_2 from the lens appears as a circle larger than c. The images of all points between u_1 and u_2 appear as circles smaller than c. If c is equal to the limit of resolution of the eye, then all points between u_1 and u_2 appear as equally sharp images at the film plane when a *contact print* of the image is viewed by the unaided eye at minimum comfortable viewing distance. In other words, they all will appear to be "in focus." This circle on the negative which corresponds to the limit of resolution of the eye on the print is called the limiting circle of confusion. All other points on the axis will appear as circles and are "out of focus." Hence, all objects between u_1 and u_2 are in focus, and all other objects will appear out of focus. The distance u_2 (the maximum distance that is in focus) is designated D_2, and u_1 (the minimum distance that is in focus) is designated D_1. The distance $D_2 - D_1 = D$ is called the *depth of field*.

The above discussion assumes that a contact print is made from the negative, which is not the usual case in small format photography. If an enlargement of the print had been made, then c would be larger than the limit of resolution of the eye and the depth of field would have been reduced. If the magnification on enlargement is M, then the limit of resolution that must be imposed on the negative is the limit of resolution of the eye divided by M.

The limit of resolution of the eye has been defined in terms of the size of a limiting circle viewed from a distance of 10 in. It is instructive to think in terms of

FIGURE 5.21 Angular resolution of the eye.

the angle (α) subtended at the eye by this circle (see Fig. 5.21). This is called the *angular resolution.* The drawing shows that α is 0.01/10 \sim .001 rad \sim 0.06 deg \sim 3.5 min. This is a constant independent of viewing distance, provided that the object is beyond the minimum comfortable viewing distance. Hence, the limit of resolution of the eye is proportional to the viewing distance.

▶ **Example 5.7**

I have a 35 mm negative that is 24 \times 36 mm or approximately 1 \times 1½ in. The negative is to be enlarged to an 8 \times 10 in. print, which requires a tenfold magnification of the negative. This print is to be viewed at a distance of 10 in. What is the limiting circle of confusion to be imposed on the negative so that the relevant part of the negative will appear in focus?

Note that a 10X enlargement of a 0.001 in. diameter circle yields a circle 0.01 in. in diameter, the limit of resolution of the eye at minimum viewing distance. Hence, the limiting circle of confusion for the relevant in-focus part of the negative (that part of the scene included in the depth of field) must be less than or equal to 0.001 in.

Now, assume that a mural is to be made and is to be viewed at a minimum distance of 60 in. (5 ft). What enlargement of the negative can be tolerated if the quality of the print is to be preserved?

Quality will be preserved if the in-focus part of the scene remains the same. Because the viewing distances is six times as great (60/10), the limit of resolution of the eye increases to 6 \times 0.01 in. = 0.06 in. If a 10X enlargement yields a limiting circle 0.01 in. in diameter, a 60X enlargement makes this circle 0.06 in. in diameter.

Depth of field also depends on the f-number setting of the lens. The reason for this can be seen from Figure 5.22. Consider a point at u_1, imaged at v_1. When the lens is wide open, the image on the film plane (a distance v from the lens) is a circle just equal in diameter to the limiting circle of confusion, and u_1 is the minimum distance that will be in focus (D_1) when the lens is wide open and focused on some

FIGURE 5.22 Effect on depth of field of reducing the aperture.

object at u. An object at u'_1 does not appear in focus when the lens is wide open, because the circle of confusion at the film plane is larger in diameter than c. However, when the lens is stopped down as shown, the bundle of rays from the point at u'_1 forming an image at v'_1 is in diameter equal to the limiting circle of confusion at the film plane because the peripheral rays have been eliminated. Consequently, the point appears in focus. The minimum in-focus distance (D_1) decreases and depth of field increases. The rays passing through the perimeter of the lens are the ones that limit the depth of field. The reader can, by a similar diagram, become convinced that the maximum in-focus distance (D_2) increases as one stops down the lens, further increasing the depth of field.

As the camera is focused on objects that are farther from the camera, the film plane is moved closer to the lens. This causes the circle of confusion to increase for nearby objects and to decrease for distant objects (see Fig. 5.20). Hence, D_1 *must* increase, and D_2 *can* be increased for a given limiting circle of confusion. Because D_2 increases more rapidly than D_1, the depth of field increases as the photographer focuses on objects further from the lens.

The depth of field decreases for a given object distance when a change is made to a lens of longer focal length. This occurs because D_2 decreases and D_1 increases with increasing focal length if all other parameters are held constant. This is not easy to discern on the basis of simple geometrical arguments.

■ MATHEMATICAL TREATMENT OF DEPTH OF FIELD

Using simple geometry it is possible to show that for a thin lens the maximum depth at which objects appear in focus for a limiting circle of confusion c is

$$D_2 = \frac{df(m + 1)}{md - c} \tag{5.7}$$

where d is the diameter of the aperture and m is the magnification.[6] The minimum distance at which objects will appear in focus is given by

$$D_1 = \frac{df(m+1)}{md+c} \tag{5.8}$$

The depth of field is then

$$D = D_2 - D_1 = \frac{2fdc(m+1)}{m^2d^2 - c^2} \tag{5.9}$$

Similar relations can be derived for the case of thick lenses, but distances are measured relative to the position of the entrance pupil and the pertinent aperture diameter is that of the entrance pupil.

▶ **Example 5.8**
Let's examine D when m is relatively large. If $m = 1$ and c is 0.001 in., then d^2 will be large compared with c^2 and

$$D\,(=)\,\frac{4fdc}{d^2} = 4cf/$$

because $f/ = f/d$. In such a situation if $f/ = 16$, then $D = 0.064$ in., which is very small. This reminds us that the depth of field is very small in macro work.

As the camera is focused on objects further away, m becomes smaller and both D_2 and D_1 increase. Because D_2 increases more rapidly than D_1 the depth of field increases. When $md = c$, D_2 (and D) becomes infinite and the depth of field is infinite. The distance at which the camera is focused so that $md = c$ and $D_2 = D = \infty$ is called the *hyperfocal distance*.[7] The symbol H is used to designate this distance. This number is of considerable practical importance. Solving simultaneously the equations

$$md = c$$

$$m = \frac{v}{u}$$

$$\frac{1}{u} + \frac{1}{v} = \frac{1}{f}$$

and

$$f/ = \frac{f}{d}$$

[6] J. Morgan, *Introduction to Geometric and Physical Optics,* New York: McGraw-Hill, 1953, p. 153.

[7] The hyperfocal distance is sometimes defined as D_1 when $u = \infty$. This is not rigorously true, as can be seen by using Equation 5.13 and considering the limit as u approaches infinity. The definition is satisfactory insofar as Equation 5.11 is accurate (see Eq. 5.17).

for the case $u = H$ it is found that

$$H = \frac{f^2}{cf/} + f \qquad (5.10)$$

In most instances

$$f \ll \frac{f^2}{cf/}$$

so that the approximation

$$H (=) \frac{f^2}{cf/} \qquad (5.11)$$

is sufficient. Because f, $f/$, and c are readily known quantities, it is a simple matter to find H. Note that when Equation 5.11 is valid, H is proportional to f^2 and inversely proportional to the f-number. It is possible to express D_2 and D_1 in terms of H, u, and f. This involves using $f/ = f/d$ and $m = f/(u - f)$ to express Equations 5.7 and 5.8 in terms of variables compatible with Equation 5.10.

Using the exact expression for H (Eq. 5.10) it is found that

$$D_2 = \frac{u(H - f)}{H - u} \qquad (5.12)$$

$$D_1 = \frac{u(H - f)}{H + u - 2f} \qquad (5.13)$$

These can be solved simultaneously to express u and H in terms of D_1, D_2, and f. The results are

$$u = \frac{2D_2 D_1}{D_2 + D_1} \qquad (5.14)$$

$$H = \frac{2D_2 D_1}{D_2 - D_1}(u - f) + f \qquad (5.15)$$

Using the approximate expression for H (Eq. 5.11) and following the same procedure, it is found that

$$D_2 = \frac{Hu}{H - (u - f)} \qquad (5.16)$$

$$D_1 = \frac{Hu}{H + (u - f)} \qquad (5.17)$$

$$u = \frac{2D_2 D_1}{D_2 + D_1} \qquad (5.18)$$

$$H = \frac{2D_2 D_1}{D_2 - D_1}(u - f) \qquad (5.19)$$

If Equation 5.11 is valid and if in addition u is much larger than f, then D_2, D_1, u, and H relate as follows:

$$D_2 = \frac{Hu}{H - u} \tag{5.20}$$

$$D_1 = \frac{Hu}{H + u} \tag{5.21}$$

$$u = \frac{2D_2D_1}{D_2 + D_1} \tag{5.22}$$

$$H = \frac{2D_2D_1}{D_2 - D_1} \tag{5.23}$$

These equations cannot be used in macro work. Equations 5.16, 5.17, 5.18, and 5.19 are quite satisfactory in most cases, however.

▶ **Example 5.9**

Consider a macro photography problem in which a 2 in. focal length lens is used stopped down to f/16 to photograph part of a flower placed 6 in. from the lens. The limiting circle of confusion is to be 0.001 in. Find the exact and approximate values of H, D_2, D_1, and D.

Using Equation 5.10, the exact value for H is found to be 252 in. Using Equation 5.11, the approximate value is found to be 250 in. Substituting in the equations for D_2 and D_1 one finds that the exact equations (5.12 and 5.13) and the first approximation equations (5.16 and 5.17) give the same result ($D_2 = 6.10$ in.); $D_1 = 5.91$ in.) and $D_2 - D_1 = D = 0.19$ in. The second approximation equations (5.20 and 5.21) give $D_2 = 6.15$ in.; $D_1 = 5.86$ in. and $D = 0.29$ in. The value for D in this case is about 50 percent larger than the correct value.

▶ **Example 5.10**

Assume that you are photographing a scene which is to appear in focus between the object distances 10 and 3 m. Assume that the limiting circle of confusion is 0.025 mm, and that the focal length of the lens is 55 mm. What is the focusing distance and what f/ should be used to get this depth?

The object distance (Eq. 5.22) will be $2 \times 10 \times 3/(10 + 3) = 4.6$ m. To obtain the f/, H must first be calculated. In this instance $u = 460$ cm and $f = 5.5$ cm. Hence, $f \ll u$, and the most approximate equations can be used. The value for H (Eq. 5.23) is $2 \times 10 \times 3/(10 - 3) = 8.6$ m. From Equation 5.11

$$f/ = \frac{5.5^2}{0.0025 \times 860} = 14$$

Hence, the camera should be set for the half stop between f/11 and f/16.

This mathematical treatment gives insight into the quantitative aspects of depth of field, but is not very practical for anything but the most exacting situations. In

practice, camera lenses are thick lenses, and this makes the object distance difficult to determine, because measurement should be relative to the position of the entrance pupil rather than the object distance u. This creates a problem in macro work. For the case in which $u \gg f$, a simple rule can be deduced from the equations for D_2 and D_1, which can be very helpful in the field. Note in this case that if $u = H$, not only is $D_2 = \infty$ but $D_1 = H/2$. If one focuses at $u = H/2$, then $D_2 = H$ and $D_1 = H/3$.

In general, if the camera is focused at

$$u = \frac{H}{n} \tag{5.24}$$

then

$$D_2 = \frac{H}{(n - 1)} \tag{5.25}$$

and

$$D_1 = \frac{H}{(n + 1)} \tag{5.26}$$

If H is not known, it is a simple matter to obtain H from Equation 5.11.

■ THE DEPTH OF FIELD CALCULATOR

It is more practical to use a depth of field calculator, which is frequently built into the lens. The calculator in Figure 5.19 shows a number between 10 and 7 (about 8) opposite the diamond. This implies that the camera is focused at 8 ft (2.4 m). Note that something like 15 ft is opposite one 16 and less than 7 ft is opposite the other 16. This means that the camera is in focus between these two distances if the camera is stopped down to f/16. At f/8, the in-focus depth is from about 7 to 10 ft.

Unfortunately, although a great deal of information is contained on one of these calculators, the information is not as precise as might be desired. Not only must considerable interpolation be done on a scale that is nonlinear but in addition, most manufacturers mark the range scale so that it actually indicates $(u + v)$ instead of u. That is, the range markings give the distance to the film plane rather than the principal plane. Even so, the depth of field calculator can be very useful and is well worth understanding.

Because the hyperfocal distance is the minimum distance where the camera can be focused and still be in focus at infinity, all that is necessary to determine the hyperfocal distance is to set the ∞ mark at the specified f-number and then read the range at the range mark (diamond in Fig. 5.23). In this case the distance is about 20 ft (actually 21 ft) for f/16. To maximize the depth of field, the camera should be focused at H. In such a situation $D_2 = \infty$ and $D_1 = H/2$. If the lens is set so that $u = \infty$, then $D_2 = \infty$ and $D_1 = H$, which yields less total in-focus depth despite the fact that the depth of field is infinite in both cases. Having found H, it

FIGURE 5.23 Depth of field calculator set for determining hyperfocal distance. (ENM, 1983)

is possible to use Equation 5.11 to find c and determine the design criteria for the calculator.

By remembering H for a given f/, f, and c, simple ratios and the approximate relation for H (Eq. 5.11) can be used to find H for any other focal length and/or f-number, assuming c is unchanged.

▶ **Example 5.11**

I have a 55 mm focal length lens on a 35 mm SLR camera, for which it is known that the calculator was designed for $c = 0.001$ in. If H equals 21 ft for f/16, what is H for f/8? What is H for a 110 mm lens when stopped down to f/8 if the second lens satisfies the same limitation on c?

H is approximately proportional to 1/f/. Hence, if the f-number is halved, H doubles and becomes $16/8 \times 21 = 42$ ft. H also is approximately proportional to f^2. In the case of the 110 mm lens H is $(110/55)^2 \times 42 = 4 \times 42 = 84$ ft.

▶ **Example 5.12**

Assume that we are using the 55 mm focal length lens of Example 5.11 at f/8. If the object distance is 7 ft, what are the values of D_2 and D_1?

Using Equation 5.24, we find that $n = 42/7 = 6$. From Equations 5.25 and

5.26, we find that $D_2 = 8.4$ ft and $D_1 = 6$ ft. The approximations for D_2 and D_1 can be used because $u = 7$ ft $= 84$ in. is considerably larger than the focal length ($f = 55$ mm (\cong) 2 in.).

Finally, consider a situation in which it is known what is to be in focus. How are the f-number and object distance determined to achieve the specified depth? As shown earlier, the equations can be used to determine this. However, the calculator and the camera can also be used to make this determination. First, the camera is used as a range finder to find the maximum and minimum object distances within which the subjects are to be in focus. With an SLR camera, this is done most easily with the lens wide open. The lens is set so that D_2 and D_1 are equally distant from the range mark on the calculator. The f-number opposite D_2 (and D_1) is that which allows the desired part of the field to be in focus.

▶ **Example 5.13**
Suppose that in photographing part of an old shipwreck, I decide that subjects from 10 to 30 ft distant are to be in focus. The lens has a focal length of 55 mm. The depth of field calculator is set as shown in Figure 5.24. In this case the camera should be focused at about 15 ft. If the f-number is set at f/11, the depth of field will be as specified.

FIGURE 5.24 Depth of field calculator as set for Example 5.13. (ENM, 1983)

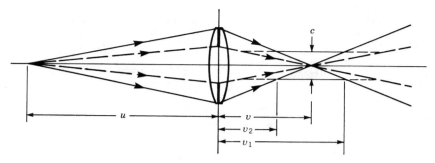

FIGURE 5.25 Illustration of depth of focus.

■ DEPTH OF FOCUS

The concept of *depth of focus* is illustrated in Figure 5.25, where a point object at u is focused at v. Recognizing that all circles of confusion smaller than the limiting circle of confusion (c) appear as points, it can be seen that when the lens is wide open, the object appears in focus if the film plane is placed so that v is greater than v_2 but less than v_1. The quantity $v_1 - v_2$ is the depth of focus. Note that if the lens is stopped down as indicated by the dashed lines, the depth of focus increases. This is one reason why critical focusing with an SLR camera or on ground glass when using a veiw camera, should be done with the lens wide open. The depth of field is reduced also when the lens is opened, but this only improves focusing capability insofar as the attention of the photographer is directed to the object of interest. The increased illumination in the field of view allows the eye to operate at smaller aperture, which also improves the focusing capability.

The depth of focus can be derived rather easily from a simple geometrical argument with the help of Figure 5.26. Note that the depth of focus (F) is symmetrical about the image point. From the similar triangles AOB and JOK

$$\frac{d/2}{v} = \frac{c/2}{F/2}$$

Solving for F

$$F = \frac{2cv}{d} = 2cf/eff = 2c(m + 1)f/ \tag{5.27}$$

because $v/d = f/eff = (m + 1)f/$ (see Eq. 5.6). At f/16 for $c = 0.001$ in., F varies from 0.032 in. for an object at infinity ($m = 0$) to 0.064 in. for an object at $2f(m = 0)$. The depth of focus is quite small, even when the camera lens is stopped down. This puts a rather stringent requirement on the mechanical precision of the camera and on flatness of the film. For this reason, special pressure plates are necessary to help keep the film flat against the guide rails.

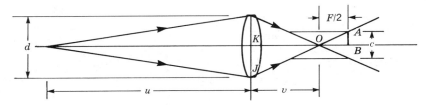

FIGURE 5.26 Determination of depth of focus.

■ STOPPING MOTION

The limiting circle of confusion (c) can be used to develop a criterion for the maximum exposure time to be used so that the image of a moving object does not appear blurred on the film. If the image of a point does not move more than a distance of the order of c on the film during the time the shutter is open, then the image will certainly appear sharp.

In Figure 5.27, consider an object moving at a velocity V perpendicular to the line of sight. Assume that the object is far enough away that it is imaged at the focal plane and the shutter is to be open for a time t. The point object travels a distance equal to Vt while the shutter is open. From the similar triangles AOB and EOD, $Vt/u = c/f$ and the maximum exposure time for no blurring is

$$t = \frac{uc}{Vf} \tag{5.28}$$

▶ **Example 5.14**

Consider a runner who can run 100 m in 10 sec. Assume that the limiting circle of confusion is 0.025 mm and that you are using a lens of 50 mm focal length on a camera having a minimum exposure time of 1/1000 sec. What is the minimum distance from which a photograph can be taken and still stop the general motion of the runner? Assume that the optical axis of the lens is perpendicular to his direction of motion.

The speed of the runner is

$$V = \frac{100 \times 100}{10} = 1000 \text{ cm/sec}$$

Solving for u in Equation 5.28 and substituting

$$u = \frac{1000 \times 5.0 \times \dfrac{1}{1000}}{0.0025} \text{ cm} = 2000 \text{ cm}$$
$$= 20 \text{ m}$$

You may be tempted to substitute a longer focal length lens to get a larger image, but this is of no avail because increasing f forces you to increase u pro-

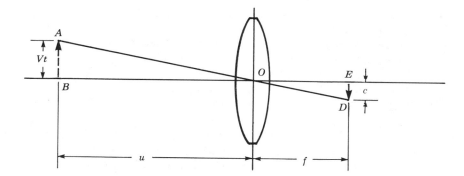

FIGURE 5.27 Stopping motion perpendicular to the optical axis.

portionally (see Eq. 5.28). Increasing the enlargement in the darkroom does not help either, because this puts a more stringent requirement on c and requires an increase in u.

If the object is moving at an angle (θ) less than 90° with respect to the line of sight, it is easy to show that instead of V, the component of V perpendicular to the line of sight should be used in the above equation and

$$t = \frac{uc}{fV \sin \theta} \qquad (5.29)$$

This assumes that because of a change in object distance, the image size does not change appreciably during the time the shutter is open.

This raises the question of how close a photographer can be to an object that is moving directly toward (or away from) the camera and still eliminate blurring caused by a change in image size. Using a geometrical argument similar to the one above and imposing a limitation on the change in image size based on the limiting circle of confusion, it can be shown that for an object of height h above the optical axis at a distance u from the camera moving toward the camera at a velocity V, the maximum time the shutter can be open will be

$$t = \frac{u^2 c}{Vhf}$$

where f and c are defined as before.

▶ **Example 5.15**
In Example 5.14, if the runner had been moving toward the camera with the camera at ground level and if the runner was 2 m tall, the minimum distance at which he can be photographed forming an unblurred image will be about 6 m.

In general, motion along the line of sight causes fewer problems when a photographer is trying to "freeze" motion, but this statement must be tempered by consideration of the size of the subject being photographed. A runner bearing down on a photographer is one thing. An elephant is another!

■ SHUTTER EFFICIENCY AND EFFECTIVE EXPOSURE TIME

Shutters do not open instantaneously, which may affect their precision and in some instances cause the *effective exposure time* to vary as the f-number is changed.

A *leaf shutter* (between-the-lens shutter) is so constructed that the blades spiral outward when it is opened (see Fig. 2.3). Because the bundle of light passing through the shutter from any point in object space is a cone of finite diameter (see Fig. 5.28), and a finite time is required for the shutter to clear the cone, the illuminance increases and decreases gradually. In Figure 5.29, this opening and closing sequence is shown both in terms of position relative to the bundle of light in Figure 5.29*a*, and in terms of illuminance (I) as a function of time (t) in Figure 5.29*b*. The graph is idealized because the opening rate is seldom constant. The numbers on the graph in Figure 5.29*b* correspond to specified shutter positions in Figure 5.29*a*. The ratio of the area of the trapezoid to the area of the rectangle enclosing the trapezoid (dashed lines) multiplied by 100 is defined as the *shutter efficiency*.

As the exposure time is decreased (broken lines in Fig. 5.29), the shutter is totally open for a shorter time. Because the same amount of time is spent opening and closing the shutter, the shutter efficiency decreases. For exposures as long as 1 sec, the shutter is very nearly 100 percent efficient. At 1/50 sec the efficiency typically drops to 85 or 90 percent and at 1/250 sec the efficiency may be as low as 65 percent.

The effective exposure time (t_E) is the time that an ideal instantly opening and closing shutter would have to be open to give the same exposure to the film as that of the real shutter. In Figure 5.29, this is the time that elapses between the

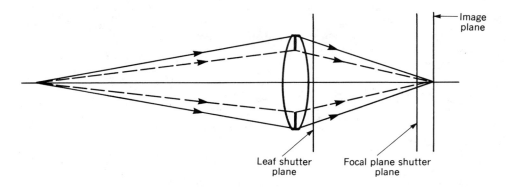

FIGURE 5.28 Shutter planes for focal plane and leaf shutters.

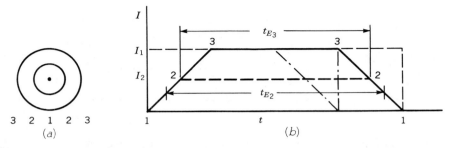

FIGURE 5.29 Opening and closing sequence for a leaf shutter.

instant the shutter is half open and the instant it is half closed and is designated t_{E3} for the full bundle of light. If the lens is stopped down as in Figure 5.28 (dashed lines) and the bundle of light is reduced in diameter to that designated by 2 in Figure 5.29a, the shutter clears the bundle of light at 2 in Figure 5.29b and t_E increases to t_{E2}. This means that as a camera with a leaf shutter is stopped down, effective exposure time increases.

Decrease in shutter efficiency with decreasing exposure time can be compensated by designing the shutter to give proper effective exposure time for each exposure setting. However, change in effective exposure time with change in aperture must be corrected by the photographer when using the camera in the manual mode. If the exposure time is 1/500 sec, a lens with a maximum opening of f/1.8 will overexpose about one stop if it is stopped down to f/16. The overexposure is reduced to ½ stop at f/16 if the exposure time is increased to 1/250 sec. A camera with a built-in light meter operating in an automatic mode may be able to correct for this overexposure, depending on such factors as response times of the electronics of the shutter and the photosensitive elements. Experiment and caution are advised. Incidentally, Figure 5.29b shows that shutter efficiency increases with decreasing aperture, but this problem is better considered in terms of effective exposure time as will be seen when the focal plane shutter is discussed.

Because the film must be in the image plane, it is not possible to put a focal plane shutter in the focal plane. Because a focal plane shutter must lie in a plane slightly forward of the image plane, it must also cut a bundle of rays (see Fig. 5.28). The simplest focal plane shutter consists of two rubberized cloth blinds moving horizontally (see Fig. 2.9). The opening of the first exposes the film to the bundle of rays in the sequence (1–5) as shown in Figure 5.30a. The closing sequence is the same, because the closing blind moves in the same direction. Figure 5.30b shows graphically how the illuminance varies with time. The diagram is idealized with shutter efficiency defined as before.

Shutter efficiency decreases with decreasing exposure time in a manner qualitatively similar to that of a leaf shutter. As one stops down the lens, however, shutter efficiency increases, but effective exposure time is unchanged. The reason for this can be seen in Figure 5.30. When the camera is stopped down, the diameter of the bundle of light is reduced (see Fig. 5.28) to that of the inner circle in Figure

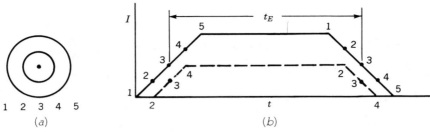

FIGURE 5.30 Opening and closing sequence for a focal plane shutter.

5.30*a*. The exposure sequence is changed to that shown by the dashed lines in Figure 5.30*b*. The shutter does not start to open until 2, is half open at 3, and fully open at 4. The closing sequence is similar. Hence, the shutter starts opening later but is fully open sooner. It begins closing later but is fully closed sooner than before. The important point is that the shutter is always half open and half closed at 3. Hence, the effective exposure time does not change with change in aperture, and no correction needs to be made when the lens is stopped down.

EXERCISES

5.1. Using a 35 mm camera with a 100 mm (4 in.) focal length lens, how close must you be to a 10 × 15 ft painting if you are to just fill the frame?

5.2. If a camera lens of twice the focal length of the standard lens is substituted for the standard lens, how will the magnification of a distant object be changed?

5.3. If you are photographing a 6 ft man at a distance of 12 ft, how tall will he appear on the film if the focal length of the lens is 2 in.?

5.4. A common so-called wide-angle lens for a 35 mm camera has a focal length of about 28 mm. What is the approximate angle of view for such a lens?

5.5. The image of a snail in a macro picture is full size ($m = 1$). I am photographing the snail on a bright sunny day using a film with an ASA film speed of 125. If I choose to stop down to f/22, what will be the correct exposure time for a lens opening of f/22?

5.6. You are assigned to make an architectural photograph of the front of a large building. The vertical (and the horizontal) lines in the face of the building must be parallel. What condition must be satisfied in setting up this photograph?

5.7. I have taken a picture of an old well using a 55 mm focal length lens. A ten times enlargement of this negative preserves the proper impression of depth when the enlargement is viewed from 45 cm (18 in.). The same scene was photographed from the same place using a lens of 165 mm focal length. What enlargement should be used if the impression of depth is to be preserved for the same viewing distance? To make a salon print of this last negative which is to be viewed at 180 cm, what enlargement should be used if perspective is to be preserved?

5.8. I want to make a portrait of a person so that the person will appear on the photograph as he/she appears when viewed from 6 ft. How far should the camera be placed from the subject to accomplish this?

5.9. If the maximum allowable circle of confusion for a hand-held print is 0.25 mm, what is the maximum allowable circle of confusion for a photographic ceiling mural which is to be viewed from a distance of 6 m?

5.10. Why does the depth of field of a lens increase as the lens is stopped down?

5.11. If a lens is opened up one stop, what is the approximate change in the hyperfocal distance?

5.12. You switch from a lens of 55 mm focal length to one of 110 mm focal length. What is the approximate change in the hyperfocal distance if the circle of confusion and f-number are unchanged?

5.13. Where should a camera be focused if the minimum and maximum in-focus depths are 5 ft and 10 ft?

5.14. I find that the depth of field calculation on my 135 mm (5 in.) lens indicates that when the lens is stopped down to f/16, the in-focus range is from 12 to 15 ft. What is the hyperfocal distance for this lens and f-number?

5.15. The hyperfocal distance for a 55 mm lens on a 35 mm camera is about 21 ft when stopped down to f/16. If the camera is focused at 7 ft, what will be the minimum and maximum distances that will be in focus?

5.16. Having taken a picture of an automobile moving across his/her field of view, a photographer wishes to retake it at half the distance. How should the shutter speed be changed if the original shutter speed was just adequate to stop the motion of the automobile?

part
·3·

LIGHT-SENSITIVE RECORDING SYSTEMS

chapter
·6·

The eye and some other photodetective processes

It is time to shift from the camera and optics to a study of the recording medium (film). In this chapter the eye (both the optics and the recording medium) and then several different kinds of *photodetectors* (including photographic film) will be studied. In Chapter 7 the photographic process will be studied in more detail.

For the most part, light will be considered as photons in this discussion. As stated in Chapter 4 each photon has an energy proportional to the frequency of the light. To record an image, the energy of a photon must be used to alter matter in some way. The systems used for recording optical images are either *photochemical* or *photoelectric*. In a photochemical process, the photon alters the chemical structure of matter so that image information is stored (at least temporarily) in the altered atomic arrangement of the material. In a photoelectric process, the photon alters matter so that an electron is liberated, and image information is stored (temporarily at least) in the liberated electrons. In most processes (both photochemical and photoelectric), the photon first interacts with an electron, causing a redistribution of electrons, but the key difference is the method of information storage.

The photographic process may be divided into three steps: exposure, development, and fixation. This three-part division also is convenient in discussing some other processes. Generally, exposure is the interaction of the photon with matter to form at least a temporary image. Development is a process in which the image is made visible and fixation is one in which the image is made permanent. Consid-

erable amplification of the recorded information may take place during development.

■ THE EYE

The optical system of the eye (see Fig. 6.1) consists of the *cornea,* the *crystalline lens,* the iris, and a transparent viscous fluid called the *vitreous humor* (index of refraction 1.336). The principal imaging of the eye is performed by the cornea which, with the crystalline lens, has a focal length of about 20 mm. One side of the cornea is bounded by air and the other by the vitreous humor, whereas both surfaces of most camera lenses are in air. Furthermore, the retina is curved and is immersed in the vitreous humor. The net result is a one surface lens that can be highly curved and still perform rather well.

The curvature of the crystalline lens surfaces can be adjusted by relaxing and contracting the muscle fibers to which it is attached. The focal length of the adult eye can be varied from approximately 18.7 to 20.7 mm. This adjustment makes it possible to focus both on far and nearby objects. By comparison, the camera lens is moved relative to the film to focus on objects at different distances from the camera. As it ages, the crystalline lens loses it flexibility, and the muscles are no longer able to change its focal length. The system assumes its ''rest'' focal length that focuses the normal eye at infinity and gives rise to *presbyopia* (farsightedness), making eyeglasses necessary for near vision. As the crystalline lens ages it also may

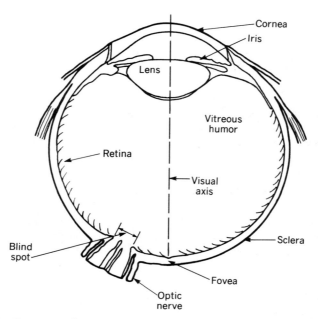

FIGURE 6.1 Diagram of the human eye.

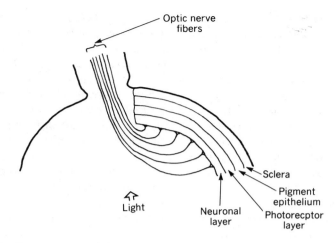

FIGURE 6.2 Cross section of the retina.

become semiopaque resulting in a severe reduction in visual capability. This clouding is called a *cataract* and correction often requires surgical removal of the lens. It is replaced by another lens to form an in-focus image on the retina.

The diameter of the iris of the eye can be adjusted from about 2 to 8 mm by peripheral muscles attached to it. This adjustment normally is an autoresponse that varies inversely with the brightness of the ambient light. In this way the f-number of the eye can be varied from about f/10.4 to f/2.3. The larger f-number increases the depth of field, making it possible for a person to focus on nearer objects in bright light.

The lens system is only moderately well corrected for aberrations. Because the eye is subject to spherical aberration, it performs best when stopped down. In addition, the eye has considerable longitudinal chromatic aberration. Many people cannot focus on a pure blue object unless it is nearby. As a person with a normal eye ages, the asymmetric physical configuration surrounding the eye (primarily eyelids and positioning muscles) causes the spherical cornea to develop a cylindrical component with the axis of the cylinder in the horizontal plane. This phenomenon is called *astigmatism of the eye* and should not be confused with the aberration called astigmatism, which was mentioned earlier in our discussion of aberrations of spherical lenses (Chapter 4). Astigmatism of the eye can also occur as a congenital defect with the axis of the cylindrical component of the lens in any direction in a plane perpendicular to the optical axis of the eye. In most cases the visual aberration can be corrected with eyeglasses.

The eye would have an angle of view of 180° were it not for the limit imposed by the nose, eyebrows, and cheekbones. Even so, the two eyes together provide a horizontal field of view of 180°.

The photodetecting surface, the *retina,* covers more than half of the back surface of the eye. Light enters the retina through a *neuronal layer* (see Fig. 6.2) and activates cells in the *photoreceptor layer.* Some of the photons that are not utilized

in the photoreceptor layer are absorbed by the *epithelium,* reducing back scattered light that otherwise would cause image quality deterioration. The sclera, the tough outer coating of the eye, contains and protects it.

The photoreceptors are divided into two groups: about 120×10^6 *rods* responsible for *scotopic* (dark) vision and about 6×10^6 *cones* responsible for *photopic* (daylight) vision. Although the rods are sensitive to low levels of illumination, they do not distinguish colors and are unable to resolve very small objects. The cones, although unable to respond to low levels of illumination, can distinguish colors and provide for *visual acuity* (the ability to resolve fine detail). Neither rods nor cones are distributed uniformly across the retina. The periphery of the retina is composed primarily of rods, and the region at the center of the retina called the *fovea* (see Fig. 6.1) is composed primarily of cones. The central part of the fovea (a region 2.5 mm or less in diameter) contains about 34,000 cones but no rods. In addition, the neuronal layer is much thinner in the foveal region, and it is in this region that the eye has its greatest acuity and color discrimination. The fovea appears to be covered with a yellow filter called the *macula* whose function is not entirely understood, but may serve to filter out some blue light to reduce scattering and improve vision in the blue part of the spectrum. Because the periphery of the retina is composed primarily of rods, the most sensitive vision at low light level occurs in peripheral vision.

The neuronal layer contains cells that couple the photoreceptors to the *optic nerve* fibers. Because there are only about 800,000 fibers in the optic nerve, several photoreceptors must share a nerve fiber in most instances. However, the individual cones in the fovea do not share optic nerve fibers with other receptors. This undoubtedly is a factor that contributes to the superior acuity of this part of the eye.

Information is transmitted to the brain in the form of electrical impulses. It is not known precisely how the photons generate these electrical impulses in the eye. It is known that the process is photochemical and that a family of chemicals (pigments) called *rhodopsins* contained in the rods are the photosensitive materials responsible for photopic vision. One component of all the rhodopsins is a form of vitamin A, and this is the part of the molecule that absorbs the photon. It is believed that the photon acts to change the structure of the rhodopsin and causes an electrical impulse to be transferred to the optic nerve. The structure of the photoreceptors is peculiar in that the rhodopsin is in the part of the photodetector most removed from the incident light.

Figure 6.3 shows a diagram of a rod in which the triangles near the top of the figure represent the rhodopsin molecules. Light passes through the neuronal layer, enters the rod through the *synaptic terminal,* and is finally detected in a rhodopsin cell, several thousand of which are embedded on platelike disks at the rear of the cell. The *nucleus* is the replicating element of the cell and the *mitochondria* are the energy sources for the cell. They manufacture the molecule *adenosine triphosphate* (ATP), which is also the energy-storing molecule for the cell and the body in general. The process in which the photon alters the rhodopsin is analogous to exposure of photographic film. The process in which the altered rhodopsin generates a series of electrical signals and in which these signals are transmitted to the

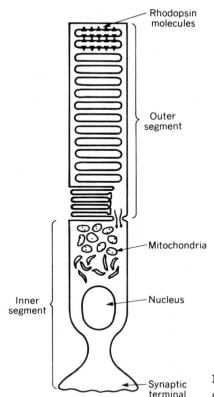

Rhodopsin molecules

Outer segment

Mitochondria

Inner segment

Nucleus

Synaptic terminal

FIGURE 6.3 Cross-sectional schematic view of a rod cell in the eye of a vertebrate.

brain, corresponds to development. Considerable amplification takes place during development in this case. The process of fixation might be likened to memory.

Presumably the cones function in a similiar fashion using different pigments, although the mechanism is less well understood. As stated earlier, the cones make it possible for the normal eye to resolve fine detail and distinguish colors. They are small enough that the resolution of the eye is aberration and/or diffraction limited. The overall spectral responses of the rods and cones are shown in Figure 6.4. Note that the vertical axis is logarithmic and that the two curves are adjusted to the same maximum value. The peak in sensitivity for the cones occurs at 550 nm (corresponding to yellow-green in color) and that for the rods at 510 nm (corresponding to blue-green in color). Because the rods are absolutely more sensitive (at least 1000 times) and relatively more sensitive at the shorter wavelengths, a dimming of the overall illumination (e.g., as storm clouds develop on a bright summer day) gives rise to a phenomenon called the *Purkinje effect*. Greens and blues will appear unnaturally bright compared with the reds when the illumination is suddenly reduced. This may explain the folklore observation that tornadoes are preceded by a green sky because rapid and intense clouding frequently accompanies tornadoes.

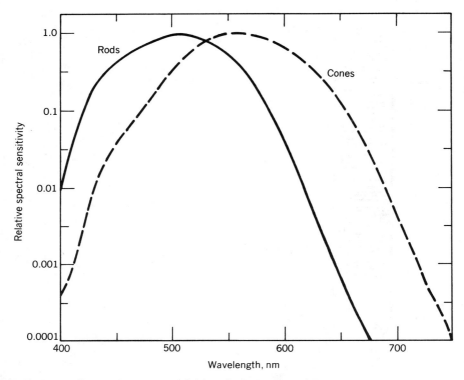

FIGURE 6.4 Spectral response of the rods and cones of the human eye.

In the normal eye (as opposed to the color blind eye), the cones can be classified by kind of pigment into three groups. These pigments have different spectral responses (see Fig. 6.5). Although these curves overlap considerably, the pigment and those cones with the greatest relative response at the shortest wavelength will be called blue (B), those with the maximum at intermediate wavelength green (G), and those with the maximum at long wavelengths red (R). The blue cones are about one-tenth as sensitive as the red and green cones. Presumably color is assigned on the basis of the relative stimulation of the three kinds of cones.

How versatile is the eye? Among mammals, some primates have competent color vision. Otherwise, color vision is limited to some diurnal birds and reptiles, some fish, mollusks, and crustaceans. The absolute sensitivity of the human eye is exceeded only by the eyes of certain carnivores, and its ability to resolve detail is exceeded only by the eyes of some predatory birds. A fully dark adapted eye can respond to a minimum flux of about 10^{-16} w/cm^2. This is equivalent to approximately 1000 relative short wavelength blue-green quanta passing through a square centimeter in one second. If this amount of energy was absorbed by one gram of water for 150 million years, the temperature of the water would increase only one degree centigrade provided no energy is lost from the water. If the sensitivity of the eye is considered in terms used to describe the sensitivity of film (ASA film speed), the dark adapted eye for a 1/60 sec exposure would have an ASA film

speed of 16 million. If the exposure is extended to 1/2 sec, the ASA film speed increases by a factor of 10. The cones (photopic vision) are 1000 times less sensitive than the rods (scotopic vision).

The iris controls the amount of light reaching the eye over a range somewhat greater than four stops (20:1); not nearly as great as a typical standard SLR camera lens (at least six stops). However, the threshold sensitivity of the retina changes with ambient light level over a range of 10,000:1. In Chapters 7 and 8 it will be shown that the sensitivity of film (film speed) can be changed by altering development, but this change is limited in practice to a factor of about four. This change in threshold sensitivity of the eye, called *adaptation,* typically occurs in less than 1/10 sec under daylight conditions, but full dark adaptation typically requires about 45 minutes. Because the cones adapt instantly under daylight conditions, brightness and color seem to remain constant under varying light conditions at these light levels.

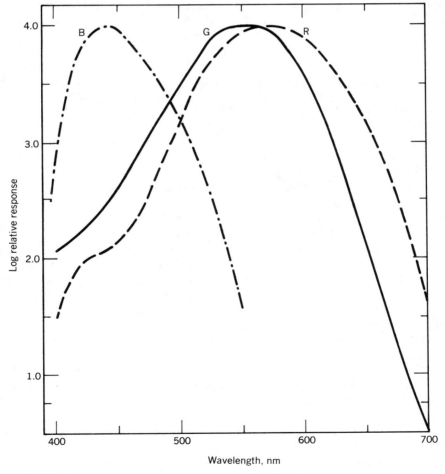

FIGURE 6.5 Relative spectral responses of each of the three pigments in the cones.

If a scene or a test object is illuminated at a daylight level, the eye can discriminate among different *luminances* over a range of about 1000:1. The best that can be achieved in a black-and-white print is a range of less than 100:1, and in a black-and-white transparency the range is about 200:1.

The resolving capability of the eye is very high compared with the *resolving power* predicted by the aberration limitations of the eye. The increased acuity is due to constant scanning of a scene by the eye. Apparently a more detailed mental construct of the scene is formed by comparing the stored information of these multiple scans.

■ OTHER PHOTOCHEMICAL RECORDING PROCESSES

The photographic process is photochemical. A silver halide grain, made up of an ordered array of silver and halide atoms (e.g., chlorine), on exposure to light is struck by several photons. An incident photon breaks the bond holding together a silver and chlorine atom in the array, and consequently, a silver atom becomes lodged with other silver atoms on the surface of the grain. This tiny speck of silver on the grain's surface retains the information that light has exposed this part of the film. The image would not be visible to the eye even if it could be viewed in light.

In the development step, the entire exposed grain is converted to a grain of silver. Those grains that were not exposed to light are not converted to silver. Thus, a visible negative image is formed. Because the unexposed silver halide grains are still sensitive to light, it is necessary to remove them or convert them to some compound that is insensitive to light. In the normal fixing process, the unexposed silver halides are removed. The development step is one of great amplification which is nearly unique among photochemical processes. Only the photochemical process in the eye has greater amplification in its development phase. The photographic process will be discussed in more detail in the next chapter.

One of the older photochemical processes, the *blueprint* process, is commonly used to copy line drawings. This is one of several processes in which ferric salts are reduced to ferrous salts on exposure to electromagnetic radiation. In one form of this process, the paper is coated with ferric ammonium citrate and potassium ferricyanide. The paper is then exposed by shining a very bright light through tracing vellum until a faint image is formed. Where light strikes the paper, the ferric compound is reduced to a ferrous compound. When the paper is immersed in water for development, the ferrous compounds are converted to a blue-colored cyanide compound $Fe_4[Fe(CN)_6]_3$, resulting in a negative image. No fixing is necessary, although the image is not particularly stable over long periods of time. A positive can be made by this process using somewhat different chemistry. The development step of the blueprint process causes a color change, but little if any amplification occurs compared with that which occurs in silver halide development.

The *diazo process* is another photochemical process used extensively in copy work. In one form, a selected diazo compound (a member of a class of organic chemicals), a development control substance (usually an acid), and a *coupler* are

applied to paper to construct the image forming medium. The diazo compound, when exposed to ultraviolet or violet light in the right chemical environment (e.g., a base), is converted to a nearly colorless compound. In that same environment, the unexposed diazo compound combines with the coupler to form a colored azo dye. Exposure is through the transparent or semitransparent original. The control substance normally inhibits the coupling process. However, a base such as ammonia vapor is used to neutralize the acid control substance during exposure. Those parts of the sensitized paper exposed to the light will be colorless, and those parts that are unexposed, due to opaque areas on the original, will become colored. Exposure and development may be concurrent, although exposure and development are separated in some systems. A color change takes place during development, but very little amplification occurs compared with that which occurs in silver halide development. No fixing is necessary, although the diazo print is not very stable for long periods of time.

In the *thermographic process,* the original is exposed to long wavelength radiation (infrared). The copy paper is sensitized with a material whose chemical composition and color are changed irreversibly on heating. Because the dark areas of the original absorb more radiant energy than the light-colored areas, the copy paper in contact with the original is heated more in these areas, a color change takes place, and a positive copy is formed. The process is photochemical, but the interaction of the photons is not with individual atoms in the photosensitive medium but with aggregates of atoms, and exposure and development occur in a single step. No fixing step is used, although the final copy is not stable for long periods of time. A color change takes place in this development step, but no amplification occurs.

■ PHOTOELECTRIC RECORDING PROCESSES

Photoelectric recording will be divided into two classes for this discussion. The first is *xerography* in which an image is made on a piece of copy paper, and the second is electronic recording, the video camera being a common example. In all of these processes, a *photoconductor* or a *photoemitter* is used as the photosensitive material. Photoconductors act as insulators in the dark but behave like electrical conductors when exposed to light. Photoemitters, on the other hand, are materials that emit electrons when exposed to light, especially if the material is in an evacuated vessel and if an appropriate electric voltage is applied to the photoemitter.

In xerography, a photoconducting material such as selenium coated on a metal plate (frequently in the form of a drum) acts as the photosensitive recording material. The process is shown schematically in Figure 6.6. The metal drum is passed under a corona wire at high voltage. The electric field surrounding the wire causes a charge to accumulate in the selenium (Fig. 6.6a). Exposure (Fig. 6.6b) takes place when light reflected off the original illuminates the drum. The bright areas of the original reflect considerable light onto the drum, causing the drum to conduct, and the induced charge is neutralized. The dark areas reflect little light, and the charge is retained in these areas. In the development step (Fig. 6.6c), carbon black com-

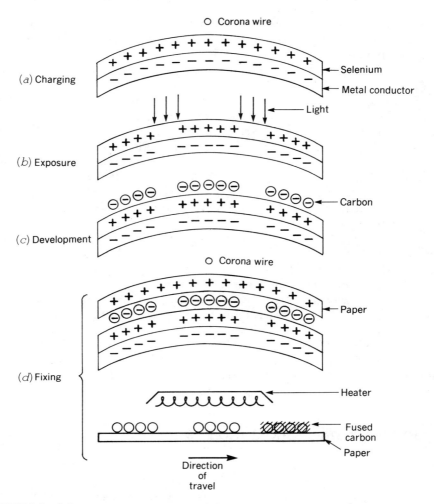

FIGURE 6.6 Schematic representation of the xerographic process.

bined with a heat-sensitive resin or some colored synthetic resin powder is dusted onto the drum. The powder, charged by friction, sticks to those parts of the drum that are charged. When an electrostatically charged piece of paper is placed in contact with the drum, some of the charge powder is transferred to the paper (Fig. 6.6*d*). The fixing process is completed by passing the paper under a radiant heater that melts the resin and fuses the powder to the paper. The process, at various stages, utilizes the principle that unlike charges attract and like charges repel each other.

Xerography works well in copying line material and the printed page, but it does not copy large dark areas well, because the retained charges in these areas repel each other and build up at the perimeter of the dark area. The absence of charge,

and hence powder, in the center of such areas causes them to be light. The copy is positive and reversal of right and left is usually managed by reflecting the light from the original onto the drum by a mirror. It can be shown that little if any amplification occurs during the development process in the sense that amplification takes place during the development of a silver halide.

All video camera tubes have one unique feature compared with all of the recording systems thus far discussed. The image formed on the photorecording surface is scanned by some means and is recorded serially in time. In the domestic commercial television system, this scanning time is about 1/30 sec. During that time, a probe (frequently an electron beam) scans the image on the recording surface point by point, scanning continuously, horizontally from left to right starting in the upper left corner of the image. When the probe reaches the right side, it is returned to the left side and stepped down for a second scan. Five hundred twenty-five horizontal scans are required to complete the picture, although the vertical spacing of the scans is such that the tube is scanned twice in each 1/30 sec interval. The sequence is shown schematically in Figure 6.7.

The information is processed electronically and may be used to modulate an electromagnetic wave transmitted through space to a compatible television receiver. Alternatively, the information may be recorded on video tape (somewhat like the tape used in an audio cassette recorder). This is somewhat analogous to taking a picture using a camera with a focal plane shutter. The recording of the image is spread in time in both instances. However, the image is not necessarily spread in time in the case of the photographic record. For example, a camera with a between-the-lens shutter could be used to record the image. This spread in time is not necessary for the video record; however, to achieve resolution comparable with that achieved in the serial recording process, the order of 3×10^5 (525^2) probes would be needed to make an instantaneous record. This is not technically practical. Just as in the case of the focal plane shutter, this scanning technique places some limitations on the use of video recording systems (e.g., distorted images due to movement during the scan) although the limitation is, in many instances, minor.

FIGURE 6.7 Schematic for the scanning sequence of domestic commercial television cameras.

FIGURE 6.8 Schematic diagram of an image orthicon video camera tube.

Many different kinds of video camera tubes have been used during the development of commercial television.[1] The *image orthicon* represents a fairly modern example of those tubes that use photoemitters to record an image. In this device, the image of the object (see Fig. 6.8) is focused on a photocathode inside an evacuated glass envelope. The photocathode is a thin element coated with a photoemitter such as one of the more active metals (e.g., sodium). The photoelectrons emitted by the photoemitter are accelerated by an appropriate voltage to a target screen. The number of photoelectrons at each point on the target is proportional to the number of photons illuminating a corresponding spot on the photocathode. An electron beam scans the target point by point and neutralizes the photoemitted electrons. This neutralization modulates (reduces) the return electron beam in proportion to the number of photoelectrons that are located at each spot on the screen. This modulated beam is amplified by an electron multiplier, and the resultant electrical signal used to record the video information on tape or to modulate a television signal.

Exposure might be likened to the part of the process involving illumination of the photocathode and the transfer of the photoelectrons to the target. Development corresponds to the scanning of the target and the electron amplification. Fixing corresponds to recording the information on tape. In this system considerable amplification takes place during the development step.

The *vidicon* (see Fig. 6.9) is an example of a video camera tube that uses a photoconductor to record a light image. An optical image is focused on a photoconductive target inside an evacuated envelope. In the dark the electrons in the photoconductor are immobilized because they are tied to the atoms of the photoconductor (e.g., cadmium sulfide). When a photon strikes the photoconductor, an electron inside the material is freed so that it can move about, and the local region where the electron has been freed becomes a conductor. However, to gen-

[1]A. R. Rose, *Vision: Human and Electronic,* New York: Plenum, 1973, p. 55ff.

FIGURE 6.9 Schematic diagram of a vidicon camera tube.

erate an electrical signal a current must flow, and this requires a circuit with a voltage across it. The ciruit is completed by the scanning electron beam under the influence of an appropriate potential.

The amount of current is proportional to the number of excited photoelectrons (and hence photons) generated at each point on the photoconductor. As the beam scans, the current is proportional to the number of photons that have struck each point on the photoconductor. This varying signal is amplified and recorded on tape or used to modulate a television signal. Exposure in this system corresponds to the liberation of the photoelectrons in the photoconductor; development corresponds to the formation of the current by the scanning beam and the subsequent amplification of the signal; fixing corresponds to recording the image on tape. Again, considerable amplification takes place during the development step.

The two devices discussed above depend on an electron beam in an evacuated envelope to do the scanning. Special solid-state devices belonging to the family of *integrated circuits* are another group of devices for recording optical images. In an integrated circuit, an entire electrical circuit is fabricated on a single piece of support material (frequently a wafer of silicon, sapphire, or glass). Fabrication involves evaporation and/or ion implantation of metals and insulators onto the wafer through appropriate masks together with heat treatment of the assembly. Using such techniques, photoconductors, amplifiers, and switches can be incorporated on one wafer (see Fig. 6.10). This class of photodetectors includes *self-scanned arrays* and *charge-coupled devices.*

The photoconductive surface used to record the image is not continuous but is made up of a series of discrete spots electrically isolated from adjacent elements. For example, the detector on the upper wafer in Figure 6.10 consists of a square array of spots; there are 256 elements on a side covering an area of a little more than one square centimeter. Each element of the photodetector records an electrical signal proportional in amplitude to the number of photons striking that element. The array is scanned electronically instead of using a scanning electron beam. The electrical signal is amplified using solid-state elements, and the amplified

1.3 cm

FIGURE 6.10 Photograph of integrated thin film sensor deposited on two glass wafers (center). The wafers are mounted on a circuit board and the dark lines are electrical connectors fabricated on the board. (Courtesy Paul K. Weimer)

signal can be recorded on tape. Considerable amplification takes place during development (the scanning and solid-state amplification step).

■ COMPARISON OF LIGHT RECORDING SYSTEMS

These various recording systems could be compared point by point. The characteristics on which the systems might be judged would include sensitivity to light, ability to resolve detail, capacity for storing a large amount of information, ability to record a range of luminances, ability to form and produce an image quickly, long-term stability, spectral response, cost, and convenience. Such a discussion might consider ultimate or state of the art capability. The comparison would be found to depend on the particular mode in which the system was being judged. For example, the ability to record a range of luminances is quite different for photographic film and photographic paper. The comparison will be made on the basis of the strengths and weaknesses of each process in current state of the art systems.

If photoemitter and/or photoconductive devices are considered part of a television system, it is concluded that the major assets of such a system are very high

sensitivity (ability to form images at very low light levels) and ability to produce an image almost instantaneously. The ultimate sensitivity of the video camera is an order of magnitude more sensitive than its next competitor, the eye. In most other respects the system is no better than the silver halide process as used today.

The main asset of xerography is that the process is inexpensive, convenient, and quick. Other attractive features are that ordinary paper can be used as the support medium and that the process is a dry one. However, compared with good photographic images, the quality of the xerography image is very poor. Thermography, once a competitor of xerography, is in most ways inferior to it and hence, has become almost obsolete.

Historically, the blueprint process and to a lesser extent the diazo process have been used primarily to copy line drawings. This is what they are best suited for and are still used for today. The process is inexpensive, quick, and can accommodate and copy large originals at one-to-one magnification. In most other respects, the process produces a product which is inferior to that of the silver halide process.

When the silver halide process is judged on the basis of criteria mentioned at the beginning of this section, the process appears to be very competitive. Its sensitivity is exceeded only by the eye and some of the photoelectric processes. Its resolution might be exceeded in principle by some of the photoemitter/photoconductor devices but is not in any practical system. The silver halide process has a capacity greater than any of the systems mentioned. The process can record a considerable range of luminance (although it doesn't match the eye) and the photoconductor/photodetector devices are more linear in this respect. The long-term stability of its copy is probably the best of any of the systems discussed.

In current usage, the *spectral response* of the silver halide process is better than any of the other systems discussed here. It is not the least expensive process and, with the increase in the price of silver, is becoming more expensive. However, if cost is a factor, most of the silver can by recycled. Perhaps its greatest limitations are the inconvenience and time required to develop and fix the image. The process is basically wet and must be performed in the dark. However, it is easy to see why the silver halide process has survived and why it is likely to be used for some time to come.

The eye has been compared with these various processes. The retina-brain recording system is superb, and in many ways it is better than any of these other processes. Unfortunately, no way is known to isolate it and duplicate it as a recording system independent of a human being. One might wonder if some organic system might someday be synthesized which would displace these other processes (including the silver halide process). All that can be said now is that this hasn't been done, and at present, the silver halides are as good as anything available.

EXERCISES

6.1. Discuss the optical limitations of the eye. What unusual features of the eye, compared with a camera lens, reduce these aberrations?

6.2. Compare the focusing mechanism of the eye with that of a camera.

6.3. What are the main defects that can occur in the eye, either as a consequence of congenital defects or aging?

6.4. Compare the way in which sensitivity in the eye and the camera are varied? How do the threshold sensitivities compare?

6.5. Describe the function and distribution of the rods and cones of the eye.

6.6. Designate the ''development'' step in each of the following systems: the human eye, the silver halide process, the blueprint process, the diazo process, the xerography process, the television recording process. Compare the amplification in the ''development'' steps of these processes.

6.7. Still video camera systems are now or soon will be marketed. How does this recording system compare with still photography as a recording medium? List the advantages and disadvantages of each system.

6.8. For what kinds of image recording is the diazo process superior to the photographic process? In what instances is the opposite true?

6.9. Compare the relative merits of xerography and photography for recording images.

chapter ·7·

The photographic process

This chapter describes the structure of photographic film and paper, outlines the photographic process, and considers in detail the way in which an image is formed.

■ STRUCTURE OF PHOTOGRAPHIC MATERIALS

The base (see Fig. 7.1) for film is usually a transparent, flexible organic material, although glass still is used for some applications. Originally cellulose nitrate was used as a base for flexible film, but because of its high flammability and general chemical instability, it has been replaced by more stable organic materials. Today, polyethylene terephthalate is the material of choice (Dupont calls this material Cronar and Eastman calls it Estar). It is quite stable chemically and dimensionally and yet flexible enough to use in roll form.

The light-sensitive silver halide crystals and other essential chemicals are incorporated in a thin gelatin layer attached to the substrate. Frequently, more than one photographically active layer must be used in a given film to achieve a desired photographic end. For example, high-speed black-and-white films usually have at least two light-sensitive layers. These light-sensitive layers are referred to as the *photographic emulsion.* A top layer of gelatin protects the emulsion from mechan-

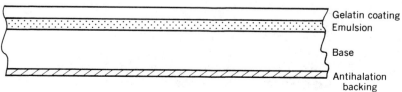

FIGURE 7.1 Structure of photographic film.

ical damage. When light is incident on a film, some is absorbed by the silver halide *grains,* some is scattered by the emulsion, and some reaches the backing where it can be reflected or transmitted. Any light reflected back into the emulsion at the rear surface may be absorbed by silver halide crystals causing image deterioration. To reduce these reflections, the back surface of the base frequently is coated with an *antihalation backing,* which absorbs any light reaching that surface. The coating is removed during development and does not interfere with the printing process. If a point light source (e.g., a streetlight on a dark night) is photographed using a film having no antihalation backing, a halo will be formed around the image of the light source by light reflected from the back surface of the base — hence the term antihalation.

The paper base of photographic printing material may or may not be coated with a resin to inhibit the absorption of water (and other chemicals) into the paper fibers. The front surface of the paper frequently is coated with an intensely white compound (barium sulfate) that improves the reflectivity of the paper. The emulsion, which may be multiply layered, is the next layer, with a protective layer of gelatin forming the top coat.

Emulsions for film and paper are similar but differ in detail. The vehicle is a *colloid,* almost always gelatin, which (among other things) provides mechanical support for the silver halide crystals. The photosensitive material is one or more of the light-sensitive silver halides [silver chloride (AgCl), silver bromide (AgBr), and silver iodide (AgI)] which will be designated generically as AgX. In addition, *sensitizing agents* (primarily sulfur compounds) are incorporated in the gelatin and act at the surface of the AgX grains to make the emulsion more sensitive to light. The light reflected from a print passes through the emulsion twice, but light projected through a transparently backed negative passes through only once. Hence, emulsions on paper are thinner than those on film. Both are very thin compared with the thickness of the support.

Typically, AgX occupies about 12 percent of the total volume of the emulsion in negative material and about half that amount in paper. Of the three silver halides, AgI is most sensitive to light, whereas AgCl is the least sensitive. Because film needs to be more sensitive to light than paper, AgBr and AgI might be expected to predominate in film, with AgCl and AgBr being more common in slower working paper. However, AgI fixes very slowly and this severely limits the amount and form in which it can be used in emulsions. The grains of the silver halides may contain AgI in the form of mixed crystals of silver bromide and iodide. From 30 to 95 percent of the AgX in paper emulsion is AgCl; the remainder is AgBr. The faster papers contain more bromine.

The sensitivity of film is determined primarily by controlling the size of the grains in the emulsion. Grain size is determined primarily in two manufacturing steps called *emulsification* and *ripening.* In the former operation, the crystals of AgX are precipitated as a dispersion in the gelatin, and in the latter step the size and size distribution are altered by a heating cycle prior to flowing the gelatin onto the base. The distribution in grain size plays a major role in determining the contrast of film and paper. If all of the grains are the same size, the film tends to be of high contrast.

The mean diameter of the grains in fine grain roll film is about 800 nm, and those in high speed roll film have a mean diameter of about 1100 nm.

The silver halides are sensitive to blue light and to other electromagnetic radiation of higher frequency. The photons corresponding to light of longer wavelength (lower frequency) do not have enough energy ($E = hf$) to alter the structure of the AgX permanently and form a latent image. Silver chloride ceases to be sensitive to light at shorter wavelengths than does silver iodide. Silver bromide, which is intermediate between the two in long wavelength cutoff, does not absorb light at wavelengths longer than about 500 nm. A mixed crystal composed of 3 percent AgI and 97 percent AgBr does not absorb light at wavelengths longer than 540 nm. To make the silver halides sensitive to light in other parts of the visible spectrum, polymethine dyes are added to the emulsion, where they adsorb to the surface of the silver halide grains. If the added dyes extend the sensitivity into the green part of the spectrum, the films are called orthochromatic. Those emulsions that have been sensitized to all of the visible part of the spectrum are called panchromatic.

■ OUTLINE OF THE PHOTOGRAPHIC PROCESS

The standard photographic process can be summarized in the following way. Film or paper is exposed in a camera or enlarger. Those grains of AgX that absorb a sufficient number of photons generate small specks of silver on the surface of the grains *(development sites)*. Those that are inadequately illuminated are unchanged (see Fig. 7.2a). This collection of exposed grains is the latent image. If the emulsion could be viewed at this stage of the process, no image could be detected with the unaided eye because the silver specks would be too small.

The film (or paper) is then developed using a selective reducing agent *(developer)* that converts to pure silver those grains of the latent image (see Fig. 7.3b). The specks of silver act as *catalysts* in the development process. The developer is an electron donor, and in the development process, electrons are attached to positive silver ions to form silver atoms.

If the remaining silver halide atoms are not removed or made insensitive to light, subsequent long-term exposure to light will convert them to silver, ruining the image. In the fixing process, those unexposed, essentially insoluble, silver halide compounds are converted to water soluble compounds that are washed out of the emulsion (see Fig. 7.2c). The fixer or hypo (see Chapter 1) may contain an acid to stop the development, or a stop bath may be used between the developing and fixing steps. The fixer must be chosen so that it converts the unexposed silver halides to water soluble compounds but does not dissolve the silver of the image.

Finally, the film or paper is washed to remove the by-products of the developing and fixing processes. If this is not done, the by-products will, in time, strain the emulsion and degrade the image. Because the fixer is difficult to remove from the film or paper, a *hypo eliminator,* which converts some of the fixing by-products to colorless stable compounds, sometimes is used to make the image more permanent. This is especially important for images that are to be archival in nature.

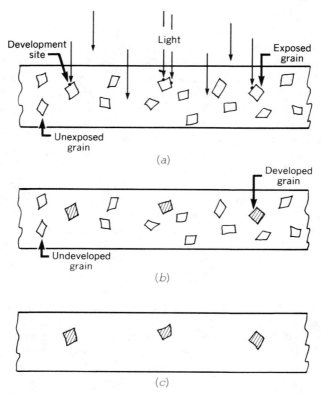

FIGURE 7.2 Exposure (a), development (b), and fixing (c) of a photographic emulsion.

■ STRUCTURES OF AGX GRAINS

In solid form the silver halides are classified as *crystals*. A perfect single crystal is an ordered array of atoms so arranged that the position of all atoms in the crystal can be predicted when the location of a selected few is known. Silver chloride and silver bromide are arranged so that the silver atoms are at the corners and on the centers of the faces of a cube (see Fig. 7.3). The halide atoms are similarly placed. The corner of their cube is at the center of the cube used to describe the position of the silver atoms. Such a crystal is a member of the class of *face-centered cubic* (fcc) crystals. The entire crystal can be visualized by repeating the structure shown in Figure 7.3 in all three directions (note the arrows). If silver chloride and silver bromide are precipitated simultaneously, mixed crystals of fcc structures may be formed in which the halide sites are populated by either chlorine or bromine. Silver iodide at room temperature and atmospheric pressure forms in a different struc-ture. In the small concentration of AgI of interest here, however, mixed crystals of silver bromide and silver iodide form in the fcc structure.

FIGURE 7.3 Structure of silver chloride and silver bromide (○—silver atoms, ●—halide atoms).

The spacing between silver atoms along the edges of the cube, which varies with the halide concentration, is 0.55 nm for pure silver chloride. The shape of the crystals depends on the precipitation procedure. They may be cubic, octohedral, tabular, or irregular. However, the internal structure is always as shown in Figure 7.3. Because typical grain is about 1000 nm in diameter, it will contain approximately $(1000 \times 10^{-9}/0.5 \times 10^{-9})^3 = 8 \times 10^9 (=) 10^{-10}$ face-centered cubes like that shown in Figure 7.2, and about 3×10^{10} each of silver and halide atoms.

If enough light strikes such a crystal, the silver halide will be converted to silver and the grain will appear black. It will, so to speak, print-out. Although the amount of light required to do this is very great, most printing papers were developed this way until the latter part of the nineteenth century. In the normal photographic process, as few as four silver atoms will collect as a speck of silver on the surface of the grain to form a development site (see Fig. 7.2a) and make it developable. In the development process, the remainder of the silver in the exposed grain is converted to metallic silver. Thus, the development step becomes one of great amplification with a gain, in principle, of the order of 10^{10}. The actual gain is an order of magnitude less.

These crystals are held together by *electrostatic forces*. The simplest such force is the attraction of objects with unlike charges (positive and negative) or the repulsion of objects of the same charge (Fig. 7.4). The simplest picture of the structure of an atom is a variation of the *Bohr model*. In this model, the atom consists of a positively charged heavy *nucleus* containing *protons* and *neutrons* surrounded by a cloud of light negative *electrons*. The models of the atoms for silver and bromine are shown in Figure 7.5.

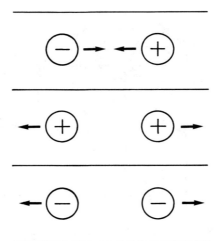

FIGURE 7.4 Unlike charges are attracted to each other, whereas like charges repel each other.

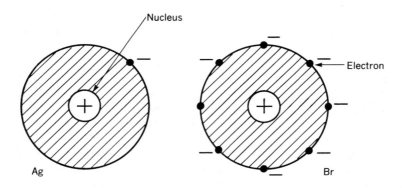

FIGURE 7.5 Bohr model of silver and bromine.

When the number of electrons equals the number of protons (and because the neutrons are neutral), the total charge of the atom is zero. The electrons can be pictured as confined to shells much like the layers of an onion. The outermost layer in silver contains only one electron, whereas the outermost layer of bromine contains seven electrons. When silver and bromine are in close proximity, as in a crystal, the odd silver electron is not held very tightly and is transferred to the bromine atom. This is the basis for holding the crystal together. After the transfer, the silver has a net positive charge and the bromine a net negative charge; both are called *ions*.

Real crystals do not have the ideal structure described earlier. Because of errors at the time of formation of the crystals and thermal excitation after formation, certain rows of ions are out of alignment, some twisting of the lattice occurs, some ions are missing, and some individual ions are wandering between rows of ions. These errors are known collectively as *dislocations* and *defects*. A very important defect called a *Frenkel defect* occurs when a silver ion is jarred from its normal lattice site and becomes a wanderer (*interstitial*) between the rows of the lattice. These ions play an important role in the formation of the latent image. The empty space left behind is called a *vacancy*.

■ FORMATION OF THE LATENT IMAGE

Gurney and Mott in 1938[1] postulated a model for the formation of the latent image which, with refinements, is still considered valid, because it is consistent with many varied experiments that have been performed to test it. It is assumed that when a photon enters a silver halide crystal, the photon interacts with the loosely bound electron (see Fig. 7.6a), freeing it (Fig. 7.6b) to wander through the lattice. This process leaves a net positive charge at the site from which the electron came. The wandering electron may be recaptured by the site from which it came, a similar site, or some other site that has an affinity for electrons. If the electron is captured internally, it probably does not contribute to the formation of the latent image.

The sensitizing agents in the emulsion mentioned earlier become a factor at this point. It is postulated that the sulfur from these compounds combines with silver atoms on the surface of the grain to form Ag_2S. Because the region around Ag_2S is more attractive to an electron than the region around AgX, it represents a more favorable site for localization of the electron and a possible site for the formation of the needed speck of silver metal on the surface of the grain. Assume that the electron under consideration does localize at such a surface site. This is shown at the lower left of Figure 7.7 in a two-dimensional model of the lattice.

In Figure 7.7, positive charges are assigned to the silver ions in the lattice and negative charges to the halide ions, because the halide attracts the outer electron of the silver atom. Near the center of the crystal, one halide ion is shown as neutral. This represents the site from which the electron was ejected by the photon. This absence of an electron is called a *hole* in the language of solid-state physics. An electron attached to a nearby halide atom may migrate to this site and in so doing cause the hole to move as shown by the dotted lines in Figure 7.7.

The net effect of this process is to place a neutral halide atom on the surface of the crystal (see Fig. 7.7 at the upper right). This step is symbolized in Figure 7.6c. The gelatin contains compounds (including sulfur compounds) that are very attractive to the halides. Because this surface halide atom is no longer bound, it can combine easily with the additives to form stable halide compounds in the gelatin (see Fig. 7.6d).

[1]R. W. Gurney and N. F. Mott, *Proc. Roy. Soc.* (London), *A 164*, 151, 1938.

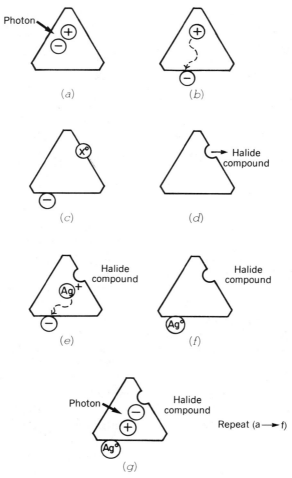

FIGURE 7.6 Schematic description of the formation of the latent image.

The next step in the process involves an interstitial silver ion, which probably exists as a consequence of the formation, at the time of the precipitation (or ripening) of the grain, of a Frenkel defect. This ion, shown at the upper left in Figure 7.7, is prone to wander because of thermal excitation. However, the ion is too large to wander between the other atoms and moves instead (dashed arrows at left in Fig. 7.7) by displacing silver ions in the lattice, which in turn become interstitials. In the absence of any attractive forces, this wandering is random. However, the electron localized near the Ag_2S represents a small source of attraction because unlike charges attract each other; the interstitial silver ion and the localized electron represent uncompensated charges in this part of the crystal. If the silver ion is close enough, it moves to the electron (Fig. 7.6e and 7.7) and the two neutralize each other (Fig. 7.6f) forming a neutral silver atom on the surface of the crystal.

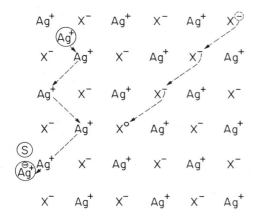

FIGURE 7.7 Two-dimensional model of AgX lattice.

A second photon can now reinitiate the process (Fig. 7.6g), and all of the steps can be repeated. A single neutral atom of silver on the surface of a silver grain is not very stable and may easily be reionized. If the above process is repeated in a short period of time so that as few as four atoms of silver are formed at the Ag_2S site, however, the speck of silver probably will be stable, and the grain will be made developable. A collection of such stable developable grains forms the latent image. If no light strikes the grain, no speck of silver is formed, and the grain will not be developed easily.

If considerable sulfur is present in the gelatin, many localized sites may form on the surface of the grain, and the resulting competition for electrons may prevent the formation of a stable speck of silver on the surface of the grain. Because four atoms of silver in one place on a grain are needed to make a grain developable, the number of developable grains is not proportional to the light intensity at low levels of illumination. Furthermore, when the illuminance is very great, so many electrons are released and so many holes formed that some electrons and holes may recombine internally. This prevents the electrons from reaching the Ag_2S on the surface of the grain, and the formation of developable grains is again not proportional to the illuminance. This lack of proportionality is aggravated further at the Ag_2S sites because each of these can accommodate only one electron at a time. The electrons have to wait in line, so to speak, increasing the probability that they will recombine internally. For a more detailed discussion of the formation of the latent image see the Slifkin article.[2]

■ DEVELOPERS

To develop an emulsion so that the latent image is converted to a visible image, a *reducing agent* must be chosen that reduces to silver those grains that have been exposed to light and leaves intact those grains that have not been exposed. This

[2]L. M. Slifkin, *Sci. Prog. Oxf., 60,* 151–167, 1972.

FIGURE 7.8 Structure of benzene (a) and the developers hydroquinone (b), p-Aminophenol (c), and p-Phenylenediamine (d).

ideal is not practically achievable, because some unexposed grains are always developed, giving rise to a background *fog*. Some of this fog is caused by grains that have been stimulated thermally or stimulated by penetrating radiation to become an unwanted part of the latent image. If the film is left in the developer long enough at a sufficiently high temperature, all of the silver halide will be converted to silver. To achieve proper development, the appropriate developer must be used at the correct temperature for the specified time. Both *inorganic* and *organic* compounds can be used as developers, but today the materials of choice are primarily organic aromatic compounds, which are derivatives of benzene.

Benzene (C_6H_6) is a hydrocarbon with six carbon atoms attached to each other and a hydrogen atom attached to each carbon atom (see Fig. 7.8). Each bar in the diagram represents a chemical bond. The organic developers are formed by replacing the attached hydrogen atoms with appropriate groups such as *hydroxyl* (OH) or *amino* groups (NH_2). These are shown in Figure 7.8b–d, where the diagram has been simplified by omitting the symbols for carbon and hydrogen. These developing agents can be classified in three broad groups. The first includes the di- and polyhydroxyl compounds, which includes hydroquinone (see Fig. 7.8b). The second group is composed of the amino hydroxy compounds of which p-Aminophenol (Fig. 7.8c) is an example. The third group includes the di- and polyamino compounds, one of which is p-Phenylenediamine (see Fig. 7.8d).

The amino compounds are shown as free bases, but they usually are sold commercially in the form of salts that are more stable and more easily dissolved in water. For instance, p-Aminophenol is marketed in sulfate form under the trade names Kodak Elon (Eastman Kodak) and Metol (Harshaw Chemical Co.). There are other important organic developers (e.g., Phenidone,, manufactured by Ilford Chemical Co., Ltd) that are not in the above categories. For a more complete discussion of developing agents, see Carroll, Higgins, and James.[3]

[3] B. H. Carroll, G. C. Higgins, and T. H. James, *Introduction to Photographic Theory.* New York: John Wiley, 1980, p. 196ff.

A developing agent in water solution forms hydrogen ions. The concentration of these ions, of which *pH* is a measure, controls the rate at which the developer reduces the silver halide to silver. The hydrogen ion concentration can be controlled by including an alkali in the developer at the time of manufacture. Such alkalis are called *accelerators,* and common examples are sodium or potassium hydroxide, sodium or potassium carbonate, and sodium borate compounds. Sodium carbonate is the familiar washing soda and borax is a commonly available borate compound. In addition to adjusting the pH of the solution, the accelerator acts to stabilize the pH level during the life of the developer.

A *sulfite* compound (e.g., sodium sulfite) sometimes referred to as sulfite is usually included in a developer. The main functions of the sulfite are to act as a scavenger of the spent developer and as a preservative inhibiting *oxidation* by the oxygen in the air. When the developer reduces the silver halide to silver, the developer becomes oxidized. This spent developer alters the rate of development, which is usually undesirable. Compounds formed by the reaction of the sulfite with the spent developer (frequently sulfonates) may affect the development process but in a more controlled way than the oxidation products themselves. Although sulfite does react with oxygen from the air to limit oxidation of the developing agents, the mechanism is not totally understood. Sulfite also can act as a mild solvent for the silver halide grains, which is important in certain fine-grain developers.

Finally, most developers contain a *restrainer* (e.g., potassium bromide) that acts as an antifogant. As development proceeds, bromide in the vicinity of the developing grain tends to retard development. However, the retardation varies inversely with the rate of development. Heavily exposed (and rapidly developing) grains are retarded less than slowly developing grains. Because fog is a consequence of the development of unexposed grains, a small amount of bromide is most effective in preventing the formation of fog. Unfortunately, a large concentration of bromide promotes the dissolution of the silver halide which, in solution is more easily developed than in granular form, and this can contribute to fog.

■ DEVELOPMENT

Historically, the development process has been presented in terms of *physical development* and *chemical development.* Generally, physical development refers to a process in which the silver halide is first dissolved and then converted in solution to silver. Strictly speaking, the silver halide in solution may come from the grain or be incorporated in the developer at some other stage in the process. James[4] calls this *solution physical development.* Chemical development refers to a process in which the silver halide in the grain is converted directly to silver. James refers to this as *direct development.* Both kinds of development can take place in the normal development of a latent image.

[4]Carroll, p. 226ff.

In either kind of development, the developer, by donating electrons to the silver halide, breaks the bond between the silver and the halide, allowing the silver to combine with other silver atoms to form a grain of silver. The silver speck of the latent image probably acts as a *catalyst* for the development process and as a nucleus for the formation of the grain of silver.

Because the developer contains no silver halide, it must first dissolve some of the silver halide if solution physical development is to occur. The rate at which this dissolution takes place depends on the kind of developing agent used and the additives in the developer. Apparently, the silver speck of the latent image promotes the dissolution of the silver halide from the exposed grain. If the developer is very active and/or the development time is extended sufficiently, however, unexposed silver halide grains are dissolved and developed. If the silver formed in this process precipitates on an exposed grain, this makes the grain larger than otherwise would occur, which may cause the negative to be overly grainy. On the other hand, this extra silver may form new grains that contribute to background fog.

The development process has been studied using both optical and electron microscopes. It has been observed experimentally that the silver grains formed by pure solution physical development are not unlike the shape of the original silver halide grains. Some commercial developers form similar grains (see Fig. 7.9a).

Direct development of the grain occurs when the developer breaks the bond between the silver and the halide virtually in situ. Again, the silver speck acts as a catalyst. In this instance, its role may be to act as a conduction electrode for electrons to pass from the developer to the silver halide, or it may function as a true chemical catalyst. The grains formed by a developer having only a slight solvent action on the silver halide have been shown to be filamentlike (see Fig. 7.10) when viewed with an electron microscope. Some commercial developers form grains which, when viewed through an optical microscope, appear spongy (see Fig. 7.9b). When such grains are studied with an electron microscope, they appear as tangled strands of silver much like those in Figure 7.10b.

Figure 7.11 shows grains in the process of being developed. The black spongy mass attached to the largest six-sided crystal is developed silver. The transparent part of the crystal is silver halide, and the etch pit on the upper left side of the crystal may be the site from which the silver halide came and which provided the silver for the spongy mass. It is tempting to speculate that the attachment point of the silver mass to the silver halide indicates the position of the original silver speck of the latent image. Whether grains are compact or spongy (see Fig. 7.9) may depend primarily on the relative rates of dissolution of the silver halide and donation of electrons to the silver halide by the developer. It may be that compact grains are formed if the solvent action dominates, and spongy grains formed if electron donation dominates.

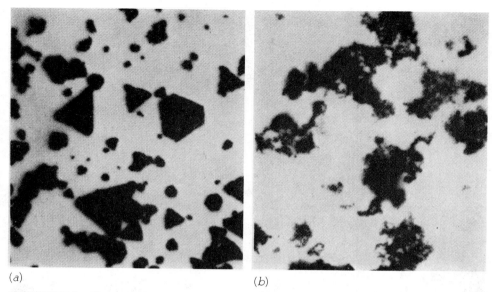

FIGURE 7.9 Compact (a) and spongy (b) silver formed by development of silver halide grains. (Mrs. J. H. Reed, F. Judd, Kodak Research Laboratories, Harrow)

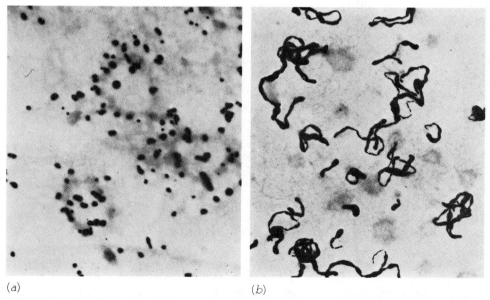

FIGURE 7.10 Silver grains formed by a metol-ascorbic acid developer in the early (a) and late (b) stages of development. (From B. Carroll, G. Higgins, and T. James, *Introduction to Photographic Theory*, New York: John Wiley, © 1980)

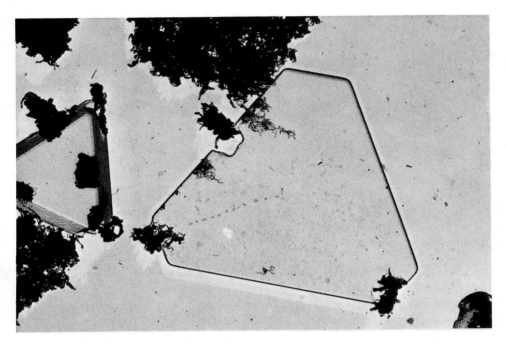

FIGURE 7.11 Electron microscope picture showing partial development of a silver halide grain. (R. B. Flint, Research Laboratories, Kodak Ltd.)

In the process of reducing the silver halide, the developer becomes oxidized and the spent developer combines with sulfite compounds. The halides liberated in the development process typically combine with alkali atoms to form soluble alkali halides (e.g., sodium bromide). The alkali atoms may come from the alkali accelerators in the developer or from the salt forms of the developing agent.

The rate at which development takes place depends on the developer, the emulsion, the temperature of the working solutions, and the agitation of the developer. The choice of developer is a factor because some developers attack the silver halides more rapidly than others and some developers have greater capacity to sustain development action. Emulsion characteristics that affect the rate of development are: emulsion thickness, diffusion characteristics of the emulsion, grain size distribution of the silver halide, and grain distribution through the emulsion.

Temperature is a major factor affecting development rate, because the developer diffuses more rapidly through gelatin at higher temperature, and chemical reactions (development in this case) proceed more rapidly at higher temperatures. Because development usually takes place in and near an exposed silver halide grain, the by-products of development (which frequently impede the process) accumulate in the vicinity of the grain. This accumulation of by-products is reflected in the composition of the developer at the adjacent surface of the emul-

sion. Agitation helps restore the developer to equilibrium and promotes more rapid and uniform development. Fortunately, tables, nomographs, and calculators are available from photographic supply manufacturers[5] that tell how to mate these four factors to achieve optimum development.

Some developers (e.g., a combination of Metol and hydroquinone) show greater development activity than would be expected from the activities of either of the constituents. Such so-called superadditive developers are particular combinations of a fast acting and slow acting developer. It is thought that the slower acting developer may replenish the more rapidly acting one at the local site where development is taking place.

The principal factors determining silver grain size in a developed emulsion are the size of the silver halide grains and their distribution in the emulsion, which in turn is determined by the precipitation and ripening steps in the manufacturing process. Grain size can, however, be altered somewhat in the development process. The main factors acting to alter grain size during development are the overall rate of development, the solvent action of the developer on silver halide grains, and the relative rates of solution physical development and direct development. If part of a grain is dissolved, either by the developing agent itself or an additive such as a sulfite in the developer, and the rate of solution physical development is slow, the grains may be reduced in size.

Kodak Developer D-76 seems to work this way, because the developing agents do not dissolve the grains appreciably, and act relatively slowly, and the developer contains sodium sulfite that acts as a mild solvent for the silver halides. On the other hand, if a large portion of a grain is dissolved and the rate of solution physical development is high, the grains actually may increase in size, because the developer may partially dissolve unexposed grains and solution physical development may cause some of this silver to plate out on a nearby exposed developing grain.

The grainy character perceived when looking at a developed film or print usually is caused by clumps of, rather than individual grains, because the unaided eye seldom can resolve an individual grain. The potential for forming clumps of grains is a function primarily of the manufacturing process. However, the size of the developed clumps can be affected by the developer just as the size of the individual grain is affected. Hence, the evident grainy character of the film or print can be a function of the developing process.

■ PROCESSING AFTER DEVELOPMENT

After the film or paper has been developed, it usually is placed in a weak acid solution (typically 2 percent acetic acid) called a *stop bath*. The reduction in pH halts the development immediately. The stop bath may contain bisulfite compounds that act to scavenge the oxidized developing agent and thus prevent stain-

[5]*Kodak Master Darkroom Guide, Third Edition,* Rochester, N.Y.: Eastman Kodak Co., 1969.

ing of the emulsion. At this point in the process, the emulsion contains silver and undeveloped silver halides. If the silver halides are not removed, they will turn black on exposure to light.

Fortunately, the silver halides are virtually insoluble in water, because the development process depends on water solution chemistry. However, to remove them from the emulsion, they must be converted to water soluble compounds. The film or paper then is placed in a fixing bath (fixer) containing chemicals that convert the insoluble silver halides into water soluble compounds which can be washed out of the emulsion.

The most common fixing agent is sodium thiosulfate ($Na_2S_2O_3$), called hypo. The silver halide reacts with the hypo to form a water soluble silver sulfate compound. Silver chloride reacts most readily with hypo and silver iodide reacts least. The presence of silver iodide actually inhibits the reaction of the other halides with the fixer.

The fixing time depends on the kind of emulsion, the kind and condition of the fixer, the temperature of the fixer, and the degree and type of agitation. The manufacturers of photographic films and chemicals publish tables giving appropriate fixing times for various combinations of fixers and emulsions.[6] However, when working in an open tray where the film can be observed, the time when the unexposed parts of the emulsion become transparent can be determined. The elapsed time required for this clearing is called the *clearing time.* If the emulsion is fixed for twice this clearing time, the fixing action, for all practical purposes, will be complete. The reaction rate of hypo can be increased by adding ammonium chloride to hypo; such a combination is called a *rapid fixer,* although other fixers also are designated as rapid fixers.

Some fixing baths, called acid fixers, contain potassium alum, which causes the solutions to be acid. These baths do not require the use of a stop bath, although it is used by many photographers as a matter of convenience and precaution. The acid fixer has the advantage of scavenging spent developer that may not have been removed in the stop bath. In addition, potassium alum acts as a hardening agent which reduces the susceptibility of the softened gelatin to damage during processing. Acid fixers are less stable than hypo, and sulfite compounds that act as preservatives are added to them.

The film or paper must be washed in agitated or flowing water to remove the products of the developing and fixing processes. Spent developer stains, and hypo changes over long periods of time, discoloring the print.

It is very difficult to remove the last trace of hypo from photographic paper by washing in water, because the thiosulfate ion tends to combine with the sizing of the paper. Where archival standards must be met, hypo eliminators are used after the washing process. A solution of hydrogen peroxide and ammonia, acting as a hypo eliminator, converts the thiosulfate compound to a sulfate compound. Potassium bromide is added to hypo eliminator to remove the silver thiosulfate by-product of the fixing process.

[6]*Kodak Master Darkroom Guide.*

Many photographic papers are coated with resins that are virtually impervious to water. These *resin-coated* (RC) *papers* wash at about the same rate as film and at a much higher rate than uncoated fiber-base papers.

Finally, the print or film must be dried. Resin-coated paper and film are dried by convection in the air. Frequently, warmed air is blown over the emulsion to hasten the drying process. Fiber-base uncoated papers may be dried in air, in contact with a blotter, or on a heated platen or drum. Glossy uncoated papers must be ferrotyped if a glossy surface is desired. This is done by drying the print with the emulsion in contact with a heated chromium-plated metal surface in a platen or drum dryer. Resin-coated papers should not be dried on a drum or platen, because the resin will soften from the heat of the dryer.

■ STABILIZATION

The *stabilization* process substitutes a one-step semidry process for the wet fixing and washing processes, making it possible to obtain a finished print in a shorter time. This is a distinct advantage in document copying or in preparing photographs for newspaper copy.

In this process, the silver halides are converted to compounds that are relatively insensitive to light. These compounds usually are opaque but are light in color and can be used with printing paper; they are not compatible with film. They are not totally insensitive to light and the prints will darken in time. In one class of process, the silver halides are converted to water soluble products that can be washed out of the print at a later time to make a more permanent copy. Hypo is used in this way to stabilize prints. If the silver thiosulfate complexes that are a product of the fixing process remain in high concentration in the emulsion, the tendency of these complexes to decompose is reduced as is the subsequent staining. An unwashed print treated with hypo is more stable than a poorly washed one. A second class of stabilizers forms compounds that are insoluble and these cannot be washed at a later time to form a more permanent print.

Resin-coated paper is used in this kind of processing to reduce the uptake (by the paper base) of water and the products of development and fixation. This refinement makes faster processing possible and improves the final product. Although stabilization still is used, it is under increasing competition from improved xerography for document copying and continuous printing processes for other quick copy work.

■ REVERSAL

Normally, the image formed on film is a negative of the photographed object. The highlights of the subject are dark on the film, and the shadows of the scene are light on the film. It is possible to form a *direct positive* image on the film in which the tones of the scene correlate directly with the densities of the film. This kind of film processing is used to process home movie film and color slide film to form

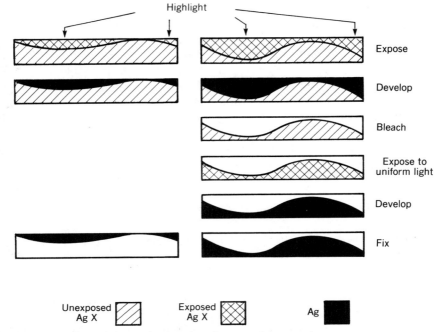

FIGURE 7.12 Comparison of normal and reversal processing.

direct positive images. After the latent image has been developed a *bleach* step (see Fig. 7.12) is used in the *reversal* process to convert the developed silver to a water soluble compound.

A solution containing potassium ferricyanide and potassium bromide frequently is used as a bleach. The film is then exposed to uniform illumination, making the rest of the silver halide developable. A second development converts the remaining silver halide to silver. The film is then fixed, because some traces of undeveloped silver halide may remain. If the washed and dried film is projected onto a screen, the *highlight* areas (see Fig. 7.12) will be bright because little silver remains in those areas and the *shadow* areas will be darker where the silver is more dense. The projection is a positive.

At first glance, it seems that all that is necessary to make a direct positive is to use reversal processing on ordinary film. However, note that when a normal film is exposed and processed (see Fig. 7.12), a very thin negative is produced. If this film had been subject to reversal processing, the originally unexposed silver halides would be developed to silver in the second development step (see Fig. 7.13) and the highlight areas of the film would not be transparent. For this reason, reversal films are made thinner than most negative working films, and silver halide solvents are added to the developer to dissolve some of the smaller grains. The solvent in the first developer dissolves the smaller unexposed silver halide grains in the highlight areas, which otherwise would develop as fog during the second development. Reversal films must be more uniform in thickness than negative working

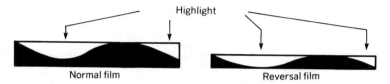

FIGURE 7.13 Comparison of normal and reversal films that have been reversal processed.

films, because variations in thickness cause variations in the density of the direct positive other than those due to exposure of the film.

A proper match of exposure and development time is very important when working with reversal materials. This means that proper exposure of reversal materials is critical, and any deviations from standard exposure must be compensated by an appropriate change in development. If the film is underexposed, first development has to be increased so that correspondingly more silver halide is removed, especially in the highlight areas. The resulting direct positive will be less dense, and hence, more acceptable than it would be had normal development been used.

■ DIFFUSION-TRANSFER PROCESS

The most common black-and-white *diffusion-transfer process* today is the Polaroid process developed by Edwin H. Land. The instant color processes of Kodak and the Polaroid Corporations are also diffusion-transfer processes.

In the black-and-white diffusion-transfer process an emulsion, usually on a paper base, is exposed in the camera. After exposure, this donor layer (negative) is sandwiched (see Fig. 7.14) with a white receiving layer (positive) having many colloidal metal or metal sulfide development nuclei on the surface. In the process of forming the sandwich, a solvent developer is smeared between the donor layer and the receiving layer. Figure 7.15*a* shows the configuration at the start of the develop-

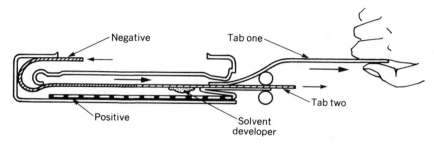

FIGURE 7.14 Initiation of development in the Polaroid diffusion transfer process. Pulling tab one positions negative opposite receiving layer. Pulling tab two initiates development.

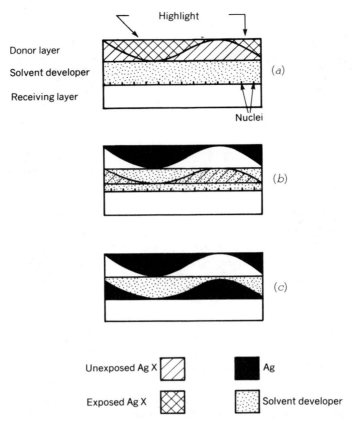

FIGURE 7.15 Schematic representation of development in the diffusion transfer process.

ment process. The developer immediately starts to develop the exposed silver halide on the donor layer (Fig. 7.15*b*), and the solvent starts to dissolve the silver halide. If solvent and development rate are properly balanced, the developer acts on the exposed silver halide before much of it can be dissolved. Hence, in the shadow areas of the picture, more silver halide diffuses toward the receiving layer than in the highlight areas (Fig. 7.15*b*).

If the developer is not too active, little of the diffusing silver halide is developed. When the diffusing silver halide reaches the receiving layer and comes in contact with the development nuclei, the developer initiates development on the receiving layer and a positive is formed. A negative is formed on the donor layer. The receiving layer may contain as many as 10^{13} nuclei per square centimeter. The developed grains in the positive are much smaller than the developed grains in the negative (see Fig. 7.16). However, because the distribution of grains in the positive is determined by the grains in the negative, the clumping of the fine grains in the positive makes the apparent grain size in the positive seem much larger when examined under modest magnification.

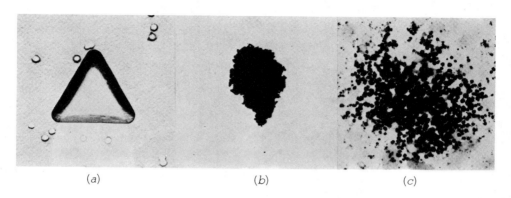

(a) (b) (c)

FIGURE 7.16 Comparison of an undeveloped grain (*a*), a developed grain in the negative (*b*), and developed grains in the positive (*c*) in the diffusion-transfer process. (Copyright © Society of Photographic Scientists and Engineers. Photo courtesy of Dr. Land.)

The grain size in ordinary printing paper is about 0.01 microns in diameter, and the number of grains per square centimeter in printing paper is about equal to the number of nucleation centers per square centimeter in the receiving layer of the diffusion-transfer process. The observed graininess in an ordinary print is a function of the grain size in the negative, just as in the case of the diffusion-transfer positive.

The success of the diffusion-transfer process depends on a proper balance among the rates of the solvent, diffusion, and development processes in the donor layer, the solvent developer layer, and the receiving layer. Proper choice of dispersal medium in the donor layer can enhance the rate of development of the exposed silver halides. The relatively high density of nucleation centers enhances the development rate of the unexposed silver halides in the receiving layer.

EXERCISES

7.1. Compare the physical structure of the commonly used photographic films and papers.

7.2. Discuss the silver halide composition of the commonly used photographic films and papers. What is the rationale for the proportions of $AgCl$, $AgBr$, and AgI in paper and film?

7.3. List the usual constituents of the photographic emulsion and state the function of each.

7.4. Outline the exposure and processing of photographic film. What is the function of each step?

7.5. Describe qualitatively the Gurney and Mott theory of the formation of the latent image.

7.6. List the constituents of a typical developer and state the function of each.

7.7. Compare solution physical development and direct development. State how each works and how the silver grains are constructed in each case.

7.8. Discuss fine-grained developers and how they might work. What is the relative role of solution physical and direct development in a fine-grained developer?

7.9. How does the stabilization process differ from the normal fixing process? Under what conditions can a stabilized print be fixed?

7.10. What part of the emulsion (latent image, unexposed emulsion, etc.) makes up the dark areas in a negative, reversal, and diffusion-transfer image?

chapter
·8·

Sensitometry

■ TONE REPRODCTION

Now that something is understood about the way in which the silver halides record light, the overall problem of properly recording a scene on a piece of film will be considered. In this chapter the technical background material called sensitometry will be presented. In the next chapter this will be applied to taking pictures.

Typically a scene that is illuminated by one or more light sources is being photographed. The illumination may or may not be uniform. Some objects reflect a great deal of light (e.g., white cards), whereas other objects reflect very little light (e.g., black velvet). The reflected light is not always of the same color. However, assuming that the film is panchromatic it will respond to the amount of light reflected from the scene and will not discriminate too much on the basis of color (color film is discussed later). The more light that strikes the film the darker will be the developed film. A range of gray tones is recorded on the film, and this range of tones can be used to produce tones ranging from white to black on the printing paper. The lightest areas on the film produce the darkest tones on the paper.

The amount of light reflected from a given part of a scene is called the luminance. In photography, luminance is measured in candles per square meter. Reflected light meters measure luminance or something proportional to it. The contrast of a scene is described in terms of the *luminance ratio*. This is the ratio of the luminance of the brightest object to the dimmest object in the scene and sometimes is called simply the highlight to shadow ratio or the *contrast*. Photographers frequently use the word tone to describe not only a shade of gray on film or paper but also the luminance of a part of a scene.

■ LUMINANCE RATIOS IN SCENES

A landscape on a clear blue day typically receives 90 percent of its illumination from the sun. On an average sunny day 80 percent of the light comes directly from the sun; the remainder comes from sunlight reflected from surrounding objects and

the clouds, and also from light scattered by dust particles and molecules in the air. In extreme situations, the luminance ratio outdoors on a sunny day exceeds 1000/1. If the *specular highlights* (e.g., light from the sun reflected by glass or bright metal) and the blackest blacks (e.g., the open doorway of an unlit room) are neglected, the contrast will be about 160/1. By comparison, the luminance ratio of a scene at the beach on a gray day is about 10/1.

■ RECORDING CAPABILITY OF PAPER

The contrast between the whitest and blackest tone of glossy paper is about 70/1. Semimatte and matte papers have somewhat less contrast. Hence, the average scene cannot be recorded on paper as it appears to the eye. The tones must be compressed. On the other hand, a gray day at the beach can be rendered as it appears. In fact, the tonal range in the beach picture can be expanded to get a more pleasing picture. How the tonal range is compressed (or expanded) determines to a great extent the impact of the final print. If a photographer chooses to be as visually literal as possible when photographing a scene of high contrast, he/she usually chooses to represent the middle tones of gray as uncompressed and compresses the highlights and shadows. This is demonstrated by a bar graph in Figure 8.1. The lengths of the overall bars represent the range of tones in the scene and on paper. The compression is shown by the relative lengths of the bars between the different tones.

■ RECORDING CAPABILITY OF FILM

The camera and the film alter the contrast of the scene in the process of recording the image. About 1000 times as much light can be transmitted through an unexposed and developed piece of film as can be transmitted through a piece of totally exposed and developed film. It will be shown, however, that better prints can be made if the full recording range of the film is not used.

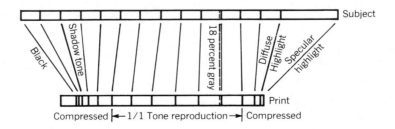

FIGURE 8.1 Compression of tones in a scene of moderate contrast.

■ FLARE

The coating of lenses to reduce reflections at their surfaces was discussed in Chapter 4. These reflections not only lead to loss of light in the image, but they also cause dark parts of the image to be illuminated, a phenomenon called flare. The amount of flare depends on the quality of the coatings, the contrast of the scene, and the kind of lens. Old uncoated lenses and zoom lenses used at small apertures outdoors on a bright day may have as much as 10 percent flare. This means that as much as 10 percent of the light in a given part of the scene is lost from that part of the image. On the other hand, multicoated lenses of moderate focal length (neither extreme wide angle nor telephoto) have no more than 1.5 percent flare and sometimes virtually none. Most single-layer coated lenses have flare ranging from 1.5 to 4.5 percent when used in contrasty situations. Under low flare conditions, such as most interior and studio situations, flare will be low for all lenses.[1] Flare always reduces contrast, but the extent of this reduction depends on the situation.

▶ **Example 8.1**

I have a 55 mm focal length lens for my 35 mm camera which I am using to photograph an outdoor scene. The flare of this lens is about 3 percent. If the luminance ratio of the scene is 160/1, what is the luminance ratio of the image? Assume that one-fifth of the light scattered from the highlight illumination is scattered into the darkest shadows.

The amount of light lost from the highlight is, in arbitrary units, $0.03 \times 160 = 4.8 \simeq 5$. The highlight luminance is reduced to 155. The shadow luminance is increased by about $5 \times \frac{1}{5} = 1$ due to added light from the highlight and reduced about 0.03 due to light scattered from that part of the image, so that the shadow luminance is 1.97. The luminance ratio is reduced to $155/1.97 \simeq 80/1$. A scene that had over a 7 stop range ($2^7 = 128$, $2^8 = 256$) is reduced by the lens to an image having a range of a little over 6 stops ($2^6 = 64$).

■ EXPOSURE

Before discussing the rendition of different luminances in a scene in terms of different tones on paper, the way in which different amounts of light affect the blackness of the film must be related systematically. As stated earlier, exposure (E) is equal to the product of the illuminance (I) and the time of exposure (t) or:

$$E = I \times t \tag{8.1}$$

When this equation was used earlier (the reciprocity law), the concern was with the average exposure of the film. In this discussion, the concern is with the exposure of the different parts of the scene. The illuminance (I) of different parts of the

[1]*Kodak Professional Black-and-White Films*, Rochester, N.Y.: Eastman Kodak Co., 1976, p. 15.

film by light from different parts of the scene is of special interest. The illuminance in photography often is measured in terms of meter-candles. The time is measured in seconds and the exposure in meter-candle-seconds (mcs). The time of exposure is the same for all parts of a given picture. The illuminance, however, differs for various parts of the scene — shadow areas give rise to low illuminances and high-light areas give rise to high illuminances. This variation produces a range of exposures (E) on the film.

■ LOGARITHMIC NATURE OF THE EYE

Ultimately the eye will be the judge of the relative blackness of different parts of a print. It would seem sensible to define this blackness for the print and the negative in some fashion compatible with the way the eye responds to different levels of illumination.

Consider a light meter whose response is linear. This means that if the luminance is doubled, the response is doubled. Imagine a situation in which the eye (and the brain) perceives that the illumination has doubled. The meter will indicate that it has been squared. This means that the eye's subjective response to light level is logarithmic. Exposure as defined in Equation 8.1 is measured linearly, and photometers that work like light meters often read linearly.

▶ **Example 8.2**
You are assigned to take a photograph of a rock wall illuminated by diffuse sunlight. In judging the wall visually, you decide that some of the highlight areas appear to be twice as bright as some of the shadow areas. Using a photometer, you find that the light reading in the shadow area is 10 (arbitrary units). What will be the light reading in the highlight areas if your eye has evaluated the scene correctly?

Because the subjective visual sensation has doubled, the second light reading will be $10^2 = 100$.

This relationship between meter response and eye response shown in the example can be generalized and is shown for several powers of 10 in Table 8.1. Recall that, in considering the relationship between f-number and exposure time, the discussion was in terms of stops and it was noted that the exposure changed by a factor of 2 between adjacent stops. This factor of 2 in exposure is measured using the same linear scale as the meter response discussed above. If the meter response changes by a factor of 2, the visual response changes by 0.3. In other words, if the

TABLE 8.1 Relationship Between Meter Response and Eye Response for Several Powers of 10

Meter Response	(Linear)	1	10	100	1000	10,000	100,000	1,000,000
Subjective Visual Response	(Log)	0	1	2	3	4	5	6

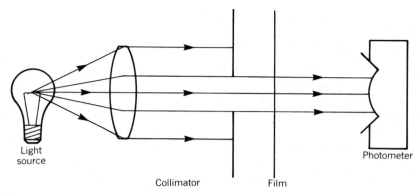

FIGURE 8.2 Densitometer for measuring transmittance of film.

meter response changes from 10 to 20, the visual response changes from 1 to 1.3. A meter response change from 1 to 2 implies a visual response change from 0 to 0.3. A meter response change from 2 to 4 implies a visual response change from 0.3 to 0.6, and so forth. A change in illuminance of one stop always means a logarithmic change of 0.3. Incidentally, light meters used in photography usually are designed and/or marked to read in a way compatible with visual response. This will be discussed further in Chapter 9 in the discussion of metering.

■ DENSITY

In quantifying the blackness of a negative, some physical quantity is desirable that increases with increasing blackness and is compatible with the response of the human eye. This quantity is called the density (D), equal to

$$D = \log \frac{1}{T} \tag{8.2}$$

where T is the *transmittance*. The transmittance can be defined by an experiment. Imagine that a blank, uniformly illuminated white wall is photographed using five successive exposures, each of which increases by one stop more than the previous one. The film is developed in a standard fashion, and the negatives are cut apart. Each is a uniform shade of gray, the first being the lightest and the last the darkest. A measuring apparatus *(densitometer)*, shown schematically in Figure 8.2, is used to measure how much light each piece of film absorbs.

The apparatus consists of a stable light source, a collimator to give a well-defined parallel beam of light, a film holder, and a *photometer* (light meter) to measure the luminance of the transmitted light. First, the luminance of the light from the source is measured when the film holder is empty. Call this luminance I_0. The luminance of the light at the photometer is then measured with each of the five pieces of film in place ($I_1 \ldots I_5$). The transmittance of each is the fraction of the light transmitted by that piece of film $I_1/I_0 \ldots I_5/I_0$). The reciprocal and, finally, the log of each reciprocal is taken to determine the density. Example 8.3 should clarify this.

▶ **Example 8.3**

To illustrate the previous discussion, assume that all five photographs are made at 1/125 sec at successive f-numbers of f/16, f/11, f/8, f/5.6, and f/4. Assume further that the luminance of the light source (I_0) with no film in place is 32 and that $I_1 \ldots I_5$, are, respectively, 16, 8, 4, 2, and 1. Find the density of each of the pieces of film.

Consider the first piece of film for which I_1 is 16. Because I_0 is 32, $T_1 = 16/32 = 0.5$, and $1/T = 2$. As noted earlier, log 2 = 0.3, and hence $D = 0.3$. A summary of the entire solution to the problem is shown in Table 8.2. The suc-

TABLE 8.2 Summary of Results for Example 8.3

Exposure	f/	I	$T = I/I_0$	$1/T$	$D = \log 1/T$
1	16	16	0.5	2	0.3
2	11	8	0.25	4	0.6
3	8	4	0.0125	8	0.9
4	5.6	2	0.0062	16	1.2
5	4	1	0.0031	32	1.5

cessive exposures are designated by the f-number, and the transmittance has been rounded off in exposures 4 and 5. The last column can be obtained from a table or calculator, but if one remembers that log 2 = 0.3 and that doubling a number increases its logarithm 0.3, the final column can be reconstructed from memory.

It would be convenient to relate the density to the exposure of the film. Table 8.2 contains such information for a hypothetical case. This example is synthetic, however, and the exposures are relative, but a curve can be drawn relating relative exposure to density (Fig. 8.3). The ordinate (vertical axis) is the density as calculated in Table 8.2. The abscissa (horizontal axis) is the logarithm of the exposure expressed in arbitrary units. Recognize that the adjacent exposures differ by a fac-

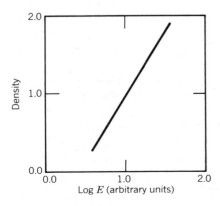

FIGURE 8.3 Relation between density and exposure in Example 8.3.

tor 2, and that the log of the exposure will increase by 0.3 for each succeeding exposure (recall the discussion of the visual response of the eye). The origin on the x axis is arbitrary.

■ THE H & D CURVE

In the 1880s, F. Hurter and V. C. Driffield performed experiments on photographic emulsions which, in principle, were similar to the example above. These experiments resulted in a relationship between exposure and density which, when plotted graphically, is called a H & D curve; an example of such a curve is shown in Figure 8.4.

The part of the curve from A to B is called the *toe*. This particular curve represents what is called a *short-toed film*, because the increase in density starts rather abruptly. In a *long-toed film*, the change is more gradual and the break is sometimes imperceptible. The variation in grain size determines whether a film is long toed or short toed, with greater variation in the former film. The density in the toe region increases very slowly, because a discrete number of silver atoms must be accumulated at a site on a grain (see Chapter 7) to make that grain developable. The exposure in this region is so small that it is difficult to reach the threshold before thermal effects cause the silver to redistribute in the grain. The density never reaches zero in this region, because the base absorbs some light and because some grains are always developable due to sensitization by heat and/or background radiation. These developed background grains are called fog and the minimum density of the film is sometimes called *base-plus-fog density*.

The region from B to C is called the *straight-line* portion of the curve. Here, the increase in density is more or less proportional to the increase in the logarithm of the exposure. Much less compression of tonal values of the scene occurs here than

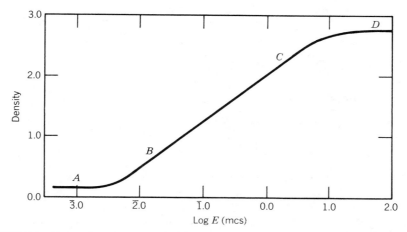

FIGURE 8.4 Typical H & D curve for a film.

in the toe region of the curve. It would seem that the straight-line portion of the curve would be the preferred part of the curve to use for recording a scene. It will be seen later that this is not necessarily the case.

The part of the curve from C to D is called the *shoulder* (or *knee*). Tones again would be greatly compressed in this region, and this region is seldom used in normal black-and-white photography. The lact of proportionality in this region occurs because most of the grains are made developable with smaller exposures, and few grains are left to be made developable by the added photons.

The ordinate on this graph is given in terms of the density. The abscissa is given in terms of the log E, where E is measured in meter-candle-sec. The vincula over the numbers 3, 2, and 1 (as $\bar{3}$, $\bar{2}$, and $\bar{1}$) mean that the logarithm of numbers less than one are being represented.

In Example 8.1, it was found that an average scene with a luminance ratio of 160/1 corresponds to a scene spanning over seven stops. Because 0.3 on the log E scale corresponds to a one stop change in the exposure, the exposure of a film to a scene whose luminance ratio is 160/1 is distributed over approximately 7 × 0.3 = 2.1 on the log E scale. This discussion neglects the effects of flare of the lens.

The density of the film depends not only on the range of luminances in the scene (modified by flare) but also on the overall exposure and the manner in which the film is developed. Both of these effects are illustrated in Figure 8.5. In Chapter 7 it was shown that if the developing time is increased, an exposed negative becomes blacker. Hence, the upper curve (2) in Figure 8.5 is a consequence of longer development than that associated with the lower curve (1).

Increasing the exposure moves the exposure from E_S to E_L, but the range of the exposure on the abscissa is unchanged. The densities will be moved to larger values and the range of densities usually will change. In this example, D_{L1} is greater than D_{S1}. Increasing developing time also increases the density and density range

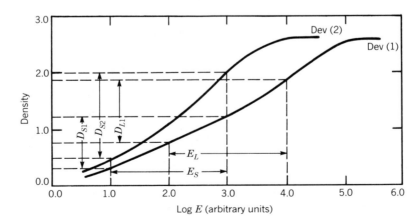

FIGURE 8.5 Effect of different development and exposure on the density of a film exposed to a given scene.

(D_{S2} is greater than D_{S1}). The problem is to decide (1) how to expose the film, (2) how long to develop it, (3) which developer to use, and (4) at what temperature to make the best print possible.

■ AVERAGE GRADIENT, GAMMA, AND CONTRAST INDEX

In principle, a set of H & D curves could be generated for each film. Each set would be complete only if a curve existed for every combination of developer, time, and temperature. For such a set to be reasonably complete, as many as 300 curves might be needed for each film. These then could be used to predict the range of density of a given negative as a function of how the film was exposed and developed.

Instead, a few curves are made, and the dependence on some of the above factors are described in terms of a few parameters. One important parameter is the rate at which density changes with exposure. This was first expressed in terms of the slope of the straight-line portion of the H & D curve and is called *gamma* (γ). For the curve in Figure 8.6, this is

$$\gamma = \frac{D_2 - D_1}{\log E_2 - \log E_1} \tag{8.3}$$

However, because most modern films do not exhibit a well-defined straight-line section of the curve, finding γ is not easy. Furthermore, to get the most acceptable print from a negative, proper exposure is such that part of the scene (shadow areas) is usually recorded in the toe region of the H & D curve. In fact, proper exposure occurs for the usual case when discernible (and desirable) shadow detail is exposed, so that the density is about 0.1 above that of base-plus-fog. The average scene occupies approximately two units on the log E scale. Hence, a better

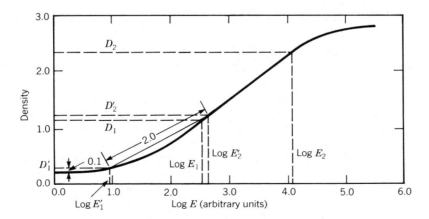

FIGURE 8.6 Determination of γ and average gradient for a hypothetical film.

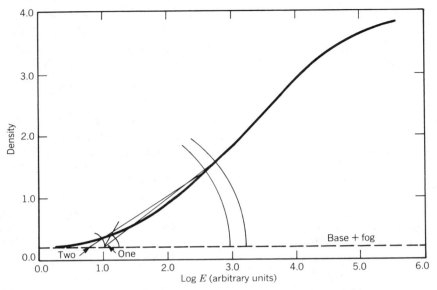

FIGURE 8.7 Determination of the contrast index for a hypothetical film.

measure of this gradient might be the slope of a chord two log E units in length extending from a point on the H & D curve where the density is 0.1 above base-plus-fog intersecting the H & D curve at the appropriate point on that curve. This slope will be called the *average gradient* and designated S. From Figure 8.6

$$S = \frac{D'_2 - D'_1}{\log E'_2 - \log E'_1} \tag{8.4}$$

Ilford[2] uses a parameter it calls *Gee Bar* (\overline{G}), which is similar to the average gradient. Log E'_1 is defined as in the average gradient definition, but log $E'_2 - \log E'_1$ is fixed at 1.5, and D'_2 is determined by finding the density on the H & D curve corresponding to the new log E'_2. Gee Bar is the slope of the straight line connecting these points on the H & D curve. In other literature average gradient and \overline{G} are used interchangeably and designate parameters different from those defined here.

Eastman[3] uses a number called the *contrast index,* which is more complicated to determine but gives about the same result as the average gradient for slopes less than one (the usual case). In determining the contrast index, first find the base-plus-fog level for the film and draw a line parallel to the abscissa through this ordinate (see Fig. 8.7). Choose a point on that line and swing two arcs of 0.2 and 2.2 log E units radius intersecting the H & D curve (see point one). Draw chords to the H & D curve from the center of the arcs. If the chords do not coincide, select a new origin on the base-plus-fog line and repeat until the two chords coincide (see point

[2]H. Asher, *Photographic Principles & Practices,* Garden City, N.Y.: Amphoto, 1975, p. 200.

[3]*Kodak Professional Black-and-White Films,* p. 13.

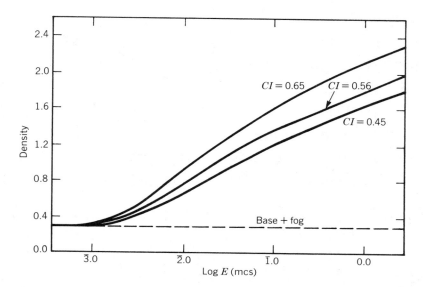

FIGURE 8.8 H & D curves for Kodak Tri-X Pan film.

two). The slope of these coincident chords is the contrast index. In practice, an analog calculator in the form of a transparent scale is used to make the computation.[4] A simple homemade calculator for this purpose is described by Kodak.[5] In Figure 8.8, typical H & D curves for Kodak Tri-X Pan film are plotted for selected development times using Kodak D-76 developer. The numbers, designated as CI, are the contrast indices for the specified development times.

▶ **Example 8.4**

The H & D curve for Panatomic X film developed for 6 minutes in D-76 developer is shown in Figure 8.9. Find the average gradient (S) for this film developed under these conditions, and compare it with the contrast index (about 0.6).

To determine S, first find the point 0.1 above base-plus-fog on the H & D curve, then swing an arc of length log $E = 2$ about that point such that it intersects the H & D curve. Find the slope of the line connecting these two points. Because $D_2 = 1.35$, $D_1 = 0.3$, log $E_2 = \overline{1}.85$ and log $E_1 = \overline{2}.1$.

$$S = \frac{1.35 - 0.3}{\overline{1}.85 - \overline{2}.1} = \frac{1.05}{1 + 0.75} = \frac{1.05}{1.75} = 0.6$$

This is the quoted value of the contrast index. Note that the exposure range (1.75) is somewhat greater than the fixed 1.5 for the \overline{G} system.

[4]H. N. Todd and R. D. Zakia, *Photographic Sensitometry,* Hastings-on-Hudson, N.Y.: Morgan and Morgan, 1969, p. 71ff.

[5]*Kodak Professional Black-and-White Films,* p. 13.

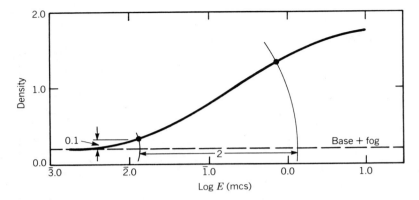

FIGURE 8.9 H & D curve for Kodak Tri-X Pan film showing construction for determining S.

Figure 8.10 shows how the contrast index of Kodak Tri-X Pan film depends on development time for several different developers. These curves were derived for a typical lot of film.

Because the shape of the H & D curve also depends on the temperature at which development takes place, it is necessary to use correction tables if the developer is used at a temperature other than the accepted standard (usually 68° F = 20° C). If the temperature is elevated, development time should be reduced. If the development temperature is reduced, development time should be increased. Many other factors affect the shape of the H & D curve, such as the size of tank used for development, the kind of agitation, and the manufacturing details of a given

FIGURE 8.10 Contrast index as a function of Kodak developer and development time for Kodak Tri-X Pan film. The temperature is 68° F unless otherwise indicated. (1) HC 110 (dilution B), (2) Polydol, (3) D-76, (4) D-76 (1:1) and Microdol-X, (5) Microdol-X (1:3) at 75° F, (6) DK-50 (1:1).

lot of film. Tables and/or calculators that give correct developing times for various combinations of these parameters are available from film manufacturers.[6] When a film lot is to be used for an application requiring great precision, it is usually necessary to determine the H & D curve for that lot experimentally under development conditions identical with those to be used in the application.

The steeper the curve, the greater will be the contrast index. In Figure 8.5, the curve associated with Dev (2) would have a higher contrast index than that of Dev (1). Dev (2) caused the density range (D_{S2}) to be greater than the density range (D_{S1}) for Dev (1) for the same exposure E_S. Hence, increasing the contrast index by whatever means gives rise to a greater density range for a given exposure of a given scene. In the discussion of printing paper, it will be shown that the correct contrast index also depends on the characteristics of the paper. However, one other parameter used in describing the characteristics of film must be discussed before the characteristics of printing paper can be considered.

■ FILM SPEED

In Chapter 2 the concept of ASA film speed (ASA) was introduced and used to help determine correct exposures. Strictly speaking, the ASA film speed is defined only for a standard H & D curve of a given film, such as that shown in Figure 8.11 for a typical black-and-white film. A curve is considered standard if a change in density between 0.1 above base-plus-fog and 0.9 above base-plus-fog occurs when the log exposure changes by 1.3 units. Development has to be adjusted to yield such a curve. That is, the standard H & D curve is specified in terms of the average slope of that curve. The exposure is measured in meter-candle-sec. The ASA is found by

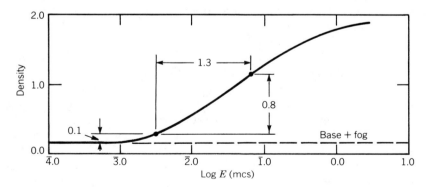

FIGURE 8.11 H & D curve for determining film speed of a black and white film.

[6]*Kodak Black-and-White Dataguide, Seventh Edition,* Rochester, N.Y.: Eastman Kodak Company, 1980.

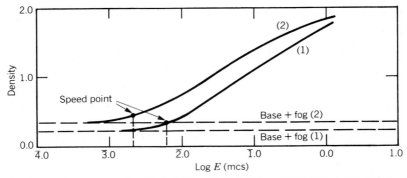

FIGURE 8.12 H & D curves for Kodak Plus-X Pan (1) and Tri-X Pan (2) films.

determining from the standard curve, the log exposure that gives a density 0.1 above base-plus-fog (the *speed point*). The ASA film speed then is

$$ASA = \frac{0.8}{E} \tag{8.5}$$

where E is the antilog of the above log exposure measured in meter-candle-sec.

This definition of film speed gives a measure of the minimum exposure that produces a usable gradient in the density of the film. A usable gradient in a negative is necessary, because the goal is to record different luminances in a scene as different densities in the negative. There are at least three good reasons for using the toe region of the H & D curve when properly exposing a film. First, it is desirable to use the minimum exposure feasible that gives a satisfactory print so that images can be recorded at low light levels. Frequently, too little rather then too much light is available to form an image on the film. It is relatively easy to reduce an exposure if too much light is available. A more sensitive film requires less exposure to light to get a usable gradient in density than does a less sensitive film. Hence, E will be less and the ASA film speed will be greater. The standard H & D curves for two common commercial films are shown in Figure 8.12. The log exposure values used in determining ASA film speeds for each are marked on the abscissa to demonstrate how film speed changes with film sensitivity.

The definition of film speed presented here applies to conventional black-and-white films. ASA film speeds for color negative and color reversal films are defined differently.[7] However, the definitions are such that a light meter calibrated in ASA film speeds for black-and-white films can be used in the same way for color and reversal films. The ASA film speed is not defined for certain films (e.g., high-contrast films, x-ray films, and infrared films). In such cases, the manufacturer usually designates a speed or *exposure index* that can be used to determine proper exposure, where light levels have been measured using meters calibrated in ASA film speeds.

[7]Todd and Zakia, p. 165ff.

TABLE 8.3 Comparison of ASA, DIN, and BS Film Speed

ASA	DIN	BS
1000	31°	41°
800	30°	40°
640	29°	39°
500	28°	38°
400	27°	37°
320	26°	36°
250	25°	35°
200	24°	34°
160	23°	33°
125	22°	32°
100	21°	31°

The acronym *ANSI* is sometimes used to designate the calibration scale of a meter. This is the same as ASA, but reflects the fact that the American Standards Association is now called the American National Standards Institute.

Although ASA film speed is the accepted system of film sensitivity measurement in the United States, different scales are used in other parts of the world. The British use the *BS* (British Standard) *scale*, whereas much of Europe uses the DIN (Deutsche Industrie Norm). The standard H & D curves for which these scales are defined are the same as those for the ASA system and are defined in terms of an exposure 0.1 above base-plus-fog. All three scales define acceptable standard sensitivities in one-third stop intervals. However, the BS and DIN scales have an inverse logarithmic relation to exposure rather than the inverse arithmetic dependence of the ASA scale. Table 8.3 shows comparative values of ASA, DIN, and BS for one decade of the ASA scale.

To get the prescribed ASA film speeds for films with ASA greater than 1000 this scale is multiplied by 10 (i.e., 1250, 1600, etc.). Dividing by 10 or 100 results in ASA film speeds for less sensitive films. Both the DIN and BS scales increase integrally with each one-third stop increase in sensitivity. The difference between these two is a consequence of the difference in the reference base of each. A value of unity on the DIN scale corresponds to an ASA value of one. A value of unity on the BS scale corresponds to an ASA value of 0.1. Other scales include the ANSI Apex scale, the Russian Gost scale, and BS arithmetic scale.[8] The BS scale referred to here is the BS logarithmic scale. A current agreement between the United States and Europe is to indicate both ASA and DIN film speeds as ISO speed. For example, ISO 125/22° indicates a film for which the ASA film speed is 125 and the DIN film speed is 22°. Unfortunately, several other designations are being used at the same time, such as ISO 125 and ASA/ISO 125 for a film with an ASA film speed of 125.

[8]Todd and Zakia, p. 163ff.

▶ **Example 8.5**

Find the exposure index from the H & D curve in Figure 8.11. Assign the proper ASA film speed to the film, and determine the corresponding DIN and BS film speeds.

From the curve we see that log E for the speed point is $\overline{3}.5$. The symbol $\overline{3}.5$ means $-3 + 0.5 = -2.5$ and the antilog is $10^{-2.5}$. This gives an exposure of 0.00316 mcs, for which we find the exposure index to be $0.8/0.00316 = 267$. This is very close to the ASA film speed number of 250, and because the standards allow some variation, this value should be assigned to the film. The corresponding DIN film speed is 25° (see Table 8.3) and the value on the BS scale is 35°.

From the preceding discussion it is evident that it is inappropriate to discuss how the ASA film speed depends on development procedure (time, temperature, and kind of development), because such speed is defined for only one H & D curve for a given film.

One may wonder, however, how exposure index depends on development procedure. Table 8.4 shows how the exposure index and contrast index of a film change with development time. The film has a rated ASA film speed of 125 and is an older version of Kodak Plus-X Pan developed in Kodak D-76 diluted 1:1.

Note that both the exposure index and contrast index increase with increasing development time. This will be important when pushing a film is discussed in the next chapter. Pushing refers to exposing a film at a greater exposure index than the rated ASA film speed.

■ **CONTRAST IN PHOTOGRAPHIC PAPER**

Density, as discussed thus far, implies *transmission density*. However, photographic papers must be discussed in terms of *reflection density*. An experiment similar to one described for photographic film earlier in this chapter could be performed to define the reflection density, except that sheets of photographic paper

TABLE 8.4 Dependence of CI and Exposure Index on Development Time for a Film of ASA Film Speed 125

Development Time (min)	CI	Exposure Index
22	1.00	200
18	0.85	178
12	0.70	145
8	0.56	122
4½	0.40	53

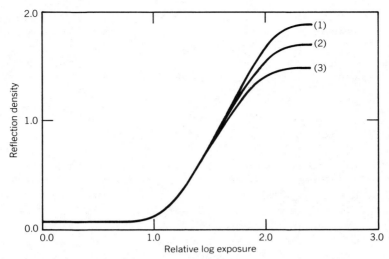

FIGURE 8.13 H & D curves for typical glossy (1), semimatte (2), and matte (3) paper surfaces.

would be exposed to various levels of uniform illumination, and then light reflected from the finished prints would be measured. Considerable light would be reflected from unexposed but developed paper, and little light would be reflected from extensively exposed and subsequently developed paper. The reflection density (D_r) is defined as

$$D_r = \log \frac{1}{R} \tag{8.6}$$

where R is the reflectance of the paper. The reflectance is defined as

$$R = \frac{I_R}{I_0} \tag{8.7}$$

where I_R is the intensity of the light reflected from the exposed and developed paper, and I_0 is the intensity of the light reflected from the paper base.

A plot of the reflection density as a function of log E for three different paper surfaces is shown in Figure 8.13. The exposures are relative, so that the toe regions of these H & D curves can be matched.

These curves show that *glossy* paper yields the greatest range of tones and *matte* the least. This is due primarily to the specular character of the reflecting surface of glossy paper. The tonal range, sometimes called contrast, is typically 70/1 for glossy paper, 35/1 for semimatte, and 20/1 for matte. This tonal range, expressed logarithmically, is sometimes called the *density range*.

▶ **Example 8.6**
Find the density range and contrast of the papers for which the H & D curves are shown in Figure 8.13.

The minimum density that can be recorded on each of the papers is about 0.1. The maximum density for glossy paper is about 1.9. Hence, the density range is 1.9 − 0.1 = 1.8. The antilog of 1.8 is 63 and the contrast is 63/1. Similar calculations yield a density range of 1.6 for the semimatte paper and 1.4 for the matte paper. The contrasts are 40/1 for semimatte and 25/1 for matte.

■ PAPER GRADES

The different densities of a negative, when placed in an enlarger, modulate the light from the enlarger bulb, causing a range of exposures of the printing paper. Low-contrast negatives yield a small range of exposures, whereas high-contrast negatives yield a greater range of exposures. In most instances, the entire tonal range of the photographic paper is used. A given type of paper usually is made in more than one grade, so that the paper will better match negatives of different contrasts. The *paper grade* is a qualitative way of describing the exposure range over which it can be used. The exposure range of a given grade of paper cannot be altered significantly by changing the development process.

Figure 8.14 shows the H & D curves for six different grades of a given kind of paper. For comparison purposes, the reflection density is plotted as a function of relative log exposure. The numbers 0–5 shown on the figure are the paper grade numbers. As the grade number increases, the range of exposure over which the total density is distributed becomes smaller. Papers of higher grade (e.g., 4) are considered *harder* than the *softer papers* (e.g., 1). Very few papers are made in

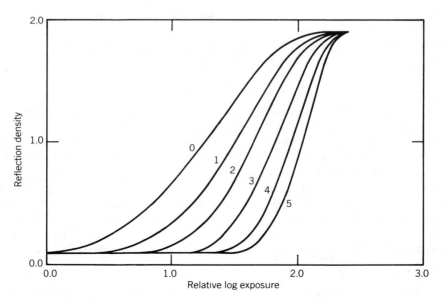

FIGURE 8.14 H & D curves for six different grades of one kind of photographic paper.

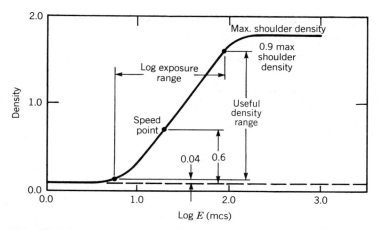

FIGURE 8.15 H & D curve for a typical paper showing log exposure range, useful density range, and speed point.

all grades; however, some glossy papers are made in five grades. The grades are designed so that a normal negative will print best on no. 2 paper, although some photographers prefer to use no. 3 paper with what they consider their normal negative.

Certain kinds of photographic paper are known as *variable contrast papers*. These are made with two emulsion layers. One emulsion is of low contrast and is sensitive only to blue light. The other is of high contrast and is sensitive to blue and yellow light. No blue light is allowed to reach this layer, however, because a temporary filter is built into the emulsion that is removed in the developing process. The contrast of this paper is changed by using different colored filters between the enlarger illumination and the paper to control the relative amount of exposure of the two emulsions. Typically, a range of grades from 1 to 4 in half-grade steps can be achieved using different filters. The obvious advantage for the small user is a reduction in inventory. However, sodium vapor *safelights* or special *safelight filters* must be used when working with this paper, because it is so sensitive to some light in the yellow part of the spectrum.

Log exposure range is a term used to describe the print exposure range needed to give a density that ranges from the faintest highlight tone to a full black tone. This range is demonstrated for a typical paper in Figure 8.15. The faintest highlight tone is defined as one that is 0.04 density units above base plus fog, whereas full black is defined as 0.9 of the maximum shoulder density. The log exposure range is defined as log E_B − log E_A where E_B and E_A are, respectively, the exposures required to yield full black and the faintest highlight tones. Typical values of log exposure range for the various grades of a given paper are shown in Table 8.5.

It is sometimes useful to have a speed number for paper much like the ASA film speed. This can be helpful in determining the proper relative exposure of different papers; an *ANSI paper speed* is defined for some papers. The development procedure for the paper is prescribed, just as it is in determining ASA film speed, and

TABLE 8.5 Log Exposure Range for Five Grades of One Kind of Paper

Contrast Grade Number	Log Exposure Range
1	1.5
2	1.3
3	1.1
4	0.9
5	0.7

this is defined currently in terms of the latest ANSI Standard: *Sensitometry of Photographic Papers,* PH 2.2 — 1972. For papers developed according to that standard, the ANSI paper speed is defined as

$$S = \frac{10^3}{E_{0.6}} \tag{8.8}$$

where $E_{0.6}$ is the exposure necessary to give a density of 0.6 above base plus fog (see Fig. 8.15). The prescribed ANSI paper speed numbers are similar to the ASA film speed numbers (see Table 8.3) except that 630 rather than 640 is used as a base for the number between 500 and 800. In instances where the ANSI standard does not apply (e.g., stabilization papers), the term *effective paper speed* is sometimes used.

▶ **Example 8.7**

Find the log exposure range and ANSI paper speed for the paper whose H & D curve is shown in Figure 8.15.

We see from the graph that log E_B = 1.9 and log E_A = 0.7. Hence, the log exposure range is 1.2 (1.9 − 0.7). This might be a no. 2 or a no. 3 paper. From the graph, we see that log $E_{0.6}$ = 1.3. The antilog of 1.3 is 20. Hence, the ANSI paper speed is 1000/20 = 50, which is a relatively slow speed.

▶ **Example 8.8**

We are printing using a variable contrast paper whose ANSI paper speed with no filter is 320. This yields a contrast close to grade 2. We want more contrast and choose to insert a filter that will give us a contrast corresponding to grade 3. The ANSI paper speed is reduced to 160. How should the exposure in the enlarger be changed to get the same average density in the print?

Because the ANSI paper speed has been halved, exposure must be doubled either by opening up one stop or by doubling the exposure time, provided corrections are made for reciprocity failure in this last instance.

■ ROLE OF THE ENLARGER

The range in density over which the pertinent luminances of the original scene have been recorded in the negative is called the density range. This range of densities in the negative is to be distributed over the available range of densities in the paper (see Fig. 8.15). A paper should be chosen in which the log exposure range equals the density range of the negative. To a first approximation, this is a sound approach. However, do not be too rigid in following such a rule, especially when trying to achieve a special effect.

In making a contact print, the nature of the printing illumination has a minimum effect on the final print. Most printing is done with an enlarger, however, and the kind of illumination used in the enlarger modifies the appropriate relationship between the log exposure range of the paper and the density range of the negative. Enlargers can be classified broadly as either *diffusion* or *condenser enlargers,* although each term covers a range of instruments.

In a condenser enlarger (see Fig. 8.16*a*), a more or less point light source is placed beyond one focal point of what is usually a combination of two positive lenses

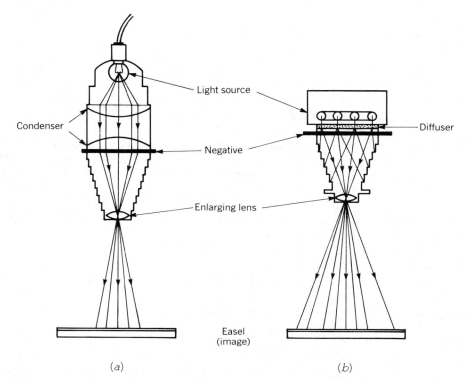

(a) (b)

FIGURE 8.16 Schematic of a condenser enlarger (*a*) and diffusion enlarger (*b*).

called a *condenser*. This causes a converging beam of collimated light to illuminate the negative. The beam of light is modulated by the negative mostly through absorption but also by some scattering. The transmitted light is focused on the easel by the *enlarging lens*. The entire head can be raised or lowered to adjust the image size, and the enlarging lens can be moved within the head to form an in-focus image on the easel. In the diffusion enlarger (see Fig. 8.16b), the condenser is replaced by a *diffuser* (frequently a ground or opal glass plate), which scatters the light onto the negative. These scattered rays are modulated by the negative, and those that strike the enlarging lens are focused by it on the easel. Image size and focusing are accomplished as in the condenser enlarger. The modulated light reaching the enlarging lens in the condenser enlarger is more collimated than that in the diffusion enlarger. Hence, a print made from a negative using the former enlarger will have higher contrast than a print made from the same negative using the latter. Negatives to be used in a diffusion enlarger should, in general, be developed so that they have a greater range of density (higher contrast index) than those to be used in a condenser enlarger. Diffusion enlargers can be used to hide defects and blemishes in both subject and negative, but the prints will not be as sharp as those made with a condenser enlarger.

■ RELATING NEGATIVE TO PRINT

The luminances of the scene now can be related to the reflection density range of the final print. Note that the luminances of the scene will be modified by the flare of the lens, the optical image modified by the negative, the image from the negative modified by the enlarger, and the optical image from the enlarger modified by the printing paper to yield a print whose tonal rendition is to be compared with the original scene. Figure 8.17 shows how these modifications take place and the nature of the net result for an average scene, where the tonal spacing of the midtones has been preserved and both the shadows and highlights have been compressed. This bar graph is like that of Figure 8.1 except that all the intermediate steps are retained.

Flare scatters light from the highlight areas of the scene into the shadow areas of the optical image. The reduction in highlight luminance is small, but the increase in shadow luminance is significant. This tends to compress the luminances in the shadow area.

The density range of the negative is much less than the potential density range of the film (about 1.05 compared with about 3) and less than the density range of the paper. Note also that the lower density part of the H & D curve of the negative (toe) is used. This preserves the one-to-one correlation between scene and print of the midtones and is a second reason for using the toe of the H & D curve. Figure 8.18 shows quantitatively why this is so. Quadrant 1 shows the relation between the luminances of the scene (exposure of the negative) and the density of the negative when using the toe of the H & D curve for the negative. Quadrant 2 shows how the luminances are transferred to the print through the enlarging process. Quadrant 2 is actually the H & D curve for the paper rotated 90° clockwise with

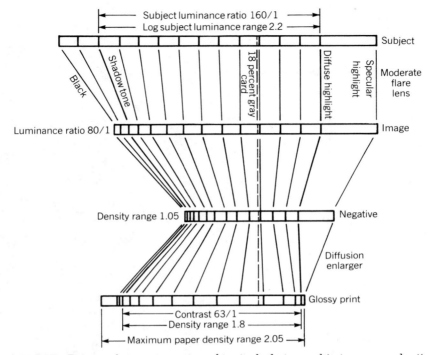

FIGURE 8.17 Bar graph representation of typical photographic tone reproduction.

respect to the usual way of representing it (e.g., Fig. 8.15). (Note the compression of the shadows.) Quadrant 3 is used to preserve the spacing and to transfer the tone values of the print, so that they may be compared with the original luminances of the scene in quadrant 4 by means of a tone reproduction curve. Note that the average proportionality between luminance and tone is preserved with some compression in the highlight and shadow areas of the print.

Figure 8.19 shows quantitatively the relationship between the luminance of the scene and the tone value of the print when the straight-line portion of the H & D curve of the negative is used. Note that the relationship between the luminance of the scene and the tone value of the print is more nonlinear and is similar to the inverted H & D curve for the paper. By comparing Figures 8.18 and 8.19, it is seen that the toe region curvature of the negative's H & D curve has been used to reduce the effect on the print of the toe region curvature of the paper. Using the toe region of the negative does aggravate the problem of printing on the shoulder region of the H & D curve of the print, but in a proper print, little of the most nonlinear part of the shoulder region is used (see Fig. 8.15). If the most important part of the picture is to be rendered as nearly black, then it may be desirable to alter the exposure and/or development procedure to reduce the compression of the shadow areas in the print. This is discussed in the next chapter.

In this quantitative discussion, the effects of flare in the camera lens and scattering in the enlarging process on the tone reproduction curve have been neglected.

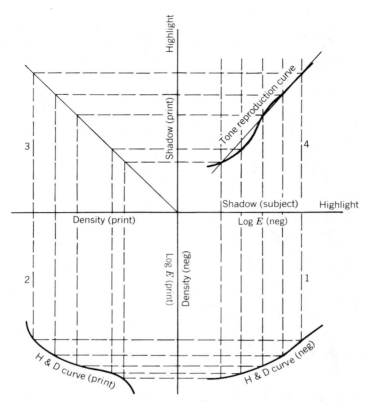

FIGURE 8.18 Relation between luminances of scene and tone values of print when the toe of the H & D curve of the negative is used.

As mentioned earlier, flare tends to compress the shadow tones (Fig. 8.17). In the enlarging process, some light transmitted through the less dense parts of the negative (shadow areas in the scene) illuminates the highlight parts of the print and tends to compress the highlights (see Fig. 8.17). This effect is more pronounced when using a diffusion enlarger.

Figure 8.18 shows that the density range of the negative must be such that it provides the range of exposures of the printing paper necessary to obtain the full density range of the developed paper. As the density range (and contrast index) of the negative increases, a paper whose log exposure range is greater must be used (a softer paper). Hence, the grade of paper used decreases as the contrast index and density range of the negative increase. The exact relationship between contrast index and paper grade depends upon the subject, enlarger, developing procedure, and desired effect. See the references below for a more complete discussion of the subject.[9] They provide a good starting point to determine the

[9]*Kodak Professional Black-and-White Films; Kodak B/W Photographic Papers* G-1, Eastman Kodak Comapny, 1978.

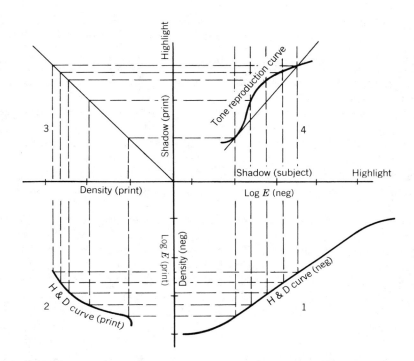

FIGURE 8.19 Relation between luminances of scene and tone values of print when the straight line portion of H & D curve of the negative is used.

proper relationship between film and paper. However, it is often necessary to experiment with individual equipment and facilities to determine how to make the best print.

■ EXPOSURE EFFECTS

Several unexpected effects occasionally occur in the exposure process. Some are identified by terms descriptive of the phenomenon, whereas others are identified by the name of their discoverer.

Recall that the reciprocity law states that the exposure (E) of the film is equal to the product of the illuminance (I) and the time (t) of the exposure. This law implies that exposures of $f/16$ at $1/125$ sec and $f/11$ at $1/250$ sec give the same film density, provided the illumination of the subject is unchanged. If the illuminance of the film is very high or very low, however, this law is no longer valid; a phenomenon called *reciprocity failure*.

If the illuminance is low, few photons strike a given grain per unit time, and the build-up of the silver speck on the surface of the grain to a size sufficient for development takes considerable time. A single silver atom in or on a silver halide grain is not very stable, because thermal agitation tends to cause it to reionize and

recombine with the halide. The latent image decays as fast as it is created. This process competes with the exposure process and causes low intensity reciprocity failure.

If the illuminance is very high, many photons strike a given grain per unit time generating many free electrons, silver ions, and halide atoms. So much recombination takes place that many electrons and silver ions do not reach a development site on the grain surface. This recombination process competes with the exposure process and causes high-intensity reciprocity failure.

Reciprocity failure is a consequence of either too low or too high illumination. However, because the number of photons striking the grain per unit time is the critical parameter, the limits on reciprocity failure usually are stated in terms of exposure time. In general, high-intensity reciprocity failure occurs for exposure times of 1/10,000 sec or less, and low-intensity reciprocity failure occurs for exposure times of 1 sec or greater. The exact correction depends on the particular film.

In some instances, the exposure of a film is so low that no developable latent image is formed. This can occur, for example, when trying to record scientific data photographically. Assume that the threshold for development is four atoms of silver collected as a single speck of silver on a silver halide grain. Further, assume that the usual exposure provides only one atom of silver on those grains that receive maximum exposure. If the film is developed in the usual fashion, no discernible image is formed. However, if the entire film is exposed uniformly to light of sufficient illuminance to cause three atoms of silver to be formed on each grain, those grains which, on subsequent exposure, form one more atom of silver on their surface would develop. All other grains would not be developable and a discernible image would be retained. This process of prefogging a film to increase its threshold sensitivity is one kind of *hypersensitization.*

Our example is hypothetical but illustrates the principle. The technique is not as successful as our example implies, because the thermally initiated instabilities that give rise to low-intensity reciprocity failure play a role here, also. The best chance for success occurs if the fogging is done immediately before the latent image has been formed, if the temperature of the film is not too high, and if the film is developed immediately after exposure. Lowering the temperature during the exposure of the film reduces the thermally initiated instabilities. If some time must elapse between exposure and development, refrigerating the film helps retain the latent image. The term *latensification* refers to a process in which slightly underexposed film is subsequently subjected to relatively low uniform illumination to increase detail in the shadow areas of the image. Both hypersensitization and latensification can also be done chemically.

Intermittency is an example of a phenomenon in which high-intensity reciprocity failure is a factor. Figure 8.20 illustrates graphically a situation in which each of two identical films is exposed to high illuminance in different but equivalent ways. In the first instance (solid lines), the film is exposed to high illuminance in four intervals of time separated by equal intervals in which no exposure takes place. In the second instance (dashed lines), the film is exposed to the same illuminance for one continuous interval that is equal in time to the sum of the four intervals in the first case. If the films are developed in the same fashion and if the illuminance is high enough,

FIGURE 8.20 Graphic representation of the intermittency effect.

the density in the first case will be greater than the density in the second case, even though the total exposures are the same. The high illuminance generates many electrons, silver ions, and halide atoms in both instances, but in the first case the interruption of exposure interrupts the build-up of these particles and allows some of the halide atoms to escape into the gelatin. High-intensity reciprocity failure is reduced, and the density of the negative is higher than in the second case where the interruption does not occur.

It has been implied that the density of film increases with increasing exposure until all of the silver halide is made developable. If the intensity of the light falling on the film is sufficiently high, the density can actually decrease. Under such circumstances, the H & D curve might appear as in Figure 8.21. This effect is believed to be caused by the same phenomena that cause high-intensity reciprocity failure. The very large number of photons striking the individual grains generate so many silver ions, electrons, and halide atoms, and so much recombination occurs that the overall density is reduced. This phenomenon is called *solarization*. The effect is analogous to a game of musical chairs in which everyone gets up and moves about, but most people finally sit down in a different chair with a few being left out.

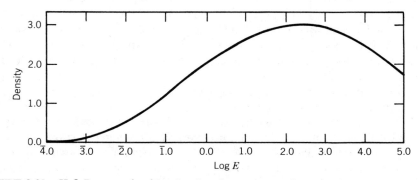

FIGURE 8.21 H & D curve for film that has been exposed to very high illuminance.

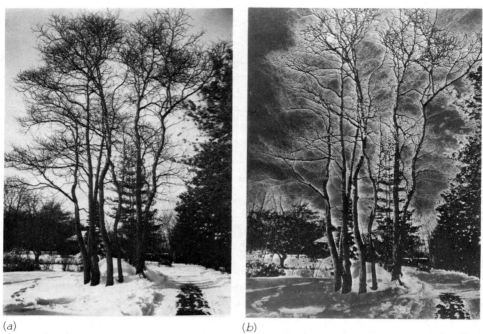

(a) (b)

FIGURE 8.22 Comparison of a normal (a) and a Sabattier print (b), Yale Joel. (*Life Magazine,* copyright © 1970 Time, Inc.)

An effect that is often (incorrectly) called solarization is sometimes used to generate a print whose tones are partially reversed. Historically, the effect is called the Sabattier effect. After a latent image has been formed on printing paper, it is developed normally and washed. The print is then illuminated by diffuse light for a short time (e.g., by turning on the room lights for a second or so) and once again developed, then fixed and washed. In Figure 8.22, a normal print and one subjected to the Sabattier process, both made from the same negative, are compared.

The effect is due primarily to the differential screening of the previously unexposed silver halide grains during the second exposure. This screening is caused by the silver grains formed during the first development. The parts of the print receiving the most illumination during the first exposure will receive the least during the second exposure because of the screening; hence, the tones are reversed. The reversal is not complete, however, because all of the silver formed in both developments remains.

An effect that does give a direct positive is called the *Albert effect*. In this process, a considerably overexposed latent image is formed on the film, which is then placed in an acid that dissolves the silver of the latent image. The film is then exposed to diffuse light, developed, and fixed. The resulting transparency will be a direct positive much like that formed by the reversal process discussed in Chapter 7. Normal first exposure and development in a low solvent developer can be substituted for overexposure in the first step.

FIGURE 8.23 Illustration of the Clayden or black lightning effect. (Courtesy Kodak Museum, Harrow)

The *Clayden* or black lightning *effect* is another phenomenon that is probably a result of solarization. Figure 8.23 is a picture made from a negative exposed to the lightning flashes of a daytime thunderstorm. The very black vertical streak toward the left of the picture (note arrow) was caused by an intense flash of lightning occurring early in the exposure. The illuminance of the flash was sufficient to cause an extreme case of solarization. The disruption of the grains persisted throughout the exposure, so that it was impossible to record even the background illumination in these grains, and this region of film appeared as though no exposure had been made (i.e., a black streak).

As a last example of exposure effects, consider the *Herschel effect.* If a latent image is formed on an orthochromatic paper (e.g., normal printing paper) and the paper is subsequently exposed to red light to which it should not be sensitive, it is observed that the latent image is degraded (i.e., the image formed on development is less dense than that of a similar print which was not exposed to red light). The photons of the red light are thought be be sufficiently energetic to reionize silver on the surface of the developable grain. The ion wanders into the center of the grain where another electron recombines with and stabilizes it. Hence, the silver speck on the surface is degraded and some of the latent image is lost. All of this occurs despite the fact the photon lacks sufficient energy to free an electron from a silver halide pair in the grain. This recombination might be possible, because the speck of silver on the surface is made up of so few silver atoms that it is quite unstable. The same effect can be observed in orthochromatic film or panchromatic film exposed to infrared radiation.

■ GRANULAR STRUCTURE

Because the image that is formed in the print and the negative is a collection of silver grains, the clumping of this granular structure will be visible to the human eye, if enlargement is sufficient. Sometimes this granular structure may be considered an asset aesthetically, but in general it is not.

The term graininess is defined in a subjective way so that it can be related to what is seen in a print. It has been defined in various ways, but here it will be

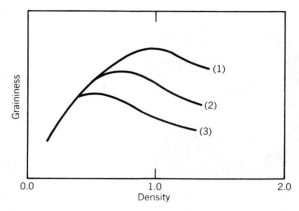

FIGURE 8.24 Dependence of graininess on density and illumination: (1) bright illumination, (2) moderate illumination, (3) dim illumination.

defined in terms of a thought experiment. Imagine that successive exposures of pieces of film are made as in Example 8.3 so that, on development, a set of negatives of different densities is obtained, and these negatives are used to make prints of the same enlargement. These prints are uniformly illuminated and a viewer is asked to approach each until the grain in each is just detectable; this distance is called graininess. Note that the smaller the distance the less observable will be the grain. If this graininess is plotted as a function of density, the result appears as in Figure 8.24. Observe that graininess is not much of a problem in highlight areas, it peaks in the middle tones, and it falls off in the blackest part of the print. Increased illumination of the print, quite predictably increases the graininess. Note also that increasing the illumination of the print shifts the peak in the graininess to higher density. Keep in mind that the grain observed in a correctly printed negative usually is a consequence of the grain that actually existed in the negative, although the term graininess relates to a characteristic of the print. As the reflection density increases, the grains are more difficult to resolve, because less light is reflected from the print, and hence, the graininess decreases.

The graininess of a negative is of little interest because a black-and-white negative is not normally viewed directly but is used in an enlarger to make a print. However, a term is needed to describe the granular structure of the negative in a way that is relevant to its use. The term *granularity* does this and is defined as follows. Imagine that the densitometer shown in Figure 8.2 is modified so that the collimator transmits a very small beam of light. Such an instrument is called a *microdensitometer*. One of the test negatives used in the graininess experiment is examined with this instrument by scanning across its width. Because the diameter of the beam of light is very small, the amount of light reaching the photometer varies as different clumps of grains scatter and absorb light from the beam during the traversal. The fluctuations in the meter readings are recorded, and from these the fluctuations in density are computed and plotted as a function of position on (distance across) the negative.

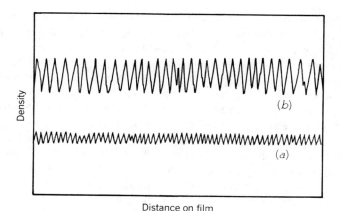

Distance on film

FIGURE 8.25 Microdensitometer trace for films of (*a*) low and (*b*) high density.

Figure 8.25 shows such a plot for a negative of low density (a) and one of high density (b). The mean density is determined and the standard deviation from the mean (σ) (a measure of fluctuation) is computed for many fluctuations. The magnitude of the fluctuations depends on the diameter of the aperture. It has been found that if the diameter of the scanning aperture is at least 10 grain diameters, then σ varies inversely with the square root of the area (*a*) of the aperture. To correct for this dependence on aperture size, the granularity (*G*) is frequently defined as

$$G = \sigma \sqrt{2a} \qquad (8.9)$$

A plot of the dependence of granularity on density is shown in Figure 8.26 for a typical film. Note that granularity increases monotonically with density. It does not decrease with density (as does the graininess) because of the way σ is defined and/ or because of the way in which the measurement is made.

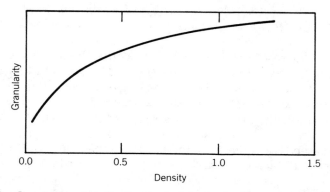

FIGURE 8.26 Graph showing the dependence of granularity on density for a typical film.

Because most of the graininess seen in an enlarged print is a result of the grain in the negative, an effort is made to minimize the effects of granularity in the negative. The most obvious way to reduce graininess in the print is to use a negative of minimum density. This, then, is the third reason for using the toe region of the H & D curve. A diffusion enlarger may be used to reduce the impression of graininess but at the expense of sharpness in the print. The effect of grain in the negative can also be reduced by reducing the contrast in the negative, because high contrast in the negative emphasizes the presence of grain. Because graininess is most evident in the middle tones, and because the viewer is more conscious of graininess in large, uniformly dense areas of a print, the impression of graininess can be reduced by not printing such areas at middle densities. This is easier said than done, because the overall esthetic intent of the print may suffer in the process of trying to control graininess.

Much has been written about the reduction of the effects of graininess by using fine-grain developers, especially in 35 mm photography. To reduce grain size by controlling development, the individual grains must be partially developed. Most developers used with small format film are designed to give partial development. With some, such as Eastman's D-76, this is achieved by using developers of low capacity, so that the grain is partially developed, and the rest of the grain is dissolved in the fixing process. In others, the developer contains a silver halide solvent, so that development and dissolution of the grain occur simultaneously. This second type is truly a fine-grain developer, because the grain size will be small even if development time is long, provided solution physical development does not occur (see Chapter 7). In the former case, grain size depends to a great extent on development time. Fine-grain developers, however, yield negatives of reduced density unless exposure is increased, which implies that the speed of the film is reduced. Hence, a slower finer-grain film could be used at the outset.

■ IMAGE DETAIL

In the previous section, the concern was with grain in the print and the reproduction of tone. In this section, the concern is recording fine detail. This involves a discussion of *resolving power,* sharpness, *acutance,* and *modulation transfer function* (MTF).

To determine the resolving power of a film, a photograph is made of a resolving power test chart such as that shown in Figure 8.27. Each set of lines is such that the width of the line is equal to the spacing between them. The line plus space is called a *line pair.* Each set differs in spacing from the adjacent set by some fixed mathematical factor. The processed photograph of the test chart is examined with a microscope. The set of lines with the closest spacing for which individual lines can be distinguished is identified and the spacing of these lines noted. The resolving power is defined as the reciprocal of this spacing and usually is quoted in line pairs per millimeter or, more commonly, lines per millimeter. Note that the resolving power is a subjective measure, because a human observer determines whether the lines can be resolved. Actually, the resolving power of a system is being mea-

FIGURE 8.27 Typical resolving power test chart. (Courtesy Eastman Kodak)

sured, for the final result depends on the quality of the optical systems (camera and microscope), the quality of the test chart (contrast and sharpness of lines), the exposure, and the development procedure.

Resolving power decreases considerably for very small and very large exposures. Results are usually quoted for optimum intermediate exposures. Resolution typically decreases by a factor of 2 or 3 as the contrast of the chart is reduced, and it is frequently quoted for both low and high contrast charts. The resolution of the optics (R_o) can be determined independent of the film by using the microscope to look at the test chart image formed by the camera lens. If the resolution of the system (R_s) as measured on the film is known, the formula

$$\frac{1}{R_S^2} = \frac{1}{R_F^2} + \frac{1}{R_0^2} \tag{8.10}$$

where R_F is the resolution of the film is often used to give an approximate prediction of the resolving power of the film. The resolving power of commercial films ranges from about 25 lines/mm for a low-contrast image on a very high-speed film to about 200 lines/mm for a fine-grain film under high-contrast conditions. Special purpose films can achieve resolving powers approaching 1000 lines/mm. In general, fine-grain low-speed films have high resolving power and high-speed large-grain films have low resolving power.

Other factors besides grain size, however, influence resolving power. Resolving power alone is not a measure of the sharpness of an image on a film as determined by a human observer. Figure 8.28 shows the resolving power test charts for Kodak 2475 film (Fig. 8.28*a*) and Kodak 4127 film (Fig. 8.28*b*). The two charts indicate that Kodak 4127 film has a higher resolving power than Kodak 2475 film. Actually Kodak 4127 film has about twice the resolving power of Kodak 2475 film. Figures 8.29*a* and *c* show pictures taken of the front and back of a pocket watch, using Kodak 2475 film. Figures 8.29*b* and *d* show pictures of the same watch taken under the

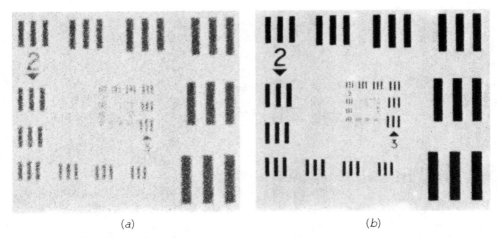

(a) *(b)*

FIGURE 8.28 Resolving power photographs for (a) low resolution and (b) high resolution films. (ENM, 1983)

same conditions using Kodak 4127 film. Generally the figures on the right appear sharper than those on the left. Scratches on the back of the watch are more evident in the picture on the right and the face seems cleaner in Figure 8.29d compared to Figure 8.29c. However, shadow detail on the back near the stem of the watch (near the numeral 16) is much better on Figure 8.29a, as is the shadow detail on the largest solid wheel at the left. Furthermore, the shadows of the minute hand in Figure 8.29c are more evident than those in Figure 8.29d, as is the shadow caused by the relief around the second markings. In general, the fine markings indicating minutes and seconds as well as the name "Hamilton" are more evident in Figure 8.29c.

Some insight into the cause of this can be obtained by performing the following thought experiment. Imagine that a sharp knife edge (e.g., a razor blade) is placed on each of two films A and B, and that the films are exposed to collimated light. After the films are developed, a microdensitometer is used to measure the density of each sample as a function of position on the film as the film is traversed at right angles to the knife edge. If the density is plotted as a function of position for each film, the result might be as shown in Figure 8.30.

Film A renders an edge which appears sharper than does that of film B. This edge sharpness is a function of grain size, emulsion thickness, and the scattering characteristics of the emulsion and can be described quantitatively. A film that renders a very sharp edge is called a high acutance[10] film. One that renders a diffuse edge is called a low acutance film. It might seem that fine-grain films that generally have

[10]Mathematically, the acutance (α) for film A is given by

$$\alpha = \frac{1}{(X_2 - X_1)(D_2 - D_1)} \int_{x_1}^{x_2} \left(\frac{dD}{dx}\right)^2 dx$$

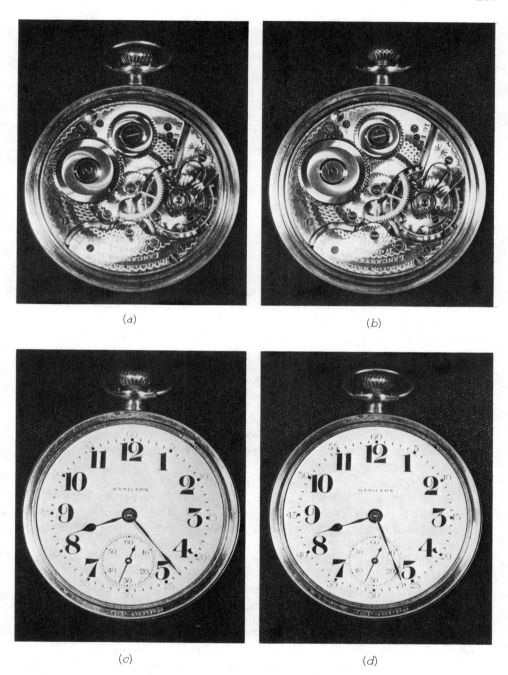

(a)

(b)

(c)

(d)

FIGURE 8.29 Photographs (*a*, *c*) and (*b*, *d*) made using the same films respectively as those used for Figures 8.28*a*, and 8.28*b*. (ENM, 1983)

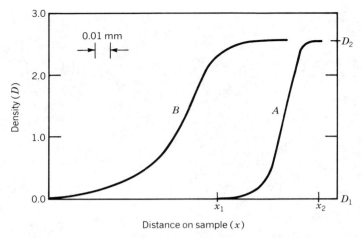

FIGURE 8.30 Contours of density at a sharp edge for two different films, A and B.

higher resolving power might also have higher acutance. That this is not always the case is shown in Figures 8.28 and 8.29, in which the film used to make Figures 8.29a and c has higher acutance than that used to make Figures 8.29b and d. It is not possible to correlate acutance and resolving power in a generalized manner.

■ MODULATION TRANSFER FUNCTION

The most sophisticated way to analyze the recording capability of a film is to determine its modulation transfer function. The procedure is somewhat like one of the methods used to determine the fidelity of a high-fidelity electronic amplifying system (hi-fi system) designed to reproduce acoustic signals. In a hi-fi system, pure sinusoidal electrical signals of different frequencies are introduced into the system, and the ability of the system to reproduce these signals at the output is measured. A curve showing the relative capability of the system to reproduce these signals as a function of frequency, called a frequency response curve, is plotted. Why is such an analysis useful?

Recall from Chapter 4 in the discussion of wave motion, it was mentioned that waves could be represented graphically by plotting the amplitude of the wave at any point in space as a function of time (see Fig. 4.7). The representation in Figure 4.7 is a simple sinusoidal wave. Any sound, no matter how complex, can in principle be represented as the sum of a series of sine waves. In general, the more complex the sound the wider the range of frequencies needed to represent the signal adequately. Hence, knowledge of how well an amplifying system transmits sine waves provides information about how well it will transmit more complex signals. The fact that this sine wave representation is possible should not be too surprising, because the tones that make up music scales are in their purest forms, sine waves. If a more complex wave (such as

FIGURE 8.31 Diagram of a complex acoustic wave showing dependence of amplitude on time.

the tones heard as an orchestra plays an overture) is plotted in a similar fashion, it might look as shown in Figure 8.31.

If a microdensitometer is used to measure the density as a function of position across a developed film that has been used to record a scene, the resulting graph might be similar qualitatively to that in Figure 8.31, except that the abscissa would be a measure of distance instead of time.

To make a spatial frequency response measurement for a film which is analogous to that used for hi-fi systems, a test signal is needed. This should be in the form of a test target on which the densities vary sinusoidally as a function of position and on which density variations of different spacings are represented. This could be much like the resolving power test chart in Figure 8.27 except that the bars would have shaded edges rather than sharp edges. The spacings usually are given in terms of the spatial frequency in cycle/mm, which corresponds to the description used on resolving power charts (lines/mm). The chart is photographed, and a microdensitometer is used to compare the amplitude of the output density for the film with that of the input density for the test target. The ratio of the output density to the input density is called the modulation transfer function (MTF) and often is quoted in percent. A plot of a modulation transfer function for a typical film is shown in Figure 8.32.

Note that the MTF exceeds 100 percent at some of the low frequencies due to some development artifacts. This rather sketchy description omits some important considerations, such as the problem of the nonlinearity of the film, the problem of making a good test chart, and the details of the procedure for removing the influence of film contrast on the measurement. Let it suffice to say, regarding the last point, that the H & D curve of the film is used to demodulate the density measurement made on the film. For a more detailed description of the procedure see Neblette.[11]

This technique can be used to measure and discuss the MTF of a system much as is done in the case of resolving power, but the analysis is simpler and less

[11]C. B. Neblette, *Fundamentals of Photography,* New York: Van Nostrand Reinhold, 1970, p. 70ff.

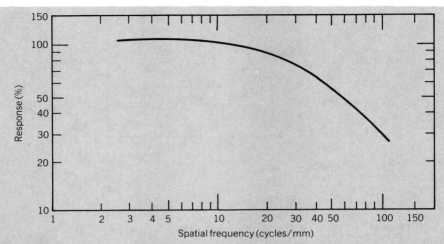

FIGURE 8.32 Typical modulation transfer function for Kodak Plus X-Pan film.

subject to debate for the MTF. If the MTF of a film and an optical system is known at a given frequency, the MTF of the system at that frequency is the product of the two known MTFs.

▶ **Example 8.9**
Figure 8.32 shows the MTF as a function of spatial frequency for Kodak Plus-X Pan film when developed in a standard way. Figure 8.33 shows the MTF as a function of spatial frequency for a good photographic lens (curve *A*).

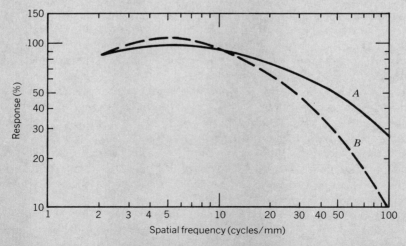

FIGURE 8.33 MTF as a function of spatial frequency for a photographic lens (*A*) and the lens in combination with Kodak Plus X-Pan film (*B*).

Find the MTF for a system in which Kodak Plus-X Pan is used with this lens, and the film is developed as in the case for Figure 8.33.

Multiply the percentages at each frequency to solve this problem. The result is plotted as curve *B* in Figure 8.33.

■ DEVELOPMENT EFFECTS

In the process of developing film, several effects occur that reduce the fidelity of the negative compared with the image formed by the lens. Most of these effects are a consequence of migration of developer or development by-products between heavily exposed and minimally exposed adjacent regions. The first of these is the *border effect*. Assume a situation much like that in the acutance test in which one part of a film is uniformly heavily exposed and an adjacent part receives partial exposure. It is expected that, on development, the heavily exposed area will be a uniform shade of dark gray and the partially exposed area light gray (see Fig. 8.34). In such a situation, a boundary line at the border may appear in a heavily exposed area, which is darker than the rest of the heavily exposed area. This is a consequence of unused developer from the unexposed region migrating into the exposed area causing increased development at the boundary.

In the adjacent partially exposed region, a lighter line in the low density region may be seen adjacent to the dark line (see Fig. 8.34). This is called the *fringe effect* and is a result of by-products of development generated in the heavily exposed parts of the film migrating into the lesser exposed regions, where they act as restrainers and thus inhibit development. The two lines are sometimes called *Mackie lines* and the two effects are known as *edge effects*. Streaking is also caused by development by-products migrating downward through the emulsion from the heavily developed region when the plane of the film is vertical during development. This can be avoided by proper agitation during development.

If a film is exposed to circles of light of increasing diameter with equal luminances, it is found that for small circles the densities in the developed film increase with decreasing circle diameter. This is called the *Eberhard effect*. The cause is similar to that for the border effect. Unspent developer migrates parallel to the

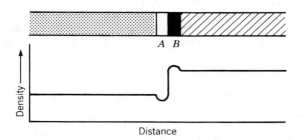

FIGURE 8.34 Fringe (*A*) and border (*B*) effects in developed film.

plane of the film into the more highly exposed regions increasing development. The effect of the migration is greater for smaller spots.

If two small circles of light illuminate adjacent regions of a film so that the edges of the circles are very close, upon development it is found that the adjacent regions are less developed than the regions diametrically opposite. This is called the *Kostinsky effect.* In this case, the adjacent regions are competing for developer and at the same time generating restraining by-products, which tend to reduce development in this region.

Most of these effects are of little importance in general photography but can generate considerable problems in scientific photography. For instance, the Kostinsky effect increases the separation of the two spots on the film compared with the separation of the optical images. If these spots are used to measure the relative position of two stars on an astronomical photographic plate, the measurement will be in error if no correction is made for the effect.

■ SHARPNESS OF A PICTURE

Sharpness may or may not be a desirable characteristic of a photograph. It was mentioned in Chapter 3 that some portraits are more flattering if the image is not too sharp. Sometimes intentional blurring is used to give the impression of motion. It is appropriate to summarize here the factors that determine the sharpness of a photographic image.

A picture can be no sharper than the subject it represents. Relative motion of camera and subject decreases sharpness. The sharpest picture is made when the subject is at rest and the camera is supported rigidly. If the contrast of the subject is low, either because of soft lighting or inherent low contrast of the subject, the picture will appear less sharp. A sharp image cannot be formed on the film unless the subject is in focus. Even an in-focus subject may not be sharp if the lens is subject to excessive aberrations.

A sharp image on the film can only be rendered as sharp if the film has sufficient resolution and acutance to record the details of the image. The performance of the film is a function of the way in which it is processed. Film contrast and resolving capability can be altered markedly by development procedures.

Finally, how sharp the final picture appears depends on the enlargement used to make the final print and the conditions under which it is viewed. If a print is viewed from afar with low levels of illumination, it may appear sharp despite gross deficiencies in objective sharpness. On the other hand, no print will appear sharp if it is overenlarged and viewed from too close a vantage point under bright illumination.

EXERCISES

8.1. How does the contrast of an average outdoor scene on a sunny day compare with the recording capability of photographic paper?

8.2. For routine work, why should we choose glossy paper rather than matte paper?

8.3. The flare of a lens refracts (and reflects) light from the highlight area of the image to the shadow area of the image and vice versa. Which loss of light contributes most to a decrease in the contrast of the image?

8.4. We say that the eye is logarithmic. If this is so, what changes in visual sensation take place if luminance (as measured by a meter) is doubled?

8.5. Film A is twice as dense as film B. What is the ratio of the light transmitted through B compared with the light transmitted through A?

8.6. In the usual exposure of film, the tones of the scene are recorded on and near the toe of the H & D curve. State three reasons why this is done.

8.7. From the graphs in Figure 8.8, determine the average gradient (S) for Kodak Tri-X Pan film developed for 9 minutes in D-76. Determine the contrast index and compare your values with the stated value of the contrast index.

8.8. If the development time of Kodak Tri-X Pan film in D-76 diluted 1:1 is increased from 8 minutes to 10 minutes, what is the percentage increase in the contrast index?

8.9. In general, what is the effect on contrast index of increasing the development time of a film? What happens to the density range of a given exposure if the development time is increased?

8.10. From the graphs in Figure 8.12 find the exposure index for Kodak Tri-X Pan and Kodak Plus-X Pan films, and compare these values to the rated ASA film speeds of these films.

8.11. Find the log exposure range for the no. 2 grade paper for which the H & D curve is presented in Figure 8.14.

8.12. How does the log exposure range of a given kind of paper change as the grade number is increased?

8.13. I have two negatives of the same scene. One has a density range of 1.1; the other has a density range of 0.7. Which negative should be printed on the higher grade paper?

8.14. Design a simple experiment to demonstrate reciprocity failure using your camera and a readily available black-and-white film.

8.15. Describe an experiment to demonstrate the intermittency effect.

8.16. How does graininess change with increased exposure of the film and increased illumination of the test prints?

8.17. How does granularity change with increased exposure of the film?

8.18. Although most grain problems result from grain in the negative, we speak of granularity as being relevant for evaluation of a negative and graininess as being relevant for evaluation of the print. Why is this so?

chapter
·9·

Exposure determination

To determine the proper exposure of a scene, the amount of light reflected from the scene to the camera must be determined. This can be done by estimating or measuring the amount of light incident on the scene or by measuring the amount reflected by the scene. In Chapter 2, use of the rule of thumb was emphasized for determining exposure. Although some problems related to the use of reflected light meters were discussed there, meters and metering will be considered in more detail in this chapter. Some systems that can be used to determine the desired exposure of a scene will also be presented.

■ METERING MODES

To get a proper average exposure of a scene using the rule of thumb, the amount of light incident on the scene is estimated based on the lighting conditions (e.g., bright sunny day, cloudy bright, etc.). An incident light meter can also be used to measure the incident illumination. When using such a meter, the photographer faces the light sources and measures the light reaching the scene (see Fig. 9.1). If the illumination is relatively uniform, this technique yields a proper exposure suitable for standard printing, described in the last chapter. Because in-camera light meters (which are reflected light meters) are prevalent today, it is more common to meter the reflected light to determine the exposure. In such a situation, the meter in the camera or a hand held meter is read while it is pointed toward the scene (see Fig. 9.2). The reading of the meter depends on the illumination and the nature of the reflecting surfaces in the scene. For an average scene (one that reflects an average of 18 percent of the incident light), this technique yields a proper exposure suitable for standard printing. The merits and pitfalls of both methods will be discussed later.

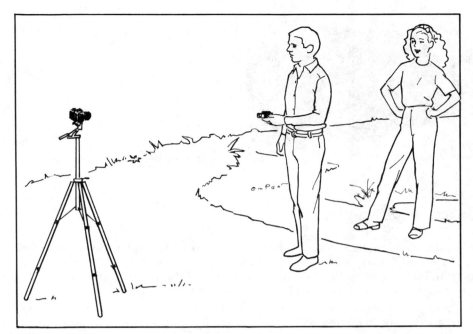

FIGURE 9.1 Use of an incident light meter.

FIGURE 9.2 Use of a reflected light meter.

FIGURE 9.3 Typical hand held meter. (ENM, 1983)

■ LIGHT METERS

Many hand held light meters are designed to be used both as incident and reflected light meters. A translucent dome (see Fig. 9.3) used for incident measurement can be moved in front of the sensing element when the meter is used in that mode and moved away for reflected light readings. Because the same meter movement is used to measure the incident and reflected light, the translucent dome must absorb about 80 percent of the incident light. Most meters in use today have a photoconducting sensing element. The resistance of the photoconductor decreases as the amount of incident light on the photoconductor increases. The electrical circuit for such a meter is shown schematically in Figure 9.4a. As the resistance in the circuit decreases, the meter deflects more because the battery voltage is constant.

Some meters use a digital readout instead of a galvanometer for display. Until recently, the photoconductors were made of cadmium sulfide or some variation thereof. Today, more and more of these elements are made of a modified form of gallium arsenide or silicon. These newer materials provide a more linear response to a greater part of the electromagnetic spectrum and respond more rapidly to changes in illumination. Most in-camera light meters work in a fashion similar to this family of hand held meters, except that they are designed to operate in a reflected light mode only.

FIGURE 9.4 Electrical circuits for a photoconducting light meter (a) and a photovoltaic light meter (b).

Some older hand held (and a few in-camera) meters use a *photovoltaic cell* as the light-sensing element. The element is made of selenium and is such that the voltage generated by the cell increases with increasing illumination. As the voltage increases, the meter reading increases (see Fig. 9.4*b*). This type of meter needs no battery for operation but is much less sensitive to light and hence, cannot be used at light levels as low as those detectable by a photoconducting meter.

A calculator (see Fig. 9.3) for determining proper exposure usually is part of the meter. Once the light level has been determined using the meter, proper exposure is determined using the calculator set for the kind of film that is to be exposed. Many in-camera meters are null reading or match point meters. In such a meter, proper exposure is determined by adjusting the aperture and/or shutter speed for a null indication of the meter while measuring the light reflected from the scene. The sensitivity of the meter is adjusted to match that of the film. Some hand held meters are match point meters, in which the calculator is adjusted to achieve a null indication.

▶ **Example 9.1**

I am photographing a small group (candid) in a modestly lighted room using an incident light meter to determine exposure. The film has an ASA film speed of 400. The light meter reads 11. Find a proper exposure for this situation. The calculator is set for an ASA film speed of 400.

Because the meter reads 11, this number is set opposite the indicating mark on the calculator. A complete set of acceptable exposures is displayed across the top of the calculator (f/2, 1/250; f/2.8, 1/125; f/4, 1/60; f/5.6, 1/30 . . .). For a small group of people, an exposure of f/4 at 1/60 sec is needed to get the maximum depth of field and still compensate for someone moving. If the group is more animated, a more acceptable equivalent exposure might be f/2 at 1/250 sec.

A *spot meter* is a special kind of reflected light meter that can be used to measure the luminance of a very small area in a scene. The user aims the instrument by looking through a monocular viewer having about a 20° field of view. Typically, the sensitive element subtends an angle of about 1 degree in the center of the field of view denoted by a circle in the field of view. A meter or digital readout is also placed in the field of view, so that the scene can be probed point by point to determine the luminance of different parts of the scene. Exposure settings are determined using a calculator much like that shown in Figure 9.3. Some conventional light meters can be fitted with an adapter making it possible to use them as spot meters. The field of view of the light meter is reduced from its usual value of about 30° to one comparable with that of a spot meter.

In-camera reflected light meters are used to monitor the entire field of view of the camera. Some of these meters, however, are center weighted, so that more emphasis is placed on the light reflected from the central part of the scene. A few cameras incorporate a built-in spot meter. Most of these can be operated in both a spot and an averaging mode.

Some light meters are marked with an EV scale, where EV denotes *exposure value*. The scale is logarithmic and is arranged so that the indicated exposure

increases by a factor of 2 (one stop) between adjacent increasing integers. Zero on the EV scale is equal to an exposure of f/1 for 1 second or its equivalent.

■ EXPOSURE FOR SUBJECTS OF AVERAGE REFLECTANCE

The *reflectance* (R) of an object is the fraction of the incident light reflected from it. When quoted in percent, this is called the *reflectivity*. In this section, consideration will be given to the various methods that may be used to obtain exposures of subjects whose reflectance is average (0.18), and are such that the desired picture is one that has the tones distributed in the print, such as those in Figure 8.17. An example is an average outdoor scene for which a standard print is desired, with middle tones distributed uniformly and highlights and shadows compressed.

If the illumination is relatively uniform, an incident light meter can be used to determine the proper exposure of the scene. If the light source is distributed (e.g., an outdoor scene illuminated by the sky on an overcast day), metering is straightforward. Point the meter toward the camera from the scene and determine the exposure.

Much has been written about the positioning of the light meter if the main illumination is a single point source (e.g., the sun on a clear day). Sometimes the photographer is advised to point the meter halfway between the sun and the camera for a front-lighted scene. The reason for this can be seen with the help of Figure 9.5. If the meter is pointed at an angle α with respect to a point source that is far away (e.g., the sun), part of the hemisphere is shaded and the cross-sectional area of the intercepted beam is reduced. For an ideal diffuse hemisphere, it can be shown that the relative collection efficiency (C) for such a source is

$$C = \frac{1 + \cos \alpha}{2} \tag{9.1}$$

If α is zero (normal incidence), $C = 1$. If $\alpha = 90°$, $C = 0.5$. At 45° the relative collection efficiency is 0.85. If a scene is top or side lighted and the meter is pointed at the camera ($\alpha = 90°$), half the light from the point source will be measured and

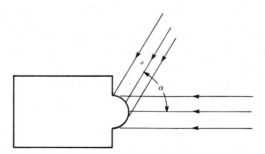

FIGURE 9.5 Comparison of the illumination of a hemispheric incident light collector for normal and oblique incidence.

one runs the risk of overexposing the highlights. This kind of illumination usually causes some of the subject to be shaded, however, and some increase in exposure frequently is needed. Hence, the admonition to point the meter in a direction midway between that of camera and source. In most front-lighted situations, the correction can be ignored and the meter can be pointed toward the camera because even for $\alpha = 45°$, the correction is only 15 percent. Certain specialized incident light meters have flat translucent integrating domes. The relative collection efficiency of this type of meter when used with a distant point source is

$$C = \cos \alpha \tag{9.2}$$

Very few situations exist in which all of the illumination comes directly from a point source. Out-of-doors on a clear day, no more than 90 percent of the illumination comes directly from the sun; the rest of the illumination comes from the sky and nearby reflecting surfaces. For example, a subject standing on white concrete on a clear day receives nearly half its illumination by reflection from the concrete. This is consistent with the rule of thumb, which states that if the subject is on sand or snow, the lens should be closed down one stop.

Determining correct exposure of backlighted scenes can be most difficult. If the entire scene including some top-lighted subject matter is to be photographed, reading incident light usually leads to overexposure in some highlight areas, and it is necessary to stop down as much as a stop and a half to correct for this overexposure. On the other hand, if a close-up photograph is being made and the object is truly backlighted, very little adjustment of the indicated exposure will be necessary. Incident light meters work well and require little interpretation in most other lighting situations provided the subject is more or less uniformly illuminated. Keep in mind that in this mode the meter is integrating all of the light in front of it. Perhaps the most important admonition is to experiment with the meter, record what is done, evaluate the final product, and think.

► **Example 9.2**

I am using an incident light meter with a hemispheric dome to determine the exposure for a picture of a side-lighted individual. The highlights are to be properly exposed and the shadowed parts of the face without detail. When the incident light meter is pointed toward the camera, the indicated exposure is f/11 at 1/125 sec. What should be the correct exposure?

Because the light source is at 90° with respect to the direction of light measurement, the collection efficiency is 0.5 and the exposure will have to be reduced to f/16, 1/125 sec to avoid overexposed highlights.

When reflected light meters are used to determine the exposure of front-lighted scenes of average reflectance, few problems are encountered. However, many scenes are not average. For instance, a landscape in summer with much green foliage would seem to be average, because the reflectance of green foliage is about 0.20. The illumination scattered from the sky, however, frequently will be much more than that reflected from the foliage. Care must be taken to avoid monitoring too much of the sky with a reflected light meter, because this will result in underexposure of the foliage. If the source of illumination is in front of the camera

as is the case in back- or side-lighted situations, it is important to shade the meter from the light source. In addition, a correction in the exposure may be necessary to avoid burned out highlights.

■ EXPOSURE FOR SUBJECTS OF OTHER THAN AVERAGE REFLECTANCE

If a subject is not of average reflectance, no change in procedure is needed when using an incident light meter, provided the illumination is more or less uniform, and the final product is to be a standard print. This is not the case with a reflected light meter.

As mentioned earlier, a reflected light meter is calibrated so that it can be used to measure light reflected from an 18 percent gray card, which is defined as the reflectance of an average scene. If the reflectance of the subject is higher than that of the gray card and no correction is made, the subject will be underexposed. For instance, the average Caucasian face reflects about 35 percent of the light incident on it. The meter has no way of "knowing" that it is "looking" at a Caucasian face and indicates an exposure appropriate for an 18 percent gray card. If standard printing and developing are used, the face in the print will reflect 18 percent instead of 35 percent of the light, and the result is a face that is too dark. In a sense, the meter "thought" the luminance was larger than it actually was and indicated an underexposure. If the reflectance of the subject is less than average, overexposure will be indicated by the meter unless some correction is made. Beginning photographers often find this information hard to believe. It may be helpful to consider taking a photograph of a black person and a white person. If a meter reading is taken off the face of each, the indicated exposures may differ as much as 3½ stops. Yet it is known that it is possible to make an acceptable photograph of the two people together using one exposure.

TABLE 9.1 Exposure Corrections for Key Tones of Selected Subjects

Key Tones		Reflectance	Correction* Stops	Correction* Time	Light Meter Setting
White		0.90	+2½	x5	ASA/5
Skin tones	Palm of hand	0.35	+1	x2	ASA/2
	Fair	0.35	+1	x2	ASA/2
	Olive	0.30	+1	x2	ASA/2
	Tan	0.25	+⅔	x1.4	ASA/1.4
	Brown	0.18	0	x1	ASAx1
Gray		0.18	0	x1	ASAx1
Skin tones	Dark brown	0.12	−⅓	x.7	ASAx1.5
	Black	0.06	−1⅔	x.3	ASAx3
	Very black	0.035	−2½	x.2	ASAx5
Black		0.032	−2½	x.2	ASAx5

*These corrections are accurate to ±⅓ stops.

If the reflectance of a given subject is known, it is a simple matter to correct an indicated exposure. Table 9.1 lists the reflectances of several selected tones and shows three different sets of correction factors. These tones are sometimes called *key tones*. To use this system, meter one of the key tones with a reflected light meter; then correct the exposure using the appropriate factor from the table. The correction can be made by a change in either the f-number or the exposure time. If the same tone is being measured repeatedly in a given photographic situation, the correction can be made at the outset by setting the meter calculator for an altered film speed setting determined from the last correction column in Table 9.1. The key tone system can be used with all reflected light meters, although spot meters are easiest to use because they can monitor small areas more accurately. If an in-camera meter or a hand held meter is used, special care must be taken to fill the field of sensitivity of the meter with a single desired tone. Skin tones are included because facial tones appear in many pictures, and accurate rendering of them usually is important. White, gray, and black are included in the table because they can be well defined. Although standardized white and gray cards are commercially available, a clean white handkerchief can be substituted as a white subject. Another convenient key is the palm of the hand. Although the reflectance of faces varies greatly with race, the reflectance of the palms of the hands varies much less.

▶ **Example 9.3**

On a trip to Yucatan some of the Mayan ruins are photographed. A clean handkerchief is used to determine the exposure for a film with as ASA film speed of 125. When the calculator is set for the ASA of the film the indicated exposure is f/14 at 1/5000 sec. What exposure should be used to take the picture? If the handkerchief is used repeatedly to determine the exposure of other ruins, for what ASA should the calculator be set in order to read the correct exposure directly from the calculator?

The reflectance of the handkerchief is about 0.9; hence, it will be necessary to open up about 2½ stops. This corresponds to an exposure of f/5.6 at 1/500 sec. To get more depth of field, close down two stops and increase the exposure time by a factor of four (f/11, 1/125 sec). To read the calculator directly, it should be set for an ASA film speed of 125/5 = 25.

The correction factor for any other key tone can be determined using either an 18 percent gray card or a standard light source. A convenient "standard" light source is outdoor illumination on a bright sunny day. The exposure reading is taken of the selected key tone, the calculator is then set for the indicated numerical reading, and the ASA adjustment is altered until the designated exposure is f/16 at 1/ASA sec or an equivalent exposure. The meter can be used to measure this particular key tone under any lighting condition provided the same film is used. The reflectance of the key (R) is equal to

$$R = 0.18 \times \frac{ASA}{I} \tag{9.3}$$

where ASA is the ASA film speed of the film, and *I* is the ASA setting of the calculator.

To calibrate an unknown key using an 18 percent gray card, first determine (for the film being used) the indicated exposure using the gray card. Illuminate the unknown key with the same illumination used for the gray card, and take a light reading of the unknown key. The calculator is then set for the indicated numerical reading, and the ASA setting is altered until the indicated exposure on the calculator is that determined using the gray card. The reflectance of the unknown key can be determined using Equation 9.3.

When using a reflected light meter to determine the exposure of colored objects, caution is in order. In general, yellow has the highest reflectance (as high as 0.75) and purple the lowest (as low as 0.06). It is not possible to list the reflectances of various colors, because the reflectance depends on the shade of the color and the efficiency of the dye used to make the color. For instance, blue sometimes has a reflectance of 0.18, but a particular dark blue shirt has a reflectance of 0.12 and a pale blue one a reflectance of about 0.7. In the case of fluorescent dyes, the reflectance may, in a sense, be greater than one, because some electromagnetic radiation in the ultraviolet is converted to light causing more of the visible to be reflected than that which is incident on the object.

▸ **Example 9.4**

I am photographing a model wearing a rose colored dress. I choose to key on her dress. Using an 18 percent gray card and a reflected light meter, it is found that the proper exposure under incandescent illumination for Kodak Ektachrome 160 film (ASA 160) is f/1.4 at 1/60 sec. The numerical reading of the meter is 6⅓ when monitoring the gray card and 7⅓ (one stop higher) when monitoring the dress illuminated by the same light. How should the calculator be set for correct exposure of this film if this meter is to monitor the dress under different incandescent lighting situations?

Set the calculator to 7⅓. Adjust the ASA setting until an exposure of f/1.4 at 1/60 sec is indicated. The meter can now be used to monitor the dress as described. The indicated ASA is 80, and the reflectance of the rose dress is 0.18 × 160/80 = 0.36.

The key tone system, as described here, when used with standard developing and printing techniques, yields prints for which the tonal distribution is like that in Figure 8.1. This means that the highlights and shadows are compressed. If, for example, a very black face is being photographed and the correction of Table 9.1 is used, barely discernible detail will appear in the face. Because this usually is not desirable, it will be necessary to increase the exposure. One way to do this is to key the very black face as a black face (see Table 9.1).

Dark keys and blacks, in particular, are more difficult to use as reference points. Recall that when light strikes an insulating surface, some of the light is reflected and some transmitted through the surface (see Fig. 9.6). The adsorbing dye usually is embedded in the material at the surface. The light that reaches a black dye will be absorbed. Some light is always reflected at the surface, however, and the amount depends on the nature of the surface. The fraction of the incident light reflected

FIGURE 9.6 The contribution of surface reflected light to the overall luminance of a black object (*a*) and a white object (*b*).

from the surface of the white card may equal that reflected from a black card if the two surfaces are the same. However, because the white dye absorbs very little light reaching it, and the black dye absorbs most of the light reaching it, a significant fraction of the light reflected from the black object may be light reflected at the surface. Even though the same amount of light may be reflected from the surface of the white object, the contribution to the total amount of reflected light is small. This is shown graphically in Figure 9.6 by the width of the arrows representing the light rays. If the surfaces are diffuse reflectors, this reflected light is not so trouble-some (see Fig. 9.7) because it is reflected in all directions and the measurement is made only in one direction. Unfortunately, most surfaces are somewhat specular and subject to glare. Hence, the apparent "blackness" of a black object depends not only on how "black" it is but also on the viewing direction, particularly when

FIGURE 9.7 Reflection of light from diffuse (*a*) and specular (*b*) reflecting surfaces.

illuminated by a point light source. To achieve a reliable true black, a surface is needed that reflects as little light as possible and little of that specularly.

If direct positive materials (e.g., reversal film) are being used, care must be exercised in determining exposure, especially if the scene has a large luminance ratio. Because the recording capability of such material is very nonlinear for a contrast range greater than five stops, any scene having a greater luminance ratio will be severely compressed in the highlights and/or shadows. If important information is contained in the highlights or shadows, the exposure determined using the key tone system must be adjusted to retain detail in the highlights or shadows.

A gray card can be used to determine the exposure of a scene for which the reflectance is not average. The exposure is determined by taking a reading from the card when it is placed in the scene. The card should be placed parallel to the main surfaces of the subject. Reading specularly reflected light from the card should be avoided, especially when using point light sources such as the sun. If the glare of the gray surface is compared with that of the white surface of a standard test card, the problem of measuring the true reflectance of a black object will be apparent.

If a scene is not of average reflectance and/or is not uniformly illuminated, an averaging technique can be used to determine exposure. In its simplest form, averaging involves measuring reflected light from the brightest and the darkest parts of the scene. The average of the two is used to determine the exposure. Such a measurement can be made using a spot meter or a reflected light meter close to the subject.

■ EXPOSURE DETERMINATION FOR NONSTANDARD PHOTOGRAPHS

Usually, a nonstandard photograph is made because a standard one would be esthetically unsatisfactory. For example, in the last section we discussed modifying exposure in a picture so that details of a black person's face could be enhanced. It may be desirable to modify film exposure and/or development to make a nonstandard print. It may also be desirable to change paper grade. Several relatively simple ways of modifying the exposure and/or development procedure will be discussed, and a brief discussion of the *zone system* will be presented from the point of view of the H & D curves discussed in the last chapter.

If a scene of extremely low or high contrast is to be photographed, some modification of exposure and/or development may be desirable. The negative of a low- contrast scene (e.g., a seascape on a gray day), if exposed and developed normally, has a limited density range. If printed on no. 2 paper, the full range of tones of the paper will not be utilized, and the picture will be *flat*. Sometimes this is desirable, but often it is not. This difficulty can be corrected by printing on a harder paper because, in this case, less density range in the negative is required to yield full tonal range on the paper.

▶ **Example 9.5**

I photographed a seascape on a gray day using Kodak Plus-X Pan film. The exposure range of the scene spanned four stops (contrast range of 16:1). The exposure was based on an uncorrected incident light reading. Development was standard using HC-110 (dilution B). Examination of the negative reveals that minimum discernible detail is recorded on the film at a density that is about three times base-plus-fog density. Would the finished photograph look flat if printed on no. 2 paper? If so, could any other grade of paper be used to yield a full tonal range in the print?

Figure 9.8*a* shows the H & D curve for Kodal Plus-X Pan film developed as described (the bottom curve). The H & D curves for various grades of a glossy paper that might be used to print the photograph are shown in Figure 9.8*b*. Because base plus fog density is about 0.18, the density for minimum discernible detail is 0.54. This corresponds to a log exposure of $\overline{2}.5$. Because the total exposure range is four stops, the range in log exposure is $4 \times 0.3 = 1.2$, and the maximum exposure is $\overline{1}.7$. The exposure range is shown in Figure 9.8*a*. This yields a maximum density of 1.23, so the density range as shown in the figure is about 0.7. Neglecting the effect of the enlarger, this 0.7 range in density translates into a 0.7 range in log exposure of the paper. Because the log exposure range of this no. 2 paper is about 1.1, the print will be flat regardless of exposure of the printing paper in the enlarger. The effect of enlarger flare will be to make the print even flatter. If it is printed on no. 2 paper as shown in Figure 9.8*b*, the reflection density range of the print would be 1.0, whereas the density range of the paper is about 1.65. On the other hand, if the negative was printed on no. 4 paper as shown in Figure 9.8*b*, a print of almost full tonal range could be made.

Note that in the above example the negative is denser than it need be, and as a consequence the benefits of being lower on the H & D curve (less exposure, better tonal separation, and less grain) are lost. If the exposure had been reduced without any other change, the density range of the negative would have been further reduced compounding the problem of a flat print. If exposure is reduced and development time is increased, however, a negative of greater density range can be made that utilizes the lower part of the H & D curve.

▶ **Example 9.6**

Assume that the scene described in Example 9.5 had been photographed using the same film, but that the exposure had been reduced by two stops. Further assume that the same developer was used, but the development time had been increased by 60 percent. What would be the range of density of this negative, and how does it compare with the log exposure range of the papers graphed in Figure 9.8*b?*

If the exposure is reduced by two stops, the minimum log exposure will be $\overline{3}.9$ and the maximum log exposure will be $\overline{1}.1$. With the specified increased development time, the minimum density will be 0.32, the maximum density

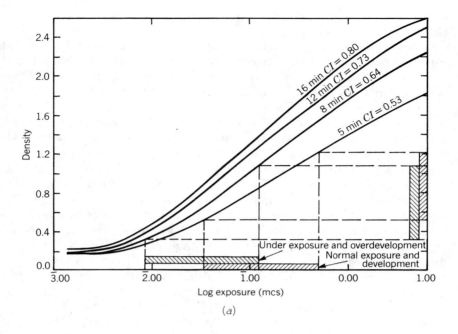

(a)

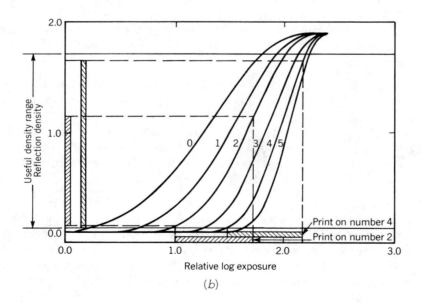

(b)

FIGURE 9.8 H & D curves for Kodak Plus-X Pan film (a) and typical glossy papers (b).

1.08, and the range of density, 0.75 (see Fig. 9.8a). We see that the minimum and maximum densities have been reduced and the range of density increased. The log exposure range of the no. 3 paper shown in Figure 9.8b is about 0.85, and we probably could get a satisfactory print using the new negative and paper combination. However, the no. 4 paper with its smaller log exposure range might be a better choice.

The example above is somewhat extreme. Unless extensive spot metering is done, it is more prudent to make exposures of visually flat scenes about one stop less than normal and to increase development time by 25 percent. Flat scenes usually are a consequence of diffuse lighting such as overcast sky, open shade, and bright days where a great deal of light is reflected into the scene. A deceptive example of this last situation is photographing a subject on a bright sunny day on snow. Although the situation may seem contrasty because the illumination is very bright, the reflected light from the snow tends to wash out the shadows and causes the subject to appear flat.

The *contrasty* scene, in which the luminance ratio may be 1000/1, is at the other end of the scale from the flat scene. The exposure range spans 10 stops (three on the log E scale). If Plus-X Pan film is exposed to such a scene and subsequently developed in a standard fashion (see Fig. 9.8a), the range of density will be about 1.5. Because the log exposure range of a typical grade one glossy paper is about 1.2 (see Fig. 9.8b), it will not be possible to make a print from such a negative that is not contrasty. In such a situation, it is possible to overexpose the film and underdevelop it to reduce the contrast of the negative. Unless extensive spot metering has been done, it is prudent to overexpose about one stop and reduce the developing time to 75 percent of the normal time. The underdevelopment reduces the contrast index, whereas the overexposure improves shadow details. This can be visualized by imagining that the H & D curve is lowered and the exposure moved to the right about 0.3 (see Fig. 9.8a, for example).

Contrasty scenes usually are a consequence of pointlike illumination. Stage lighting (especially of solo performers) and outdoor illumination on a bright sunny day are common examples of such illumination. The former situation can be particularly vexing because the illumination, although contrasty, may be relatively dim, and the temptation is to underexpose rather than overexpose as should be done if the tonal rendition of the final print is to be improved. Even after modification of exposure and/or development, it may be necessary to make the final print on a softer paper to improve tonal rendition.

Films are classified as long-, medium-, or short-toed depending on the shape of the toe of the H & D curve (see Fig. 9.9). Note that the long-toed film shows a continuous change in slope (steepness) with increasing exposure, whereas the slope of the short-toed film changes more abruptly. Long-toed films are more suitable for high-contrast lighting situations (point light sources), whereas short-toed films work better in situations where the illumination is more diffuse.

There is an old saw that recommends exposure for the shadows and development for the highlights. That is, the exposure is to be long enough to get discernible

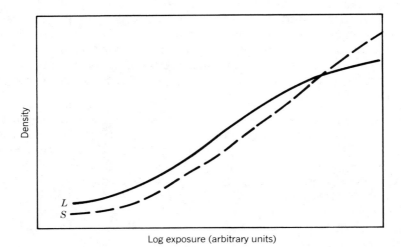

Log exposure (arbitrary units)

FIGURE 9.9 H & D curve for a short toed (*S*) and a long toed (*L*) film.

details in the shadows and development short enough to retain details in the high-lights. This is sound advice, but with the advent of panchromatic film, almost impossible to follow to the letter, because the film cannot be observed as it develops.

■ THE ZONE SYSTEM

The zone system, which has been considerably refined by Ansel Adams and others, is considered by some to be the best and most sophisticated method for deter-mining proper exposure and development. In using the zone system, both expo-sure and development are manipulated to achieve a desired end. In some versions, paper grade is also manipulated. This is an alternative to controlling development, however, and is discussed separately here.

 In the zone system, the *exposure range* is divided into *exposure zones* so that the interval of each *zone* spans one stop (a factor of 2 in the luminance). The number of exposure zones needed to represent the total exposure range depends on the contrast of the scene. Most zone systems are restricted to 9, 10, or 11 zones. Ten exposure zones accommodate a contrast ratio of slightly over 1000/1, and the range on the log *E* scale of the H & D curve is about three (10 × 0.3). In Figure 9.10, 10 exposure zones are distributed along the log *E* axis of the H & D curve. If the film is exposed as indicated in Figure 9.10, and developed so that the H & D curve is as shown, the 10 exposure zones will be distributed as 10 zones in film density as shown. Note that although the exposure zones are equal and each spans one stop, the *density zones* usually are not equal in density range. The neg-ative can then be used in an enlarger to make a final print, and the relationship between the density zones in the negative and the distribution of the *gray scale zones* in reflection density in the final print might be as shown in Figure 9.11.

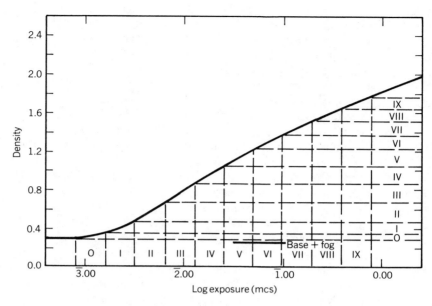

FIGURE 9.10 H & D curve for film showing relationship between exposure zones and density zones for normal development.

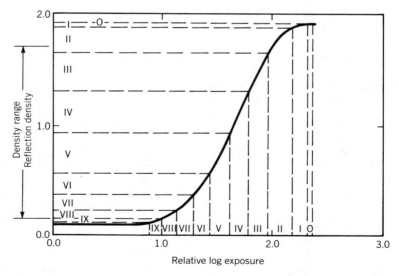

FIGURE 9.11 H & D curve for paper showing the relationship between exposure zones and gray scale zones. The exposure zones are those resulting from the density zones in Figure 9.10.

In general, the span of the individual gray scale zones are not equal and not the same as the span of comparable density zones. If the exposure and development are normal, the center of exposure zone V corresponds to the exposure of an 18 percent gray card, and the center of the gray scale zone V reflects 18 percent of the light incident on it. In this example, the center of zone V on the gray scale reflects 18 percent of the light falling on it (log reflection density equals 0.74). However, it is not possible to print 10 distinct zones on this no. 2 paper. Nine distinct zones can be identified, but only six-plus zones lie between the usual accepted printing limits (i.e., in the density range). In practice, every luminance in the scene cannot be measured, but a luminance corresponding to something near the center of each zone, such as the luminance of an 18 percent gray card for zone V, can be measured. In principle, 10 zones could be printed, because the center of zone 0 and zone I would be at different points on the reflection density curve.

If, in measuring the luminances of the scene, it is found that the exposure range spans considerably less than 10 zones (e.g., four zones), the scene is called *short scaled.* If, in such a situation, normal development, exposure, and printing are used, the resulting picture will be flat, which usually is not desirable. On the other hand, if the luminances of the scene are such that the exposure range considerably exceeds 10 zones (e.g., 12), the scene is called *long scaled* and normal exposure, development, and printing yield a contrasty print, which usually is undesirable. If the subject is such that the major interest appears in very dark tones (e.g., a black person's face) or very bright tones (e.g., details on snow), normal exposure, development, and printing usually yield an undesirable print.

The aim of the zone system is to control exposure, development, and printing systematically so that the final picture appears as visualized when the scene was evaluated. This evaluation is called *previsualization* by zone system photographers and is a combination of measuring luminances of the scene and deciding how the final picture is to appear. Control is exercised by modifying exposure and/or development. To use the zone system effectively, a given film first must be evaluated to determine those conditions of exposure, development, and printing that will yield a final print in which the 18 percent gray of the scene appears as 18 percent gray in the print, and in which the luminances corresponding to the zones are distinguishable as different tones in the final print. This so-called normal (N) exposure and development might look as in Figure 9.10.

The next step in calibration is to alter development time to change, systematically, the density range of the negative. Altering development time and hence contrast index, so that the density of zone V is the same as that for zone IV for normal development is called $N - 1$ development. The density range of the negative decreases as does the average density. All of these effects are compared graphically in Figures 9.10 and 9.12. If density zone V, using altered development, is the same as density zone III for normal development, this is called $N - 2$ development. Also determined are the times for $N + 1$ and $N + 2$ development that correspond to an increase in contrast index and move up zone V density to zones VI and VII, respectively, of normal development. In general, $N-$ development decreases the overall density and density range of the negative (see Fig. 9.12) and $N+$ devel-

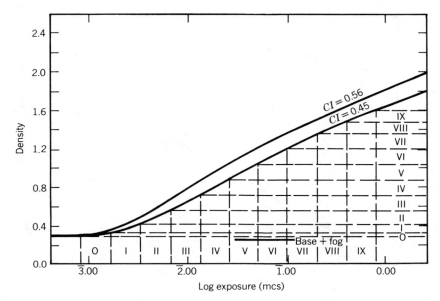

FIGURE 9.12 Graphic representation of the relationship between exposure zones and density zones for the film of Figure 9.8 assuming $N - 1$ development.

opment increases the overall density and range of density. The reader is referred to the source listed below for more details.[1]

An increase or decrease of exposure from normal is designated as $N+$ or $N-$ exposure. For instance, $N - 1$ exposure means a decrease in exposure so that zone V density is the same density as zone IV density for normal exposure (see Fig. 9.13). The effect of $N-$ exposure is to decrease the density and the density range of the negative, whereas $N+$ exposure has the opposite effect. In the example, the effects of $N - 1$ exposure and $N - 1$ development are almost equivalent. This is demonstrated graphically in Figure 9.14. $N - 1$ development reduces the density range slightly more than $N - 1$ exposure.

Systematic use of this knowledge can solve some rather vexing photographic problems. If a scene is flat (e.g., an exposure range of six stops), increased development time can be used to increase density range, resulting in a print having greater tonal range, which may achieve more nearly, desired esthetic goals (see Fig. 9.15). By increasing development time, six exposure zones have been spread over the density range normally occupied by eight zones. Alternatively, normal development and a more contrasty (harder) paper could have been used to make the print. If this method is compared with the procedure outlined in Example 9.5, it is seen that in the example the print was made on a harder paper, whereas in

[1]M. White, R. Zakia, and R. Lorenz, *The New Zone System Manual,* Hastings-on-Hudson, N.Y.: Morgan and Morgan (1976), p. 123.

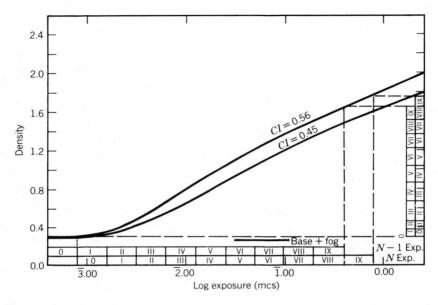

FIGURE 9.13 Effect of $N - 1$ exposure on density for a negative developed normally.

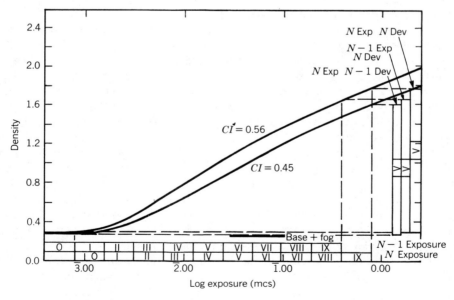

FIGURE 9.14 Comparison of the effect of $N - 1$ exposure and $N - 1$ development.

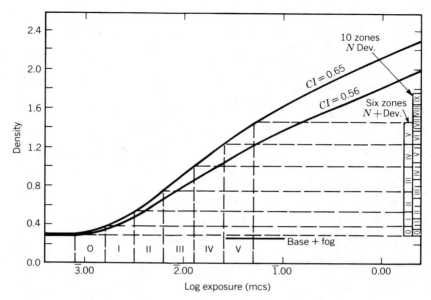

FIGURE 9.15 Use of $N+$ development to make a print of increased tonal range.

this case increased development time was used to solve the problem. In the discussion of Example 9.6, it was suggested that when photographing a flat scene, an increase of development time should be accompanied by a decrease in exposure. The exposure decrease compensates for the increase in density, which is usually an unwanted side effect of increased development time. In the example graphed in Figure 9.15, further reduction in exposure is undesirable, because the negative is already quite thin. It is well worth remembering that, although it is desirable to use this system without further manipulation in the printing process to achieve the desired result, the photographer is still at liberty to either increase or decrease the exposure of different parts of the printing paper. The former is called burning in and the latter dodging.

Much is said in the popular literature about pushing film. This is the process of underexposing the film one or more stops and increasing development time of the film to compensate for the underexposure. The practice is advised in cases where the illumination level of the scene is too low for a normal exposure. When this technique is considered from the viewpoint of zone system photography, the proper procedure is not always obvious. If the subject is very contrasty but dimly lighted, the best procedure may be to underexpose one stop and develop the film normally, especially if little important pictorial material is in the shadowed parts of the scene.

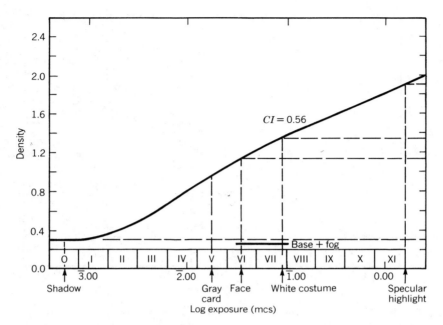

FIGURE 9.16 H & D curve for Kodak Tri-X Pan film showing the relationship between exposure and density for Example 9.7.

▶ **Example 9.7**

I have been assigned the task of photographing a solo stage performance of a rock musician. The lighting is primarily by spotlight. A spot meter is used to determine that the luminances span a range of at least 12 stops. By measuring the luminance of a white face and correcting for its reflectance, it is determined that an 18 percent gray card will be underexposed one stop when using Kodak Tri-X film exposed at the maximum aperture opening and at the longest exposure time for which the camera can be held steady without support. This is very close to $N - 1$ exposure. Using a standard developing time, what will be the density range of the negative, and what kind of print can be made on no. 2 glossy paper?

Eighteen percent gray corresponds to an exposure of $\overline{2}.55$ on the log E scale in Figure 9.16 for N exposure. The one stop under exposure corresponds to about $\overline{2}.25$ on the log E scale. The center of zone 0 (the darkest shadows not illuminated by the spotlight) is about $\overline{4}.75$. The Caucasian performer's face is at $\overline{2}.55$, the white of the performer's costume at $\overline{2}.95$, and the specular highlights of reflections from the instruments are in zone 11 at 0.20. The corresponding densities would be: base-plus-fog = 0.3, white face = 1.15, white costume = 1.35, specular highlights = 1.9. The density range of the negative is 1.9 − 0.3 = 1.6. Table 8.5 shows that the log exposure range of no. 2 paper is typically 1.3 and that of no. 1 is 1.5. If detail in the glints from the instrument are to be

retained, print on no. 1 paper and do not increase development time. In practice, a harder paper would be used, and some detail in the glints would be sacrificed. Some of the dark key tones will be lost, and this rendition will not be satisfactory if the performer's face is black.

The zone system is indeed an elaborate and systematic way to control the photographic process to achieve a desired result. It incorporates in one system many of the methods discussed earlier. It is probably too cumbersome for routine photography, and most will abridge the system for all but the most exacting work. Different grades of paper may be used instead of altering development, especially when using roll film and photographing different subjects on a single roll of film. If the zone system is chosen, the exposure process will be retained, and this may be abridged by reducing the number of zones. One may choose to measure only the luminance of a highlight, a shadow, and an 18 percent gray card, or the key tone system may be used to determine exposure.

EXERCISES

9.1. Compare the relative merits of using a light meter in a reflected and incident metering mode. Under what conditions is each preferred? What are the advantages and disadvantages of each mode?

9.2. How do selenium cell and cadmium sulfide cell meters differ in their operation? List the advantages of each.

9.3. Compare the operation of in-camera light meters, normal hand held light meters, and spot meters. What are the advantages of each?

9.4. For what standard are reflected light meters usually calibrated? If you are monitoring a scene that is higher in reflectance than an 18 percent gray card, how should the indicated exposure be altered?

9.5. I am using my light meter in a reflected mode to measure light reflected from the palm of my hand. The calculator is set for the ASA film speed of the film in the camera. The indicated exposure is f/11 at 1/125 sec. What would be a correct exposure for a normal negative? How could the ASA film speed setting of the light meter be changed to make it read the proper exposure?

9.6. What is the purpose of the key tone system?

9.7. How would you determine the ASA film speed setting of a light meter calculator for an unknown key tone using a standard light source? Using an 18 percent gray card?

9.8. If you are photographing a black person and a white person together, how should you alter the normal exposure to get the best rendition of their faces? Why?

9.9. If the luminances of a scene do not cover a very wide range, how can exposure and development of the film be altered to improve the final print? If you choose to correct this difficulty by changing paper grade, what change would you make?

9.10. In the zone system, when you use $N + 2$ development, what do you do?

9.11. In the zone system, if you use $N + 1$ exposure, what do you do? Use Figure 9.13 to show the density range for the example in that figure.

part ·4·

LIGHT, COLOR, AND FILTERS

chapter ·10·

Light sources for photography

■ **SPECTRAL DISTRIBUTION**

In Chapter 4 the nature of the electromagnetic spectrum was discussed, and it was noted that light occupies a very small part of that spectrum (from about 400–700 nm). In Chapter 7 it was noted that the silver halides are sensitive to electromagnetic radiation of wavelengths shorter than or equal to that of blue light. By the addition of appropriate sensitizing dyes, the film can be made sensitive to the rest of the visible part of the spectrum and part of the infrared. For photography in the visible part of the spectrum, light sources which yield adequate illumination in that part of the spectrum and little in other parts are preferred. Most of the light sources are either *blackbody* or *line spectrum* light sources.

■ **BLACKBODY LIGHT SOURCES**

If the element of an electric stove is turned on in a darkened room, initially the element cannot be seen. As it heats, it turns first a dull red and finally becomes bright orange. If more power is applied to the element, it might appear almost white like an electric light bulb. Such light sources are called *incandescent* and emit light in a continuous spectrum. This continuous spectrum approximates what is called a blackbody radiation curve. The spectral distribution of the radiation from a blackbody depends only on the temperature of the light source. The curves in Figure 10.1 show the relative intensity of the radiation at a given wavelength as a function of wavelength for two incandescent bodies at different temperatures. As the temperature of the body (like the stove element) is increased, the peak in the distribution of the radiation intensity moves to shorter wavelengths. The Wien dis-

FIGURE 10.1 Blackbody radiation curve for an incandescent body at two different temperatures.

placement law, which describes how the maximum in the distribution changes with temperature, is given by

$$\lambda_M T = \text{constant} \tag{10.1}$$

where T is the absolute temperature of the blackbody and λ_M is the wavelength at which the maximum in the distribution occurs. The absolute temperature is the Celsius (formerly centigrade) temperature plus 273° and is called the Kelvin temperature. In effect, the zero of the scale is moved from the melting point of ice to a temperature 273° lower, which is called absolute zero and represents the theoretical lower limit of how cold an object can be. As the temperature increases, the amount of radiation also increases. In an idealized case, the increase is proportional to T^4.

▶ **Example 10.1**

The radiation curves in Figure 10.1 represent radiation from objects at 4000 K (T_2) and 2000 K (T_1). Verify the Wien displacement law. What would be the temperatures of the objects on the Celsius scale? The peak of the higher temperature curve occurs at about 700 nm; that of the lower temperature curve at about 1400 nm. Because $T = 4000 \times 700 = 2000 \times 1400$, the law is confirmed for this case. The Celsius temperatures are $4000 - 273 = 3737°C$ and $2000 - 273 = 1727°C$.

Because the spectral distribution of the radiation from a blackbody is a function of its temperature only, that temperature can be used to label the radiation. Such a specification is called the *color temperature*. The color temperatures of the bodies emitting the radiation represented in Figure 10.1 are 2000 K and 4000 K. Many other light sources have distribution characteristics approximating blackbody sources and are characterized in terms of their color temperatures. Most daylight illumination can be so characterized. The range of color temperatures for various kinds of outdoor illumination is summarized in Table 10.1. In general, the lower temperatures apply to illumination in winter and the higher temperatures apply for summer conditions. Note that the color temperatures listed in Table 10.1 characterize the nature of the radiation and not the temperature of the source. It is not meant to imply that the blue sky is hotter than the sun.

Incandescent light bulbs emit radiation for which the color temperatures vary from 2800 K for a 75 watt household bulb to 3400 K for a photoflood lamp. Note that all of these color temperatures are below those for daylight illumination. In general, the color of a light source is a minor problem in black-and-white photography, but this is not the case for light sources in color photography.

The color temperature of an incandescent light bulb usually decreases as the bulb ages, because metal from the filament is deposited on the surface of the glass envelope as it burns. To overcome this evaporation problem, some incandescent bulbs are filled with a special gas to reduce this evaporation. An example is a quartz iodide lamp which is filled with iodine vapor and has a quartz envelope to allow it to operate at a higher temperature.

TABLE 10.1 Color Temperatures for Various Kinds of Daylight Illumination

Condition	Low Temperature	High Temperature
Direct sunlight alone, midday	5400 K	5800 K
Direct sunlight alone, morning or evening	4900 K	5600 K
Sunlight plus light from clear sky—midday	6100 K	6500 K
Sunlight plus light from clear sky—morning or evening	5700 K	6200 K
Sunlight plus light from hazy sky	5700 K	5900 K
Overcast sky light	6700 K	7000 K
Light from hazy sky	7500 K	8400 K
Light from blue sky (open shade)	12000 K	27000 K

Another quantity used to characterize the radiation from a particular blackbody light source is the *mired* (M) which is

$$M = \frac{10^6}{T} \qquad (10.2)$$

where T is the temperature of the radiation source in degrees Kelvin. Note from Eq. 10.1 that the position of the peak of the blackbody radiation curve specified in wavelength is proportional to $1/T$ and hence, proporational to M. Changes in mired values can be equated to peak shifts in the blackbody radiation curve. Because of the way the eye perceives color, the term mired is particularly useful in characterizing *light-balancing filters,* as is discussed in more detail in Chapter 13.

▶ **Example 10.2**

Assume that on a clear day the color temperature of the light from the sun plus the clear sky is T_s = 6000 K and that of the light from the blue sky alone is T_b = 12000 K. Find the color temperature in mireds for each of these light sources, and compare it to the mired value for an incandescent light source whose color temperature is T_i = 3000 K.

For the sunlight plus clear sky case, we get M_s = $10^6/6000$ = 166.67; for the blue sky case M_b = $10^6/12000$ = 83.33, and for the incandescent bulb case M_i = $10^6/3000$ = 333.33 micro reciprocal degrees. These results are tabulated in Table 10.2. Although the color temperature difference between the

TABLE 10.2 Summary of Results in Example 10.2

Light Source	Color Temperature	
	T (K)	M (10^6/TK)
Blue sky	12000	83
Sun plus blue sky	6000	167
Incandescent	3000	333

two daylight sources is twice that of the difference between sun plus blue sky and incandescent sources, the mired change is half as great in the former case as in the latter case. Hence, the shift in the peak of the radiation is half as great in the former case as in the latter case. In general, changes in the color temperatures of cool light sources have more effect on the color characteristics of such light sources than do similar changes in the color temperature of relatively hot sources.

Because photographic film is sensitive to radiation in the *ultraviolet* part of the spectrum, blackbody radiation in the ultraviolet can create exposure problems for film. As the temperature of the light source is increased, more of the radiation is in the ultraviolet where the film is sensitive, and hence, the exposure increases more than is perceived by the eye. Fortunately, optical glass, in most cases, screens out much of the ultraviolet, compensating somewhat for the increase in the ultraviolet radiation.

■ FLUORESCENT ILLUMINATION

Fluorescent lamps are filled with mercury vapor which, when electrically excited, emits ultraviolet radiation. This radiation, in turn, excites *phosphors* on the inside wall of the envelope and causes them to emit radiation in the visible part of the spectrum. The nature of this excitation is such that most of the radiation from the phosphors is restricted to discrete wavelengths of radiation, although these bands are superposed on a continuous background. Figure 10.2 shows a plot of the spectral distribution of the light from a typical fluorescent lamp.

The color of the light from these lamps as seen by the eye depends on the mixture of phosphors and the spectral response of the eye (see Chapter 6).

Because color film does not have the same spectral response as the eye, film will "see" the light differently. For this reason, fluorescent illumination is very difficult to manage in color photography. In addition to problems generated by differences in the spectral response of the eye and color film, the colors of dyes depend on the nature of the illuminating light. For instance, two dyes that appear identical to the eye when viewed in sunlight may be vastly different when viewed under daylight fluorescent light. This will be discussed further in Chapter 11. Fluorescent illumination presents few problems, however, in black-and-white photography.

FIGURE 10.2 Spectral distribution of radiation from a daylight fluorescent bulb.

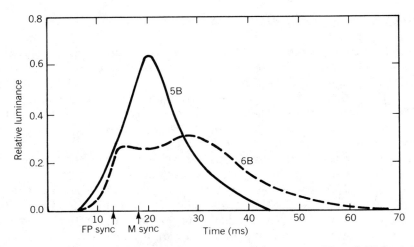

FIGURE 10.3 Time dependence of illumination from number 5B and 6B flash bulbs.

■ FLASH BULBS

Flash illumination may be accomplished using either a bulb or electronic flash. The modern flash bulb consists of a glass envelope filled with aluminum or zirconium metal (wire or foil) in an oxygen environment. A primer in the bulb is ignited percussively or by an electric current from a battery, which in turn ignites the metal causing it to burn violently. The emitted radiation has a color temperature between that of incandescent tungsten illumination and daylight illumination. The bulb envelopes usually are covered with a blue filter to balance the color so that they may be used with daylight color film.

After ignition, time is required for the illumination to attain maximum value. Figure 10.3 shows how the luminance varies with time after ignition for two different kinds of flash bulbs. The more common bulbs behave like the no. 5B bulb. Such a bulb is designated a class M bulb and is designed for use primarily with cameras equipped with leaf shutters.

When the 5B bulb is used with a between-the-lens shutter, the *synchronization* of the flash illumination with the shutter operation is such that the bulb is ignited before the shutter is opened. This is necessary because it takes about 20 milliseconds (2/100 sec) for the bulb to reach peak illumination. This delay in reaching peak illumination would cause a great deal of difficulty at fast shutter speeds (1/500 sec = 2 ms) if the actuation of the shutter was not also delayed. The exposure of the film would be completed before the bulb illuminated the scene. No such problem exists for long exposures. Such synchronization is called *M sync,* and on more sophisticated cameras having more than one kind of synchronization, a connection or a switch position is designated *M* for use with this kind of bulb *(M flash bulb).*

Figure 10.3 shows that the illumination varies during the exposure. The variation is small for short exposures (1/1000 sec–1 ms) but is considerable for longer exposures (e.g., 1/50 sec–20 ms). This means that the exposure of the film is not proportional to the exposure time, and therefore some method is needed to characterize the illumination that accounts for this variation.

A bulb can be characterized in terms of its total illumination of the subject during the exposure. For a given exposure time, the amount of light reaching the film depends on the amount of light reaching the scene and the f-number. The amount of light needed to give a proper exposure depends on the sensitivity of the film. For convenience the *guide number* (G) is used to determine the proper exposure of the film. The guide number is a function of the light output of the bulb during the exposure and the film sensitivity. For a given film and shutter speed

$$G = f/xd \tag{10.3}$$

where d is the distance from bulb to subject, assuming that the bulb illuminates the subject directly. The guide number depends on the units in which d is measured. When d is measured in meters, the guide number is about one-third its value for d measured in feet.

To understand the rationale behind this relation, imagine that a person in a darkened room is trying to read by the light of a candle. The farther the person is from the candle, the dimmer the light will be. Figure 10.4 shows how the illumination

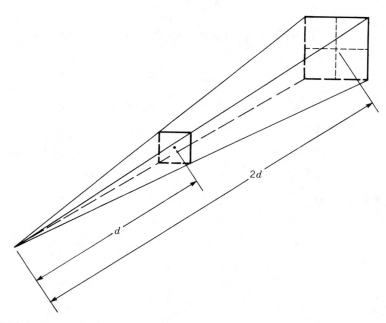

FIGURE 10.4 Dependence on distance of the illumination of a scene by a point light source.

decreases with distance when the distance is doubled. Note that the same cone of light that illuminates an area A at distance d must illuminate an area $4A$ at a distance $2d$, because both the width and height of the square double with distances. Hence, the illuminance of the area at $2d$ is one-fourth that at d. This can be generalized to state that the illuminance of a scene is inversely proportional to the square of the distance between the light source and the subject. It has already been established that the illuminance of the film is inversely proportional to the square of the f-number. If the distance from bulb to subject is doubled, one-fourth as much light reaches the subject. If the film is to receive the same exposure, the aperture must be opened two stops. This means that the f-number must be reduced to one-half its former value, and the product ($d \times$ f/) is unchanged.

The amount of light reaching the subject depends also on the kind of reflector with which the bulb is used and the nature of any nearby reflecting surfaces.

Guide numbers are specified either for polished or diffuse reflectors and assume that the bulb will be used in an average-sized room with moderately light-colored walls. If the reflector is deep so that significant focusing of the light occurs, the distance used in calculating the f-number is the distance from the apparent source of the light rather than the actual bulb. In Figure 10.5, the distance to be used in calculating the f-number is not d_1 but d_1 plus d_2. The smaller the value of d_1, the greater will be the error incurred by neglecting d_2. When working outdoors, in a very large room, or in a room with very dark walls, the guide number must be reduced to correct for the absence of reflected light from the walls. In extreme situations when an open reflector is used, the correction factor may be 2 or more.

The guide number is also proportional to the square root of the ASA film speed. Why this is so can be seen if it is remembered that for proper exposure the f-

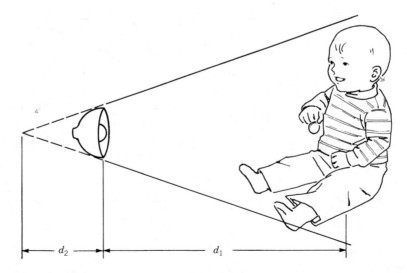

FIGURE 10.5 Distance to be used in calculating the f-number when using a focusing reflector with flash.

LIGHT SOURCES FOR PHOTOGRAPHY

number is proportional to the square root of the ASA film speed. From Equation 10.3, it follows that the guide number is proportional to the f-number.

No simple analytical relation exists for relating G to the exposure time. This is determined empirically and such information is supplied by the manufacturer with the bulbs. Handbooks[1] are available that summarize the characteristics of many different kinds of bulbs.

▶ **Example 10.3**

I have a small, polished shallow bowl reflector that I use with 5B bulbs. The guide number (in feet) of this bulb for exposure of 1/60 sec is 120 when used with ASA 125 black-and-white film. If this bulb illuminates a subject directly in an average room and the aperture is set at f/16, at what distance should the bulb be placed from the subject? For outdoor color film (ASA = 64) what is the new guide number and f-number assuming that the distance is unchanged?

From Equation 10.3 we see that $120 = 16\ d$. Hence, d is equal to 7.5 ft. When we switch to the slower film, G is reduced by the factor $\sqrt{64/125}$. This is approximately the reciprocal of $\sqrt{2}$ (about 0.7). The new guide number will be about 85, and the new f-number will be about f/11. To retain the original f-number, the new distance would have to be $85/16 = 5.3$ ft. Incidentally, the guide number for this bulb and film combination is 60 for a shutter speed of 1/500 sec, and the maximum guide number is about 150.

A 6B bulb is classified as a *FP flash bulb* and is designed to be used with cameras having focal plane shutters. It is constructed so that it reaches peak illumination slightly earlier than the 5B bulb (see Fig. 10.3) and has a more nearly constant peak illumination for a longer time. Recall that typically it takes 1/60 sec (17 ms) to take a picture with the most common focal plane shutter, even though the exposure time for any part of the scene may be as little as 1/1000 sec (1 ms). Suppose that a 5B bulb is used to illuminate a uniformly painted wall, and that a picture is to be taken with a camera equipped with a focal plane shutter set for an exposure of 1/1000 sec. Figure 10.3 shows that no 20 ms. interval exists when the illumination is constant. If the shutter is actuated at the time designated as *FP sync* on the graph, the illumination is brightest when the central part of the scene is recorded (about 10 ms after the shutter is actuated) and much dimmer when the edges of the scene are recorded. On the other hand the 6B bulb, with its more uniform illumination over a longer time span, yields a more uniform image.

The FP sync jack or switch setting on cameras with focal plane shutters is such that the delay of the shutter, after the ignition of the bulb, allows the bulb to reach peak illumination before the shutter starts to open. The same guide number system is used for both FP and M bulbs. If the illumination is constant in time, the guide number is proportional to the square root of the exposure time for this kind of

[1]*M & M Photo Lab Index — Section 10 — Lighting and Exposure,* Hastings-on-Hudson, N.Y.: Morgan and Morgan, Inc.; *Kodak Professional Photoguide — Kodak Publication R-28,* Rochester, N.Y.: Eastman Kodak Co., 1975.

bulb. This can be understood by recalling the dependence of G on f/, and noting that doubling exposure time is equivalent to opening up one stop when using constant illumination (e.g., floodlamps).

■ ELECTRONIC FLASH ILLUMINATION

The tube of an electronic flash unit consists of a quartz envelope that is usually filled with xenon gas under pressure. Other gases are included to achieve the proper spectral balance of the illumination. A large capacitor charged to high voltage is discharged through the tube causing the gas to ionize and emit visible radiation. The gas is so chosen that the radiation approximates daylight in spectral distribution. A schematic diagram of the circuitry for an electronic flash unit is shown in Figure 10.6. The power supply may be operated from AC line voltage or from batteries. The supply itself operates at about 200 Hz causing a hum when the unit is operating. The DC voltage across the capacitor and tube depends on the particular unit and ranges from 350 to 20000 volts. Typical small portable units operate at less than 1000 volts. The exciter voltage (E) comes from the power supply and provides a very high-intensity electromagnetic field to initiate the discharge. When the switch S is closed, the exciter starts the discharge and the capacitor discharges through the tube. After the discharge, the power supply recharges the capacitor. The duration of the flash is a function of the voltage across the tube and is typically 1/500 to 1/1000 sec for small portable units. The light output of a unit varies directly with the size of the capacitor and the voltage across the tube. In portable units, the total light output that can be obtained before batteries must be replaced or recharged depends on the size of the batteries.

The illumination capability of electronic flash units is rated either by guide number for a specified film (similar to flash bulbs) or in terms of *luminous flux-time* in *beam candle power seconds* (bcps). Sometimes the term *effective candle power seconds* (ecps) is used, although the two are equivalent. The total light output per flash is proportional to bcps. For a given film, the guide number is proportional to the square root of the bcps rating. Because *candle power* is a measure of the rate of light output of a light source, candle power seconds is a measure of the total

FIGURE 10.6 Schematic diagram of electronic flash unit showing power supply, capacitor (C), switch (S), lamp (L), and exciter (E).

light output of an intermittent source, and beam candle power seconds is a measure of the total light output of a directed source. Some small portable electronic flash units have very deep-dished reflectors, which can cause some difficulty when using the guide number to determine the exposure. The effective distance from subject to lamp (see Fig. 10.5) may be considerably different from the actual distance, especially when the flash unit is close to the subject. Electronic flash units frequently seem to be overrated if the rated guide number is used to determine exposure. This difficulty probably is due to the difficulty in relating the space in which the unit is used to the space in which it was calibrated.

The electronic flash unit has been refined considerably in recent years with the advent of modern microelectronics. There are automatic units available which have light sensors attached to them so that the amount of light reflected back toward the camera can be monitored. The flash tube is turned off by these sensors when a predetermined amount of light reaches the sensor. Essentially, a flash-reflected light meter monitors the reflected light and controls the length of time of illumination. To be effective, the monitor should be on or near the camera and pointed in the direction of the subject.

Because the monitor is functioning as a reflected light meter, all the caveats that apply to reflected light meters are applicable. In particular, remember that reflected light meters are calibrated for an average scene (18 percent gray card) and not all scenes are average. Because the length of exposure frequently is reduced to less than 1/1000 sec by these units, correction for reciprocity failure may be necessary. The earliest automatic units discharged the capacitor by grounding it to terminate the illumination resulting in unneeded loss of energy from the battery. Today, modern electronic devices (usually *thyristors*) extinguish the tube so that the remaining stored charge in the capacitor can be retained. Less energy is needed to recharge the capacitor, resulting in reduced charging time and extended battery life.

Because electronic flash illumination is of such short duration, it is necessary to delay the initiation of the flash until the shutter is fully open. This delay is achieved by connecting the flash unit to a switch that closes after the shutter is completely open. This connection is labeled X or X *sync* on most cameras. The delay is minimal for leaf shutters but usually is 1/60 or 1/125 sec for small format cameras with focal plane shutters, because this amount of time is required to get the leading blind clear of the field of view. Because the illumination is of such short duration, electronic flash cannot be used with focal plane shutters for exposure times less than the time required to open the shutter fully. To do so would cause part of the picture to be obscured by the trailing blind, which starts across the field of view before the leading blind has cleared it. This limitation can be an inconvenience when mixing electronic flash illumination with available light illumination.

Many electronic flash units have an attached calculator that does the arithmetic for the user, based on Equation 10.4. Such a device is shown in Figure 10.7. The calculator is set for the ASA of the film in the camera, and all correct combinations of f-number and distance are displayed opposite each other. Because the calculation is so simple, some photographers use the calculator primarily to provide a convenient place to determine the guide number of the unit for a specified film.

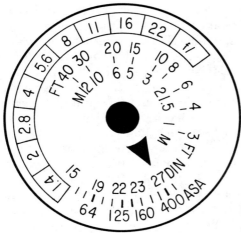

FIGURE 10.7 Typical guide number calculator for an electronic flash unit.

▶ **Example 10.4**

From the calculator in Figure 10.7 determine the guide number of this unit for a film for which the ASA film speed is 400. What is the guide number for a film whose ASA film speed is 800?

From the calculator we see that 30 ft is opposite f/8 when the calculator is set for ASA 400; hence, the guide number is about 240 expressed in feet, or about 8 × 10 = 80 in meters. Because ASA 800 film is twice as fast as ASA 400 film, the lens can be closed down one stop for the same illumination distance, resulting in a guide number of about $\sqrt{2} \times 240 = 340$ ft or about 110 m.

■ APPLICATIONS OF FLASH ILLUMINATION

Because flash illumination (either bulb or electronic unit) is so dependent on the lamp reflector and the reflecting surfaces of the space in which it is used, it should not be too surprising that guide number and bcps ratings are, at best, merely guides for determining proper exposure. Average is not well defined, and photographic situations are far from average. For instance, if a flash unit is used outdoors where no reflecting surfaces are available, the guide number often must be reduced by a factor of at least 2 (two stops). *Flash meters,* designed to measure the incident and/or reflected light from flash illumination, can be very helpful in determining proper exposure. These units monitor a short burst of light and usually ignore continuous background illumination. Using such a meter, it is possible to determine the proper exposure for a given subject or to calibrate a flash unit to be used in a particular room. The choice between using electronic flash and flash bulbs depends on the particular application and the circumstances. If the photographer does not often use flash illumination, then flash bulbs probably are the best choice, because the maintenance of batteries and/or capacitors of intermittently

used electronic flash units is an irritating chore. On the other hand, electronic flash units used continuously require little maintenance and are much more reliable in the field than flash bulbs, because the bulbs are ignited by a low voltage and the resistance of oxidized contacts can be quite high. The embarrassment and inconvenience of retaking a picture when the flash bulb fails to ignite are only moderately compensated by rubbing the bulb on the seat of one's slacks while swearing profusely.

If, on occasion, a great deal of flash illumination is needed, it usually is cheaper to use flash bulbs, because a rather large amateur electronic flash unit delivers about the same illumination as a 5B bulb. A no. 50 bulb delivers approximately 10 times as much light. *Open Flash* is used to take advantage of the total light output of a flash bulb where this is the only source of illumination. In such a situation, the shutter is first opened (bulb or time position on the shutter), and the bulb is ignited. The same can be done in another, more convenient, way by using X sync to ignite the bulb after the shutter is open and a long exposure (order of a second) to delay the closing of the shutter until after the bulb is extinguished.

If more illumination than can be obtained from one flash unit is needed, several units can be used together. If several units of equal light output are used to illuminate a scene so that the light from these units does not overlap (see Fig. 10.8), the guide number for the system is equal to the guide number of any one of the units. If N units having equal guide numbers (G) are used to illuminate a scene so that total overlap occurs (see Fig. 10.9), the guide number for the system of flash units (G_N) is

$$G_N = \sqrt{N}\, G \qquad\qquad (10.4)$$

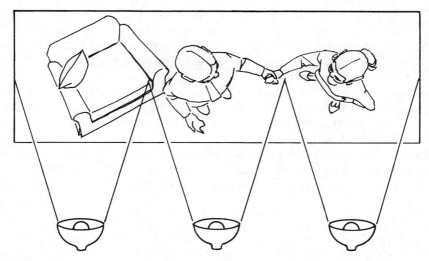

FIGURE 10.8 Use of three flash units to illuminate a scene with no overlap.

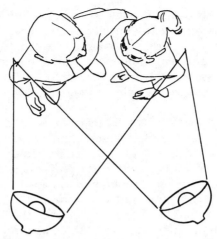

FIGURE 10.9 Use of two flash units to illuminate a scene with total overlap.

This follows because the illuminance of two light sources used together is equal to the sum of the illuminances of each used by itself. Since the light output of a single source is proportional to the square of the guide number, Equation 10.4 follows.[2] In the case where several light sources with different guide numbers (G_1, G_2, . . .) are used to illuminate a scene with total overlap, the guide number system (G_N) will be

$$G_N = \sqrt{G_1^2 + G_2^2 \ldots + G_N^2} \tag{10.5}$$

The proof of this is similar to the proof of Equation 10.4.

When several flash units are used simultaneously, it is not necessary to connect all of them to the camera to synchronize them with the exposure of the film. Synchronization can be accomplished by connecting one unit to the camera and attaching photodetectors to each of the other flash units. These electronic devices, sometimes called *slave units,* act as switches and trigger the flash units. They are actuated by the burst of light from the flash unit that is connected electrically to the camera. To make them work, all that is necessary is that the light-sensitive element be able to "see" the burst of light. This kind of unit is built both for electronic flash units and flash bulb units, although those designed for use with flash bulbs are less reliable and not very common.

If the flash unit is not placed along the optical axis of the camera lens, the effectiveness of the unit is reduced. In Figure 10.10 a somewhat flat subject is placed perpendicular to the camera lens axis. If the angle between the axis and the direc-

[2]Let I be the illuminance of one flash unit and I_N the illuminance from N units. It follows that $I_N = NI$. Because $I = KG^2$ and $I_N = KG_N^2$, where K is a constant of proportionality, substituting G and G_N for I and I_N, $G_N^2 = NG^2$ and $G_N = \sqrt{N}\, G$.

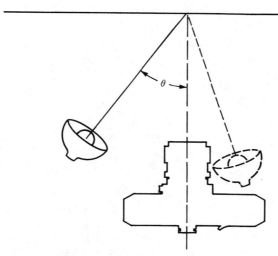

FIGURE 10.10 Placement of a flash unit off the optical axis.

tion of illumination is θ, then the illuminance of the scene by the lamp is propor-
tional to cos θ. This is so because the area illuminated by the lamp is proportional
to 1/cos θ. Because the guide number is proportional to the square of the illumi-
nance, the guide number of the flash unit placed as in Figure 10.10 (G_θ) is

$$G_\theta = G\sqrt{\cos \theta}$$

(10.6)

where G is the guide number for the unit when the axis of illumination is perpen-
dicular to the surface. The result is only approximate, because few surfaces are like
the idealized flat surface depicted here.

▶ **Example 10.5**

I have two flash units that have guide numbers of 150 for ASA 125 film. If a
diffuser (such as a cotton handkerchief) is placed in front of one of them, the
illumination from the lamp is reduced to one-half its former value. These units
are used to make portraits in an average room, the arrangement of which is as
shown in Figure 10.10. The camera-to-subject distance is 7 ft, as are the dis-
tances from each flash unit to the subject. The unit near the camera has a dif-
fuser on it. The angle, θ, is 45°. What is the guide number for this combination?
What will be a proper f-number setting using an ASA 125 film?

The guide number of the on-camera flash unit is reduced to $150/\sqrt{2} = 106$
by the diffuser (one stop). The guide number of the main light is reduced to
$150 \times (\cos 45°)^{1/2} = 150 \times 0.84 = 126$ (Eq. 10.6). From Equation 10.5, the
guide number of the combination is $(126^2 + 106^2)^{1/2} = 165$ and from Equation
10.3, $f/ = 165/7 = 23$. Hence, we should set the lens at f/22. If the correction
for the angle and the diffuser had been neglected, the guide number would be
210, the indicated f-number about 30, and the portrait would be underexposed
about one stop.

FIGURE 10.11 Configuration for bounce flash illumination.

Bare flash illumination tends to be harsh. As mentioned in Example 10.5, a diffuser can be used with the unit to reduce this harshness. An alternative to a diffuser is *bounce flash;* instead of pointing the flash unit directly at the subject, the unit is directed toward a light-colored diffuse reflecting surface as in Figure 10.11. The surface may be a wall, a ceiling, poster board, an umbrella, or a card mounted on the unit. In such a case, the relation between guide number, f-number, and distance becomes

$$G = 2(d_1 + d_2) \, \text{x} f / \qquad (10.7)$$

where d_1 and d_2 are as shown in Figure 10.11. The factor 2 is introduced to correct for absorption by the reflecting surface and to compensate for the diffuse reflecting characteristic of the surface. The relationship is approximate, because the nature of the surface may alter the correction factor considerably, and *bracketing* will be necessary in many instances.

▶ **Example 10.6**
A subject is photographed seated in a room with a white ceiling that is to be used as a reflector for flash illumination. The subject is 8 ft from the flash unit, but d_1 and d_2 are each about 5.5 ft. If the guide number for the flash unit is 150 for the film being used, what f-number should be selected for bounce flash? Compare this with the f-number to be used if the flash unit is pointed directly at the subject.

From Equation 10.7, we get $f/ = 150/[2(5.5 + 5.5)] = 6.8$ for bounce flash. In the second case, using Equation 10.3 we get $f/ = 150/8 = 19$. The difference is about 2½ stops, because in the former case we would set the aperture at the ½ stop between 5.6 and 8, and would probably set the lens at $f/16$ for the latter one. We see that bounce flash gives less harsh illumination but at considerable sacrifice in depth of field.

When flash illumination is combined with available light, it is sometimes called *fill-flash*. In such a situation, one of the two light sources is used as the main source of illumination and the other as the fill light for shadows. The lighting ratio is the ratio of the amount of light illuminating the highlighted areas to that illuminating the shadow areas. In Figure 10.12, for example, if light source A provides twice as much illumination of the figure as light source B, then A is the main light and B the fill light. The left surface of the figure is the highlight area and the right surface the shadow area. The lighting ratio is $3:1$, because both A and B illuminate the highlight area, whereas only B illuminates the shadow area. In this case, either source might be a flash unit and the other an incandescent lamp.

In using fill-flash it is desirable to be able to adjust the lighting ratio. In principle, this can be done using either electronic flash or class M flash bulbs. Electronic flash is more versatile, however. To understand how the lighting can be adjusted when using electronic flash, recall that the duration of the flash illumination is typically 1/1000 sec. Because most shutters do not provide for exposure times of less than 1/1000 sec, the adjustment of exposure time does not affect the exposure of the film to the flash illumination. Recall the caveat, however, that for a focal plane shutter,

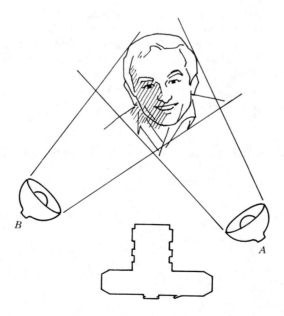

FIGURE 10.12 Use of a second light source to fill the shadows of the first.

TABLE 10.3 Correction Factors for Guide Numbers (G) and ASA if Available Light is Principal Source of Illumination

Lighting Ratio	Relative Intensity of Sources		Multiply G by	Multiply ASA by
	Available	Flash		
2:1	1	1	$\sqrt{2}(=)\,1.4$	2
3:1	2	1	$\sqrt{3}(=)\,1.7$	⅔ = 1.5
4:1	3	1	$\sqrt{4} = 2$	⅘(=) 1.3
5:1	4	1	$\sqrt{5}(=)\,2.2$	¾(=) 1.2

the exposure time must be such that the shutter is completely open for the 1/1000 sec that the flash is illuminating the scene. In practice, this means that the exposure must be 1/60 sec or longer for the typical 35 mm SLR camera with a focal plane shutter (shorter if the shutter is metalized). Consistent with this limitation, the time can be used to adjust the available light exposure of the film independent of the flash exposure.

The aperture controls the film exposure for both available light and flash. Hence, the electronic flash exposure can be set by adjusting the aperture (f-number), while the exposure time is adjusted to obtain the proper available light exposure consistent with the previously determined f-number. A convenient way to do this is to modify the guide number of the flash and the ASA film speed so that the total highlight area illumination by the two sources together gives the proper exposure of the highlights, while the fill illumination generates the chosen lighting ratio. If available light is selected as the principal source, use Table 10.3 to find the modified guide number and ASA for the chosen lighting ratio. Table 10.4 is used if flash illumination is the principal source. The modified guide number can be used to determine the f-number. Using a light meter to measure the available light, the modified ASA can then be used to determine the proper exposure time. Alternatively, an exposure guide such as the rule of thumb (Chapter 2) can be used with the modified ASA to determine the exposure.

TABLE 10.4 Correction Factors for Guide Number (G) and ASA if Flash Is Principal Source of Illumination

Lighting Ratio	Relative Intensity of Sources		Multiply G by	Multiply ASA by
	Flash	Available		
2:1	1	1	$\sqrt{2}(=)1.4$	2
3:1	2	1	$\sqrt{3/2}(=)1.2$	3
4:1	3	1	$\sqrt{4/3}(=)1.1$	4
5:1	4	1	$\sqrt{5/4}(=)1.1$	5

To use class M bulbs in fill-flash illumination, the exposure must be longer than 1/30 sec, because this is the approximate burning time of the bulb. Practically speaking, this long exposure time limits fill-flash with class M bulbs to tripod photography of static objects.

Because the guide number is equal to the product of the f-number and the lamp-to-subject distance, the distance rather than the f-number could be adjusted to determine the proper exposure for flash illumination. The correction factors are the same as those in Tables 10.3 and 10.4. Because the lamp-to-subject distance should not determine camera position, linking the flash unit to the camera can be a problem. Either a long *PC* (flash) *cord* or a slave and a second flash unit pointed away from the subject may be necessary for this linkage. A light stand or an assistant may be needed to support the flash unit, which reduces the portability of the system. However, this does avoid some of the limitations on using electronic flash with cameras equipped with focal plane shutters. Exposures still are limited to those no shorter than 1/60 sec for cloth shutters (shorter for metal shutters); however, it is not necessary to use exposures longer than this, because the f-number can now be used with the exposure time to get the proper available light illumination, and the lamp-to-subject distance can be used to obtain the proper flash illumination.

If the output of the flash unit is adjustable, it can be altered instead of changing the flash-to-subject distance. Some units have less than full power settings. Automatic flash units can be adjusted by altering the ASA film speed setting of the unit to values other than that of the film in the camera.

If the flash unit is too bright, a *neutral density filter* or diffuser can be placed over the flash unit to reduce the illuminance.

▶ **Example 10.7**

For fill-flash, we decide to use an electronic flash unit for which the guide number (in feet) is 75 with a diffuser in place (handkerchief) for ASA 125 film. An arrangement much like that shown in Figure 10.12 is set up to make a portrait. The main light at *A* is an incandescent lamp, the filtered flash unit is placed at *B* as fill light, and a 3:1 lighting ratio is desired. The distance from flash unit to subject is 6 ft. The light meter indicates that if only the incandescent lamp is used, the proper exposure is f/11 at 1/125 sec. Find the proper f-number and exposure time using this fill-flash configuration.

From Table 10.3 we find that the modified guide number is $75 \times 1.7 = 128$. Because the lamp-to-subject distance is 6 ft, the f-number should be $128/6 = 21.5 (=) 22$. Again, from Table 10.3, the modified ASA is $125 \times 1.5 = 188$. We can imagine as far as available illumination is concerned that we have switched from an ASA 125 film to an ASA 188 film. The proper exposure should be reduced by a factor of 125/188. A proper exposure would be f/11 at 1/188 sec. Hence, a proper available exposure would be f/11 at 1/250 sec. Flash illumination requires that the f-number be 22, however, so the exposure compatible with both light sources is f/22 at 1/60 sec. This exposure would be satisfactory with either a focal plane or a between-the-lens shutter provided

we have a lens that will stop down to f/22, which is frequently necessary with portrait lenses. Because of the discrete nature of our choice of aperture and exposure time, the approximation is well within the latitude of the film. In this kind of problem, the aperture is determined first and then the exposure time, regardless of whether the flash unit is to be the fill light or the main light.

▶ **Example 10.8**

Assume that you are photographing a person out-of-doors on an overcast day (cloudy-bright) using an ASA 125 film. You choose to use a lighting ratio of 2:1 and to use the available light as fill. You have a flash unit with a guide number (in feet) of 150 as your main light and are using a camera with a focal plane shutter that properly synchronizes with electronic flash at 1/60 sec or longer. Where must the flash unit be placed to get a proper exposure?

TABLE 10.5 Suggested Exposures for Available Light Photography with a Film of ASA 400

Subject	Time†	f/
Brightly lighted street scenes at night	1/30	f/2.8
Neon signs and other electric signs	1/30	f/5.6
Store windows	1/30	f/4
Floodlit buildings	4	f/8
Exterior Christmas lighting	3	f/11
Christmas tree lighting indoors	1 sec	f/16
Burning buildings, campfires	1/60	f/4
Moonlit landscapes	7 min	f/4
Brightly lighted rooms	1/60	f/2.8
Average room at home at night		
Churches	1/30	f/2
School auditoriums and stages		
Ice shows, spotlit subjects	1/125	f/5.6
Ice shows, floodlit subjects	1/60	f/4
Fireworks, near bright displays	1/125	f/16
Fireworks	Time	f/16
Illuminated fountains	1	f/2.8
Television screen	1/30	f/3.5
Indoor floor sports	1/60	f/2.8
Night football	1/125	f/2.8
Wrestling and boxing	1/125	f/4
Stage shows	1/60	f/2.8
Circus, spotlit acts	1/125	f/4
Circus, floodlit acts	1/60	f/2.8
Sunset, sun above horizon	1/60	f/5.6*
Sunset, sun below horizon	1/30	f/2.8*
Subject illuminated by headlights, 15 ft	1/15	f/1.4
Subject illuminated by nearby candle or match	1/15	f/1.4

†Sec unless otherwise noted
*With red filter.

Because distance is variable, we will determine the available light exposure first. The rule of thumb (see Chapter 2) indicates an exposure of f/8 at 1/125 sec for this available light situation. From Table 10.4, we find that the ASA should be 125 × 2 = 250. Hence, the modified available light exposure is f/8 at 1/250 sec. Because you must synchronize with electronic flash, a satisfactory exposure would be f/16 at 1/60 sec. The modified guide number would be 150 × 1.4 × 210, and the lamp-to-subject distance should be 210/16 (=) 13 ft. If this photograph is to be a head and shoulders portrait, the camera-to-subject distance would be about 6 ft, and the flash unit could not be near the camera. If a heavy diffuser or neutral density filter is used on the flash unit to reduce the guide number by a factor of 2, the flash unit could then be placed about the same distance from the subject as the camera.

It is worth noting that fill-flash can be set up much more easily using a flash meter. The flash meter determines exposure on the basis of the ASA film speed, and thus the ASA setting of the flash meter is multiplied by the square of the factors indicated for the guide number in Tables 10.3 and 10.4. Because an automatic electronic flash unit is controlled by a sensor that works like a reflected light meter, similar factors can be used in modifying the performance of these units for fill-flash setups. Keep in mind, however, all the provisos mentioned in our earlier discussion of automatic electronic flash units.

■ **UNUSUAL LIGHTING SITUATIONS**

There are several available light situations for which it is difficult to determine proper exposure. Several of these are listed in Table 10.5, which is based on experience; exposures are stated for an ASA film speed of 400. When film of another ASA rating is used, the correct new exposure will be inversely proportional to the ratio of the ASA of the film to 400. This table should be viewed as a starting point for proper exposure, and bracketing is encouraged. Advance trial exposures can also be of considerable help, where possible.

EXERCISES

10.1. Blue sky has a color temperature of 12000 K. At what wavelength does the peak in its blackbody radiation curve occur?

10.2. Light from a hazy sky varies in color temperature from 7500 K to 8400 K. Convert these temperatures to mireds and find the mired interval between the two limits.

10.3. Which of the following light sources has the highest proportion of blue light in its spectrum? Direct sunlight at midday; sunlight plus light from clear sky at midday; open shade on a clear day.

10.4. Compare the spectrum of daylight illumination with that of a daylight fluorescent lamp.

10.5. I find that I have to use a 5B bulb (class M) with a focal plane shutter. The exposure

time is 1/1000 sec (1 ms). The camera is synchronized for electronic flash at 1/60 sec. Using the graph in Figure 10.3, determine the relative illumination of the edges of the scene compared with the center of the scene assuming that FP sync is used.

10.6. Why is a focal plane shutter less versatile than a leaf shutter when used with electronic flash units?

10.7. My flash unit has a guide number of 100 (in feet) for an ASA 125 film. What will be the guide number for this unit when used with an ASA 64 film? Determine both guide numbers in meters as well.

10.8. I have two flash units for which the guide numbers are 200. What will be the guide number of the combination if they are used to illuminate a scene as in Figure 10.9 (total overlap)?

10.9. I am using a flash unit with a guide number of 200 for the film in the camera to illuminate directly a scene that is 18 ft from the unit. What f-number should be used for proper exposure of the scene? If a handkerchief is placed over the unit, the camera must be opened up one stop. What will be the guide number of the unit in this case?

10.10. I am using a flash unit with a guide number of 60 in meters when used with ASA 125 film. This unit is to be used in a bounce configuration (see Fig. 10.11). The ceiling is light in color and the distance from the flash unit to ceiling is about equal to that from ceiling to subject (2 m in each case). What f-number should be used to get a proper exposure?

10.11. Consider a photographic situation similar to that described in Example 10.6. However, the lighting ratio is to be 2:1 instead of 3:1. Determine the proper exposure for this situation. Is the resulting exposure one that can be used with a camera equipped with a focal plane shutter?

10.12. I have a photographic situation similar to Example 10.7 except that I want to use a 4:1 lighting ratio. Determine the proper exposure and position of the flash unit for this situation.

10.13. I am taking pictures of aerial fireworks using an ASA 64 color film. What exposure should be used?

chapter ·11·

Color

In Chapter 12 the way color photography works will be described and practical matters related to color photography will be considered. Prior to this, consideration must be given to why objects and light sources are colored and how they are seen as colored. Much of the discussion will be couched in general terms. Because the interest is in color as it applies to color photography, however, some discussions will be simplified and relate best to that application. For a more complete discussion of color see the references listed below.[1]

■ COLORED OBJECTS

Probably the most common way for an object to appear colored is by *absorption* of light. If white light is incident on a colored substance *(colorant)*, and if all the light except that which is called red is absorbed by the substance, the colorant is called red. In this process, the absorbed light excites molecules in the colored substance, and the energy of the absorbed light usually is lost as heat. The best explanation of the absorption mechanism requires knowledge of some modern physics. However, some feeling for the mechanism can be obtained by thinking of pushing a child in a swing (see Fig. 11.1). If the child is pushed each time just as the swing reaches the peak of the arc, the swinging process will continue. The frequency of successful pushing is determined by the natural frequency of swinging, because the child and swing behave like a pendulum. If the swing is pushed at a different frequency, the pushing energy is not coupled into the swinging process. The molecules that give colorants their color behave somewhat like complicated pendulums. They can absorb light energy at certain frequencies and not at others. Hence,

[1]S. J. Williamson and H. Z. Cummins, *Light and Color in Nature and Art,* New York: John Wiley, 1981; Y. Le Grand, *Light, Color and Vision,* London: Chapman and Hall, Ltd., 1968.

FIGURE 11.1 Resonance in pushing a child in a swing.

certain frequencies of light are absorbed and others are not. Those that are not are freely transmitted by the dye (see Fig. 11.2).

If a red dye of the type used in photography is coated on an opaque white reflecting surface (e.g., a sheet of white paper), the white surface appears red when viewed in white light (see Fig. 11.3). All light except red is absorbed, the red light is reflected back through the dye, and the paper appears red. If the red dye had been coated on a black surface, the red light would have been absorbed by the black surface, and the surface would appear black.

White light → Red light →

Transmitting
red dye

FIGURE 11.2 Transmission of red light by a red dye.

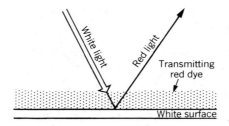

FIGURE 11.3 Reflection of red light from a white surface coated with a red dye.

Some colorants that traditionally are called *pigments* appear opaque. In many of these materials, the pigment is an opaque particulate matter that reflects, transmits, and scatters light over a large part of the visible spectrum. The pigment absorbs all but the selected color. In many of the naturally occurring pigments, the absorbing molecules are in the *scattering* particles.

Scattering also can cause material to be colored. If light is incident on gas molecules, the oscillations of the electromagnetic light waves excite the molecules and cause the electrons to oscillate. These oscillating electrons reemit electromagnetic radiation at the same frequency as that of the incident radiation. The amount of radiation emitted in a given direction depends on the nature of the incoming light and the structure of the molecule. This scattering of light by a gas *(Rayleigh scattering)* can give rise to color, because the amount of light scattered by the molecule varies inversely with the wavelength, provided the size of the molecule is small compared with the wavelength. This is why the sky appears blue and a sunset red. When the sky is viewed during the day, the molecules are seen illuminated as in Figure 11.4*a*, where blue light is preferentially scattered, and some of it reaches the observer. At sunset (Fig. 11.4*b*), the blue is again scattered preferentially, and the transmitted light, deficient in blue, appears red.

If the particle size of the scattering material is very large compared with the wavelength of light, (as is usually the case with granular material in a pigment), scattering is independent of wavelength and no color discrimination occurs as a consequence of scattering.

Objects also can be colored as a result of *fluorescence*. In the discussion of fluorescent lights in Chapter 9, it was noted that ultraviolet radiation excites phosphors, which emit light in the visible part of the spectrum. Certain dyes are fluorescent, because they can be illuminated by light of one color and emit light of another color. For example, if most white shirts are illuminated by ultraviolet radiation (so-called black light) in a darkened room, they will appear brilliantly bluish-white, whereas many other materials will scarcely be visible. A fluorescent dye that responds to the ultraviolet radiation of the sun by emitting white light has been added to the cloth, making the shirts "whiter than white." Some laundry detergents contain fluorescent materials that enhance the effect. If a dye fluoresces, the exciting radiation must be of shorter wavelength (higher energy) than the fluores-

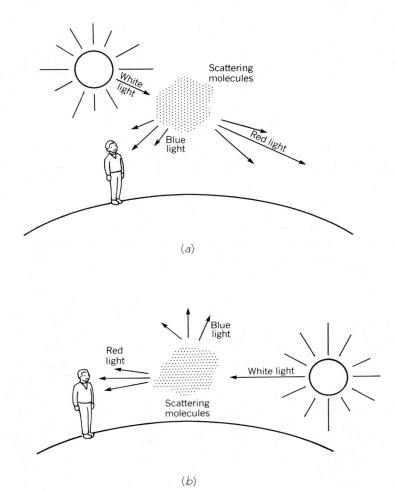

FIGURE 11.4 The appearance of the sky at midday (*a*) and sunset (*b*).

cent radiation. In other words, photons of higher energy excite the dye to emit photons of lower energy.

In the discussion of the coating of lenses in Chapter 4 it was shown that the thickness of a film could be such that the reflections from two adjacent surfaces destructively interfered, thus reducing surface reflections. If the thickness of the film is adjusted so that the waves constructively interfere (see Fig. 11.5), then a particular color will be enhanced. In this way, soap bubbles and oil slicks on water become colored. Because the bubbles and the oil slicks are seldom of uniform thickness, a spectrum of colors usually is observed.

As mentioned in Chapter 4, a prism can be used to disperse white light into a spectrum and so obtain color. In the discussion of absorption of light, it was tacitly assumed that the absorber was an insulator, implying that the electrons in the

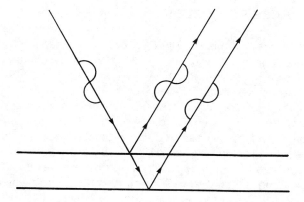

FIGURE 11.5 Constructive interference by reflection from two adjacent surfaces.

material are tied to atoms and do not wander about. If the material is an electrical conductor so that the electrons are free to wander about the lattice, absorption may not occur. If light is incident on a good conductor, it does not penetrate very far, because the free electrons reflect the optical radiation without absorption. If the radiation is reflected equally at all wavelengths in the visible part of the spectrum, the surface appears white. If reflectance is greater at some wavelengths than others, the surface may appear colored. This is why gold is yellow, copper is red, and silver and aluminum are white (see Fig. 11.6). Metallic paints behave in a similar fashion.

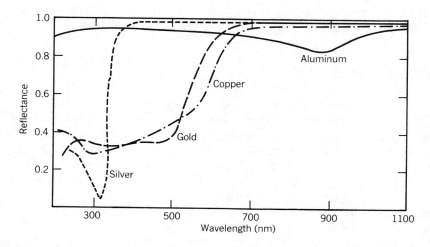

FIGURE 11.6 The wavelength dependence of the reflectance of various metals.

■ LIGHT SOURCES AND COLOR

The apparent color of an object depends not only on the spectral characteristics of the dyes that color it but also on the color of the illumination. A red object illuminated by red or white light is red. A blue object is blue when illuminated by white light but black when illuminated by red light.

In Chapter 10 the more common light sources used in black-and-white photography were discussed. The spectral distribution of the light of most of these sources was noted, and it was observed that the details of the distributions would be very important in color photography. Figure 10.2 shows the spectral distribution of a daylight fluorescent lamp. This overall distribution gives the visual impression of daylight illumination when used to illuminate some colored objects and renders especially the color of Caucasian faces accurately. The peak of the continuous distribution (about 465 nm) matches well that of a 6000 K blackbody radiation curve, which is about the color temperature of the combination of the sun and the light from the sky on a clear or hazy day. If an object is colored so that it absorbs or reflects selectively at one or more of the wavelengths corresponding to the bands in the fluorescent illumination, however, the object's color will be very different when viewed in natural daylight and in daylight fluorescent illumination. Because of the adaption of the eye and modest memory, the difference may go unnoticed in casual observation. This is not generally the case if the object is photographed while illuminated by each of the sources separately and the two photographs are compared.

Although fluorescent illumination yields some bizarre color effects, altering the color temperature of an incandescent light source can cause noticeable changes in color, especially when comparisons are made photographically. Visually, a Caucasian face does not appear rosy when viewed under tungsten illumination compared with the same face viewed in daylight. Photographs using the same color film show the difference dramatically. The change in color when a multicolored cube is photographed under natural daylight (*a*) and cooler artificial incandescent (*b*) illumination using daylight color film is demonstrated in Plate I.

■ COLOR PERCEPTION

The human eye is sensitive to light of all the wavelengths from about 400 to 700 nm in the electromagnetic spectrum. Most colored objects respond to a continuous band or bands of light in the spectrum. The eye discerns colors as a consequence of the response of the cones (see Chapter 6) in the retina (photopic vision). It is believed that the eye distinguishes color by the relative response of three different kinds of cone receptors (see Fig. 6.5). These will be called blue cones (*B* response curve), green cones (*G* response curve), and red cones (*R* response curve). If a green light of about 540 nm illuminates the eye, the blue cone response will be the least, the green cone response the greatest, and the red cone response intermediate between the two. These responses, encoded as an electric signal, are transmitted to the brain and the color is identified as green; the details of the pro-

a

b

PLATE I: Multicolored cube illuminated by natural daylight (left) and artificial incandescent illumination (right), photographed using the same color film. (From *Light and Color in Nature and Art* by S. J. Williamson and H. Z. Cummins, John Wiley & Sons, N. Y., 1983.)

PLATE II: The mixing of three primary lights to yield white light (left). (From *Light and Color in Nature and Art* by S. J. Williamson and H. Z. Cummins, John Wiley & Sons, N. Y., 1983.)

PLATE III: The absorption of complementary colors by the subtractive primaries (right). (From *Light and Color in Nature and Art* by S. J. Williamson and H. Z. Cummins, John Wiley & Sons, N.Y., 1983.)

a

b

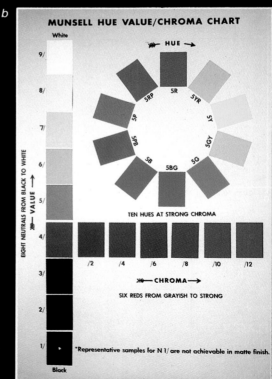

PLATE IV: The Munsell system of color notation. (Courtesy Munsell Color, Macbeth Division, Kollmorgen Corporation.)

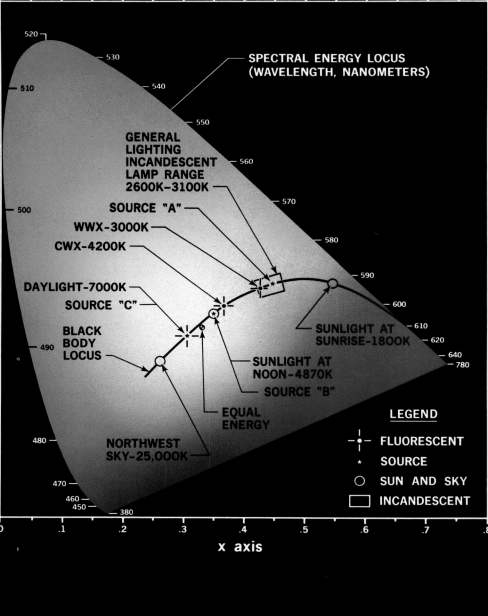

PLATE V: CIE chromaticity diagram
showing the locus of the spectrum
and the loci of blackbody radiators.
(Courtesy General Electric.)

Original Subject, Represented by Colored Patches

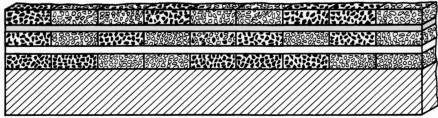

Cross Section of Color Film after Exposure in Camera and Development of Latent Image

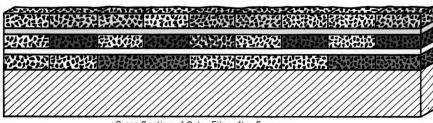

Cross Section of Color Film after Exposure
to Uniform Illumination and Subsequent Color Development

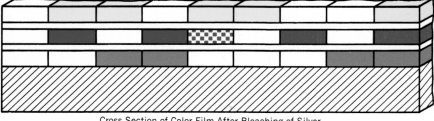

Cross Section of Color Film After Bleaching of Silver

Dye Images as Seen When Viewed by Transmitted White Light

cess are not understood. The eye is the bridge between color as perceived and the physical world of color stimulated by the visible part of the electromagnetic spectrum. However, the presence of only three kinds of cones in the eye has profound implications for the way in which colored pigments, dyes, and systems that record color, such as color photography, are made.

When individuals try to describe the colors of the visible spectrum, many would identify the six distinct colors; red, orange, yellow, green, blue, and violet. These colors are called *hues*. However, many would consider orange as a combination of red and yellow and violet as a combination of red and blue. Hence, the number might be reduced to four. That part of the spectrum called red contains many pure spectral colors of different wavelengths which are called red. Two *pure* spectral colored lights of the same wavelength may be identified as different, because one may be brighter (more luminous) than the other. Two colored lights may differ in still another way. One color might be identified as purer than another, or the purer one might be called more saturated. This difference in *saturation* could be a consequence of mixing white light with a pure spectral colored light.

The color of objects can be described using similar terms, except that the term *lightness* is often substituted for *brightness*. When two objects of the same hue differ in brightness, the brighter one departs more from an appropriate neutral gray than the less bright object.

Some authors[2] feel that the perception of a color cannot be adequately described using just three terms such as hue, brightness, and saturation. For instance, some believe that the color of an object cannot be specified without including the color of the surroundings.

■ PRIMARY COLORS

Thomas Young (1773–1828) and later James Clerk Maxwell (1831–1879) showed that it is possible to take three colored lights widely separated spectrally and superpose them on a white surface in proper proportions so that the superposition appears white (see Plate II). Many different combinations will do this, and the members of any set that will in combination form white are called *primaries*. The primaries, when mixed in proper ratios, can be added to produce many other colors and are sometimes called *additive primaries*. The fact that three primaries can be added to yield most other colors is certainly a consequence of the way color is seen, and is probably a result of the different spectral sensitivities of each of the three groups of cones. The primaries do not have to be what is perceived as red, green, and blue. (Many painters consider the primary colors to be red, yellow, and blue.) Nor do the primaries have to be spectrally very pure, and it should not be expected that each primary excites only one of the three groups of cones.

The colors accepted as red are grouped in wavelengths about 650 nm, those called green are grouped about 530 nm, and those called blue are grouped about

[2]Ralph M. Evans, *The Perception of Color*, New York: John Wiley, 1974, p. 83ff.

485 nm. From Figure 6.5 it is seen that a red primary excites both the red and green cone receptors, and that the green and blue primaries stimulate all the cones. However, the response of each kind of cone is not the same for a given primary.

In many instances there exists, for a given spectral color, a second color that, when added to the first, yields white. The dyes used in photography and colored lights behave in this way. Such pairs of colors are said to be *complementary*. For instance, the complement of blue is yellow, and the complement of red is cyan. The complement of green is a color called magenta which does not exist in the spectrum but can be formed by mixing red and blue light. The complementary colors of a set of primaries are called *negative* or *subtractive primaries*. A characteristic of a subtractive primary colored filter is that it subtracts from white light its complementary primary color. The relationship between a set of primaries and the complementary set of negative primaries can be better understood by means of equations.

$$\text{red} + \text{green} + \text{blue} = \text{white} \qquad (11.1)$$
$$\text{white} - \text{blue} = \text{red} + \text{green} = \text{yellow} \qquad (11.2)$$
$$\text{white} - \text{green} = \text{red} + \text{blue} = \text{magenta} \qquad (11.3)$$
$$\text{white} - \text{red} = \text{green} + \text{blue} = \text{cyan} \qquad (11.4)$$

Equation 11.1 indicates that three primaries can be added to form while light. Equation 11.2 shows that subtracting blue from white light leaves red and green, the complementary color to blue, namely, yellow. Similarly, Equations 11.3 and 11.4 relate green and red to their complements. Plate II shows that if red and green light are added, the resulting color is yellow; if red and blue are added, the resulting color is magenta; and that the addition of green and blue yields cyan.

The primaries and the subtractive primaries can also be considered as absorbing dyes. If filters dyed each of the primary colors red, green, and blue are placed one by one in front of white light, each primary is transmitted in turn. If any two are placed in front of the light source, however, no light will be transmitted. This happens because each primary filter absorbs two of the other primaries. For example, a red filter absorbs green and blue, and a green filter absorbs red and blue. No common color can be passed through the two filters used together (Fig. 11.7).

If the subtractive primaries are used as dyes for filters, the results are not the same. If filters dyed the subtractive primary colors are placed on a light box trans-

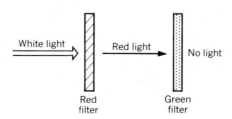

FIGURE 11.7 The absorption of all light using two primary filters together.

mitting white light so that they overlap as shown in Plate III, each of the subtractive primaries is transmitted where the filters do not overlap. In those places where any two of the filters overlap, one of the primaries is transmitted, and where all three overlap, no light is transmitted. Why this is so can be understood by studying the next example.

▶ **Example 11.1**

Show by diagram that the subtractive primaries used as filters can generate each of the primaries from white light. How can black be generated using the subtractive primaries as filters?

Figure 11.8 demonstrates that a yellow and magenta filter reduces white light to red light. If a cyan filter is substituted for the magenta filter (see Fig. 11.9), the resultant color will be green. If the magenta and cyan filters are used together, the transmitted color will be blue. If all three filters are used, no light will be transmitted and we will have generated black (see Fig. 11.10).

The subtractive primaries are used in color photography as the dying agents for both color transparencies and color prints. In the case of prints, the dyes will be on white paper, and the colors will be generated by reflection (see Fig. 11.3).

The primaries (red, green, and blue) do not work well as dying agents, because a mixture of any two that is thoroughly dispersed will transmit no light (see Fig. 11.7). If two primary pigments are mixed so that the particles of each do not block the reflected light of the other and yet are small enough that the eye cannot distinguish the particles, then the primaries can be used as colorants to form new colors.

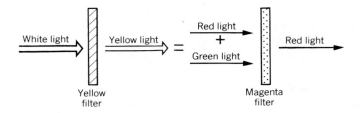

FIGURE 11.8 The transmission of red light by a yellow and a magenta filter.

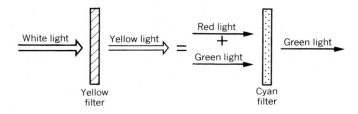

FIGURE 11.9 The transmission of green light by a yellow and a cyan filter.

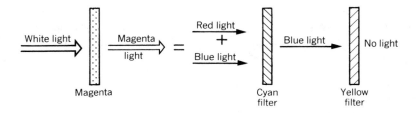

FIGURE 11.10 The transmission of blue light by a magenta and a cyan filter, and the absorption of all light by the use of all three subtractive primary filters.

The imaging surface of a color television receiver picture tube is made up of an array of very small red, green, and blue phosphors. When stimulated, these phosphors generate the colors of the image of the scene and are an example of using additive primaries to generate color. For instance, if part of a scene is yellow, the red and green phosphors are stimulated, but the blue phosphors are not. Because the phosphors are not resolved individually by the eye at usual viewing distance, the red and the green together appear as yellow. If the face of the tube is examined with a small hand magnifier, the resolved red, green, and blue phosphors are evident.

■ SYSTEMS OF COLOR SPECIFICATION

As mentioned earlier, at least three descriptors (hue, brightness or lightness, and saturation) are needed to characterize a color. Names are used to identify color. For example, pink indicates a very light unsaturated shade of red and rust a very dark unsaturated one. Few would call something rust that the majority calls pink. On the other hand, considerable disagreement might occur about calling a given light red, pink or cherry. As long as the color of two objects can be matched, the language is not important. For instance, as a boy, the author was often detailed to buy thread for his mother, who was a professional dressmaker. This usually was not difficult, because she always gave him a sample of the cloth and instructed him to match the thread with the cloth in daylight. If he had no sample and was instructed to buy pink thread, however, he might find a half-dozen shades of red that could pass for pink. Even with a sample to match, he and the clerk sometimes had difficulty finding the appropriate color. If the cloth was of a borderline hue between green and yellow, they sometimes sorted through both the tray of yellow spools of thread and those classified as green — the problem was one of organization.

The *Munsell system* of color notation is the best known and most widely used system of color organization in the United States. The system can be thought of as a way to organize pigment samples in a three-dimensional array. The dimensions are given the names hue, *value,* and *chroma.* The arrangement of the samples is

shown in Plate IV. Value is somewhat analogous to brightness or lightness, and chroma is analogous to saturation. In one form of this color chart, the individual pigment samples of a given hue are arranged on transparent sheets. The sheets are arranged radially about a vertical axis according to hue (Plate IV*a*). The coordinate system is analogous to a cylindrical coordinate system. The angular coordinate corresponds to hue, the radial coordinate corresponds to chroma, and the vertical coordinate corresponds to value (Plate IV*b*).

The hues are divided into ten major divisions, each of which is divided into ten hues, so that the total number of hues is 100. The spacing between all adjacent hues is the same as determined by a *normal observer* viewing the samples under standardized illumination. The colors of a given hue are arranged as shown at the bottom in Plate IV*b*. Value orders the colors from the darkest to the lightest on a vertical scale. The scale of reference is a gray scale that arranges 11 tones at equal intervals from the blackest black (theoretically 0 percent reflectance) to the whitest white (theoretically 100 percent reflectance). The spacings are determined by a normal observer viewing the gray tones under standardized conditions. Pure black is labeled zero and pure white ten. Because the eye is logarithmic, equal perceptual intervals between adjacent tones imply equal ratios of reflectance between adjacent tones, and the midpoint of the gray scale is not far from that of an 18 percent gray card.

The normal observer matches the values of a given hue to the values of the gray scale. Some hues do not have pigment samples corresponding to all values (see Plate IV*a*). Finally, colors of a given hue and value are arranged in increasing chroma from neutral gray (zero), on the axis, to the most saturated pigment sample available (as high as 16 for some hues), at the outer edge. The perceptual spacing between any two pigment samples of the same value and hue but adjacent chroma is approximately the same for all adjacent chroma as judged by a standard observer.

The Munsell system, considered as a solid, is not symmetric. The highest chroma in red is 14, whereas the highest in blue-green opposite red is only six. The highest value of chroma for each hue does not always occur for the same value. Yellow has a maximum chroma of 12 at a value of eight. A purple-blue has the same maximum of chroma but at a value of three. The samples may also be arranged in book form and are given a numbering system so that unknown pigment samples can be matched to the Munsell system and described using its nomenclature. The coordinate system is designated "hue value/chroma" or H V/C. For example, a yellow might be designated 47 8/12, implying a yellow hue (47) with a value of eight and a chroma of 12.

This system of color representation is psychological in nature, because the eye of a human observer is the measuring instrument. This is as it should be, since the intent is to catalog and describe what people see. If the goal is to preserve for posterity the description of a given pigment, the above system might not be suitable. Instead, physical instruments might be used to characterize the pigment. It could be illuminated with a standard source, and its spectral response measured using a spectrophotometer to characterize the optical properties of the pigment very precisely. However, until the pigment had been reconstructed that duplicated

the spectral response, posterity would not know what color was being described. The "normal" observer has been mentioned in a somewhat cavalier fashion; it might be better to speak of an average observer. Certainly some observers are abnormal (e.g., the color-blind individual), but among the normal observers there is still considerable variation, and yet agreement and repeatability do occur between different observers. The human eye is a reliable judge of relative measurement. It measures differences surprisingly well, but it is not a very reliable measurer of absolutes. For instance, it can judge accurately the relative brightness of two light sources seen at the same time but cannot tell how bright either is.

The *CIE* (Commission Internationale de l'Eclairage) system of color representation is another system that depends on the human eye for characterizing color. However, this system is related to the spectral characteristics of light sources and the spectral response of the eye. Hence, the term *psychophysical* is used to classify it. The system is useful for characterizing the colors of the spectra and all of the colors that can be formed with it. It is used to characterize transparent colored materials such as photographic filters, and it is useful in characterizing diffusing colored materials.

When primary colors and the way the eye responds to color (i.e., its trivarient nature) were discussed, it was implied that three additive primaries could be used to form many but not all other colors. This hedging is necessary because of the nature of the pure spectral lights and the way they add.

If the deepest reds are added to the deepest violets, new pure colors called purples are formed. These purples, figuratively, tie the opposite ends of the spectrum together. Magenta, mentioned earlier, is a purple and the purples are the complementary colors for the greens. A wavelength cannot be used to identify the purples, because they are not spectral colors. But these colors can be identified in terms of their spectral complements. For example, a green color near the center of the greens has a wavelength of 520 nm. Its complementary purple might be designated 520C. If these purples and the spectral colors are called pure colors, then the following is true: if two pure colors are added, they can always be matched visually by a color formed by adding another suitably chosen pure colored light to white light.

Symbolically this means that

$$L_1(\lambda_1) + L_2(\lambda_2) = L_w(w) + L_4(\lambda_4) \tag{11.5}$$

where $L_i(\lambda_i)$ ($i = 1, 2, 4$) is a light of wavelength λ_i and luminance L_i. $L_w(w)$ is white light of luminance L_w. Generally, *luminance* in *colorimetery* is the brightness of a light as measured visually. Equation 11.5 is a color matching equation and has some of the same characteristics of an arithmetic equation (e.g., additivity, identity, and associativity), but it is not numerical. These arithmetic characteristics were established experimentally using the eye as a detector and are known as Grassman's laws. Assume that λ_1, λ_2, and λ_3 are the wavelengths that have been chosen for primary pure spectral colored lights. Then

$$L_A(\lambda_1) + L_B(\lambda_2) + L_C(\lambda_3) = L_w(w) \tag{11.6}$$

where L_A, L_B, and L_C are the luminances of primaries necessary to form the proper white light in Equation 11.5. If the left side of Equation 11.6 is substituted in Equation 11.5 and L_A, L_B, and L_C are transposed to the left side, then

$$[L_1(\lambda_1) - L_A(\lambda_1)] + [L_2(\lambda_2) - L_B(\lambda_2)] - L_C(\lambda_3) = L_4(\lambda_4) \tag{11.7}$$

Equation 11.7 demonstrates that to match the pure colored light $L_4(\lambda_4)$ at least one of the spectral primaries must be subtracted from the other two. This is true when any three arbitrary spectrally pure primary colored lights are used to match a fourth spectrally pure colored light. Equation 11.5 can be generalized so that the luminances L_1 and L_2 need not be pure colors, and yet the right side of the equation will reduce to the sum of white light and a pure spectral colored light.

The CIE system is based on matching three pure primary spectral lights to the other spectral colors one by one. In the supplementary material above it was shown that one of the primaries will always be negative (not always the same one). Hence, in practice, two of the primaries must be matched to the sum of a third primary and the selected spectral color. Matching is done using special spectrometers called *colorimeters,* and normal human observers judge when the colors are matched. In most instances, the relative luminances of the primaries are adjusted initially so that the sum matches a selected white as judged by the observers, and each primary is, in subsequent color matching, scaled in terms of the amount of the primary needed to match the selected white. The scales of the primaries, as measured by a physical instrument (e.g., a photometer), are not usually identical. The fractional amount of each primary needed to match a spectral color is determined and recorded.

Figure 11.11 shows the results of such an experiment performed by W. B. Wright.[3] Wright did not balance the three primaries to match a selected white at the outset of his experiment but did something equivalent. The spectral primaries were red ($\lambda = 650$ nm), green ($\lambda = 530$ nm), and blue ($\lambda = 460$ nm). Guild[4] made similar measurements about the same time as Wright (1930). The CIE system is based on the average of the results obtained by these two researchers. In the CIE system the results of such experiments are not presented in terms of the spectral primaries but in terms of three primaries that are related mathematically to the spectral primaries. These primaries are not real and are designated x, y, and z. This is done to eliminate the negative values that are unavoidable in any system based on real spectral primaries. In addition, because the main interest is in the relative amounts of each primary needed to match a spectral line, the sum of the three primaries is normalized so that

$$x + y + z = 1 \tag{11.8}$$

[3]W. D. Wright, *Researchers on Normal and Defective Colour Vision,* London: H. Kampton, 1946.

[4]J. Guild, *Phil. Trans. Roy Soc.* A, *230,* 149, 1931.

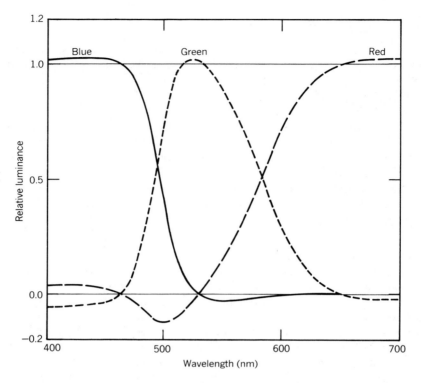

FIGURE 11.11 Relative luminances of three primaries needed to match the colors of the spectrum.

If x and y are known, z can be determined using Equation 11.8. Plate V shows the *CIE chromaticity diagram*. The horseshoe-shaped outline represents the locus of the colors of the spectrum. For instance, the values of x and y for a spectral color whose wavelength is 480 nm (a blue hue) are about $x = 0.09$ and $y = 0.13$. Hence, $z = 1 - 0.09 - 0.13 = 0.78$. The *white point* is located at $x = y = z = 0.33$ and is designated as the equal energy point in the figure. Note that in assigning equal values to x, y, and z for the white point, the coordinates have been scaled in terms of the amount of each primary necessary to form this particular white light. The blackbody sources labelled "A," "B," and "C" are standard *illuminants* used in CIE colorimetry.

Remember that this diagram is based on observations made by a group of observers matching real colors. The average response of these observers is called the response of the *CIE standard observer*. The results are applicable to color vision limited to the central field of view (photopic vision), which is dominated by the response of the cones of the eye. Incidentally, some people can see wavelengths of light shorter than 400 nm and some can see wavelengths of light longer than 700 nm.

The CIE chromaticity diagram is a plot of all possible colors that can be formed using the colors of the spectrum. Using pure colors, it is possible to form any color whose coordinates lie inside the area bounded by the horseshoe and the straight line that connects the points representing 400 nm and 700 nm. This straight line, as stated earlier, is the locus for the pure purples found by mixing 400 nm (violet) light and 700 nm (red) light.

In general, if two spectral colors are mixed, the locus of the color of the mixture will lie on the straight line connecting the loci of the spectral colors on the CIE diagram. For instance, if white light (0.33, 0.33 on the CIE diagram) is mixed with a spectral yellow of 520 nm wavelength (0.06, 0.84), the mixture will be on the line connecting (0.33, 0.33) and (0.06, 0.84). In fact, the same is true for mixing any two colors that can be plotted on the CIE chromaticity diagram. The purest colors, of course, are the spectral colors. Those formed by adding a pure spectral color to white, lying near the spectral line, are classed as purer than those that lie near the

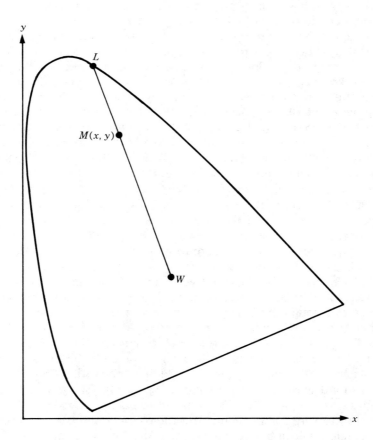

FIGURE 11.12 Determination of excitation purity and dominant wavelength for the color *M*.

white point. The spectral color is called the *dominant wavelength,* and a color can be described in terms of its purity and dominant wavelength. The color M (see Fig. 11.12) on the chromaticity diagram, formed by adding a pure spectral color (L) to white light (W), can be described in terms of its imaginary primaries (x, y) or in terms of its dominant wavelength (\underline{L}) and its *excitation purity* (p), where p is the ratio of the lengths of the chords \overline{WM} and \overline{WL}. The purity of white is zero, and the purity of the spectral color is 1. Intuitively, it is easier to think in terms of dominant wavelength and purity than imaginary colors.

Although purity and dominant wavelength describe color in psychophysical terms, their respective counterparts in psychological color terms are saturation and hue. It might be expected (or hoped) that colors of the same hue would lie along the chord connecting the white point and the dominant wavelength (the line \overline{WL}, for example). In general, the lines are not straight but slightly curved.

The third psychological descriptor for color — brightness or lightness — has no counterpart in the CIE chromaticity diagram. The counterpart would be luminance or its equivalent, and the CIE diagram provides no information on this variable.

If the spectral distribution of a light source (e.g., a tungsten lamp) is known, it is possible to determine the position of its color on the CIE diagram. Recall that in the discussion of blackbody radiators, these sources were characterized in terms of their color temperatures. Because the spectral distributions for the blackbody radiators are known (e.g., see Fig. 10.1), the chromaticity coordinates for these sources can be calculated (see Fig. 11.13). The numbers along the curve are the Kelvin temperatures of the blackbody sources having the specified chromaticity coordinates. The letters A and C show the loci of two standard illuminants used in colorimetry. Illuminant A is an illuminant for which the color temperature is 2856 K and corresponds to the illumination from a high-wattage tungsten lamp. Illuminant C is an illuminant with a color temperature of 6774 K and approximately equivalent to daylight illumination. These illuminants are also shown on Plate V. The white point is designated W in Figure 11.13. These light sources are of particular significance in the use of color films with different kinds of illumination and in the use of filters in color photography.

Recall that complementary colors are those pairs which, when added together, yield white. Because the color resulting from the addition of two colored lights lies on the line connecting the loci of the two on the CIE diagram, it follows that complementary colors must be located on the CIE diagram so that the line connecting the two passes through the white point. If the white point is selected as W (Fig. 11.13), then the complementary spectral color of every spectral color can be determined by drawing a chord through W connecting the two spectral colors. For example, the complement of a 580 nm spectral colored light is a spectral colored light at about 480 nm, and the two added in the correct proportions yield a white corresponding to the white point (see Fig. 11.13). Two less-pure colors lying on the chord \overline{GM}, one on either side of the white point, can also be added to form white and they too are complements. The complement of the spectral color at 700 nm is in the blue-green at about 494 nm (Plate V). The complement of the spectral color at 400 nm is in the yellow-green at about 570 nm.

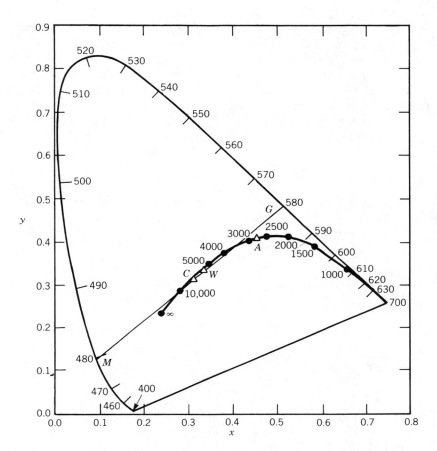

FIGURE 11.13 CIE diagram showing loci of the chromaticity coordinates for black-body radiators.

The white point is arbitrary, and what is chosen as white depends on the environment and the detailed behavior of the eye. Even the so-called normal or average eye sees different colors as white depending on the surrounding conditions. What are seen as complementary colors depends, to some extent, on what is chosen as white. For instance, if Illuminant C (Fig. 11.13) is chosen as white, and a normal observer is asked to find the complement of a 580 nm yellow spectral color, the observer would choose a 480 nm blue to add to the yellow-red to make a white matching Illuminant C. This complement is not unlike that obtained when the white point (*W*) was chosen for white. If a tungsten lamp (Illuminant *A*) – Fig. 11.13) is chosen as white, however, the complement of the same yellow-red is a spectral light of about 465 nm wavelength, which is distinctly violet. This is only a hint of the problems encountered in color photography using common light sources of different spectral characteristics.

Although the CIE chromaticity diagram was devised and is most applicable for studying the behavior of colored lights, it can be applied (if used judiciously) to other color systems. The Munsell colors with the highest chroma are shown on the CIE diagram in Figure 11.14 and represent the approximate boundary for printing inks. Artistic license has been taken in Plate V in showing printing colors throughout the interior of the horseshoe.

Finally, the range of colors that can be produced by mixing the yellow, magenta, and cyan dyes of the type used in color films is shown in Figure 11.15. The trian-

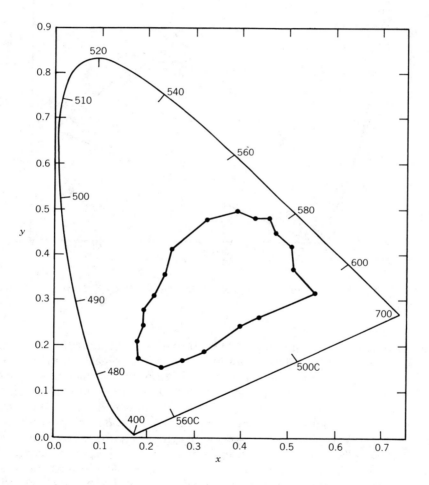

FIGURE 11.14 Dots are the loci of 20 of the Munsell samples of highest chroma plotted on the CIE diagram.

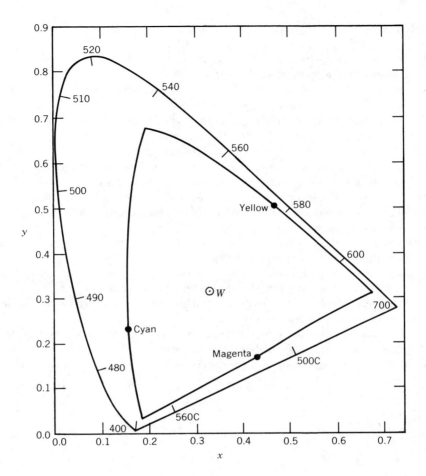

FIGURE 11.15 CIE chromaticity plot of the colors that can be obtained using the yellow, magenta, and cyan dyes of color photography.

gular shaped figure inside the spectral horseshoe encompasses the colors that can be obtained from these subtractive primary dyes.

For a more complete discussion of *trivariant vision* and the CIE color system see Le Grand.[5]

[5]Le Grand, p. 132ff.

EXERCISES

11.1. Describe four different ways in which an object can be colored.

11.2. Explain why the sky is blue and a sunset is red.

11.3. How can a piece of cloth reflect more visible light than the total amount of visible light incident on it?

11.4. What color would a red photographic dye be if illuminated by each of the following colored lights: red, green, white, magenta, cyan?

11.5. Why are we able to use three primary colors to generate all the other colors?

11.6. What are the primary colors as we define them in color photography? What are the subtractive primaries and how are they related to the primaries?

11.7. If a yellow filter and a green filter are used to filter white light, what will be the color of the transmitted light? What color is transmitted if a yellow and red filter are used?

11.8. Why are the primaries not unique?

11.9. Why don't primaries work well as dying agents but are very satisfactory for the phosphors of a color television screen?

11.10. Name two colors of different hue. Name two of the same hue but different brightness. Name two of the same hue but different saturation.

11.11. Relate hue, brightness, and saturation of colorimetry language to hue, value, and chroma of the Munsell system.

11.12. Compare the Munsell system of color representation to the CIE system. In what ways are the two alike, and how do they differ?

11.13. Why can't three primary colored lights be added to match any other pure colored light?

chapter
· 12 ·

Color photography

■ **HISTORY OF COLOR PHOTOGRAPHY**

This discussion of color photography history will not be exhaustive but will mention the major technical discoveries in its development. For more details, refer to the books by Newhall[1] or Evans, Hanson, and Brewer.[2]

Since the development of the daguerreotype, photographers have wanted to record scenes in color. James Clerk Maxwell, in 1861, developed a technique in which colored images could be formed by projection. In that year he showed the Royal Institute of London a projected color image of a red ribbon. Thomas Sutton had recorded the colors in three photographs of the ribbon on black-and-white film taken successively through a red, a green, and a blue filter. Each of these negatives recorded, respectively, the red, the green, and the blue components of the color of the ribbon. Positive transparencies were made from the negatives, and each was used to project through the same colored filters the red, green, and blue information of the subject. These projected images were superposed, and the resulting image was a color picture of the ribbon. This is an example of using *additive color* to form a color photograph. The process was cumbersome, the images poor, and the process useful only for still life, but it was a color photograph. In retrospect, it is surprising that the process worked, because the film that Sutton used could not record red or green. The filters are known to have been dilute, and it may be that only ultraviolet and blue light exposed the plates. When panchromatic film became available, a system based on Maxwell's demonstration was developed that was partially successful.

Several other additive processes were developed for making positive transparencies using a single emulsion. All of them involved using many minute red, green, and blue filters that the eye could not resolve at normal viewing distance. Perhaps

[1]B. Newhall, *The History of Photography,* New York: The Museum of Modern Art, 1981, p. 191ff.

[2]R. M. Evans, N. T. Hanson, Jr., and W. L. Brewer, *Principles of Color Photography,* New York: John Wiley, 1953, p. 271ff.

the earliest successful system was the *Autochrome* process developed by the Lumière brothers. In this process, minute starch grains were dyed red, green, and blue. The three colors of starch grains were sprinkled on a glass plate in equal amounts and coated with emulsion. The plate was exposed through the back and developed by reversal to make a positive transparency. The process was developed in 1903, marketed in 1907, and discontinued in 1932. Other processes used more regular arrays of minute filters similar to the arrangement of the color phosphors on a color television screen, which was discussed in Chapter 6. Before considering color photography based on the subtractive primaries, it is worth noting that Maxwell's method of recording red, green, and blue information using filters and black-and-white film is still the best method for archival storage of color images.

■ SUBTRACTIVE COLOR PHOTOGRAPHY

The earliest successful *subtractive color* system *(color carbon process)* was developed independently by Louis Ducos du Hauron and Charles Cros in 1869 and evolved from the carbon process already in use in black-and-white printing. Three *color-separation negatives* are made, just as Maxwell did in his experiments. Each negative is used to expose a film of bichromated gelatin containing the subtractive primary that corresponds to the primary of the negative. Bichromated gelatin hardens in proportion to the amount of light that reaches it. For example, the "blue" negative is used to expose a film of yellow gelatin. Those parts of the "blue" negative that correspond to the blue part of the scene are very dense and allow little light to reach the yellow gelatin. The yellow gelatin is fully illuminated in those parts of the gelatin that are exposed through the transparent part of the "blue" negative. The unexposed gelatin is not hardened and can be dissolved in hot water. A yellow relief image is formed that is thin in the blue part of the scene and thick in the regions that contain no blue. The "red" and "green" negatives are used to expose gelatin dyed the color of their respective subtractive primaries. The three relief images of gelatin are then superimposed, and a satisfactory color transparency can be produced.

The following example may help. Imagine that a piece of blue paper is photographed against a black background using the color carbon process. The yellow gelatin is thin in the areas that correspond to the position of the blue card (see Fig. 12.1) and thick in all other regions. The magenta (complement of green) and cyan (complement of red) gelatins are thick in all regions, because the red and green negatives are uniformly thin. Using arguments similar to those used in Example 11.1, it can be seen that no light will pass through that part of the sandwich corresponding to the black part of the scene, and only blue light will pass through the parts of the sandwich corresponding to the blue part of the scene. When satisfactory panchromatic plates became available, the color carbon process became commercially feasible (about 1877).

About 1900, Thomas Manly developed a process that ultimately became known as *trichrome carbro,* which refined the color carbon process by incorporating

FIGURE 12.1 Color carbon process gelatins that have been used to make a photograph of a blue card against a black background.

some of the discoveries of Ernest H. Farmer. Farmer discovered that when finely divided silver, gelatin, and a soluble bichromate are brought in contact, a hardened gelatin is formed that is insoluble in water. In the carbro process, the separation negatives are used to make ordinary black-and-white photographic prints. If the subtractive primary gelatin tissues (similar to those used in the color carbon process) are saturated with bichromate solution and brought in contact with the prints made from their respective primary negatives, hardening of the gelatin occurs in the regions in contact with the silver of the print (the black areas). After dissolving the unhardened gelatin, the three gelatin tissues in register form a positive color transparency. If the transparency is mounted on white paper, the result is a color print. Many considered the carbro prints to be of very high quality.

The *dye transfer process,* using, for example, Kodak Matrix Film 4150, is representative of the current state of art for producing color prints and transparencies from color-separation negatives. The *matrix film* is exposed through the base (see Fig. 12.2a) and one of the separation negatives. A yellow dye in the emulsion of the matrix film limits the depth of exposure of the blue-sensitive film to the layers near the base. The thinnest parts of the separation negative allow the deepest exposure of the matrix film. A *tanning developer* hardens the gelatin in regions of the film where development is taking place. The thickness of the hardened gelatin (see Fig. 12.2b) is proportional to the exposure.

After fixing in a nonhardening fixer, the unhardened gelatin is dissolved (Fig. 12.2c), and the hardened gelatin is dyed the subtractive primary color that corresponds to the positive primary represented by the separation negative (Fig. 12.2c). The amount of dye in any part of the matrix is proportional to the thickness of the hardened gelatin. This dyed gelatin, called a *dye matrix,* is then placed in contact with a *mordanted gelatin* on paper *(dye transfer paper)* which absorbs and stabilizes the dye (Fig. 12.2d). After the three dye matrices have been placed in register in contact with the transfer paper, a very high quality color print is obtained. Note that this process starts with color-separation negatives. If the subject is fixed, the negatives can be made much as Maxwell and Sutton photographed the colored ribbon. The separation films can also be made simultaneously using appropriate filters in a beam-splitting camera, also called a *one-shot camera.* Today, color separation negatives frequently are made from an original color negative or *transparency* using appropriate filters and films.

A film was needed that, after exposure in an ordinary camera, could be used to make a color print or transparency from one negative. Leopold D. Mannes and

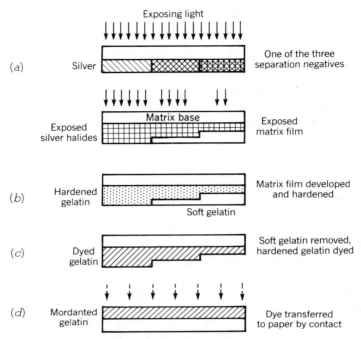

FIGURE 12.2 Use of matrix film to form a dye transfer print.

Leopold Godowsky, working with researchers at Eastman Kodak Company, were successful in adapting a process patented by Rudolf Fischer, called *dye coupling*, to produce such a film. In 1935, subtractive color films were introduced in which three color sensitive layers supported on a common base could be exposed simultaneously in an ordinary camera. Upon proper processing, a positive transparency could be made of this exposed film. This film and several others using similar dye-coupling techniques have become the films of choice for color photography. The remainder of this chapter is devoted to discussing how these films work and how they are used.

■ MODERN COLOR FILMS AND PAPERS

Typically the films and papers used in color photography today are *integral tripack* or *unipack* films or papers. In such materials, three layers of sensitized emulsion are deposited on a base (Fig. 12.3). Each of these layers is designed to record one of the primary colors. The base is either a resin-coated paper or a transparent antihalation-backed plastic, much like that used for black-and-white photographic material. The top layer is designed to record blue information, the center layer green information, and the bottom layer red information. Because all of the silver

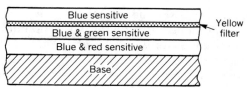

FIGURE 12.3 Schematic cross section of a typical color film.

halides are sensitive to blue light, a yellow filter is incorporated in tripack film between the top and middle layers, so that blue light will not reach the bottom layers. This filter is *colloidal silver,* which is removed with the rest of the silver during a bleaching step in the processing of the film. The colloidal silver is formed by precipitating silver with tannins and is sometimes called *CLS silver* after its discoverer — Matthew Carey Lea. The yellow layer is omitted in color printing paper because silver chloride, which is not very sensitive to blue light, is used as the light-sensitive material in the two bottom emulsions. Appropriate dyes, much like those used in panchromatic black-and-white film, are added to the middle and bottom emulsions to make them sensitive to green and red light, respectively.

The *spectral sensitivity curves* for a typical color film are shown in Figure 12.4. This sensitivity is inversely proportional to the light energy of a given wavelength necessary to produce a prescribed density of the dye in the developed layer. Blue refers to the spectral sensitivity of the top layer, green to that of the middle layer, and red to the bottom layer. If this recording system is compared with the color response of the cones of the average eye (see Fig. 6.5), it is seen that the film response overlaps less than the visual response, especially for the green- and red-sensitive layers. Because the eye is the ultimate judge of the quality of a color

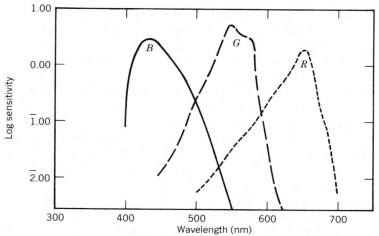

FIGURE 12.4 Spectral sensitivity curves for Kodak Ektachrome 64 Professional film.

photograph, it would be somewhat advantageous to have the spectral response of the film and the eye the same. That the responses do not match is, in part, the cause for difficulties in taking pictures under certain kinds of illumination (e.g., fluorescent lights). Although each of these color sensitive layers has been described as homogeneous, each may consist of several layers so that the sensitivity and spectral response may be as desired.

Although the silver halides are used to record the color information, they cannot be used to form the colors themselves. Granular silver is black whether in black-and-white or in color film. Color is introduced into the finished film or print by means of couplers that are activated during a *color development*. Couplers were mentioned in the discussion of the diazo process (Chapter 6). The couplers are colorless compounds placed in the film either at the time of manufacture or during development. These compounds become colored if they are subject to a chemical process called color development. In the regions of the film where development is taking place, the silver halide is reduced to silver, and the developing agent is oxidized (see Chapter 7). In color development, the oxidized developer reacts with the couplers to form colored dyes in the local regions where development is taking place. In normal development, sulfite is added to the developer to prevent this reaction. The color of the dye in each layer is the subtractive primary corresponding to the primary to which the layer is sensitive. Hence, the top layer is colored white − blue = yellow, the middle layer white − green = magenta, and the bottom layer white − red = cyan in those regions where color development takes place. The *spectral dye density curves* of the three layers for a typical *color reversal film* are shown in Figure 12.5. The overlapping curves show the characteristics of the yellow (Y), magenta (M), and cyan (C) layers of the film, and the top curve shows the combined response of the three together. The dyes are normalized (adjusted) so that the density of the three layers would appear neutral gray to the average eye and have a density equal to one. (The eye is the ultimate judge of color.)

The density plotted here is called *diffuse density*. In Chapter 8, the measurement of *specular density* was described. Although only the parallel beam passing through the film (see Fig. 8.2) is shown, in practice some light is also scattered by the film (see Fig. 12.6). If the transmitted parallel light is measured as in Figure 8.2, the density is called specular density. If all the transmitted light is measured, the density is called diffuse density.

Note that the *visual neutral curve* does not indicate the same response at all wavelengths. Physical measuring instruments can detect this nonuniformity but the eye cannot; thus it sees the film as gray. Note also that the yellow, magenta, and cyan curves overlap. This overlapping in particular, and the nonuniform spectral response to a lesser extent, are factors that cause certain images to appear degraded in color. The couplers can be incorporated in the film when the film is manufactured or when it is developed. In Kodachrome (a color reversal film), the oldest of the monopack films, the couplers are introduced into the emulsion at the time of development. Because different couplers must be put in each layer, three different color developments are necessary to produce the final colored image.

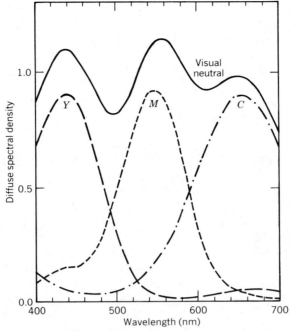

FIGURE 12.5 Spectral dye density curves for Kodak Ektachrome 64 Professional film.

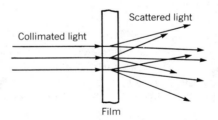

FIGURE 12.6 Scattering of a collimated beam of light by a film.

At first the couplers could not be put in the emulsion at the time of manufacture, because they tended to wander from layer to layer before the color development occurred. Sometime after the introduction of Kodachrome, Agfa introduced a reversal film called Agfacolor Neue in Europe and Ansco Color in the United States. The couplers were put in the emulsion at the time of manufacture and were immobilized by attaching them to long chain molecules. In 1942 Eastman Kodak Company introduced Kodak Kodacolor film and Kodacolor paper, the first monopack negative-positive system for making color prints. Incorporated in these materials at

the time of manufacture, the couplers are immobilized by first dissolving them in an oily liquid that is then dispersed in the emulsion. In Ektachrome film, another reversal film, the couplers are dispersed in the emulsion much as in Kodacolor materials.

■ REVERSAL FILMS

The reversal process for black-and-white photography was discussed in Chapter 7. The color reversal process is similar for films like Ektachrome. The steps for the two processes are shown in Table 12.1. Note that in the color process, the second development is a color development, and the bleach step is placed after the second development. The exposure of the remaining silver halide can be accomplished by exposing the film to uniform light, as described in the discussion of black-and-white reversal, or it can be done chemically. In the latter case, a fogging color developer both exposes the film and color develops it in one step.

In processing films that incorporate the couplers at the time of development (e.g., Kodachrome), each of the three emulsions is color developed separately after the first development. First, one emulsion layer is exposed through an appropriate filter, and this layer is color developed using a developer that contains an appropriate coupler. For instance, the red-sensitive layer can be exposed to red light and color developed using a developer that contains a coupler yielding a cyan dye. The process is repeated for a second layer and then the third layer is developed similarly after exposure to white light. Finally, the bleach, fix, and wash steps are performed. The process is too complicated to be practical for home processing.

That the color reversal process, as outlined in Table 12.1, will produce a positive transparency for which the colors correlate with the colors of the photographed object, can be deduced by studying Plate VI. The first development yields the usual silver image much like a black-and-white negative (top film, Plate VI). After reexposure, color development produces a film in which all the silver is developed, and the subtractive primary dyes appear in those regions where color development takes place (middle film, Plate VI). Note that when the film is exposed to orange,

TABLE 12.1 Comparison of the Reversal Process in Black-and-White and in Color Photography

Black-and-White	Color
Expose in camera	Expose in camera
Develop	Develop
Bleach	
Expose remaining silver halide	Expose remaining silver halide
Develop	Color develop
Fix	Bleach
Wash	Fix
	Wash

the green-sensitive layer is partially exposed. Hence, when this region is sensitized and color developed, the magenta dye in this region is not as dense as in those regions where there was no exposure in the camera. After the yellow filter and the silver are bleached from the film, it appears like the bottom film in Plate VI. If white light is used to illuminate the transparency, the image appears as shown at the bottom of Plate VI, which duplicates the subject at the top. Using arguments similar to those in Chapter 11 (Figs. 11.8, 11.9, 11.10, and 11.11), the reader can be convinced of the correctness of the result.

The H & D curves for a reversal film give the density of the positive transparency as a function of the exposure of the film in the camera. Because small exposure corresponds to a shadow area in the scene and high density in the transparency, the H & D curves seem reversed (see Fig. 12.7) when compared with the H & D curves for negative working materials. In addition, because this is an integral tripack film, a curve is required for each layer of the film. Recall from the discussion of black-and-white reversal material that a proper transparency uses the entire density range of the film if it is to be of the highest quality. This differs from black-and-white negative working materials in which only the lower part of the H & D curve is used. The situation with a transparency is more akin to that for a black-and-white print. Ideally, the three color H & D curves should coincide through the entire

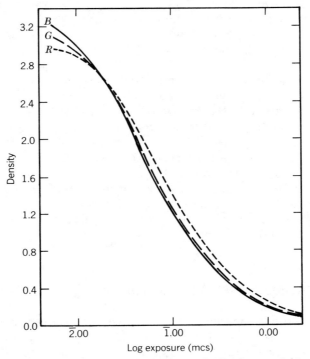

FIGURE 12.7 H & D curves for Kodak Ektachrome 64 Professional film.

range of exposure. If they do not, the color balance in the highlights, midtones, and shadows will not be the same.

Proper exposure and processing of reversal films is more critical than that of negative materials, because the entire range of densities of the transparency must be used. Moreover, a printing step is not available for correcting exposure errors. If the film is overexposed and processed normally, the transparency will be thin and appear washed out. If it is underexposed and processed normally, the shadows will be undifferentiated. The lighting ratio of a diffuse highlight compared with a dark tone in a scene is typically 160/1. This corresponds to a log exposure range of 2.2. If specular highlights and dark shadows are included, the ratio increases to 1000/1 and the exposure range to 3. The total exposure range of the film (see Fig. 12.7), if toe and shoulder are included, is no more than 2.7. The more or less straight-line portion of the curve is included in an exposure range of about 2.

▶ **Example 12.1**

Assume that we are photographing a scene in which the diffuse highlight to shadow ratio is about 160/1. If Kodak Ektachrome 64 Professional film is used to record this image, show where the exposure range should be on the H & D curve so that the tones within this ratio will have the best linear separation. What will be the density range on the transparency? If the exposure is increased by one stop, find the new exposure and density ranges.

If we compress the shadows and highlights equally, the exposure range will be about as shown in Figure 12.8 with the diffuse highlight at about 0.15. If we make the measurements on the green curve, the density range will be 3.05 − 0.15 = 2.90. If the exposure is increased by one stop (a factor of 2), log exposure increases 0.3, and the diffuse highlight is just off the graph to the right and on the toe of the H & D curve. The density range is 2.80 − 0.1 = 2.70. The diffuse highlight-to-shadow ratio in the first case is about 795/1 and in the second case about 500/1. Because the ratio in the original scene was 160/1, it seems at first glance that either transparency would be adequate. However, we have neglected camera flare and reduction in contrast due to viewing conditions. The latter may result from projector flare and/or ambient illumination in the viewing room. These effects could easily reduce the density range by a factor of at least 4. Furthermore, these effects tend to wash out the shadows since the dark areas of the transparency image are brightened by the scattered light, whereas the highlights are changed relatively little (see Fig. 8.17). In addition, the increased exposure compresses the highlights. The overall effect can be a washed-out transparency.

■ KODACHROME VERSUS EKTACHROME

Popular photographic magazines have published many articles about the relative merits of films that have the couplers added during processing (e.g., Kodachrome) and those that have them incorporated at the time of manufacture (e.g., Ekta-

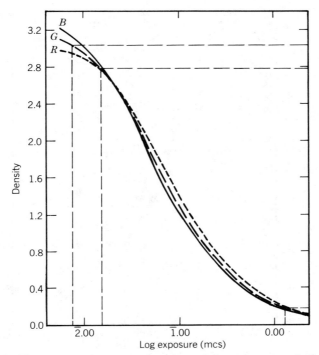

FIGURE 12.8 H & D curves showing exposure and density ranges for example 12.1.

chrome). In the end, the choice is subjective because the eye of the user and viewer is the ultimate judge. Some of the ways in which they differ technically are worth mentioning.

► **Example 12.2**
Compare Kodak Ektachrome 64 Professional film (Daylight) and Kodachrome 64 film (Daylight).

Ektachrome professional film should be refrigerated before and after exposure to retain its prescribed characteristics. Ektachrome 64 does not need refrigeration, because it is manufactured to compensate for the changes that occur at room temperature during the handling and storage of the film before and after exposure. These changes probably occur in the couplers. Because Kodachrome contains no couplers until processed, its stability is much like black-and-white film and generally it is more stable than Ektachrome prior to development. After development both films are somewhat unstable, especially under viewing conditions. Some evidence seems to indicate, however, that Kodachrome has better dark storage characteristics.

A comparison of the H & D curves for the two films (see Figs. 12.7 and 12.9) gives a slight edge to the Ektachrome film, because the three curves (R, G, and

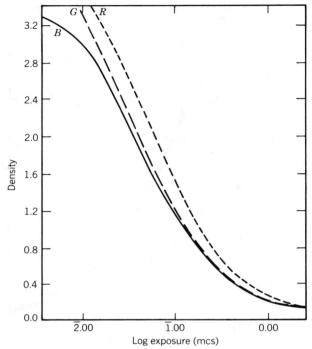

FIGURE 12.9 H & D curves for Kodachrome 64 film.

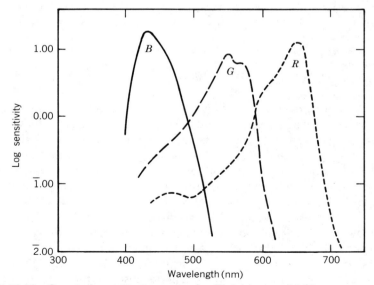

FIGURE 12.10 Spectral sensitivity curves for Kodachrome 64 film.

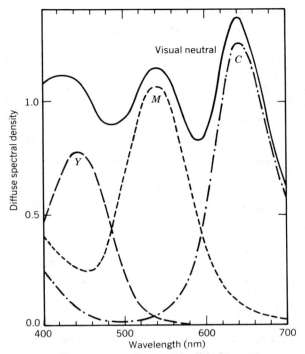

FIGURE 12.11 Spectral dye density curves for Kodachrome 64 film.

B) are more nearly coincident, suggesting that the three layers act more nearly the same throughout the normal exposure range.

The spectral sensitivities can be compared using Figures 12.4 and 12.10; the curves are quite similar. Both sets of curves have relatively sharp cutoffs at long wavelengths and at short wavelengths for the blue-sensitive layer. However, the red and green curves for Kodachrome do not cut off as sharply at short wavelengths as those for Ektachrome. If we are correct in believing that the spectral sensitivities should match those of the cones of the eye, this appears to give a slight edge to Kodachrome (see Fig. 6.5).

The spectral dye density curves can be compared using Figures 12.5 and 12.11. The visual neutral curves are different, but it is unlikely that these differences are significant. The curves for the individual layers show density as a function of wavelength.

Ideally, the yellow dye should absorb only blue (the short wavelengths), the magenta should absorb green (the intermediate wavelengths), and the cyan red (the long wavelengths). Unfortunately, the magenta dyes absorb some at short wavelengths, with the Kodachrome dye absorbing the most. The cyan dye used in Ektachrome absorbs some at intermediate and short wavelengths. The cyan dye in Kodachrome performs better than Ektachrome at intermediate wavelengths but not as well at short wavelengths. Neither yellow dye has any

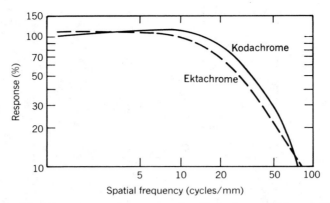

FIGURE 12.12 Modulation transfer curves for Kodachrome 64 and Ektachrome 64 Professional films.

significant problems. This unwanted absorption is corrected using *masking* techniques in negative working materials but cannot be corrected in reversal materials. On the basis of the comparison of these dye density curves, we would expect the Ektachrome film to be truer in rendering blues, and the Kodachrome film should do better with greens. Some working photographers agree with this assessment. This analysis of the dyes, however, ignores the effect of the differences in the spectral sensitivity curves of the two films.

The Modulation transfer functions in Figure 12.12 indicate the Kodachrome 64 film has slightly better spatial fidelity than the Ektachrome film. Kodachrome 64 film shows somewhat less granularity than Ektachrome 64 Professional film (see Chapter 7). However, a measurement of resolving power (see Chapter 7) shows the two films to be the same (80 lines/mm) at low contrast and the Ektachrome 64 Professional film to be superior at high contrast (125 lines/mm vs. 100 lines/mm).

Finally, it should be noted that the Ektachrome film can be processed by the user, whereas Kodachrome must be processed in a suitable commercial laboratory. It seems that neither film is clearly superior. But, as we have noted, there are differences, and choice may well depend on the particular application under consideration and the taste of the user/viewer.

■ COLOR NEGATIVE MATERIALS

Color negative films are typically made in the same way as reversal films (see Fig. 12.13). The couplers are incorporated in the three layers at the time of manufacture. Developed negative film, however, has an orange cast that is due to a self-masking feature built into it. This masking feature will be ignored for now, and the usual subtractive primary colors will be assigned to each layer (see Fig. 12.13). The emulsions of color printing paper have the same configuration as color films,

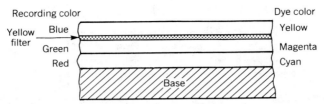

FIGURE 12.13 Structure of reversal and negative working color films.

except the yellow filter is omitted for reasons mentioned earlier. The couplers are incorporated in the emulsion at the time of manufacture (see Fig. 12.13). No masking is incorporated in the emulsion, which is deposited on a resin-coated paper treated with barium sulfate to improve its reflectance.

After exposure in the camera, color negative films are color developed, bleached, fixed, and washed to make a negative for printing. To make a positive print, color printing paper must be exposed using the negative in a color enlarger. Appropriate filters are used in the enlarger to correct for masking and the color characteristics of the enlarging lamp. If the printing paper is then color developed, bleached, fixed, and washed, a print for which the colors and tones match the original scene will be produced. The process is diagrammed in Figure 12.14. The schematic shows the production of a color print from a negative exposed to a scene containing red (R), yellow (Y), black (Bl), and white (W) subjects. Y, M, and C refer to dye colors. B, G, and R on the left refer to the effective sensitivity of the various emulsion layers and B, G, R, W, and Y with arrows refer to the colors of light incident on or transmitted through the various layers. The shaded areas represent parts of the film that are sensitized on exposure.

■ **DYE LIMITATIONS AND MASKING**

As was shown in Example 12.2, the dyes used in color reversal materials are less than ideal. Those used in color negative films and color printing papers are similar. The yellow dye is satisfactory, but all cyan dyes absorb some green and blue light, and the magenta dyes absorb some blue light.

Because it must be possible to reproduce a neutral gray as gray, the overall absorption in the blue, green, and red parts of the spectrum must be approximately equal (see Fig. 12.5). If the magenta and cyan dyes absorb excessively in the blue part of the spectrum, however, the total amount of yellow dye that can be incorporated in the film must be reduced (see Fig. 12.11) to compensate for this deficiency. Hence, even though an average picture gives good color rendition, the yellows are desaturated. But most pictures include people, and flesh tones usually contain considerable components of yellow. Unnatural rendition of flesh tones is objectionable, so it is necessary to compromise between rendering flesh tones and neutral grays accurately. Without masking, two types of errors occur. The relative brightness and saturation of different hues are distorted; blues, cyans, and greens

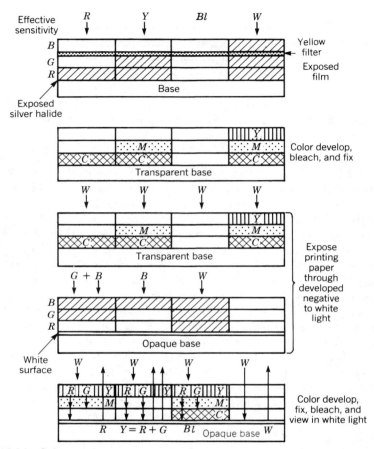

FIGURE 12.14 Schematic representation of the production of a color print using color negative film and color printing paper.

are too dark in comparison with reds, oranges, and yellows. In addition, actual shifts in hues occur. Usually the reds shift to shorter wavelengths (toward orange) as do the greens (toward blue). The magentas contain more red and the cyans more blue components.

Masking is a process for controlling the transfer of an image so that the tones of a part of the image are altered during the transfer process. In photography, this usually occurs in the darkroom during the printing process. In a sense, burning and dodging during black-and-white printing are forms of masking. In more complicated printing situations, a silhouette of a part of the image may be bound in register with the negative to manipulate a part of the exposure of the printing paper. Masking is not limited to photography; it is also used in the printing and video imaging industries. Computer-controlled masking is utilized in processing the video images taken on NASA flights (e.g., the Jupiter probes).

Masking in color photography can be used to correct for color deficiencies in dyes. The mask can be a negative or a positive and may be used with a negative or a positive. A mask can be made by copying the original on black-and-white film using an appropriate filter. The black-and-white image is developed to appropriate (usually low) contrast, bound in register with the original, and the pair used to make a print.

As stated earlier, the couplers used in reversal materials are colorless until they are subjected to color development. The couplers in modern color negative materials are not colorless but are colored in such a way that they become a mask to correct for the deficiencies of the couplers. The magenta coupler in the green-sensitive layer is yellow before color development and absorbs blue light. In the parts of the green-sensitive layer where color development takes place, the coupler changes from yellow to magenta. In the other parts of the green-sensitive layer, the coupler remains yellow. The density of the yellow matches the density of the unwanted yellow in the color developed magenta dye. The net effect of this procedure is to add a yellow filter of uniform density to the film.

The cyan coupler in the red-sensitive layer is pink before development and absorbs some blue and green light. This absorption is matched to the unwanted absorption of blue and green by the cyan dye. After color development, the overall effect is to add a uniform pink filter to the film. The two masking filters account for the orange cast of color negatives. In color printing, the color of the printing illumination is altered to correct for the filters, and the result is a more accurate match of the colors of the scene in the final print.

The spectral dye density curves for a typical color negative film are shown in Figure 12.15. These curves show the midscale density (*A*) for a neutral gray test

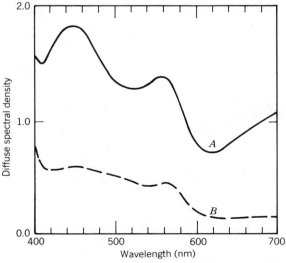

FIGURE 12.15 Spectral dye density curves for Kodacolor II film: [(*A*) midscale density and (*B*) minimum density].

object and the minimum density (*B*) of the film. The minimum density curve is essentially the density curve for the mask. The midscale density curve represents the sum of the negative image of a midscale neutral tone (gray) and the filter.

▶ **Example 12.3**

The difference between the spectral dye density curves (*A*) and (*B*) of Figure 12.15 represents the dye density curve for a midscale neutral gray after correction for deficiencies in the magenta and cyan dyes. Determine the shape of this difference curve. Compare it with the visual neutral dye density curves for typical color reversal film.

If the densities are subtracted at each wavelength and replotted, the result will be as shown in Figure 12.16 (curve *A*). For example, the midscale density at 400 nm is 1.57, the minimum density is 0.77, and the difference is 0.80. The visual neutral density curve for Ektachrome 64 Professional film (curve *B*) is plotted for comparison in this figure. The curve for the Ektacolor film decreases more with increasing wavelength than does the curve for the Ektachrome film. Because the Ektacolor film is used to make a print the decrease is no great disadvantage; the color temperature of the enlarger light source can be altered to correct for this dropoff. The two curves are quite similar qualitatively.

The H & D curves for a typical color negative film are shown in Figure 12.17. Remember that these curves represent the density of the dyes in the developed film. The density of the film is measured in the red (*R*), green (*G*), and blue (*B*) parts of the spectrum using appropriate colored filters chosen to be compatible with the spectral sensitivities of the printing paper. Usually, the negative is used to make a color print. Hence, the critical issue is how the printing paper "sees" the negative. The film is most dense in the blue part of the spectrum and least dense in the red

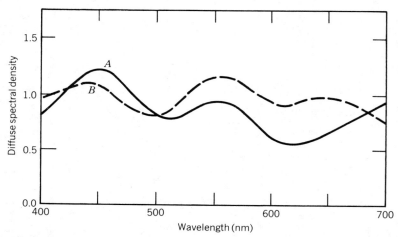

FIGURE 12.16 Comparison of difference between midscale density and minimum density of Kodacolor II with the visual neutral curve of Ektachrome 64 Professional film.

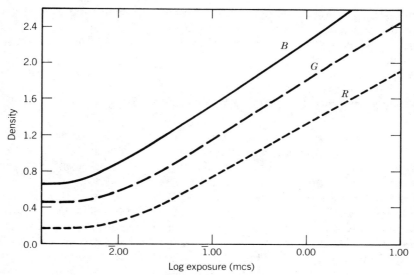

FIGURE 12.17 H & D curves for Kodacolor II film.

part, because of the masking dyes and the deficiencies in the cyan and magenta dyes.

Frequently, prints or transparent copies are made from reversal transparencies. A print or slide can be made directly using reversal film or print-copying materials. In such a process, no masking can be used to correct for the dye deficiencies of the original. Alternatively, an *internegative* can be made, and reflection prints or transparencies can be produced from this internegative. In this instance, a self-masking color film designed to correct for some of the color deficiencies of the original can be used for the internegative. The internegatives can be made on black-and-white film by copying the original using appropriate filters. Masking can, of course, be accomplished using this process, although the choice of filters can be complicated. Either kind of internegative can be used to make a dye transfer print.

Some may question the validity of masking. It is tempting to ask if this is not an example of losing information because of the limitations of the dyes. Isn't this similar to losing detail in a photograph because of limits of the resolving capability of film and camera? In such a case, if the information is not recorded, it cannot be recovered. Once the detail in the subject exceeds the limit of resolution of the film and camera, it is impossible to know whether one line is actually a single line in the object or two or more lines. The distortions in color caused by deficiencies in the magenta and cyan dyes can be calculated from the dye curves, however, and appropriate corrections can be made using masking procedures. If A represents the true colors of a scene, B the unwanted absorption of the magenta and cyan dyes, and C the final image, then symbolically $A - B = C$. B and C are known; to make a picture that looks like A, add B to C so the $A = B + C$. Masking does this.

In the case of losing detail due to limits in the resolving capability of film and camera, the deficiency (*B*) is not constant but depends on the object itself. If two lines are unresolved, *B* is one deficiency, but it is something different if three lines are unresolved.

■ LIGHT SOURCES FOR COLOR PHOTOGRAPHY

In Chapter 10 it was noted that the color of light sources is critical in color photography. The color of an object depends on the color of the light illuminating it. Hence, when an object is observed in sunlight and in incandescent light, the light reflected from it is different, and color pictures made with the same color film in the two situations appear different. Because the eye adapts to changes in illumination, it sees less difference in the two situations than the film "sees." If the two pictures are viewed under the same illumination, however, they appear different and one of the pictures is judged wrong (see Plate I). To overcome this difficulty, the spectral sensitivity of color films is adjusted so that when used with a particular light source they yield pictures that appear "natural."

Human beings tend to be very sensitive to the appearance of flesh tones in a photograph. A picture appears natural if the flesh tones in the picture appear as they would to the eye.

Because *incandescent illumination* is deficient in short wavelength radiation compared with daylight illumination, the sensitivity of film to be used with incandescent illumination is made relatively more sensitive in the blue part of the spectrum. A comparison of Figure 12.4 with Figure 12.18 shows this increase in blue sensitivity for all three emulsions in the film used with incandescent illumination. This film is balanced to be used without a filter for light sources having a color temperature

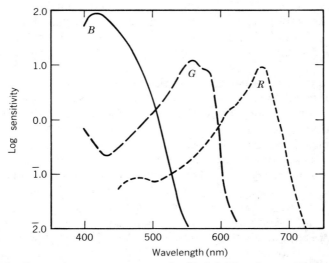

FIGURE 12.18 Spectral sensitivity curves for Kodak Ektachrome 50 Professional film.

of 3200 K. Daylight color film is balanced for a color temperature of 5500 K. A few color films are balanced for 3400 K (e.g., Kodachrome 40 film 5070).

New photoflood lamps give illumination having a balance equivalent to a 3400 K blackbody radiator (see Chapter 10). As the lamps age, their color temperatures decrease. Another class of photographic incandescent lamp, when new, yields light with a color temperature of 3200 K. A typical new household incandescent lamp yields illumination with a color temperature of about 2800 K (see Plate V). Films balanced for 3200 K are called type B color films, and those balanced for 3400 K are called type A color films. The difference between using a type B film with a 3200 K light source and using the same film with a 3400 K light source is detectable, but small. A type B film unfiltered is used frequently with household incandescent illumination, although the pictures tend to be too orange in color. If type A or B film is used with daylight illumination, the result is a picture that is too blue. If daylight film is used with *tungsten illumination,* the result is a picture that is too orange. If a color film is used with illumination for which it was not designed, filters can be used to make the appropriate corrections. This is discussed in Chapter 13.

As stated earlier, the spectral response of the eye to color (see Fig. 6.5) is not the same as that of film, and this is a second cause of difficulty in making color pictures under different kinds of illumination. This is evident particularly when color pictures are made using fluorescent illumination. For instance, the flesh tones of an average Caucasian face have a distinctly greenish cast, and grays appear green when photographed with daylight color film under cool-white fluorescent illumination. This happens because the eye responds differently than the film to the intense emission in certain spectral lines (see Fig. 10.2). The considerable overlap of the spectral sensitivity of the green and red sensors of the eye probably allows the green and yellow lines in the fluorescent illumination to stimulate both the red and green sensors of the eye. The red recording emulsion of color film, with relatively less short wavelength sensitivity, is probably not exposed as much by these lines. To correct for this difficulty, filters must be used; this is discussed in Chapter 13.

■ DETERMINING EXPOSURE

The ASA film speed of a color negative film is defined in a different way from that of a black-and-white negative film. Because there are three H & D curves (see Fig. 12.17), an average of the log E values required to achieve a specified density for the red, green, and blue recording layers is used to determine the ASA film speed.[3] The speed points are near the toe of the H & D curve but higher than that used to define the ASA film speed of black-and-white negative film (see Chapter 8). However, the ASA film speed of color film can be used to determine exposure, just as is done with black-and-white film. Proper exposure of the film will be on the toe and straight-line portion of the H & D curve.

[3]H. N. Todd and R. D. Zakia, *Photographic Sensitometry,* Hastings-on-Hudson, N.Y.: Morgan and Morgan, 1969, p. 165ff.

The ASA film speed of color reversal film is determined in a different manner from negative films, because the entire density range of the film is used in recording the image. Reversal film has three H & D curves (see Fig. 12.7), but they are more nearly coincident than those of negative color film. Instead of using an averaging method to determine the ASA film speed, an H & D curve measured employing a yellow filter is used to determine a speed point.[4] This point is chosen at a selected midtone density in the shadow region, and the ASA film speed is determined from the exposure necessary to achieve this density. The ASA film speed so determined can be used to determine proper exposure in the same way as with other films.

Example 12.1 showed that correct exposure of color reversal films is critical. In that example, underexposure would have resulted in loss of detail in the shadow regions. Reversal films work best if exposed at the recommended ASA and processed as recommended. If a compromise in quality can be accepted (increased grain and altered color balance), however, reversal films can be underexposed (pushed) as much as two stops provided the first development time is increased. Overexposure of as much as one stop can be compensated by reducing first development time. In the E-6 process currently used for Kodak Ektachrome films, an increase or decrease of the first development time of 2 minutes is recommended for a one stop change in exposure. If the film is underexposed two stops, the first development time should be increased 5½ minutes. Some commercial processors of reversal materials do such modifications of processing procedures on a more or less routine basis. The net effect of increasing development time is to move the H & D curve to the left in Figure 12.7 without too much change in the slope of the H & D curve.

Reciprocity failure (see Chapter 8) occurs with color film just as in black-and-white film. In general, exposure must be increased for extremely long or extremely short exposures. Because reciprocity failure affects the three recording layers of the film differently, both the speed of the film and the color balance of the film may be altered. In addition to increasing exposure, it may be necessary to use some *color compensating filters* to achieve proper exposure. Manufacturers provide color correction data for their films,[5] which should be followed when critical performance is necessary. Most color films will require no correction if the exposure is not shorter than 1/1000 sec or longer than one-tenth of a second, but there are exceptions.

■ COLOR PROCESSING

Color processing will not be considered in detail, because it is largely a laboratory procedure. Reversal films that have the couplers incorporated in them at the time of manufacture can be processed easily by the user. Simple kits are available for

[4]Todd and Zakia, p. 166ff.

[5]*Kodak Color Films, Eighth Edition*, Rochester, N.Y.: Eastman Kodak Co., 1980, p. DS-55.

such processing and, if exposure has been altered, there may be some advantage in the photographer doing the processing, because first development time can be altered to accommodate the exposure. The user will have to decide on the basis of the circumstances whether commercial or user development is the most economical. Keep in mind, however, that time is valuable. If a reversal film is used in which the couplers are introduced at the time of processing, commercial laboratory processing is the only practical procedure.

Making color prints from color negatives is more complicated than black-and-white printing but not prohibitively so. Color printing paper, of course, is panchromatic and must be handled in total darkness, which is a nuisance. Filters are used to alter the enlarger illumination to compensate for masking and deviations in initial exposure. Masking is quite reproducible, but deviations in the negative caused by unusual illumination of the scene can be troublesome. For example, as mentioned earlier, fluorescent illumination can cause considerable difficulty.

The color temperature of daylight illumination can vary from about 5000 to 25000 K (see Chapter 10). If filters were not used when the film was exposed in the field, they will be needed during printing if realistic pictures are to be made. Most color corrections that must be made in color photography can be traced to the ability of the eye to adapt while the film cannot and to the difference in the spectral response of the eye as compared to color film. Printing can be done most easily using color enlargers that have built-in light sources and *dichroic filters* designed for color printing. Conventional black-and-white enlargers can be used for color printing provided proper color printing or color compensating filters are used.

It might seem that color printing offers more opportunity for creativity than black-and-white printing, but this is not usually true. Color gets too close to reality and that closeness frequently restricts creativity. Once the bond of color is broken, and the abstraction of gray tones is accepted, the photographer seems freer to interpret a scene. Of course, the freedom to crop, burn, and dodge is retained in color printing, and this gives some opportunity for creativity in the darkroom. Black-and-white prints can be made directly from color negatives using panchromatic printing paper.

Earlier several ways were discussed in which color prints could be made from positive transparencies. All of these processes involve couplers. The *dye bleach* process, however, depends on the destruction of dyes to form a colored image. The sensitive layers are arranged as they are in the coupler films and papers (see Fig. 12.19). Yellow (*Y*), magenta (*M*), and cyan (*C*) azo dyes are incorporated in the layers at the time of manufacture. After exposure, the printing material is developed normally (see Fig. 12.19). The print is then subjected to an appropriate bleach that removes the dye in those regions where silver is present but leaves the dyes intact where no silver is present. The silver is removed, and the print is fixed, washed, and stabilized. The process is outlined in Figure 12.19 for a print exposed to yellow light (*Y*), white light (*W*), and no light (*Bl*). Dye bleach material, manufactured under the trade name Cibachrome by Ciba-Geigy, is available on a transparent base for projection and on plastic and resin-coated paper for making reflection prints.

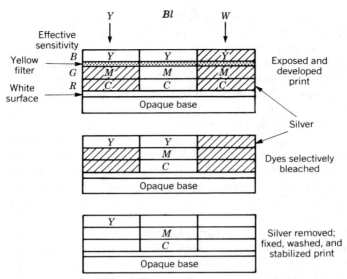

FIGURE 12.19 Printing white and yellow on Cibachrome printing material.

■ STORAGE AND USE OF FILM AND PRINTS

Excessive exposure to radioactivity and fluoroscopy affects undeveloped color film just as it does unexposed black-and-white film. Exposed but undeveloped film is more affected by radioactivity and fluoroscopy than unexposed film, because the latent image is unstable. Except for critical work, the fluoroscopy done at airports probably causes insufficient damage to unexposed film to warrant concern, especially if the film is in metal cartridges. It is good practice, however, to avoid fluoroscopy of exposed but undeveloped film.

The main factors that affect color films and papers are high temperature, high humidity, and light. The effects on the silver halides are the same as in black-and-white film. Unprocessed color materials must not be exposed to light, should not be allowed to get hot, and should not be subjected to high humidity. Ideally, relative humidity should be kept below 50 percent. Films designed for professional use and all papers should be refrigerated. General-purpose films are designed for room temperature storage, and should be stored at room temperature. However, if storage time after purchase is excessive, they should be refrigerated. Films in which the couplers are incorporated at the time of processing probably are less sensitive to high temperature and humidity before processing. Once a sealed package of color material has been opened, high humidity should be avoided. If the material cannot be processed immediately, it should be refrigerated. If it must be refrigerated for any length of time, a drying agent such as silica gel should be used.

Properly processed color material is much less stable than corresponding black-and-white material, because the dyes are much less stable than the silver grains. Light, high humidity, and high temperature cause the images to deteriorate in time.

Prints that are displayed and repeatedly projected transparencies deteriorate with use no matter what is done. If they are irreplaceable, copies should be made for use and the original negatives and transparencies stored archivally. The best storage is in a hermetically sealed metal container containing a desiccant at a temperature of 0° F (−18°C) or less. The processed material should be kept away from light when not on display, high temperature and humidity should be avoided, and it should be stored in a metal box. Metal is preferable to plastic or wood, because some of the materials used in making the latter may emit chemicals that affect the dyes.

Even modest reductions in temperature improve storage life. For instance, one manufacturer,[6] using density loss (fading) as a criteria for lifetime, states that the lifetime increases by a factor of 2 if storage temperature is reduced from 86°F (30°C) to 75°F (24°C). At 55°F (13°C) the factor increases to 8, and at 0°F (−18°C) the factor increases to 680. Relative humidity in refrigerators and freezers is very high, causing water to form on cold surfaces either as moisture or as ice crystals. Hence, material must be properly sealed and moisture-proofed before storage in refrigerated space. The material should be warmed in a dry place when removed from refrigeration.

Processed dye transfer and dye bleach materials generally are more stable than photographic materials that depend on couplers for forming colored dyes.

■ CHOICE OF FILMS

In choosing black-and-white films, the main decision usually is one of balancing film speed against resolution and/or acutance. More choices are available when photographing in color.

Deciding between reversal material and negative material is based mostly on whether a projection image or a reflection print is desired. Reversal material is less expensive, because large images can be projected by hand viewers or projectors, eliminating the need for copies. Negative materials yield prints that are more accessible for viewing. Since negative material can be masked, tone reproduction can be made more accurate in reflection prints, but the brightness range will be greater in properly projected transparency images. The transparency, being an original, can be made to show better detail than the print, because copying always degrades detail. A copy made from a transparency will not be as good as one made from negative material, because a copy made on reversal paper cannot be masked, and an internegative requires an extra copy, thus reducing detail.

If reversal material is chosen, a choice still must be made between films that have the couplers incorporated at the time of manufacture (manufacture incorporated films) and those in which the dyes are incorporated at time of processing (process incorporated films). This was discussed at some length in Example 12.2. In summary, the process incorporated films are probably more stable then the manufacture incorporated films before processing.

[6]*Kodak Color Films*, p. 33.

The slowest process incorporated films render detail better than any of the manufacture incorporated films. The manufacture incorporated films are faster, however, and can be pushed to even higher film speeds. Choice of color balance is a matter of taste and may depend on the particular subject to be photographed. Process incorporated films require commercial processing, but manufacture incorporated films can be user-processed, and this can be an advantage in some circumstances.

Manufacture incorporated films are classified as either general-purpose or professional color films. If manufacture incorporated films are stored at room temperature, color balance changes. General-purpose films are designed to be stored at room temperature. In these films, color balance is adjusted at the time of manufacture. The changes that occur as the film ages on the shelf, on the average, make the color balance correct when it is exposed and processed. Manufacture incorporated professional color film is color balanced for immediate exposure and must be refrigerated so that the color balance change will be minimal. In most instances, color balance is measured and correction filter specifications are supplied for each lot of professional film. If very precise color rendition is required, use a professional film and handle it as prescribed by the manufacturer. In most cases, a general-purpose film provides satisfactory results. If professional film is not handled as prescribed, it will, in many instances, give poorer results than a general-purpose film.

When trying to decide which ASA film speed to use, the general caveat is similar to that for black-and-white film. Determine the optimum exposure times and f-number settings needed in a given situation, and use the slowest film that is compatible with this optimum exposure. This is extremely important in small format photography, because graininess in color images is a problem just as in black-and-white photography.

To keep grain size small and still produce a fast film, Kodak has developed a color film with specially shaped and oriented grains. The silver halide grains in Kodacolor VR 1000 negative film are tabular shaped and are oriented with the thin dimension perpendicular to the plane of the film. In this way, the individual grains can intercept relatively more photons without a commensurate increase in the total amount of silver halide in the grain, which makes them relatively more sensitive to light. When the exposed grain is color developed, less silver halide is converted to silver and the total amount of dye formed at the grain is reduced, yielding a finer-grained image. Because the usual silver halide grains do not have a thin dimension, this technique cannot be used to increase the sensitivity of conventional films. In addition to the change in grain shape, the details of some of the layers of the emulsion are changed, and this increases film speed. Kodacolor VR 1000 film has an ASA film speed of 1000 when processed normally.

Color films now available to the general public in the United States are manufactured by Agfa-Gevaert, Fuji, 3M, and Kodak. Ilford offers no color films but does offer a chromogenic black-and-white film in addition to their regular black-and-white films. Agfa-Gevaert, Ilford, and Kodak offer black-and-white films, and Agfa-Gevaert offers a *chromogenic* black-and-white *film*. The widest selection of films available in the United States is manufactured by Kodak. For an overview of avail-

able films see a current copy of the *Photo Lab Index*[7] or publications by the manufacturers.

■ CHROMOGENIC FILMS

Chromogenic black-and-white films are negative materials that use couplers to make monotone images for black-and-white printing. Sometimes more than one layer of emulsion is used to improve the film speed of these materials, but the layers are panchromatic. A coupler is incorporated in the film at the time of manufacture, the film is processed in the same way that color negative material is processed, and the same processing chemicals can be used. The resulting negative contains colored dyes but no silver; in some emulsions it has a slightly reddish cast.

Agfa-Gevaert markets this type of film as Agfapan Vario-XL, and Ilford markets one designated XP-1 400. These films are designed to be used as variable-speed films. The film speed for XP-1 400 ranges from about 100 to 1600 without altering processing time. However, optimum film speed is about 400. Because development of chromogenic materials converts the couplers near a developing grain to a colored dye, the ''grains'' do not look like the grains of developed silver; rather the ''grains'' have indistinct boundaries and look like soft clouds. As film exposure is increased (film speed reduced), these clouds overlap and sharpness is reduced, but the impression of grain may actually decrease because of the diffuse nature of the boundaries of the grains. This makes it possible to overexpose the film and obtain acceptable prints from the overexposed negative. Underexposure introduces problems similar to those encountered when conventional black-and-white film is underexposed. Reports indicate that altering development does not improve negative quality. These films appear to be very useful items that broaden black-and-white photographic opportunities. Because the image is a developed dye, it probably will deteriorate with time more rapidly than do silver images.

■ INFRARED FILM

Infrared-sensitive film is manufactured both as black-and-white and as color film. The sensitivity of both kinds of commercially available films is extended to about 900 nm by the addition of appropriate infrared sensitizing dyes. The principle is similar to that used in extending the sensitivity of orthochromatic or panchromatic film. Specialized thermal recording devices are available that are sensitive to 10000 nm wavelength radiation. The longest wavelength that can be recorded photographically is about 1350 nm. General-purpose infrared films are limited to a sensitivity shorter than 900 nm to simplify the handling of the film. Because these films are sensitive to visible and ultraviolet radiation, an appropriate filter must be used to separate the infrared information from the visible information in the scene.

Infrared color film manufactured by Eastman Kodak (Kodak Ektachrome Infrared

[7]*Photo Lab Index M&M, Lifetime Edition,* Dobbs Ferry, N.Y.: Morgan and Morgan, Inc.

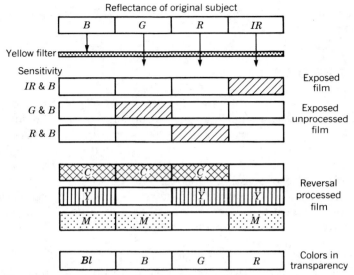

FIGURE 12.20 Color formation with infrared color film.

film) is a chromogenic film sometimes called a *false-color film*. This tripack reversal film is always used with a yellow filter and designed so that blue, green, red, and infrared in the scene appear respectively as black, blue, green, and red in the developed transparency (see Fig. 12.20). The top layer of the film is sensitive to blue and infrared, the center layer to green and blue, and the bottom layer to red and blue. With the yellow filter in place, the top layer records infrared, the center layer records green, and the bottom layer records red information. The material is processed like other color reversal film (see Table 12.1). Where color development takes place, however, the top layer of the film is colored cyan, the middle layer yellow, and the bottom layer magenta. The entire process is shown schematically in Figure 12.20. Using arguments similar to those used for color reversal film (see Plate VI), the reader can be convinced that the colors produced in the transparency are as shown in Figure 12.20, if the film is exposed to a scene like that at the top of the figure.

With the increase in fuel costs and increasing awareness of heat loss from buildings, it is tempting to try to use the commercial infrared films to measure heat loss from houses. These films are not suitable for such a purpose, because their sensitivity is restricted to wavelengths shorter than 900 nm. Special infrared detecting devices must be used for such purposes. A film that is insensitive to the heat of our hand is incapable of recording "hot" spots in a building when outside temperatures are near 0° C. Those "hot" spots are only hot relative to nearby, better-insulated surfaces. For a more complete discussion see a publication such as Eastman Kodak's publication M-28.[8]

[8]*Applied Infrared Photography*, Rochester, N.Y.: Eastman Kodak Company, 1980.

■ INSTANT COLOR

The first *instant color film* was developed by Edwin H. Land and marketed by Polaroid under the name Polacolor. The system utilized a diffusion transfer process (see Chapter 7) and could be used in cameras designed to use other Polaroid films. A cross section of the film is shown in Figure 12.21. This film does not use couplers but has the dyes in the film at the time of manufacture. Exposure is from the top, and the dyes are arranged so that the dyes above a particular recording layer transmit the light to be recorded in that layer. After exposure of the film, a reagent is spread over the top of the film, and the film is brought in contact with an image receiving surface. The reagent activates the color developers which develop the exposed AgX in the adjacent recording layers. The spent developers and the associated dyes are immobilized in the recording layers. In unexposed regions of the recording layers, the developers and their dyes migrate to the receiving layer where a mordant immobilizes the dyes. An alkali layer on the receiving surface neutralizes the acidity in the receiving layer, so the print will not oxidize on exposure to air when separated from the negative. The resultant dye image is a positive color print. Kodak's Ektaflex process, which is used to make color enlargements, appears to have some similarities to the Polacolor process. Such processes are examples of *dye-release* processes, as are the next two systems.

Polacolor is still available and is used extensively in commercial work for such purposes as making identification cards, but it has been largely replaced in the consumer market by a process that uses Polaroid SX-70 film. This film pack contains at least 14 layers, and at first glance seems impossible to understand. The film pack is a clever combination of a recording film and printing surface in a single package that does not have to be separated for viewing. The layers of the pack are tabulated in Figure 12.22. Note that the layers grouped under *F* look like those of Figure 12.21. They are very similar and form the recording layer or negative. The layers designated *D* contain the processing material. The layers labeled *P* also contain some processing material but after processing they become the print.

Base	Print
Recieving layer	

Blue recording AgX	
Yellow dye linked to developer	
Spacer	
Green recording AgX	
Magenta dye linked to developer	Film
Spacer	
Red recording AgX	
Cyan dye linked to developer	
Base	

FIGURE 12.21 Cross section of Polacolor film.

Clear polyester plastic	
Polymeric acid	
Timing layer	} P
Image recieving layer	
Processing fluid	
Antiabrasion layer	} D
Blue recording AgX	
Yellow dye developer	
Spacer	
Green recording AgX	
Magenta dye developer	} F
Spacer	
Red recording AgX	
Cyan dye developer	
Opaque polyester base	

FIGURE 12.22 Cross section of Polaroid SX-70 film pack.

During the exposure of the film, the processing fluid is not in place but is stored in a pod. The layers in *P* and *D* are transparent during exposure, and exposure is like that in Polacolor. After exposure, the film pack is ejected and at the same time the processing fluid is smeared between the image receiving layer and the antiabrasion layer. The processing fluid contains potassium hydroxide (KOH), titanium dioxide, and some opaque dyes. The opaque dyes protect the film from exposure during the development process. The KOH acts to solubilize the dye developers and a developing agent, methyl phenyl hydroquinone (MPH).

The solubilized MPH is very active and mobile and migrates through the layers toward the base. It develops the exposed silver halides and migrates to the dye developers adjacent to the developed silver halides. This dye developer is oxidized and immobilized in the process. The oxidized MPH is reduced back to its original form and is used again in the next layer. The unoxidized solubilized dye developers migrate to the receiving layer to form the color image. The potassium and hydroxide ions of the KOH also migrate into the receiving layer. The polymeric acid, which was delayed in its migration toward the receiving layer by the timing layer, neutralizes the hydroxide ions and binds the potassium ions. The opaque dyes lose their opacity, and the image forming dyes become immobilized in the presence of the acid. The image is viewed from the front against the white titanium dioxide background in the processing fluid.

Because the left to right reversal that occurs in a conventional camera cannot be reversed in an in-camera transfer or copying process, a mirror has to be included in the camera to achieve left to right image reversal when the picture is taken. The inventor, Edwin H. Land, has described this process and the early camera in more detail for those who are interested.[9]

[9]E. H. Land, "Absolute One Step Photography," *Photographic Journal, 114,* 1974, 338ff.

The process is quite popular and very intriguing, because the image appears in daylight just as an image appears on printing paper under a safelight in a darkroom. The need for instant results is satisfied. However, image quality is not as good as Polacolor and even less satisfactory than conventional color photography. Moreover, the process is more expensive than conventional color photography of a similar-sized format, a special camera is required, and multiple copies cannot be made conveniently from the original. Long-term image stability is not as good as conventional color images.

Kodak Instant Color film, introduced in 1976 as a competitor to the Polaroid SX-70 film, uses a different process to produce an instant color print. The structure of the film pack is shown in Figure 12.23. *P, F,* and *D* have again been used to designate the print part of the pack, the film part of the pack, and the processing part of the pack. In this system, the film is exposed from the bottom and the print appears at the top. The structure of the film part (*F*) is analogous to Polaroid SX-70 film. Because exposure for the Kodak material is from the bottom and from the top for Polaroid material, the order of the layers is reversed in the diagram. The dyes are immobilized in the dye-releaser layers that correspond to the dye-developer layers in the Polaroid material. The spacers of the Polaroid product are, in the Kodak product, occupied by material that scavenges the oxidized developer. Exposure is achieved in a manner similar to that in Polaroid SX-70 films. The layers in front of the recording layers are transparent to the colors recorded in a given layer. An ultraviolet absorbing layer helps to keep the system stable on exposure to ultraviolet light.

When the film is expelled from the camera, the processing fluid is spread between the UV absorbing layer and the timing layer. The developer is contained in the processing fluid and, after being oxidized as it reduces the exposed AgX,

Transparent plastic support	
Image receiving layer	
White reflecting layer	*P*
Black opaque layer	
Cyan dye releaser	
Red recording AgX	
Oxidized developer scavenger layer	
Magenta dye releaser	
Green recording AgX	*F*
Oxidized developer scavenger layer	
Yellow dye releaser	
Blue recording AgX	
Ultraviolet absorbing layer	
Processing fluid	
Timing layer	
Acid layer	*D*
Estar support	

FIGURE 12.23 Cross section of Kodak Instant Color film.

migrates to the dye-releaser layer where it releases the dye. The released dye migrates to the receiving layer where it is immobilized by a mordant. The amount of dye released in a given layer is proportional to the amount of development that takes place in the associated recording layer. If the recording layers were normal emulsions, the dye density would increase with increasing exposure, and the resulting image would be a negative.

Special emulsions are used that develop to a direct positive. For example, a solarized emulsion would do this, because density is decreased with increasing exposure in such a situation. Conventional solarization occurs only with high exposure, however, and such an emulsion would be too slow. A direct positive such as this is sometimes called an *autopositive* and should be differentiated from a reversal positive for which a bleach step must be introduced. The scavenger layers prevent migration of oxidized developer to more than one dye-releaser layer. The acid in the acid layer, after an appropriate delay by the timing layer, neutralizes the alkali environment in which development takes place. The stabilized dyes are viewed against the white reflecting layer from the top. The black opaque layer serves as a light shield for the film on one surface, and the processing fluid serves the same purpose at the other surface. Because the film is exposed from one side and viewed from the other, it is not necessary to put a mirror in the camera to reverse the image. The same limitations mentioned in our discussion of Polaroid SX-70 film apply to this process.

Polaroid has announced an instant color process called Polachrome for 35 mm photography. This is an additive color process based on their Polavision additive color screen technology. The process is expected to be most beneficial to photojournalists, who can sacrifice quality for instant availability of an image for newspaper or television.

EXERCISES

12.1. Show schematically how a color reversal film is constructed. Designate the effective sensitivity of each layer and the color of the dyes in each layer after color development has occurred.

12.2. What is the role of the colloidal silver layer found in color film? Why is this layer omitted in color printing paper?

12.3. Compare graphically the spectral sensitivity of the eye and Kodak 64 Professional film.

12.4. What is a coupler? How are couplers incorporated in the various kinds of film and paper on the market today?

12.5. If Kodachrome 64 film had been used in the photographic situation described in Example 12.1, what would the density ranges have been for the best exposure, for a one stop overexposure, and for a one stop underexposure?

12.6. What are the differences between professional and general-purpose films?

12.7. How does the processing of Kodachrome differ from that of Ektachrome?

12.8. What is masking? Why is it desirable in color negative materials? Why is it not used in color reversal transparencies?

12.9. How do color reversal and color negative development differ?

12.10. Why are color films balanced for different color temperatures needed?

12.11. Compare the film sensitivity of a daylight and a type B color film.

12.12. Discuss the long-term stability of the various color films and printing papers.

12.13. What is a chromogenic black-and-white film?

12.14. Why is infrared color film called a false color film?

12.15. How is a developing instant color film protected from light?

chapter
· 13 ·

Filters in photography

Filters are used in many ways in photography. The concern here will be primarily in their application to general black-and-white and color photography. Their application to scientific photography will not be discussed, although enough background material will be presented so that the interested individual can acquire, by further reading, any needed information. A more comprehensive treatment of filters is found in the *Handbook of Optics*,[1] and filter data are included in the guide by Morgan and Morgan.[2] Manufacturers of filters also supply brochures and booklets describing their products.[3]

■ KINDS OF FILTERS

In general, filters can be made utilizing any of the methods by which objects can be colored, as was discussed in Chapter 11. Absorbing filters are made of glass, solid inorganic materials, organic dyes, gases, or liquids in cells, and thin semitransparent metallic films. Filters utilizing the principle of interference are used in photography. Nonreflective coatings based on this principle improve the transmission characteristics of lenses (see Chapter 4). Dichroic filters in color enlargers frequently are interference filters. Light can be filtered by reflection, using the absorbing characteristics of metals (see Chapter 11). Gold, for example, absorbs light at short wavelengths causing reflected light to be yellow.

If filtering means separating part of a spectrum from a continuum for use by itself, then a prism or a diffraction grating can be considered a filter, because the spectrum is spread out in space, and a portion of it may be used for some special purpose (see Chapter 4). Scattering can be used to filter light just as the atmo-

[1]W. G. Driscoll (Ed.), Handbook of Optics, New York: McGraw Hill, 1978, pp. 8-1ff.

[2]Ernest M. Pittaro (Ed.), *Photo Lab Index*, Hastings-on-Hudson, N.Y.: Morgan and Morgan, Section 9.

[3]*Kodak Filters for Scientific and Technical Uses*, Rochester, N.Y.: Eastman Kodak Co., 1978. *Tiffen Photar Filter Glass Catalog*, Hauppauge, N.Y., Tiffen Manufacturing Corporation, 1978.

sphere scatters blue light selectively from the sun (see Chapter 11). *Polarizing filters* are constructed so that unpolarized or partially polarized light (see Chapter 4), on transmission through the filter, becomes plane polarized. In this instance, the filter discrimination is based on the oscillation orientation of the wave rather than the wavelength.

■ FILTERS IN GENERAL PHOTOGRAPHY

Absorbing glass and organic dye filters and polarizing filters are the primary ones used in general photography. The most diverse family of filters is *gelatin filters* (gels), made by dispersing organic dyes in gelatin and coating the dyed gelatin on glass. The gelatin is then stripped from the glass and cut to appropriate sizes. The gels can be used in a filter holder, or they may be permanently mounted between pieces of glass. Optically, the unmounted gels are quite good, although they reflect considerable light at the surfaces and curl quite easily. If the gel is mounted between multicoated optical glass flats, it probably will perform better than an unmounted gel, and it is more durable. The main advantages of such filters are the precision with which their color and thickness can be controlled during manufacture. Their main disadvantages are their fragile nature and the loss of light due to surface reflections. The principal supplier of gels in this country is the Eastman Kodak Company.

A more durable filter can be made by bonding two pieces of glass together using a dyed bonding material. Tiffen uses such a process in which the index of refraction of the bonding material matches that of the glass. Hence, light loss at the interior glass interface is minimized. The filters normally are not antireflection coated, and some light loss occurs at the air-glass interfaces. Coated filters of this kind are available from Tiffen by special order. It is claimed that the color uniformity of such filters is comparable with that of gels. However, less choice is available in these filters than in gelatin filters.

The most widely used camera filters are made of colored glass. Usually, the filters are coated with antireflection coatings to reduce surface reflections, and the better ones are multicoated. The main advantages of such filters are their decreased surface reflection and increased durability. Their color characteristics probably are not quite as uniform as those of gels, and the selection of colors is not as great. Currently Vivitar and Hoya supply most of these filters in the United States.

Where optical quality is not so critical, acetate filters, less expensive than gels, can be used. These are used primarily over light sources in enlargers for black-and-white and color printing. Safelight filters are made by coating a properly dyed organic material on glass and overcoating it with a protective plastic.

When unpolarized light is incident on a *dichroic crystal* of a particular orientation (see Fig. 13.1), light with one plane of polarization (see Chapter 4) is absorbed, whereas that polarized in a perpendicular plane is transmitted undiminished. Polarizing filters, widely used in color photography, are made by dispersing organic microcrystals of a dichroic material (quinone iodosulfate) in a plastic material. The microcrystals are oriented with their optical axes parallel, and the plastic material

FIGURE 13.1 The polarization of light by a dichroic material.

is cemented between two pieces of glass. The surfaces of the glass may be coated to reduce light loss at the air-glass interfaces.

Glass filters should be handled and treated like lenses. Avoid touching the optical surfaces; a brush or a clean airstream can remove large dust particles. To clean them, use lens cleaner or breathe on them to moisten the surfaces, and wipe them carefully with lens tissue or a soft cotton or linen cloth. Gels are much more fragile than glass filters and must be handled only on the edges or on the optical surfaces protected by tissue. They must be kept dry, never allowed to become warmer than 50°C, and stored flat in their original containers or in a book. Gels mounted in glass are slightly less fragile but are subject to the same temperature and humidity limitations, because they are not sealed units. Acetate is somewhat less fragile than gelatin but still must be handled with care.

When a filter is used on a camera, the total amount of light reaching the film is reduced so that exposure time and/or aperture must be increased to compensate for the diminished illuminance. The light reduction of a filter may be described in terms of a *filter factor* indicating the factor by which the light is reduced. Filter factors are stated assuming that panchromatic film is being used. For example, a filter factor of 2 implies that exposure should be increased a factor of 2, which can be achieved by opening up one stop or increasing the exposure time by a factor of 2. It is now common to state exposure corrections in terms of exposure increase in stops. If an exposure reading is taken using a built-in exposure meter that monitors the light through the lens, then correction in exposure may not be necessary if the filter is in place during the exposure reading. Exceptions to this occur with certain cameras when an ordinary polarizing filter is used and also occurs if the spectral response of the meter is not sufficiently uniform. In unusual photographic

FIGURE 13.2 Light reduction by two filters used together.

situations, a hand held light meter may be used to determine the exposure correc-
tions by taking a light reading through the filter.

If more than one filter is used, the filter factor is the product of the filter factors
for the filters used separately, and the exposure increase in stops is the sum of the
increase for the filters used separately. For instance, if two filters with factors 2 and
4 are used together, the light is reduced to one-eighth of its original value (see Fig.
13.2). The first filter reduces the light to one-half its original value, and the second
reduces the remaining light to one-fourth its value. Hence, the total reduction is ½
× ¼ = ⅛. The increase in exposure is one stop for the first filter and two stops for
the second, for a total of three stops.

Several different numbering systems exist for identifying filters. The most com-
mon one in the United States today is that first used by Kodak to designate their
gelatin filters. This system of identification is used also by Tiffen, Vivitar, and Hoya.
Harrison and Harrison uses a different designation system as does the B and W Filter
Company but both, where applicable, designate equivalent filter numbers using
the more common numbering system.

It is generous to call this common numbering scheme a "system," because it is
not very systematic. Some confusion has been eliminated by renumbering some of
the older filters. For instance, a yellow filter commonly used in black-and-white
photography to darken a blue sky was designated a K2 filter. This filter is now
designated a No. 8 filter. The old and new designations for these more common
filters are listed in Table 13.1. The change in designation groups the filters better
numerically with others of similar color. The old designation still appears in the
literature, however.

■ CORRECTION FILTERS

Most panchromatic black-and-white films are highly sensitive to ultraviolet and blue
radiation, and *correction filters* that are shades of yellow are used to correct for
this oversensitivity. The problem can be particularly burdensome in scenic photog-
raphy on a clear day, when the light of the sun and the illumination from the sky
are rich in blue and ultraviolet light. The blue sky itself, in such a situation, tends to

TABLE 13.1 Old and Current Designations for Some Older Filters

Old Designation	Current Designation	Color
K1	No. 6	Light yellow
K2	No. 8	Yellow
K3	No. 9	Deep yellow
X1	No. 11	Yellow-green
X2	No. 13	Dark yellow-green
G	No. 15	Yellow-orange
A	No. 25	Red
F	No. 29	Deep red
C5	No. 47	Blue
C4	No. 49	Dark blue
B	No. 58	Green
N	No. 61	Deep green

be washed out, and it is difficult to get adequate contrast between the blue sky and the white clouds.

▶ **Example 13.1.**

I am photographing an outdoor scene using a panchromatic black-and-white film with an ASA film speed of 125 on a bright sunny day. The sky is very blue with abundant cumulus clouds. What filter should be used, and what is the correct exposure using such a filter if the sky is to be darkened relative to the clouds?

FIGURE 13.3 Diffuse density and transmittance of Nos. 8, 15, and 25 filters as a function of wavelength.

A filter that absorbs in the blue must be used. The common filters used for this purpose are a No. 8 (K2), a No. 15 (G), and a No. 25 (A). The transmission characteristics of these filters are shown in Figure 13.3. The No. 8 is yellow, the No. 15 is deep yellow or orange, and the No. 25 is red. The latter would be used only if we want to dramatize the sky. Normally, the No. 8, which transmits no light of wavelengths shorter than 480 nm (see Fig. 13.3), is quite satisfactory, although occasionally we might resort to the use of a No. 15 filter. The filter factor is 2 for a No. 8 filter. Because the day is sunny and bright, normal exposure (using the rule of thumb of Chapter 2) could be f/16 at 1/125 sec. Use of the filter requires changing the exposure settings to f/11 at 1/125 sec or f/16 at 1/60 sec.

A filter used to generate a dramtic effect is sometimes called an *overcorrection filter*. Such an effect would occur in the above example if the No. 25 filter had been used. It is red in color, and both the blues and greens are suppressed, because no light of wavelength shorter than 580 nm is transmitted by the filter (see Fig. 13.3). Plate V shows that many of the yellows are eliminated also. The filter factor for this filter is 8, necessitating an increase in exposure setting of 3 stops. Figures 13.4, 13.5, and 13.6 show the effects of photographing a scene such as that described in Example 13.1 using no filter, a No. 8 filter, and a No. 25 filter. Note the increase in contrast between the sky and clouds as the filters progressively reduce the amount of relatively short wavelength illumination reaching the film.

In the discussion of infrared films in Chapter 12, it was stated that infrared films require filtration if they are to be used effectively. The more common infrared films, whose spectral sensitivity covers the visible part of the spectrum and extends into the infrared to about 875 nm, must be filtered to reduce the exposure in the visible part of the spectrum and hence, emphasize the infrared light reflected from the scene. If a black-and-white infrared film is used and some visible information is to be recorded on the film, a No. 15 filter (see Fig. 13.3) that records green, red, and infrared but not blue, might be used. If less visible information is to be recorded, a No. 25 filter could be used, because this filter effectively cuts out blue and most of the green light. Special infrared filters remove all or almost all of the visible light from the light path.

For example, a No. 89B filter transmits about 10 percent of the incident light at 700 nm and transmits nearly 90 percent of incident light at 800 nm. These filters are difficult to use with a SLR camera, because most photographers cannot see through them. Hence, they must be put in place after the camera is focused on the scene. Information supplied with the film should be followed to determine proper exposure and exposure correction for the filters.

Because the focal length of a lens is longer for infrared light than for visible light, a focusing correction may be necessary. Many lenses currently on the market have a red line on the depth of field calculator, frequently marked with an *R* (see Fig.

FIGURE 13.4 Scene photographed using a panchromatic film. (ENM, 1983)'

FIGURE 13.5 Scene of Figure 13.4 photographed using panchromatic film and a No. 8 filter. (ENM, 1983)

FIGURE 13.6 Scene of Figure 13.4 photographed using a No. 25 filter. (ENM, 1983)

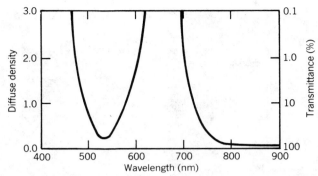

FIGURE 13.7 Diffuse density and transmittance as a function of wavelength for a No. 58 filter.

5.19); this indicates where the lens should be set for proper focus of an infrared image. The image is focused visually and the distance read at the focusing mark is then set opposite the red line. For a more complete discussion of infrared photography, see the publication listed below.[4]

■ CONTRAST FILTERS

When photographing colored objects using black-and-white panchromatic film, it is sometimes difficult to distinguish between objects of different color but the same reflectance. Red lettering on green card, for example, might be very difficult to distinguish if photographed using panchromatic film, especially if the red and green dyes have similar reflectances. If a No. 58 filter, which transmits limited amounts of blue and red light (see Fig. 13.7), is used in taking the picture, however, the final print shows dark letters on a light background. The red light reflected from the letters is filtered out, but the green light reflected from the card is transmitted by the filter. If a No. 25 filter is used, the contrast is reversed as can be seen in Figure 13.8. When filters are used in this way, they are called *contrast filters*. If the reflectances of the surfaces are sufficiently different, it is not necesary to resort to filtering to get sufficient contrast in the print.

■ HAZE CUTTING FILTERS

When photographing landscapes (especially if part of the landscape is far from the camera), haze is often encountered, which diminishes the sharpenss of the image. The haze is caused by the same phenomenon that causes the sky to be blue (see

[4]*Applied Infrared Photography*, Rochester, N.Y.: Eastman Kodak Company, 1980.

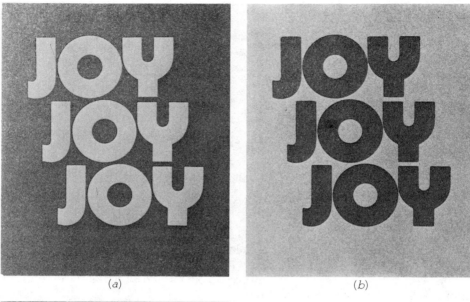

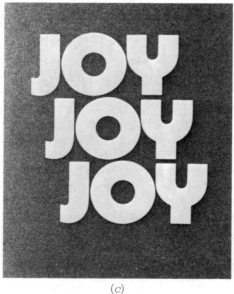

FIGURE 13.8 Use of contrast filters to increase contrast of red lettering on a green card: (*a*) no filter, (*b*) green filter (58), (*c*) red filter (25). (ENM, 1983)

Chapter 12). Light from the sun is scattered by molecules in the air. Because scattering varies inversely with wavelength, short wavelengths (blue and ultraviolet) are scattered much more than long wavelengths such as red (see Fig. 13.9). *Haze-cutting filters* such as a No. 2A modify the total rendition of scene minimally and reduce haze effects by absorbing all of the ultraviolet and some of the visible blue light (see Fig. 13.10). The tonal balance of the scene is altered somewhat, because

FIGURE 13.9 The scattering of short wavelength radiation by the atmosphere causing haze.

some of the blue light from the scene is absorbed. If more suppression of the blue colors in the scene can be tolerated, a No. 8 or a No. 15 filter might be used to reduce haze effects further. A No. 25 filter might be used in situations where the haze problem is severe, but such a drastic measure alters the tonal balance of the scene a great deal. Blue, green, and much yellow are absorbed by this filter.

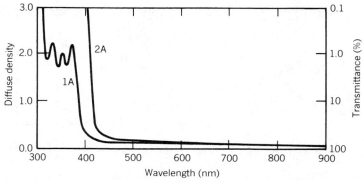

FIGURE 13.10 Diffuse density and transmittance as a function of wavelength for a No. 1A and a No. 2A filter.

Sometimes filters that are transparent in the visible part of the spectrum, called *haze-UV filters*, are recommended as haze filters and/or ultraviolet light absorbers. In most instances, the optical glasses in the lens of the camera absorb as much blue and/or UV light as this filter, so the filter offers little added benefit for such purposes. These filters are often sold as protective elements for the front surface of a lens. This may be useful when photographing under such adverse conditions as blowing sand or salt spray. However, two more optical surfaces are placed between the subject and image, which cause some reduction in the quality of the image. In general, a lens cap is a much better choice for protecting the front element of a lens. Occasionally, a No. 1A filter (skylight filter) is recommended for this purpose. This is not always desirable, however, because the filter is distinctly pink and discriminates against the blue part of the spectrum (see Fig. 13.10). The filter is beneficial in certain kinds of outdoor color photography.

■ NEUTRAL DENSITY FILTERS

In some photographic situations, it is necessary to reduce the illuminance of the film without altering the spectral character of the light. Neutral density filters in the form of gels, bonded filters, or glass are designed for such applications. The gelatin filters are made by dispersing colloidal graphite in the gelatin and are designed to be used in the visible part of the spectrum. They absorb considerable radiation in ultraviolet and transmit more in the infrared than in the visible part of the spectrum. They are not uniformly absorbing in the visible (see Fig. 13.11) but typically absorb about twice as much at 400 nm as they do at 500 nm. The bonded filters, which have the absorbing dye in the bonding agent, have more uniform absorption characteristics in the visible part of the spectrum (see Fig. 13.11).

Neutral density filters are used to reduce exposure when the subject being photographed is too bright even when the lens is totally stopped down. This often occurs when a bright light source is being photographed. If the source is too bright

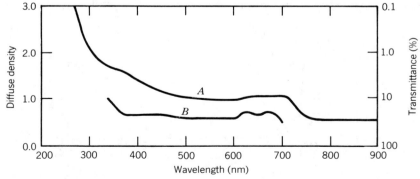

Figure 13.11 Diffuse density and transmittance as a function of wavelength for a neutral density gelatin filter (*A*) of density 1 and a bonded filter (*B*) of density 0.6.

for the film, it probably is also too bright for viewing with the unprotected eye, and a filter is needed for viewing the subject. In some photographic situations, it is desirable to reduce depth of field by using a large aperture. In such a situation, it may be necessary to reduce the overall illumination using a neutral density filter. Sometimes it is desirable to use a longer exposure to record the motion of a moving object by blurring the image. In this case it may be necessary to use a neutral density filter to reduce the overall exposure. Finally, mirror lenses (usually long focus lenses) are designed so that an aperture stop cannot be used to adjust the aperture, and neutral density filters must be used to change the brightness of the image.

■ POLARIZING FILTERS

In Chapter 11 the scattering of light by the atmosphere was discussed, in which the scattered light becomes partially polarized. That light scattered in the plane at right angles to the direction of illumination (see Fig. 13.12) is polarized most, and that which is scattered along the direction of illumination is polarized least. Because the sun is the source of illumination of the atmosphere, the scattered light from the sky is polarized most in those directions perpendicular to the line between the scatterer and the sun. For instance, when the sun is in the east, light scattered from the north or south sky is polarized the most. The light scattered from the west is polarized the least. In a similar fashion, if the sun is overhead, haze effects caused by the scattering of light by atmospheric molecules near ground level are considerably polarized (see Fig. 13.13).

Light is partially polarized also when it is reflected from an insulating surface. The amount of polarization depends on the index of refraction of the insulating material (see Chapter 4) and the angle of incidence of the light. The plane of minimum

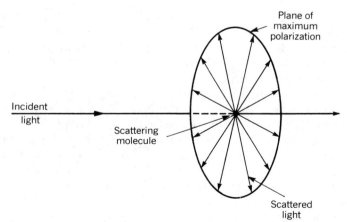

FIGURE 13.12 Scattering of light by molecules showing the plane of maximum polarization.

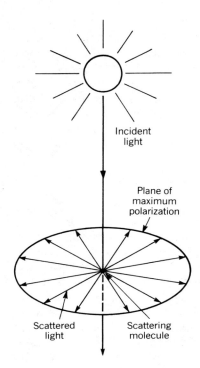

Incident light

Plane of maximum polarization

Scattered light

Scattering molecule

FIGURE 13.13 Scattering of light by atmospheric molecules causing polarized haze.

intensity of the polarized light is perpendicular to the reflecting surface, and the plane of maximum intensity is perpendicular to that plane (see Fig. 13.14). All of the reflected light is plane polarized if the angle of incidence (i) is such that

$$\tan i = n_2/n_1 \tag{13.1}$$

where n_2 is the index of refraction of the insulating material, and n_1 is the index of refraction of the adjacent medium. This angle is called the *polarizing angle* or *Brewster angle*, and Equation 13.1 is called *Brewster's law*. If the angle of incidence is zero, the reflected light is unpolarized. Both transparent and opaque insulating materials cause polarization of reflected light. The effect with good conductors, such as metals, however, is minimal.

Problems in photography caused by the scattering of light by the atmosphere have already been noted. The reflection of light from surfaces gives rise to glare, which frequently is unwanted. If the scattered or reflected light is partially or totally polarized, a polarizing filter can be used to reduce the effects of this unwanted light. A *polascreen* or polarizing filter absorbs most of the light polarized perpendicular to its axis of polarization (see Fig. 13.15). The filter typically absorbs about 40 percent of the light polarized parallel to the polarization axis of the filter. If all the unwanted light was absorbed, the overall density of the filter would be too great for most applications. Only light polarized perpendicular and parallel to the axis of polarization has been mentioned, because light with any other orientation of polarization can be resolved into the above components (see Chapter 4).

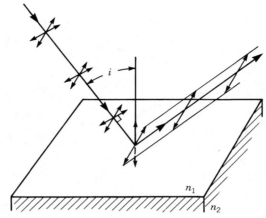

FIGURE 13.14 The polarization of unpolarized light by reflection from an insulating surface.

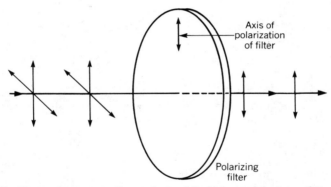

FIGURE 13.15 The polarization of unpolarized light by a polarizing filter.

If the light from part of a scene is partially polarized, the polarizer can be set to discriminate against the polarized light. That part of the scene which is the source of this light will be relatively darker. For example, when photographing a north landscape illuminated from the east by the sun on a clear day with some cumulus clouds, a polarizer can be used to darken the sky and thus increase the contrast between sky and clouds (see Fig. 13.16). This is possible because the light from the blue sky is partially polarized and that from the clouds is not. The color balance of the rest of the scene will be virtually unaltered. The brightness of the clouds will be reduced also but relatively less than the brightness of the sky.

▶ **Example 13.2**
Suppose you are trying to photograph some fruit on a glass-topped table and are getting unwanted reflections from the tabletop caused by light from a win-

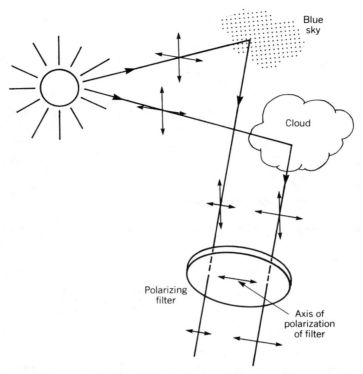

FIGURE 13.16 Using a polarizing filter to darken blue sky relative to white clouds.

dow opposite the camera (see Fig. 13.17). How would you use a polarizing filter to reduce the unwanted reflections?

The glare from the table top can be eliminated almost completely if the camera is first set at the polarizing angle (*r* in Fig. 13.17) measured from the normal to the table top. Then, set the polarizer so that its axis of polarization is vertical to the table top. Only the light from the window incident at the polarizing angle is reflected into the camera, and this light is plane polarized as shown in Fig. 13.14. Setting the polarizer perpendicular to the plane of polarization eliminates the glare. The index of refraction of glass is typically 1.5 and that of air about 1.0. Hence, from Equation 13.1, tan *i* = 1.5/1 and *i* is about 56°. The angle would be easier to measure from the table top and is 90° − 56° = 34°. If all the light illuminating the scene is unpolarized, the exposure setting will have to be increased about two stops, because virtually all of the perpendicularly polarized light is absorbed by the polarizer, and about half of the horizontally polarized light is absorbed. Meter the light through the polarizer when in doubt.

Sometimes it is not possible to remove all the glare from the scene, especially if the surfaces are not flat. In studio situations, where lighting can be controlled, glare

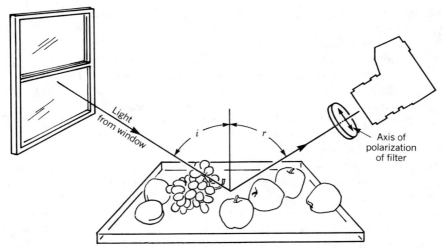

FIGURE 13.17 Using a polarizing filter to minimize reflections from a glass tabletop.

can be reduced further by using polarizing filters over both the studio lights and the camera lens. The filters for the studio lights need not be of the same optical quality as the camera filter and are available as coated plastic or glass sheets.

Occasionally it is suggested that polarizing filters be used in pairs as *variable neutral density filters*. The first filter passes light of one plane of polarization, and the second can be set to reduce this transmitted light further. If the incident light is unpolarized, the minimum reduction in intensity is about two stops (density of about 0.6), and the maximum reduction is about five stops (density of about 1.5). A light meter must be used to determine proper exposure settings. Such a filter combination must be used with great caution, especially when the filters are oriented with their axes of polarization mutually perpendicular. In such a situation, the transmitted light is distinctly blue, and the combination is not a true neutral density filter. Although a typical polarizing filter transmits a little more light in the blue (33 percent) than in the red (28 percent), this small difference does not explain the above phenomenon, because the filters, when oriented with their polarizing axes parallel, do not appear blue.

In most SLR cameras a front metallized mirror, frequently made of aluminum, is used to reflect the image into the pentaprism. This light has its polarization altered slightly on reflection, but the effect is so small that it can be ignored. If a polarizer is placed in front of the camera and unpolarized light is observed through the pentaprism, no detectable visual difference can be observed as the polarizer is rotated about the optical axis. An in-camera light meter in which photocells monitor light reflected from the mirror shows no variation in reading as the polarizer is rotated. This is the usual situation, because the photocells are typically placed under the

pentaprism. A good source of unpolarized light for such a test is the light reflected perpendicularly from a flat, painted matte surface illuminated by a diffuse light source. Using the polarizer, the surface can be examined visually to verify that light reflected from it is unpolarized.

With the advent of metering at the film plane during exposure in automatic cameras, matters have become more complicated. To make a meter reading prior to taking the picture, either two sets of photocells must be incorporated in the camera, or part of the light must pass through the mirror to reach the photocells located in the body of the camera (see Fig. 13.18). In some cameras, a semicontinuous, partially metallized area of the mirror reflects most of the light into the pentaprism and transmits about 10 percent of the light to the photocell. The rest of the mirror is totally reflecting. In other cameras, the silver mirror has many small transparent areas that transmit about 10 percent of the light to the photocell. The rest of the mirror is totally reflecting. In either type of camera, light reflected from the unsilvered or semisilvered areas is partially polarized. Hence, the transmitted light is also partially polarized.

If a polarizing filter is used on a camera with a partially metallized mirror and the incident light is unpolarized, some variation in meter reading can be seen as the orientation of the polarizer is changed. If the same experiment is performed using

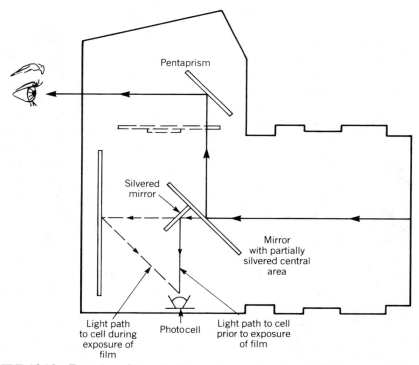

FIGURE 13.18 Exposure determination using an in-camera light meter designed to read exposure off the film plane.

a camera with transparent areas in the mirror, no change is observed. In addition, some change in the brightness of the reflected image is seen in the first case and none in the latter. The change in the meter reading is at least a half stop, and the brightness change appears to be about the same. It is not too difficult to explain why the meter readings should change in one case and not in the other. The visual effects are much more difficult to explain, however.

An in-camera meter that exhibits this asymmetry in meter reading must be used with care when monitoring light from polarized light sources such as the blue sky and light reflected from insulators. If an ordinary polarizing filter is used on a camera whose meter exhibits this asymmetry, the problem will be compounded when meter readings are made prior to exposure of the film. Circular polarization[5] is not discussed here, but circular polarizers can be used to achieve the same results obtained with ordinary polarizers and they can help reduce the asymmetry problem but not eliminate it completely.

An in-camera meter that monitors the light at the film plane should be tested as outlined above to determine whether the meter readings depend on the polarization of the light. If a polarizing filter is not available, a test can be performed by measuring the polarized light reflected from a smooth insulating surface. The meter reading should not depend on the orientation of the camera about the axis of the lens if the meter reading is independent of the polarization of the light.

Some spot meters exhibit the same asymmetry because they use partially metallized mirrors to split the beam much as is done in some SLR cameras. The same precautions apply to the use of these meters as apply to the above mentioned SLR cameras. For a more complete discussion of polarization, see Morgan.[6]

■ EFFECT FILTERS

The many kinds of filters designed to modify the normal image and produce bizarre images at the film plane can be classified as *effect filters*. Strictly speaking, some of these filters are lenses. The effect filters include those that produce stars, multiple images, multicolored images, fog effects, split field images, altered central spot images, and many other effects. Some of these filters will be discussed so that the underlying principles of their design can be understood.

A group of these effect filters modify part of an image and leave the rest unaltered. These include the filters that cause part of the scene to be soft focused, of different size, or of different color compared with the rest of the image. All of these filters are nonuniform in some way. For instance, a filter that causes half of a scene to be diffused and the other half sharp, has half of its optical surface diffusing and the other half clear. At first, this would seem logical. However, in Chapter 4 it was noted that the entire lens is used to form an image of all of the scene. If this is true, it would seem that the filter just described would partially diffuse the entire scene

[5]J. Morgan, *Introduction to Geometrical and Physical Optics*, New York: McGraw-Hill, 1953, p. 353ff.

[6]Morgan, p. 331ff.

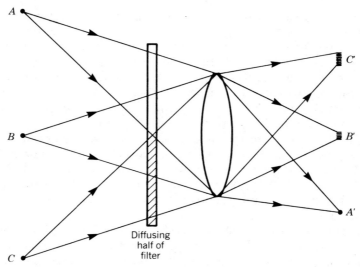

FIGURE 13.19 The effect on the image of using a half diffusing filter on a camera lens.

rather than cause only part of the scene to appear diffused. The resolution of this dilemma hinges on the fact that the filter is placed in front of the lens and not in the lens plane (Fig. 13.19). Note that the rays forming the image of the point A at A' do not pass through the diffusing part of the filter, and hence, the image A' is sharp. Some of the rays forming the image B' are diffused and some are not. Hence, a somewhat "soft" image is formed. All of the rays from C are diffused and C' is the most diffuse image. The image sharpness changes continuously across the image. Because some light from points near A may be scattered onto the image point A', its sharpness may be reduced slightly. Most of the nonuniform filters utilize this principle in some way.

If the entire surface of the filter had been diffusing, the entire image would have appeared soft. Such a filter can be used in front of a lens to produce a soft focusing effect, and is used in portraiture to help mask facial blemishes and lines. A soft focusing lens achieves the same result. In either case, the entire image is made diffuse. Some sharpness will be lost, which in some cases is desirable. The surface of the filter is either etched in some way to produce the diffusing effect or lined with concentric circular fine lines that scatter the light.

If a point light source or any other specular highlight is photographed through a screen wire, rays may radiate from the highlight in the image (see Fig. 13.20). In this case, the radiating rays are caused by the reflection of the specular light off the wires in the screen, which causes the specular image to spread out in the horizontal and vertical direction. The light from the rest of the scene is similarly affected, but because this light is so much dimmer, the effect is not noticed. Star effect filters are made by etching lines in, or marking lines on, the surface of the filter to get the same effect as that obtained with the screen wire.

FIGURE 13.20 Star effect caused by photographing Christmas tree lights through a screen wire. (ENM, 1968)

■ FILTERS IN COLOR PHOTOGRAPHY

Some but not all of the filters used in black-and-white photography can be used in color photography. Most of the correction, overcorrection, and contrast filters cannot be used in routine color photography, because they filter out considerable parts of the visible spectrum. For example, a No. 8 filter, which is yellow, eliminates all of the blue part of the spectrum and renders blue as black in a picture. This darkening may be desirable in a black-and-white picture but is not acceptable in most color pictures. An exception to this applies to infrared color film, discussed in Chapter 12. Recall that infrared color film is sometimes called a false color film. Because it is designed to record green, red, and infrared but not blue, a yellow filter must be used with this film. The recommended filter is a No. 12, although in some instances a No. 8 or a No. 15 can be used. The haze-cutting filters should not be used with color films, although a No. 1A skylight filter is sometimes used to reduce the bluish cast of subjects illuminated by open blue sky.

Polarizing filters and neutral density filters can be used equally well in color and in black-and-white photography. Because haze-cutting and correction filters cannot be used in color photography, polarizing filters will have to be used, where possible, to solve problems introduced by the molecular scattering of light.

■ CONVERSION AND LIGHT-BALANCING FILTERS

In Chapter 12, films with different spectral responses designed for use with incandescent and daylight illumination were described. Sometimes, in the interest of economy or convenience, it is desirable to expose daylight film under incandescent illumination or films balanced for incandescent illumination under daylight illumination and yet have pictures with normal color balance. *Conversion filters* make such photography possible. The blue filters used with daylight film and incandescent illumination are designated Nos. 80A, 80B, 80C, and 80D. These filters transmit blue light and discriminate rather broadly against other wavelengths (see Fig. 13.21). These filters raise the color temperature of the light reaching the film. Recall that when incandescent illumination lights a scene photographed with daylight film, the resulting picture appears too yellow. This difficulty can be corrected by placing a blue filter over the light source, but it is often easier to place the filter over the lens. These filters, in effect, increase the color temperature of the light source.

The principal amber light conversion filters designated Nos. 85 or 85A and 85B are to be used with daylight illumination and type A or type B film. These filters discriminate against blue and to a lesser extent against green but pass most of the red illumination (see Fig. 13.22). The use of all of these filters is summarized in Table 13.2. The suggested exposure increases are approximate, and in critical work a test

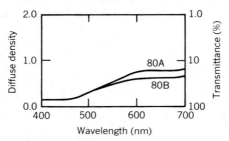

FIGURE 13.21 Diffuse density and transmittance as a function of wavelength for a No. 80A and a No. 80B filter.

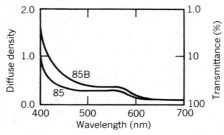

FIGURE 13.22 Diffuse density and transmittance as a function of wavelength for a No. 85 and a No. 85B filter.

TABLE 13.2 The Use of Conversion Filters to Make Various Light Sources Appropriate for Different Films

Filter Color	Filter Number	Temperature Change (°K)	Mired Shift	Film	Light Source	Exposure Increase in Stops
Blue	80A	3200 to 5500	−131	Daylight	Tungsten	2
	80B	3400 to 5500	−112	Daylight	Photoflood	1 2/3
	80C	3800 to 5500	−81	Daylight	Aluminum wire flash	1
	80D	4200 to 5500	−56	Daylight	Zirconium wire flash	1/3
Amber	85,85A	5500 to 3400	112	Type A	Sunlight	2/3
	85B	5500 to 3200	131	Type B	Sunlight	2/3

should be performed to determine the correct exposure. Strictly speaking, the tungsten light source should be a photographic tungsten bulb, but the No. 80A filter can be used satisfactorily in many household incandescent illumination situations. The No. 80C and No. 80D filters are to be used with a wire-filled flash bulb that has no filter on the bulb envelope.

The column labeled "mired shift" tells how much the mired number changes in micro reciprocal degrees Kelvin (see Chapter 10). The advantage of this system is that mired shifts are additive. Hence, if two filters are used together, the mired shift of the two is the sum of the mired shift of each separately.

The No. 85B and No. 80A filters probably are the most useful, because they make it possible to expose type B film in sunlight and daylight film under incandescent illumination. Because the filter factor for a No. 80A filter is so much higher than that of a No. 85B filter, and because indoor illumination is usually less bright than that of sunlight, the No. 85B filter probably is the more useful of the two.

Light-balancing filters make smaller shifts in color temperature than do the conversion filters. Those of a bluish color (Nos. 82, 82A, 82B and 82C) are designed to raise the effective color temperature of a light source. Those of a yellowish color, (Nos. 81, 81A, 81B, 81C, 81D, and 81EF) are designed to lower the effective color temperature of a light source. Table 13.3 lists these filters together with their exposure corrections and mired shift values. These filters are used for fine tuning light sources and may be desirable for routine work, but they are not absolutely necessary. For example, some electronic flash units tend to be too blue and render Caucasian faces as slightly gray. If this happens, using a No. 81 or No. 81A filter on the camera will correct this undesirable effect.

▶ **Example 13.3**

I want to take some pictures in a living room illuminated by 100 watt household incandescent bulbs. Kodachrome 40, a type A film, is chosen for this purpose.

TABLE 13.3 Exposure Corrections and Mired Shift
Values for Light-balancing Filters

Filter Color	Filter Number	Exposure Increase in Stops	Mired Shift Value
	82C	2/3	−45
	82B	2/3	−32
Bluish	82A	1/3	−21
	82	1/3	−10
	81	1/3	9
	81A	1/3	18
	81B	1/3	27
Yellowish	81C	1/3	35
	81D	2/3	42
	81EF	2/3	52

If the color balance is to be as correct as possible, what filter should I use in taking this photograph?

Typically, a 100 watt household bulb has a color temperature of 2900 K. Because the film is balanced for a light source of 3400 K, I must use a blue filter to increase the color temperature of the incandescent source. The mired shift must be computed to determine which filter to use. The mired shift is $10^6 (1/3400 - 1/2900) = 294 - 345 = -51$. In this instance, the best single filter would be either a No. 82C light-balancing filter or a No. 80D conversion filter. Because the No. 80D filter requires less increase in exposure than the No. 82C filter, the first choice probably would be the No. 80D filter.

▶ **Example 13.4**
I want to make a picture using daylight film (balanced for 5500 K illumination) using incandescent illumination having a color temperature of 2900 K. Show that this can be done using a No. 80A filter and a No. 82B filter simultaneously.

The required mired shift is $10^6 (1/5500 - 1/2900) = 182 - 345 = -163$. The No. 80A filter provides a mired shift of -131. Hence, an additional shift of $131 - 163 = -32$ will be needed, which is the shift provided by a No. 82B filter. You can convince yourself that this additivity of mired shifts is valid by imagining that the No. 80A filter converts the light from 3200 K to 5500 K, and that the No. 82B filter converts the light from 2900 K to 3200 K, so that $10^6 (1/5500 - 1/3200) + 10^6 (1/2900 - 1/3200) = -131 - 32 = -163$.

The Tiffen manufacturing corporation produces a set of so-called *decamired filters* similar to the conversion and light-balancing filters. Four filters of bluish color raise the effective color temperature of a light source, and four of reddish color lower the effective color temperature. Shifts of 15, 30, 60, and 120 mireds can be achieved using the filters separately.

■ COLOR COMPENSATING FILTERS

Color compensating filters are available in the colors of the additive and subtractive primaries (red, green, blue, yellow, magenta, and cyan). These filters differ from color conversion and light-balancing filters because in general, they attenuate one or two of the three primaries while transmitting one or both of the other primaries. These filters are available as gels from Eastman Kodak Company in densities of 0.025, 0.05, 0.10, 0.20, 0.30, 0.40, and 0.50. The density designates an average density of the filter. For example, a green transmitting color compensating filter for which the density is 0.30 has an average density of 0.30 in blue and red (see Fig. 13.23). This type of filter is designated CC30G. Color compensating filters bonded in glass are available also from Tiffen Manufacturing Company in densities ranging from 0.10 to 1.1, although not all densities are available in all colors. The selection in cyan and blue colors is somewhat limited.

Color compensating (CC) filters can be used in combination, but care must be exercised when they are combined. The additive primary filters subtract two of the primaries from white light, whereas the subtractive primary filters subtract only one primary. Hence, the latter type is somewhat more flexible. For example, a CC50R filter has a density in green and blue of 0.5. Because a CC50M filter has a density in green of 0.5 and a CC50Y filter has a density of 0.5 in blue, a CC50R filter has the same effect as a CC50M filter and a CC50Y filter used together except for reflection losses at two extra surfaces. This may be represented CC50R = CC50M + CC50Y; sometimes this is abbreviated 50R = 50M + 50Y. When working with filters, use the minimum number necessary, to reduce light loss due to surface reflections. Hence, the red filter is preferable to the yellow and magenta combination. When determining filter packs, it is best to think in terms of the subtractive primaries even though additive filters ultimately may be used. If two filters of the same color are used together, the density of the combination is the sum of the densities of the individual filters. If equal densities of all three subtractive pri-

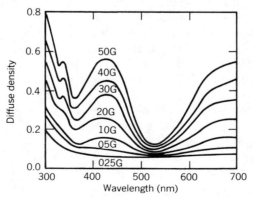

FIGURE 13.23 Diffuse density as a function of wavelength for a set of green color compensating filters.

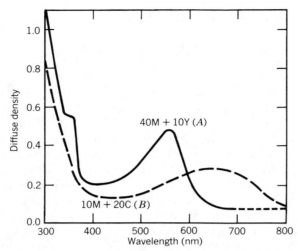

FIGURE 13.24 Diffuse density characteristics of recommended filters for filtration of cool white (*A*) and cool white deluxe (*B*) fluorescent illumination when used with Ektachrome 64 film.

maries are used together, the resulting filtration is equal to that of a neutral density filter of the same density (e.g., .1Y + .1M + .1C = .1ND).

Color compensating filters are used to compensate for anomalies in light sources and changes in color balance of film due to reciprocity failure or batch-to-batch variation in the color response of film. They can be used in copying and printing processes as well.

None of the color films gives entirely satisfactory results when used to take pictures under fluorescent illumination. Some filtration is necessary, and for precise work, the kind of filtration needed depends on the type of fluorescent bulbs and color film being used. Tables listing suitable color compensating filters for different combinations of film and fluorescent illumination are published by film manufacturers.[7] These guides are suitable for initial tests of various combinations of illumination and film. For instance, the recommended filtration for exposing Ektachrome 64 under cool white fluorescent illumination is 40M + 10Y. This means that in such a situation, a yellow filter of 0.1 density (CC10Y) and a magenta filter of 0.4 density (CC40M) should be used together. The exposure must be increased one stop to compensate for the absorption of the filter. For the same film used with cool white deluxe illumination, the recommended filtration is 20C + 10M, together with an increase in exposure of two-thirds of a stop. The density curves for these two filter combinations are shown in Figure 13.24. Both filter packs absorb in the ultraviolet, but the peak in the visible absorption is in green for the cool white filtration and in the red for cool white deluxe filtration.

[7]*Kodak Color Films Eighth Edition*, Rochester, N.Y.: Eastman Kodak Co., 1980, p. DS-54.

This example shows that for precise work no general filter can be used with fluorescent illumination. However, Eastman Kodak reluctantly suggests filter packs for average fluorescent illumination. The recommended filter for such illumination using Ektachrome 64 is a CC30M filter, together with a two-thirds stop increase in exposure. Tiffen makes a filter designated FLD to be used with fluorescent illumination and daylight color film, and one designated FLB for type B film. Hoya makes filters for the same purposes.

The density curves for the Tiffen FLD filter and an Eastman CC30M filter are shown in Figure 13.25. There are notable differences in the curves, but their general shapes are similar. The main differences are higher relative density in the blue and the sharp peak in density in the red for the FLD filter as compared with the CC30M filter. Users of the Tiffen-type filters report that they work satisfactorily. Note that, except for the sharp peak in the red, the density curve looks somewhat like the 40M + 10Y density curve of Figure 13.24. How well the sharp peak in the red of the FLD filter serves the same function as the broader peak in the red of the 10M + 20C filter combination (see Fig. 13.24) depends on the details of the spectral line structure of the fluorescent illumination. The FLD filter appears to be a good compromise for all but the most critical work.

A color light meter can be very useful for determining proper filtration in precise photography of subjects illuminated by various kinds of fluorescent or high intensity discharge illumination (e.g., mercury vapor street lights). These incident light meters measure the luminance in different parts of the spectrum and can be used to determine filter correction for unusual lighting situations. The earliest meters were designed to read only the red and blue components of the illumination and were not very satisfactory for determining filtration of fluorescent illumination. Recently, three color light meters that read the red, green, and blue components of the illumination have been marketed and can be used successfully to determine fluorescent illumination filtration. Currently, however, such meters cost about three times more than a good standard light meter.

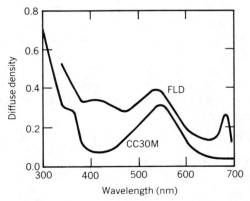

FIGURE 13.25 Diffuse density as a function of wavelength for an FLD filter and a CC30M filter.

Reciprocity failure (see Chapter 8) is not necessarily the same in the different emulsion layers of a color film. For example, with increased exposure, the blue recording emulsion in Ektachrome 64 requires more correction than do the other two emulsions. Hence, a blue filter should be used to allow relatively more blue light to reach the film. A CC15B filter and an exposure increase of one stop is recommended for use with Ektachrome 64 film for exposures of 1 sec. The manufacturers of color film provide reciprocity failure data[8] that include both exposure corrections. Typically, filtration is needed for exposures longer than 1 sec. Some color films require correction for exposures of less than or equal to one-tenth sec.

▶ **Example 13.4**

Using Ektachrome 160 film, I want to photograph a group of students working in a laboratory illuminated by cool white fluorescent lights. The recommended filtration is 10R + 50M + 50Y, together with an increase in exposure setting of one-third stop. Is this the best choice of filters? If I have only the subtractive primary filters, what combination can be substituted?

This does not seem to be the best combination because 50M + 50Y = 50R. Hence, a combination of 50R + 10R would reduce the total number of surfaces in front of the lens. If no red filters are available, then 10Y + 10M (= 10R) can be substituted, although the filter pack now includes four filters. This probably is not the best combination of film and light, because a CC30M filter can be used with Ektachrome 200 to photograph subjects illuminated by cool white fluorescent illumination. This filter requires only a two-thirds stop increase in exposure, and the number of reflecting surfaces is reduced.

■ FILTERS IN THE DARKROOM

The most common filter in the darkroom is the safelight filter. In selecting safelight filters, follow the recommendations supplied with the photographic material. Do not confuse safelight filter numbers with the numbering system used for camera filters. Although all panchromatic material should be processed in total darkness, illumination filtered by a No. 3 safelight filter can sometimes be used for a few seconds (if absolutely necessary) to inspect developing panchromatic material. This filter is very dark green. The number three is assigned to a light yellow filter in the camera filter series. In addition to using the proper filter, care must be taken to use the proper light source in the safelight, and it should be mounted at the recommended distance from the working surface. If it is suspected that the safelight might be fogging the material, a test should be performed to verify if this is true.

Because the exposure of photographic material is cumulative, the effect of prolonged exposure to safelight illumination alone may not be fogging the photographic material. For example, printing paper that has been exposed to prolonged safelight illumination may not appear fogged. However, if the same paper has been

[8]*Kodak Color Films, p. DS-55.*

FIGURE 13.26 Cumulative effect of exposing printing paper to enlargement illumination and safelight illumination. (Lee Howe, 1983)

normally exposed in the enlarger, it may exhibit significant fogging, especially in the highlight areas. In Figure 13.26, all but the upper left corner of the paper was exposed in the enlarger. The upper right half of the picture including the unexposed part was, in addition, exposed to prolonged safelight illumination. The upper left corner shows no fogging, but the areas, especially the highlights, that were exposed to safelight illumination are considerably darker than similar areas that were not exposed to the safelight illumination. Any tests of safelight illumination should be performed as outlined in the example above. As a final caveat, remember that no safelight is totally safe. Excessive exposure of photographic material to a safelight will fog the material.

Variable contrast printing papers were discussed in Chapter 8, where it was noted that filters are used to control enlarger illumination and change the effective grade of the paper. Eastman Kodak calls such paper Polycontrast paper and supplies enlarger illumination filters in acetate form, and gelatin filters that may be used in the image forming optics of the enlarger, to vary the effective grade of the paper. These filters are called *Polycontrast filters* and are available in grades one

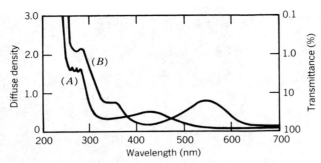

FIGURE 13.27 Diffuse density and transmittance as a function of wavelength for Kodak Polycontrast filters PC-1 (*A*) and PC-3 (*B*).

through four in half-integer intervals. These filters are designed to alter the relative amount of long and short wavelength illumination reaching the film. The filters corresponding to smaller numerical grades (e.g., PC-1) absorb more in the blue, and those of larger numerical grade (e.g., PC-3) absorb more in the green (see Fig. 13.27).

Color printing filters are used in printing color photographs. They are much like the color compensating filters and are used to control the color of the light reaching the negative. They are not of optical quality and should not be used in image forming optical paths. Such filters alter the color balance of the illumination in printing color photographs and are used in black-and-white enlargers that have been adapted for color work. Modern color enlargers have these filters built into them. They sometimes are called dichroic filters, which means that they pass two of the primary colors in some way. Such filters are thus equivalent to subtractive primary filters. Some color enlargers have separate variable blue, green, and red light sources that are mixed to provide proper illumination for color printing.

EXERCISES

13.1. What kinds of materials are used to make photographic filters?

13.2. A No. 25 filter was used to photograph the picture shown in Figure 13.6. The day was bright and sunny and Kodak Plus-X Pan film was used to take the picture. If the f-number setting was f/11, what was the exposure time?

13.3. A No. 25 filter and a neutral density filter that passes half the light incident on it are used together to make a photograph of a white light source in a scientific experiment. What is the filter factor of the combination? What is the exposure reduction in stops?

13.4. What kinds of filters are best for use in both color and black-and-white infrared photography?

13.5. I am photographing a tree with ripe red apples on it. What filters might I use to improve the contrast between the fruit and the green leaves?

13.6. Discuss the various ways that the effects of haze can be reduced in both color and black-and-white photography. Why is this problem more troublesome in color photography?

13.7. A neutral density filter with a density of 0.3 is used in a mirror telephoto lens to reduce the illuminance of the film. This is equivalent to an aperture change on a normal lens of how many stops?

13.8. Why does a polarizing filter reduce glare from insulating surfaces?

13.9. Why is a polarizing filter effective in improving contrast between clouds and blue sky? What are the limitations on its use for this purpose?

13.10. I am photographing rocks on the bottom of a placid pond. How can I reduce the glare from the surface of the pond caused by the sun's reflection? The index of refraction of water is about 4/3.

13.11. What causes the picture shown in Figure 13.20 to be as it is?

13.12. I want to take a picture using type B film outdoors on an average sunny day. What mired shift must I use if the color balance of the picture is to be correct, and what filter(s) will produce this shift?

13.13. Eastman Kodak recommends that in using Kodak Ektachrome 200 film to photograph a subject illuminated by daylight fluorescent illumination, the filtration be 40M + 20Y with a +1 stop change in exposure. What does this mean?

13.14. Describe a test that can be used to verify that a safelight is not fogging printing papers.

13.15. What factors are relevant in assuring that a safelight does not fog printing paper?

13.16. How do the filters used with variable contrast paper cause the effective grade of the paper to change?

·Glossary·

The glossary is designed to aid the reader in using this book. The definitions reflect the meanings of the words as they appear in the text. The definitions are not encyclopedic and are written with the background of the average reader of the text in mind. The selected words are those that are italicized in the text. All of these words appear in the index, and it can be used to locate them in the text.

Aberration A limitation on the image forming capability of a lens in which the image of an object differs in small detail from the object.

Absorption A mechanism in a substance that reduces the amount of light transmitted through or reflected from the substance.

Accelerator An alkali incorporated in a developer to control development rate.

Achromat 1. A positive lens made of two pieces of glass cemented together that is corrected for chromatic aberration at specified frequencies of light. 2. Any lens corrected for chromatic abberation at two frequencies of light.

Acutance A measure of the abruptness of the transition from regions of high density to those of low density in a developed film that has been exposed to a high-contrast subject.

Adaptation The ability of the recording system of the eye to change its threshold sensitivity as a consequence of a change in the ambient light level.

Additive color Color generated by using the additive primaries.

Additive primary See *primary*.

Adenosine triphosphate (ATP) The energy storing molecule for the human cell.

Aerial perspective The impression of depth in a photograph given by the differences in tone of distant and nearby parts of the scene.

Albert effect A process in which a negative can be made to yield a manipulated direct positive by bleaching the exposed photographic material prior to reexposure to uniform illumination.

Albumen paper A photographic printing paper that uses egg white as the dispersal medium for the silver halides.

Ambrotype A permanent image of a subject recorded on a collodion wet plate that is viewed against a black background to give a direct positive.

Amino Pertaining to compounds that contain NH_2 radicals.

Anastigmat A lens that is totally free of astigmatism at one object distance and subject to a minimum of curvature of field.

Angle of illumination The angle at the camera lens of the largest cone of light that can be projected through the lens to the film plane.

Angle of incidence The angle between the normal to a surface and a ray incident on that surface.

Angle of reflection The angle between a

normal to the surface and a ray reflected from that surface.

Angle of refraction The angle between a normal to the surface and a ray refracted at that surface.

Angle of view The angle subtended at the camera lens by the scene imaged on the film.

Angular resolution The angle subtended at the eye by the diameter of the circle of minimum radius that the human eye can differentiate from a geometrical point.

ANSI An acronym for the American National Standards Institute.

ANSI paper speed A number that designates the sensitivity of a photographic printing paper.

Antifoggant See *restrainer.*

Antihalation backing A coating on the back of photographic film that absorbs light that passes through the emulsion and base to reach the back of the film base.

Aperture The opening in an iris or aperture stop that determines the diameter of the beam of light that can pass through it.

Aperture priority automatic exposure An automatic exposure mode of a camera in which the photographer determines the exposure time and the built-in light meter controls the aperture.

Aperture stop A device located near or in the lens of a camera that controls the amount of light reaching the image plane by varying the diameter of the beam of light reaching the lens.

Aplanat 1. A lens that is corrected for spherical aberration and coma. 2. See *rapid rectilinear lens.*

Apochromat A lens that has been corrected for chromatic aberration at three frequencies of light.

Area magnification The ratio of the area of an image of an object formed by a lens to the area of the object.

ASA An acronym for American Standards Association, the older name of the American National Standards Institute, a U.S. standards organization.

ASA film speed A number (widely used in the United States) that designates the sensitivity of a film.

Aspheric lens A lens for which the lens surfaces are not sections of spherical surfaces.

Astigmatism An aberration of a spherical lens in which the image of an off-axis point object is a vertical and horizontal line at two different distances from the lens.

Astigmatism of the eye A defect of the eye in which images cannot be focused sharply; usually caused by a cylindrical component in the curvature of the cornea; can occur in other lenses as well but should not be confused with the spherical lens aberration, astigmatism.

ATP See *adenosine triphosphate.*

Autochrome An early successful additive color photographic process.

Automatic exposure An exposure mode of a camera in which the built-in light meter monitors the light from the subject and automatically controls the exposure.

Automatic flash An electronic flash unit that uses a reflected light flash meter to control the length of time the flash is illuminated and, thus, automatically controls the exposure.

Autopositive A direct positive image made without resort to the bleach step of conventional reversal processes.

Average gradient A measure for black-and-white film of the average slope of an H&D curve in the toe and lower straight-line portion of the H&D curve.

Background light A light used to illuminate the background in front of which a subject is being photographed.

Barrel distortion A limitation of a lens and aperture system in which the image of a square array looks somewhat like the

cross section of a barrel; the magnification of the central part of the image is greater than that of the perimeter.

Base-plus-fog density The minimum density of a film caused by the density of the support base of a film and developed background fog.

Beam candle power seconds (bcps) A unit in which the directed luminous flux-time illumination of an electronic flash unit is expressed.

Bellows A corrugated flexible cloth or plastic enclosure that surrounds the light path in folding cameras, enlargers, and some macro equipment.

Bellows factor In macrophotography, the factor by which the f-number must be increased to indicate the reduced light gathering capability of the lens.

Between-the-lens shutter A shutter, usually of leaf construction, that is located in or near the lens of a camera.

Bichromated gelatin Gelatin that has been treated with a bichromate solution. Such gelatin hardens on exposure to light.

Biprism An arrangement of a pair (or pairs) of triangular prisms used as an aid in focusing certain kinds of cameras.

Blackbody light sources A light source whose radiation spectrum is continuous and can be characterized by the temperature of an equivalent blackbody radiator.

Bleach A process in which developed silver is removed from a photographic emulsion.

Blueprint A copy of a drawing, print, or script made by a photochemical process in which ferric salts are converted to ferrous salts yielding a blue negative of the original.

Bohr model A model for an atom that depicts the atom as composed of a massive nucleus of protons and neutrons surrounded by electrons located in a finite number of shells.

Border effect A development effect in which, after development, a dark line is evident in a heavily exposed part of a film that abuts a partially exposed or unexposed area of the film.

Bounce flash A flash illumination configuration in which light from the flash unit is reflected off a light-colored diffuse surface to illuminate the subject being photographed.

Bracketing A photographic procedure in which successive exposures of a subject are made that are less than and more than the indicated exposure as determined using a light meter or some other method.

Brewster angle The angle of incidence of an unpolarized light ray at which all of the light reflected from an insulating surface will be plane polarized.

Brewster's law A law that states the dependence of the Brewster angle on the indexes of refraction of the media on either side of the reflecting boundary.

Brightness The luminosity of a colored light.

Bromoil process One of the control processes that depends on the hardening of bichromated gelatin if in contact with silver in a bromide print.

BS An acronym for British Standard.

BS scale A scale used in Great Britain to specify film speed of black-and-white film.

Broad lighting Portrait lighting in which the main light illuminates the side of the face toward the camera.

Bulb (shutter position) A shutter speed position in which the shutter remains open as long as the shutter release is depressed.

Burning in To increase the exposure of a small area of the printing paper during part of the printing process.

Butterfly lighting Portrait lighting in which both sides of the face are equally illuminated by the main light.

Calotype A permanent image of a subject recorded on paper containing a silver halide using a process invented by William Henry Fox Talbot.

Camera A device used to project images onto a light-sensitive surface where an image can be recorded.

Camera obscura An early device for projecting and copying images; dating from at least the eleventh century.

Candid portrait An unposed portrait in which the skill and hand of the photographer is evident; not a snapshot.

Candle power A unit in which luminous flux is expressed.

Carbon process One of the black-and-white control processes perfected by Joseph Swan.

Carbro process One of the control processes perfected by Ernest H. Farmer.

Carte-de-visite Small photographs made with a multiple tube camera that, when separated, could be used as visiting cards.

Catalyst A substance present during a chemical reaction that increases the rate of reaction without itself being consumed.

Cataract A defect of the eye in which the crystalline lens becomes semiopaque.

Charge-coupled device An integrated circuit photoelectric photodetector used to record optical images.

Chemical development A development process in which the silver halide is converted directly to silver in the silver halide grain.

Chroma One of the three organizing characteristics of color of the Munsell color system that is somewhat analogous to saturation.

Chromatic aberration An aberration of a lens that causes a polychromatic image to be unsharp because of the dispersion of the lens.

Chromogenic film A film that uses dyes

rather than silver to form the permanent image on the film.

CIE chromaticity diagram A two-dimensional graph that shows the locus of all the colors represented in the CIE color system.

CIE color system A psychophysical color system that describes in terms of three synthetic primaries all the colors of the visible spectrum and all those colors that can be derived from the spectrum.

CIE standard observer The average response of a group of human observers used to match colors in CIE color studies.

Circle of confusion A circular image at the image plans of a point object.

Circle of least confusion The smallest diameter circular image of a point object that can be formed by a real lens.

Clayden effect 1. An effect in which a portion of a negative (usually exposed to the light from an arc discharge such as a lightning flash) exhibits decreased density relative to the rest of the negative. 2. The black lightning effect.

Clearing time The time in the fixer required for the unexposed part of the emulsion to become transparent.

Click stops Detents on a modern photographic lens that allow the lens to be set accurately at specific f-numbers without observing the iris adjusting ring.

Close-up lens A supplementary lens placed in front of a camera lens that increases the magnification of the camera lens.

Closing down See *stopping down*.

CLS silver A finely divided suspension of silver particles that does not transmit blue light, named for its discoverer Mathew Carey Lea.

Coated lens A lens coated on the optical surfaces with a transparent material that reduces surface reflections.

Collodion wet plate A light-sensitive photographic material on a glass plate that

uses collodion as the dispersal medium for the silver halide.

Colloid A suspension of finely divided particles in a continuous medium.

Colloidal silver A suspension of finely divided silver particles.

Colorant A substance that causes an object or a material to be colored.

Color carbon process The earliest successful subtractive color photographic process.

Color compensating filter Colored filters available in additive and subtractive primary colors of various densities that are used to adjust the color of light in color photography.

Color development A development step in the processing of color film or prints in which the couplers become colored where development is taking place.

Colorimeter A measuring instrument (spectrophotometer) used to study and match color.

Colorimetry The science of the study and specification of color.

Color-separation negative One of three black-and-white negatives of a subject taken through a primary-colored filter that is used to make colored images by any one of several color photographic processes.

Color temperature The temperature of a blackbody radiator that identifies the spectral distribution of the radiation from it or that of any radiation that is equivalent to that of the blackbody.

Coma An aberration of a lens in which the image of an off-axis point object is coma shaped.

Complementary colors Two colors that when added together in proper proportions yield white. In color photography the complementary colors are red and cyan, green and magenta, and blue and yellow.

Condenser A lens system in the light source of an enlarger or projector that illuminates the negative with a collimated beam of light.

Condenser enlarger An enlarger whose light source illuminates the negative with a collimated beam of light from a condenser.

Cones Photoreceptors in the eye that are responsible for color vision and the ability to see detail.

Contact print 1. A print made by placing the negative in contact with the printing paper. 2. Any print made from a negative in which the image size of the print is the same as that of the negative.

Contrast 1. The tonal range of a print or scene. 2. The tonal range of a print or scene expressed as a ratio.

Contrast filter A filter used with black-and-white film to increase the contrast between subjects of the same reflectance but different colors.

Contrast index A measure for black-and-white film of the average slope of an H&D curve in the toe and lower straight-line portion of the H&D curve (used by Kodak for their film).

Contrasty 1. Pertaining to a scene of high luminance ratio. 2. Pertaining to a print of high contrast.

Control process Print making processes in which the printmaker can control the range and/or color of the tones in the print.

Converging lens See *positive lens.*

Conversion filters A series of blue and amber filters that shift the color temperature of the radiation from light sources so that films balanced for one kind of illumination can be used under another kind of illumination (e.g., daylight film under tungsten illumination).

Cooke triplett An asymmetric lens of three elements corrected for astrigmatism and curvature of field.

Cornea The transparent part of the outer surface of the eye that serves as a lens.

Correction filter A filter designed to cor-

rect for the oversensitivity of black-and-white film to blue and ultraviolet radiation.

Coupler A compound that is used in the diazo process and many color photographic processes to form the dyes that make up the colored images of these processes.

Critical angle The smallest angle of incidence of a ray on an optical surface at which no light is transmitted through the surface.

Cropping To eliminate part of the image of the negative in the printing process.

Crystal A material (usually a solid) composed of an ordered array of atoms.

Crystalline lens A transparent lens in the interior of the eye whose focal length is adjustable so that the eye can focus on near and distant objects.

Curvature of field An aberration of a simple lens in which the sharpest image of a plane is not a plane but a curved surface.

Daguerreotype A permanent image of a subject recorded on a specially treated light-sensitive metal plate using a process invented by Louis Daguerre; the first successful process utilizing the light-sensitive silver halides.

Daylight illumination The light from natural daytime light sources.

Decamired filters A set of light-balancing filters manufactured by Tiffen used to shift the color temperature of light in a systematic way.

Defect A departure from a perfect crystal in which individual crystal sites are unoccupied and/or atoms are located at positions other than crystal sites.

Densitometer 1. An instrument for measuring the density of developed film or plates. 2. An instrument for measuring the reflection density of developed printing paper.

Density 1. A measure of the amount of developed silver in photographic material. 2. The logarithm of the reciprocal of transmittance of a photograhic material.

Density range 1. A measure of the range of densities in a negative or a print. 2. A measure of the range of densities that can be recorded on a specific kind of photographic paper.

Density zone One of the intervals in the density range of a negative that corresponds to an exposure zone in the zone system.

Depth of field The distance between the farthest and nearest in-focus objects in a scene in a photographic image.

Depth of focus The distance between the farthest and nearest in-focus images of a specified object in the image field of a camera lens.

Develop A process in which a latent image is made visible.

Developer A reducing agent that, during development, converts to silver the exposed silver halide grains of the latent image.

Developing out A process in which the latent image on printing paper is made visible by long exposure to a bright light source without the use of a developer.

Development See *develop.*

Development sites A small assembly of silver atoms on or in an exposed silver halide grain at which conversion of the grain to silver starts during development.

Diazo process A photochemical copying process in which a diazo compound in the proper environment combines with a coupler to form a colored azo dye.

Dichroic crystal An optically asymmetric crystal that absorbs light selectively; absorption depends on the orientation of the crystal and the plane of polarization of the light.

Dichroic filter A filter that transmits two colors.

Diffraction The bending of a light wave as a consequence of its passing through a small hole or past a sharp edge.

Diffuse density Density determined by measuring all the light that is transmitted through an absorbing medium (see *specular density*).

Diffuser A ground or opal glass plate in the light source of an enlarger that illuminates the negative with an uncollimated beam of light.

Diffusion enlarger An enlarger whose light source illuminates the negative with an uncollimated beam of light.

Diffusion-transfer process A photographic process in which a positive print is made by transferring unexposed silver halides from the negative to a receiving layer where they are developed to form a positive image (e.g., the Polaroid black-and-white process).

DIN An acronym for Deutsche Industrie Norm, a German standards organization.

DIN speed A number widely used in Europe for designating the sensitivity of a film.

Diopter A unit of measure of the dioptric power of a lens; dimensionally in reciprocal meters.

Dioptric power The reciprocal of the focal length of a lens measured in meters.

Direct development See *chemical development*.

Direct positive A positive made by special reversal processing of film, plate, or paper on which a negative latent image has been formed.

Dislocation A departure in a single crystal from a perfect crystal in which one part of the crystal is displaced with respect to the rest of the crystal.

Dispersion The variation of the index of refraction of a medium with frequency of light.

Diverging lens See *negative lens*.

Dodging A procedure in which a small area of the printing paper receives relatively less exposure during exposure of the printing paper.

Dominant wavelength A spectral color that can be combined with white light to form a selected color in the CIE colorimetry.

Dye bleach process A color photographic process that depends on the destruction of a dye to produce a colored image.

Dye coupling A process used in modern color photography to produce the dyes that form the color images in most color negatives and positives.

Dye matrix The dyed gelatin used to transfer color to dye transfer paper in the dye transfer process.

Dye-release process A color photographic process in which the dyes are incorporated in the film at the time of manufacture and are subsequently selectively released to migrate to a receiving layer to form a colored image.

Dye transfer paper The paper that receives the dyes and becomes the color print in the dye transfer process.

Dye transfer process A color-separation process used to make color prints that represents the state of the art today.

Eberhard effect A development effect in which a film or plate exposed to small circles of equal luminances but of different diameters, forms images, that on development, do not have the same densities but exhibit densities that vary inversely with the diameters of the circles.

Edge effect The border and/or fringe effect(s).

Effect filter One of a class of filters designed to produce bizarre photographic effects such as multiple images, multicolored images, fog effects, split field images, star effects, and so on.

Effective candle power seconds See *beam candle power seconds.*

Effective exposure time The mean time that the shutter of a camera is open during an exposure.

Effective paper speed A measure of the sensitivity of a photographic printing paper used to determine proper exposure of that paper.

Electromagnetic wave Any one of a number of transverse waves that are composed of oscillating transverse electric and magnetic fields of which light is one example.

Electron A basic building block of matter that is about 1800 times less massive than the proton or neutron and has a unit negative electrical charge.

Electronic flash A light source of short duration that provides illumination by discharging a capacitor at high voltage through gas under pressure in a glass envelope.

Electrostatic force The force of attraction between electrical charges of unlike sign or that of repulsion between charges of the same sign.

Emulsification The precipitation of silver halide crystals as small grains in gelatin during the manufacture of photographic emulsion.

Enlarger A device for making photographic copies of transparent photographic negatives.

Enlarging lens The lens in an enlarger that projects the image of the negative onto the easel or enlarging paper.

Entrance pupil The image of the limiting aperture of a lens formed by the elements of the lens that are in front of the limiting aperture.

Epithelium See *pigment epithelium.*

Excitation purity The fraction of a color that is a pure spectral color when a color is described in terms of white and a pure spectral color in CIE colorimetry.

Exit pupil The image of the limiting aperture of a lens formed by the elements of the lens that are behind the limiting aperture.

Exposure 1. The light energy incident on a unit area of a surface during the time that it is illuminated. 2. The act of exposing photographic film, plate, or paper to light.

Exposure index A measure of the sensitivity of a film used to determine proper exposure of that film.

Exposure range The interval of exposure of a film or plate when it is used to photograph a subject.

Exposure time The length of time that a light-sensitive material is exposed to light.

Exposure value (EV) A logarithmic scale used to specify equivalent exposures.

Exposure zone One of the one stop intervals into which the exposure range of a negative is divided in the zone system.

Extension tubes Metal tubes placed between an SLR camera body and the lens that are used in macrophotography to increase image size.

Face-centered cubic crystal (fcc) A crystal in which the atoms are arranged to occupy the corners of a cube and the center of each face of the cube.

False-color film A color film in which the dye colors in the individual layers are altered so that the color recorded in a given layer is presented as a different color in the transparency or print (e.g., green in a scene appears as blue when recorded on an infrared transparency).

Farsighted See *hyperopic.*

Ferrotype See *tintype.*

Field of view That part of the scene that can be recorded on film or a plate by a camera.

Fill-flash A lighting procedure in which the light from a flash unit is used to fill the shadows generated by the ambient light or one in which the light from the ambient

source is used to fill the shadows generated by the flash illumination.

Fill light A light used to illuminate the shadows created by the main light when a subject is being photographed.

Film holder A device for holding film in place during exposure in the camera.

Filter A device placed in the optical path of a camera or over a light source that alters the character of the light passing through the device.

Filter factor The factor by which the illuminance of the film is reduced as a consequence of placing a filter between the subject and the film.

Fix 1. To dissolve halides that are undeveloped silver halides in photographic film, paper, or plates. 2. The material used in the above process.

Fixation See *fixing*.

Fixer A material used to dissolve undeveloped silver halides in photographic film, paper, or plates.

Fixing The process of dissolving undeveloped silver halides in photographic film, paper, or plates.

Flare The degradation of an optical image due to reflection of light from the surfaces of the lens and the interior of the camera.

Flash bulb An incandescent light source that provides short-duration illumination by burning fine wire, foil, or powdered metal in a reduced oxygen atmosphere.

Flash meter A light meter that measures flash illumination.

Flat 1. pertains to a print or transparency that does not utilize the entire density range of the photographic material on which it is printed. 2. Pertains to a scene that yields a flat print or transparency.

Floodlight An artificial light source that has a broad beam and bright intense illumination.

Fluorescence The emission of electromagnetic radiation by a substance as a consequence of stimulation of the substance by electromagnetic radiation of shorter wavelength than that emitted by the substance.

Flux The amount of light passing through a geometrical surface.

f-number (f/read) The focal length of a lens divided by the diameter of the aperture of the lens; a measure of the light-gathering capability of the lens.

f-number effective (f/eff) In macrophography, a measure of the light-gathering capability of the lens when it is focused on nearby objects.

Focal length 1. The distance from a thin lens at which an object at infinity is imaged. 2. The distance from the principal plane of a lens at which an object at infinity is imaged.

Focal plane 1. A plane perpendicular to the optical axis of a lens passing through the focal point. 2. The image plane formed by a lens of an object plane.

Focal plane shutter A shutter located slightly in front of the focal plane of a camera.

Focal point A point on the optical axis at which rays from an object at infinity are focused.

Focus To adjust the relative position of lens and film plane so that the image of an object becomes sharp on the film plane.

Fog Silver grains in a developed emulsion that form a continuous background for the image that are not a consequence of the image forming exposure of the emulsion.

Folding camera A camera that can be closed when not in use so that the lens can be protected and the camera made more compact; usually a bellows connects the lens to the box containing the film holder.

Formal portrait A posed portrait that relies on the features of the face to depict the subject; props, unusual surroundings, and unconventional lighting are usually not used in such a picture.

Fovea A small region in the center of the retina composed primarily of cones.

FP flash bulb A flash bulb designed to be used with a focal plane shutter.

FP Sync The flash synchronization used with class FP flash bulbs; usually found on cameras with focal plane shutters.

Frenkel defect A defect in which an ion in a crystal is not at its normal site but wanders between the rows of atoms.

Frequency The number of complete oscillations made by a periodic wave in a unit time usually measured in cycles per second and designated Hertz (Hz).

Fringe effect A development effect in which, after development, a light line is evident in a partially exposed part of a film that abuts a heavily exposed part of the film.

f-Stops 1. The f-numbers (1, 1.4, 2, 2.8, 4, 5.6, 8, 11, 16, 22, 32 . . .) of a camera or enlarging lens which change the illuminance by a factor of two between adjacent f-numbers. 2. Any f-number setting of a camera lens.

Gamma (γ) The slope of the straight-line portion of an H&D curve of black-and-white film.

Gee bar (Ḡ) A measure for black-and-white film of the average slope of an H&D curve in the toe and lower straight-line portion of the H&D curve (used by Ilford).

Gel See *gelatin filter.*

Gelatin dry plate A light-sensitive photographic material on a glass plate that uses gelatin as the dispersal medium for the silver halides.

Gelatin filter A filter made of gelatin.

Glossy Pertaining to a photographic paper with a more or less specular reflecting surface.

Grain 1. An assembly of silver and halide atoms in a more or less ordered array in a photographic emulsion that are the light-sensitive materials of the emulsion. 2. An assembly of silver atoms in a developed photographic emulsion that forms the black part of the developed image.

Graininess 1. The nonuniformity on a small but visually detectable scale of the shades of gray in a photograph caused by clumps of silver grains in the print. 2. A subjective but quantitative measure of the above.

Granularity A quantitative instrumental measure of the nonuniformity on a small scale of the shades of gray in a developed film or plate caused by clumps of silver grains in the film or plate.

Gray scale zone One of the intervals in the density range of a print that corresponds to a density zone of the negative that was used to make the print in the zone system.

Guide number A number assigned to a combination of film and flash source used to approximately determine proper exposure of the film when using the specified flash source for illumination.

Gum arabic The gum from certain African trees that after treatment with a bichromate solution hardens on exposure to light.

Gum bichromate process One of the color control processes.

H&D curve A graphical representation of the relationship between exposure and density of developed photographic material.

Hair light A light used to add a highlight to the hair of a subject being photographed.

Half stop An intermediate f-number setting of a camera lens between two adjacent f-stops that reduces the illuminance to 71% of its former value as the lens is stopped down from an adjacent f-stop.

Hard paper A photographic printing paper of relatively small log exposure range and relatively large grade number.

Haze-cutting filter A filter that absorbs ultraviolet radiation and short wavelengths of blue light that is used with

black-and-white film to photograph scenery obscured by haze.

Haze-UV filter An ultraviolet radiation absorbing filter that is suggested for use with black-and-white film to photograph scenery obscured by haze; in many instances of limited utility.

Heliograph A permanent image of a subject recorded on light-sensitive asphaltum using a process invented by Nicéphore Niepce.

Herschel effect The degradation of a latent image formed on photographic material by exposure to red light to which the material is not normally sensitive.

Highlight 1. The brightest parts of the scene. 2. The lightest tones of a positive print.

Hole The absence of an electron in a solid at a site where an electron would normally be located.

Hot shoe A mounting device on the top of a camera for attaching a flash unit that also connects the flash unit electrically to the flash synchronizing switch in the camera.

Hue The essential color of a substance (e.g., red).

Hydroxyl Pertaining to compounds that contain OH radicals.

Hyperfocal distance The minimum distance at which a camera lens set for a specified f-number can be focused so that the camera is in focus to infinity; the minimum distance at which a camera lens set for a specified f-number can be focused so that the depth of field will be infinite.

Hyperopic Pertaining to a defect of the eye in which nearby objects cannot be focused sharply.

Hypersensitization The process of fogging a photographic film or plate prior to exposure to a subject to increase its threshold sensitivity.

Hypo 1. A material used for fixing photographic film and paper. 2. Sodium thio-

sulfate formerly known as sodium hyposulfate.

Hypo eliminator A chemical added to processed film, paper, or plates that converts residual fixing by-products to colorless stable compounds.

Illuminance The light energy incident on a unit area of a surface in a unit interval.

Illuminant A light source used in color studies (e.g. CIE colorimetry).

Image orthicon A video camera tube that uses a photoemitter to record a video image.

Image plane The plane in which a plane object is imaged by a lens.

Incandescent illumination The light from an artificial incandescent light source.

Incandescent light source 1. A light source that emits light in a continuous spectrum. 2. An artificial light source that emits light in a continuous spectrum (e.g., a household electric light bulb).

Incident light meter A light meter that measures the light illuminating the subject.

Index of refraction A measure of the optical density of a medium; the ratio of the velocity of light in a vacuum to that of a particular material.

Infinite 1. Larger than any finite entity. 2. A place more distant than that denoted by any measurable distance.

Informal portrait A posed portrait that uses props, unusual surroundings, and unusual lighting to aid in depicting the subject.

Inorganic Pertaining to compounds that usually do not contain carbon.

Instant color film A color film that produces a permanent positive color image without resorting to laboratory processing.

Integral tripack film A color film consisting of three layers of emulsion each of which records one of the primary colors of the subject.

Integral tripack paper A color printing paper consisting of three layers of emul-

sion each of which records one of the primary colors of the subject.

Integrated circuit An electronic circuit consisting of several electronic components nents that is fabricated on a single piece that is fabricated on a single piece of support material by evaporation and/or ion implanation of metals and insulators.

Interference The combining of two coherent light waves of the same frequency.

Intermittency effect An effect in which relatively long exposure of a photographic emulsion at high illuminance yields reduced density compared to that for an equivalent exposure consisting of several short time intervals of equal illuminance.

Internegative An intermediate negative made from a positive that is used to make a duplicate positive transparency or a print; often used with color transparencies where masking is desirable.

Interstitial An ion or atom that is not located at a crystal site in a crystal but between the rows of atoms.

Ion An atom that has a net positive or negative electrical charge.

Iris 1. A membrane in the eye that is located behind the cornea that controls the amount of light reaching the retina. 2. See *aperture stop.*

ISO An acronym for International Organization for Standardization.

ISO speed A number for designating the sensitivity of a film that combines the DIN speed and ASA film speed.

Key light See *Main light.*

Key tone A subject of known reflectance that can be used to determine proper exposure of a scene using a reflected light meter; particularly useful if the scene is not one of average reflectance.

Kicker light A light used to add a highlight to a subject.

Knee See *shoulder.*

Kostinsky effect A development effect in which the images of two small adjacent

circles of light do not appear as circles on the developed film or plate but as oblong figures due to reduced development in the regions where the circles are adjacent.

Latensification The process of fogging a photographic film or plate after exposure to a subject to decrease its threshold sensitivity.

Latent image The image recorded on a light-sensitive material that cannot be seen with the unaided eye.

Lateral chromatic aberration An aberration of a lens in which the size of an image depends on the color of the object.

Leaf shutter A shutter made of an assembly of overlapping metal leaves that open from the center of the shutter assembly to the outer edge of the assembly; usually located in the lens assembly (see *between-the-lens shutter*).

Lens A device typically consisting of one or more pieces of glass that collects the light from a subject and changes the path of the collected light to form an image of the subject.

Lens flare See *flare.*

Light The visible part of the electromagnetic spectrum.

Light-balancing filters A series of blue and yellow filters used primarily in color photography that shift the color temperature of the radiation from light sources a small amount.

Light-emitting diode (LED) A device used to display alphanumeric information on photographic equipment that is illuminated when appropriate voltage is applied to it.

Lighting ratio The ratio of the illumination of the highlight area of a subject being photographed to that of the shadow area.

Light meter A device for measuring the amount of light incident on or reflected from a subject.

Lightness A term used in colorimetry to designate the degree to which a color is not diluted by gray.

Limit of resolution of the eye The minimum diameter circle viewed at a comfortable minimum viewing distance that the human eye can differentiate from a geometrical point.

Linear magnification The ratio of the height of an image of an object formed by a lens to the height of the object.

Linear perspective The impression of depth in a photograph given by the apparent reduction in the size and spacing of objects that were farther from the camera when the picture was made.

Line pair The line and adjoining space on a resolving power test chart patterns.

Line spectrum light source A light source in which most of the energy of the radiation is confined to spectral lines or bands.

Liquid crystal display (LCD) A device used to display alphanumeric information on photographic equipment that is composed of elements that darken when appropriate voltages are applied to them.

Log exposure range A measure on a logarithmic scale of the range of exposures that a printing paper can utilize in making a print from a negative.

Long focus lens A lens for which the focal length is considerably longer than that of a standard lens for a given camera format.

Longitudinal chromatic aberration An aberration of a lens in which the position of the image with respect to the lens depends on the color of the object.

Longitudinal wave A wave in which the direction of oscillation coincides with the direction of propagation.

Long scaled Pertaining to a scene for which the exposure range exceeds the total number of zones of the zone system.

Long-toed film A film whose H&D curve changes slope gradually at relatively low densities.

Luminance 1. The light energy reflected or emitted from a unit area of a surface in a unit interval of time. 2. In colorimetry, the brightness of a light measured visually.

Luminous flux The rate at which light energy is emitted by a light source.

Luminous flux-time The total amount of light energy emitted by a light source in a given time.

Luminance ratio The ratio of the luminance of the highlight in a scene to that of the shadow in a scene.

Mackie lines The two lines generated by the border and fringe effects.

Macro lens A lens used in macrophotography designed so that it can be focused on nearby subjects to produce relatively large images of these subjects.

Macrophotography The photography of subjects in which the image size is the same order of magnitude as that of the object.

Macula A yellow filter covering the fovea of the eye.

Magnification See *linear magnification*.

Main light The primary source of illumination of a subject.

Manipulation Any process in which the exposure or processing of the film, plate, or paper is not standard.

Manual override The capability to operate an automatic camera in a manual (nonautomatic) mode.

Masking A process for controlling the transfer of an image so that the tones of part of the image are altered during the transfer process.

Matrix film A film used in the dye transfer process that is ultimately used to transfer the dye to the dye transfer paper.

Matte Pertaining to a photographic paper with a more or less diffuse reflecting surface.

Melianotype See *tintype*.

Meniscus lens A positive lens made of a single piece of glass with one convex and one concave surface.

M flash bulb A flash bulb designed to be used with a between-the-lens shutter.

Microdensitometer A densitometer of small aperture used to measure small scale changes in the density of photographic material.

Mired A unit of measure of blackbody radiation temperature that is equal to 10^6 divided by the blackbody temperature in degrees Kelvin.

Mitochondria The energy sources of living cells.

Modulation transfer function (MTF) A measure of the ability of a photographic system or part of a system (e.g., film) to faithfully reproduce subjects of different spatial frequencies whose densities vary sinusoidally in space.

Monochromatic light Light of one frequency; a pure light.

Monochrome film A film that records in one color (e.g., black, tones of gray, and white).

Mordanted gelatin Gelatin that will accept and retain dyes.

Motor drive A device on a camera for automatically cocking the shutter and advancing the film after a frame has been exposed; usually operates at a faster rate than that provided by a winder.

M sync The flash synchronization used with class M flash bulbs; usually found on cameras with between-the-lens shutters.

Multicoated lens A lens with thin multiple transparent coatings on its surface designed to reduce reflections at the surface of the lens.

Munsell color system A three-dimensional color nomenclature that uses a normal human observer to arrange all of the available pigments systematically.

Myopic Pertaining to a defect of the eye in which distant objects cannot be focused sharply.

Nearsighted See *myopic*.

Negative 1. An image in which the tones are reversed from those of the subject. 2. A film, plate, or other material having such an image.

Negative lens 1. A lens that causes a bundle of light to diverge as it passed through the lens. 2. A simple lens that is thinner at the center than at the perimeter.

Negative primary See *subtractive primary*.

Neuronal layer A layer of the retina containing cells that couple the photoreceptors to the optic nerve.

Neutral density filter A filter that reduces the amount of light passing through it without significantly altering the spectral character of the light.

Neutron A building block of matter that is about 1800 times more massive than the electron and has no electrical charge.

Nodal points Two points on the optical axis of a lens used to describe the image forming characteristics of a thick lens; these are coincident with the principal points if the lens is immersed in a single medium.

Normal A straight geometrical line that is perpendicular to a surface at its point of contact with the surface.

Normal observer The representative observer used to evaluate color in the Munsell color system.

Normal to the surface See *normal*.

Nucleus 1. The replicating part of a cell. 2. The heavy central part of an atom consisting of protons and/or neutrons.

One-shot camera A beam splitting camera used to simultaneously make the three color-separation negatives of the dye transfer process.

One-third stop A f-number setting on a camera lens that reduces the illuminance from that of the adjacent f-stop by 20% if the aperture is smaller or increases it by 25% if the aperture is larger than that of the f-stop.

Open flash A flash synchronization in which the shutter is first opened either in the bulb or time position and the flash unit is activated while the shutter is held open.

Opening up To increase the aperture of a lens (i.e., decrease the f-number).

Optical axis The axis of rotational symmetry through the center of a circular lens.

Optical sensitizers Dyes added to photographic emulsion to increase the range of the spectral response of the emulsion.

Optical surface The boundary between two optical materials of different indexes of refraction.

Optic nerve The bundle of nerve fibers that connect the rods and cones of the eye to the brain.

Organic Pertaining to carbon compounds.

Orthochromatic Pertaining to a film, paper, or plate that is approximately equally sensitive to all colors of light except that it is insensitive to red.

Overcorrection filter A filter used with black-and-white film to generate a dramatic pictorial effect by changing the spectral balance of the light reaching the film.

Oxidation 1. The process of combining a substance with oxygen. 2. A chemical process in which a compound loses electrons.

Palladiotype A photographic print in which the dark areas are composed of palladium instead of silver grains.

Panchromatic Pertaining to a film, paper, or plate that is approximately equally sensitive to all colors of light.

Panning Swinging the camera while exposing the film so that a laterally moving object can be kept fixed in the field of view.

Paper grade A number used to identify photographic printing papers of a given kind but different log exposure ranges;

larger numbers are assigned to papers of smaller log exposure ranges.

Parallax error A difference in the image seen through the view finder compared to that formed on the image plane of the camera caused by an offset in the line of sight of the view finder compared to that of the camera lens.

Paraxial ray A ray that is very close to the optical axis.

PC cord 1. A cord that connects a flash unit electrically to a camera. 2. An electrical cord with PC connectors on the ends of it.

Pentaprism A prism used in a single-lens reflex camera to present to the eye an image of a subject as seen through the lens as it would appear if viewed with the unaided eye (i.e., uninverted and unreversed).

Perspective The impression of the three-dimensional nature of a subject given by a two-dimensional rendition of the subject as in a photograph.

pH A measure of hydrogen ion concentration in a solution; the negative logarithm of the hydrogen ion concentration in a solution.

Phosphor A material that emits light when stimulated by electromagnetic radiation.

Photochemical Pertaining to a material that is changed chemically when stimulated by light.

Photoconductor A material that is an insulator in the dark and becomes a conductor when exposed to light.

Photodetector A device that can be used to detect the presence of light.

Photoelectric Pertaining to a material that is changed electrically when stimulated by light.

Photoemitter A material that emits electrons when biased with an appropriate voltage and exposed to light.

Photographic emulsion 1. The light-sensitive layers of a photographic film, paper,

or plate. 2. The material from which these layers are made.

Photometer A physical instrument that detects and measures light incident on it.

Photon A massless bundle of energy that represents light in the quantum model of light.

Photopic Pertaining to the ability to see in bright light.

Photoreceptor layer The layer of the retina that contains the rods and cones of the eye.

Photovoltaic cell A device that generates a voltage when exposed to light.

Physical development A development process in which the silver halide is first dissolved and then converted in solution to silver.

Pigment An opaque colorant.

Pigment epithelium Pigmented membranous tissue that absorbs light that passes through the photoreceptor layer of the eye.

Pincushion distortion A limitation of a lens and aperture system in which the image of a square array looks as if it had been projected onto a hemispheric pincushion; the magnification of the central part of the image is less than that of the perimeter.

Pinhole camera A simple camera with a very small aperture and no lens.

Plane-polarized wave A transverse wave in which the oscillation of the wave is confined to a single plane containing the direction of propagation.

Platinotype A photographic print in which the dark areas are composed of platinum instead of silver grains.

Polarization A process in which a transverse wave is polarized.

Polarized wave A tranverse wave in which the amplitude of the wave is greater in one plane containing the direction of propagation than in a similar plane perpendicular to it.

Polarizing angle See *Brewster angle.*

Polarizing filter A filter that reduces unpolarized or partially polarized light on transmission through the filter to plane-polarized light.

Polascreen See *Polarizing filter.*

Polycontrast filters A set of filters manufactured by Eastman Kodak used in black-and-white printing that make it possible to change the grade of polycontrast paper.

Positive 1. An image in which the tones of the image match those of the subject. 2. A film, plate, or other material having such an image.

Positve lens 1. A lens that causes a bundle of light to converge as it passes through the lens. 2. A simple lens that is thicker at the center than at the perimeter.

Presbyopia A defect of the eye in which the eye cannot focus on nearby objects.

Previsualization A method of evaluation of a scene used by zone system photographers in which the various luminances of the scene are measured, the print is visualized, and exposure and development are adjusted to make the visualized print.

Primary Any one of a combination of three colors (typically colored lights) that when added together in proper proportions yield white; in photography these are shades of red, green, and blue.

Principal planes Two planes perpendicular to the optical axis intersecting it at the principal points used to describe the image forming characteristics of a thick lens.

Principal points Two points on the optical axis of a lens used to describe the image forming characteristics of a thick lens; these are coincident with the nodal points if the lens is immersed in a single medium.

Print An opaque positive enlargement or contact copy of a negative.

Printing out A photographic process in which a visible image is formed on a light-

sensitive material without an intermediate development step.

Proton A basic building block of matter that is about 1800 times more massive than the electron and has a unit positive electrical charge.

Psychophysical Pertaining to the relationship between physical entities and one of the senses (e.g., the relationship between the spectrum and the visual senses).

Pure light A monochromatic spectral light.

Purkinje effect A visual phenomenon in which green and blue appear unusually bright compared to red when the overall illumination is rapidly reduced.

Pushing The deliberate underexposure of a film or plate (usually in a situation where the light level is too low for normal exposure).

Quantum model A model for light in which light is represented as massless bundles of energy.

Radius of curvature The radius of a sphere with which the surface of a spherical glass lens is coincident.

Range finder A device for determining the distance to an object.

Range finder camera A camera with a built-in range finder.

Rapid fixer A fixer that has a greater fixing rate than sodium thiosulfate.

Rapid rectilinear lens A symmetric lens that can be used as a landscape lens at relatively large apertures.

Rare earth glasses Glasses of higher indexes of refraction than conventional glasses that incorporate the rare earths.

Ray 1. A representation of light in which light is described as traveling in a straight line between two points. 2. A graphical representation of the path of a beam of light.

Rayleigh scattering The absorption and reemission of electromagnetic radiation by gas molecules in a predictable manner.

Ray of light See *ray*.

Real image An image formed by a lens in which the rays from the object converge to form the image at the image plane.

Reciprocity failure A situation in which the reciprocity law is not valid; usually occurs when the illuminance of the photographic film, paper, or plate is very high or very low.

Reciprocity law A law that states that the exposure (E) is equal to the product of the illuminance (I) and the exposure time (t).

Reducing agent A substance that readily donates electrons to other substances in a chemical reaction.

Reduction The reciprocal of the magnification.

Reflect To cause a ray of light to be bent backward at the boundary between two optically different materials.

Reflectance The ratio of the amount of light reflected by a substance to that incident on it.

Reflected light meter A light meter that measures the light reflected from the subject to the meter.

Reflection density The density of a photographic emulsion backed by a reflecting surface as in developed photographic paper.

Reflectivity The reflectance in percent.

Refract To cause a ray of light to be bent as it passes through the boundary between two optically different materials.

Resin-coated paper Printing paper for which the paper base has been coated with resin to reduce the uptake of water and residual water soluble chemicals by the base.

Resolving power 1. The reciprocal of the spacing of the smallest line pair that can be identified as distinct in a photographic image of a resolving power test chart as judged visually by a human observer. 2. A similar number determined in the same way for the image of a resolving power

test chart formed by an optical system such as a camera lens.

Restrainer A substance (e.g., potassium bromide) added to developer that inhibits the development of unexposed silver halide grains.

Retina The light-sensitive membrane of the eye.

Retrofocus lens A lens of at least two elements in which a negative lens is placed in front of a positive lens in such a way that the principal planes are placed toward the rear of or behind the lens.

Reversal A process in which the tones of the film, plate, or print are reversed from those that would occur in normal processing.

Reversing ring A ring with two male threads on it placed between an SLR camera body and the reversed camera lens that is sometimes used in macrophotography to reverse the lens.

Rhodopsins Photosensitive pigments in the rods of the eye responsible for photopic vision.

Ripening A heating process applied to photographic emulsion during its manufacture that alters the grain size and grain size distribution of the silver halide grains in the emulsion.

Rods Photoreceptors in the eye that are responsible for vision in dim light.

Sabattier effect An effect in which a partial reversal of the tones of a print is achieved by exposing the print to uniform illumination after partial development but prior to fixing the print.

Safelight A darkroom light that does not fog photographic materials but allows darkroom workers to see as they manipulate these materials.

Safelight filter A filter used in a darkroom light that prevents fogging of photographic materials but allows darkroom workers to see as they manipulate these materials.

Saturation The degree to which a color is pure, that is, not diluted by white.

Scattering 1. To cause light to be randomly redirected by reflecting it off an uneven surface. 2. Rayleigh scattering.

Scotopic Pertaining to the ability to see in dim light.

Self-scanned arrays An integrated circuit photoelectric photodetector used to record optical images.

Self-timer A device on a camera that actuates a shutter after a specified time delay.

Sensitizing agent A material (usually a sulfur compound) incorporated in photographic emulsion to increase the sensitivity to light of the silver halide grains.

Sensitometry The quantitative study of the sensitivity of photographic materials to light.

Shadow 1. The darkest parts of the scene 2. The darkest tones of a positive print.

Sharp In focus.

Shift A horizontal or vertical movement relative to the axis of the camera of the back or lens board of a camera.

Short lighting Portrait lighting in which the main light illuminates the side of the face away from the camera.

Short scaled Pertaining to a scene for which the exposure range spans considerably less than total number of exposure zones of the zone system.

Short-toed film A film whose H&D curve changes slope somewhat abruptly at relatively low densities.

Shoulder Referring to the upper end of an H&D curve where the curve decreases in slope.

Shutter A device in a camera for controlling the length of time of exposure of the film or plate.

Shutter efficiency The ratio (in percent) of the effective exposure time to the total time that the shutter is open during an exposure.

Shutter priority automatic exposure An

automatic exposure mode of a camera in which the photographer determines the aperture and the built-in light meter controls the exposure time.

Shutter speed The length of time that the shutter of a camera is open while taking a picture.

Silver halide A compound of silver and one of the halogens (bromine, chlorine, fluorine, and iodine); silver bromide (AgBr), silver chloride (AgCl), and silver iodide (AgI) are darkened on exposure to light and are the light-sensitive constituents in photographic emulsions.

Single-lens reflex (SLR) camera A camera that allows the photographer to compose and focus the image of the subject through the same lens that is used to take the picture.

Slave unit An electronic device that is used to activate a flash unit as a consequence of the illumination of the device by light from another flash unit.

Snapshot A photograph in which the photographer has not planned and/or organized the taking of the picture.

Soft paper A photographic printing paper of relatively large log exposure range and relatively small grade number.

Solarization 1. The decrease in density of photographic material with increased exposure that can occur at a high level of illuminance. 2. A term mistakenly used to identify the Sabattier effect.

Solution physical development See *physical development.*

Spectral dye density curve A curve that presents the relative density of a colored dye as a function of wavelength; often used to characterize the dyes in color films and papers.

Spectral response The relative sensitivity of a light-sensitive material or system to different frequencies of light.

Spectral sensitivity curve A curve that presents the sensitivity of a photographic emulsion as a function of wavelength of light; used most often to characterize the spectral response of the individual emulsions in tripack color films.

Specular density Density determined by measuring only the unscattered light that is transmitted through an absorbing medium.

Specular highlight A highlight in a scene or photograph caused by reflection of light from a mirrorlike surface in the scene.

Speed point The point on an H&D curve at which the speed of a film plate, or paper is determined (e.g., the ASA film speed of a black-and-white film).

Spherical aberration An aberration of a lens in which a monochromatic point object on the axis of the lens is not imaged as a point but as a blurred circle.

Sports finder A view finder on a camera composed of a framing wire and a peep sight.

Spotlight An artificial light source that has a narrow beam and bright illumination.

Spot meter A reflected light meter whose sensitive element subtends a small angle that can be used to measure the luminance of a small area of a subject.

Stabilization An alternative to the fixing process in which the residual light-sensitive silver halides are converted to compounds that are light in color and not very sensitive to light.

Standard lens A lens for which the focal length is approximately equal to the image frame diagonal of the camera on which the lens is used.

Stop bath A weak acid solution (typically 2% acetic acid) used after the development step to stop further development prior to fixing photographic film, plates, or paper.

Stopping down To decrease the aperture of a lens (i.e., to increase the f-number).

Straight line Referring to that part of an H&D curve where the slope is constant.

Straight photography The making of pho-

tographs in which the process has been minimally manipulated.

Stripping film　A light-sensitive film using a gelatin dispersal medium on a paper support that is stripped from the support prior to making photographic copies of the images on the film.

Subtractive color　Color generated by using the subtractive primaries.

Subtractive primary　A color that subtracts one of the primary colors from white light; any one of the complementary colors of the primary colors; the colors in photography are shades of yellow, magenta, and cyan.

Sulfite　A chemical compound containing a sulfite radical (SO_3).

Swing　Rotation of the camera back or lens board of a camera about a vertical axis.

Synaptic terminal　The point of connection between the rod of the eye and the neuronal layer.

Synchronization　The timing of flash illumination so that the illumination occurs when the shutter of the camera is open.

Talbotype　See *calotype*.

Tangent　To have two surfaces, two lines, or a line and a surface in contact so that they touch but do not intersect.

Tanning developer　A developer that hardens gelatin in the emulsion in those regions where development is taking place.

Telephoto lens　1. A lens of at least two elements in which a positive lens is placed in front of a negative lens in such a way that the principal planes are placed toward the front of or in front of the lens. 2. See *long focus lens*.

Telextender　A supplementary lens for an SLR camera placed between the camera body and the camera lens that increases the focal length and reduces the aperture of the system.

Tessar lens　A lens of three elements in

which the back element is made of two cemented pieces of glass; the ancester of many contemporary lenses.

Thermographic process　A photochemical copying process in which infrared radiation is used to heat the copy paper in selected areas causing an image to be formed.

Thick lens　A geometrical description of a real lens that permits, for paraxial rays, a graphical and mathematical description of the image forming characteristics of the lens.

Thin lens　An idealized spherical lens for which the principal planes are coincident; makes possible a simplified description of geometrical optics.

Thirty-five millimeter format　A photographic image size of 24 mm x 36 mm on film that is 35 mm wide.

Thyristor　A solid-state device incorporated in the circuitry of an automatic electronic flash unit that makes it possible to preserve for later use electrical charge not used during a given flash exposure.

Tilt　Rotation of the camera back or lens board of a camera about a horizontal axis.

Time　(shutter position) A shutter speed position in which depressing the shutter release once opens the shutter and depressing it a second time closes the shutter.

Tintype　A permanent direct positive image of a subject recorded on a collodion emulsion coated on a black or brown-enameled metal surface.

Toe　Referring to the lower end of an H&D curve where the curve increases in slope.

Tones　1. the various shades of gray of a print. 2. The various luminances of the subject that give rise to the shades of gray of the print.

Toning　A process in which the usual color of a photograph is altered by an auxiliary chemical process.

Total internal reflection　The reflection of

all the light incident on an optical surface back into the material of higher index of refraction.

Transmission density See *density*.

Transmittance The ratio of the luminance of light transmitted through a developed piece of film to the luminance of light incident on the film.

Transparency A transparent photograph that can be viewed against a light background or by projection.

Transverse wave A wave in which the direction of oscillation is perpendicular to the direction of propagation.

Trichrome carbro A refined color carbon process.

Tripod A support for a camera that has three legs.

Trivariant vision Three color vision.

Tungsten illumination 1. The light from an incandescent tungsten bulb. 2. The light from a 3200 K tungsten photographic bulb.

Twin-lens reflex camera A camera that allows the photographer to use one of two identical lenses for composing and focusing the image of the subject and the second lens for forming the image on the film.

Ultraviolet radiation Electromagnetic radiation of wavelength just shorter than that of visible light and longer than that of x-rays.

Unipack film See *integral tripack film*.

Unipack paper See *integral tripack paper*.

Vacancy An unoccupied normal site for an atom in a crystal.

Value One of the three organizing characteristics of color of the Munsell color system that is somewhat analogous to brightness.

Variable contrast paper A photographic printing paper whose log exposure range can be varied by appropriate filtration of the enlarger illumination.

Variable neutral density filter A neutral density filter whose density can be continuously varied.

Velocity of light The speed with which light is propagated through a vacuum ($c = 3 \times 10^8$ m/s).

Vidicon A video camera tube that uses a photoconductor to record a video image.

View camera A large format bellows camera capable of shifts, swings, and tilts.

View finder A device on a camera that allows the photographer to see the same subject that the camera records.

Vignette To shade the corners of a picture either by design or as a consequence of the limitation of photographic equipment.

Virtual image An image formed by a lens in which the projected rays from the object appear to diverge from the image at the image plane.

Visual acuity The capability of the eye to resolve fine detail.

Visual neutral curve A curve that represents, as a function of wavelength, the overall spectral response of the three dyes in a tripack color film.

Vitreous humor The transparent viscous fluid that fills the eye.

Waterhouse stop An aperture stop consisting of a hole of appropriate size in a piece of metal.

Wave A disturbance in a medium or a vacuum that is propagated from point to point through the medium or vacuum.

Wavelength The disturbance in space occupied by one complete cycle of a periodic wave.

White point The locus on the CIE chromaticity diagram of a white composed of equal amounts of each of the three synthetic primaries of the CIE color system.

Wide-angle lens A lens of short focal length compared to a standard lens that allows a larger field of view and greater depth of field than a standard lens.

Winder A device on a camera for auto-

matically cocking the shutter and advancing the film after a frame has been exposed; usually operates at a slower rate than that provided by a motor drive.

Woodburytype A permanent copy made photomechanically utilizing bichromated gelatin in a process invented by Walter B. Woodbury.

Xerography A photoelectric copying process in which a photoconductor is used to transfer the image of the original to the copy paper.

X sync The flash synchronization used with electronic flash units.

Zeiss planar lens A symmetrical lens designed about 1900 that is the ancestor of many modern standard lenses used on small format cameras.

Zone See *exposure zone*.

Zone system A system for determining exposure and development of film or plates that allows the photographer to systematically manipulate the photographic process to achieve the photographer's predetermined goals.

Zoom lens A variable focal length lens designed so that any selected image remains in focus as the focal length of the lens is changed.

Index